HOW BEAUTIFUL IT IS

AND HOW EASILY IT CAN BE BROKEN

HOW BEAUTIFUL IT IS

AND HOW EASILY IT CAN BE BROKEN

———

Essays

DANIEL MENDELSOHN

HARPER ● PERENNIAL

NEW YORK ● LONDON ● TORONTO ● SYDNEY ● NEW DELHI ● AUCKLAND

HARPER ● PERENNIAL

All of the pieces in this collection originally appeared, in slightly different form, in *The New York Review of Books*, with the following exceptions: "The Passion of Henry James" and "The Truman Show" (*The New York Times Book Review*); "The Man Behind the Curtain" (*Arion*); and "Theaters of War" (*The New Yorker*). Grateful acknowledgment is made for permission to reprint here.

A hardcover edition of this book was published in 2008 by Harper, an imprint of HarperCollins Publishers.

HarperCollins books may be purchased for educational, business, or sales promotional use. For information, please e-mail the Special Markets Depart- at SPsales@harpercollins.com.

FIRST HARPER PERENNIAL EDITION PUBLISHED 2009.

Library of Congress Cataloging-in-Publication Data
Mendelsohn, Daniel Adam.
How beautiful it is and how easily it can be broken : essays / Daniel Mendelsohn.—1st ed.
p. cm.
ISBN: 978-0-06-145643-5
1. Motion pictures—Reviews. 2. Books—Reviews. 3. Theater—Reviews. I. Title.
2008 PN1995.M432
809—dc22 2007048282

ISBN 978-0-06-145644-2 (pbk.)

18 19 ID/RRD 10 9 8

for

Bob Silvers

Chip McGrath

and for

Bob Gottlieb

Contents

―――――

Introduction:
How Beautiful It Is
And How Easily It Can Be Broken

The words *critic* and *critical*, which tend to leave a slightly sour taste in the mouth of contemporary American culture ("Don't be so critical!"; "Everyone's a critic!"), are derived, indirectly, from the Classical Greek word *krinô*, "to judge." The noun that comes from that verb, *kritês*, simply denotes a person who makes judgments—this being another word that provokes a certain anxiety today. ("Who am I to judge?"; "Don't be so *judgmental!*") For the Greeks, a *kritês* could be any number of things: an arbitrator in a dispute; a historian (who, according to one Greek author writing in the second century A.D., must approach his raw data in the manner of an interrogating judge in a legal proceeding); an interpreter of dreams; or one of the aesthetic referees who judged the fiercely competitive theatrical competitions held each spring in Athens. The playwright Aristophanes liked to interrupt the action of his comedies in order to make flattering appeals to this or that *kritês* watching the show. Not infrequently, he won.

Critic, then, is a word with a rich and suggestive pedigree. As, indeed, are other words derived from *krinô*, words like *criterion* (a *means for judg-*

ing or trying, a *standard*) and—a word that you might not have suspected
is even remotely related to "critic"—*crisis*, which in Greek means a *sepa-
rating*, a power of *distinguishing*; a *judgment*, a *means of judging*; a *trial*.
For what is a crisis, if not an event that forces us to distinguish between
the crucial and the trivial, forces us to reveal our priorities, to apply the
most rigorous criteria and *judge* things?

This book is a collection of judgments: which is to say, a collection
of essays by a critic. As might be guessed from the foregoing excursion
into etymologies, the critic in question has a background in Classics.
In the late 1980s and early 1990s I did my graduate work in Greek and
Latin, with an eye to a career in academia; instead I became a journalist.
This fact will help to explain two important features of this collection.

The first, and less important, is its content. The subjects of many of
the pieces collected here, which span a number of genres—books, the-
ater, films, and translations—and represent most of the fifteen years I've
been writing as a professional critic, have some connection with Greek
or Roman culture. There are essays about a movie version of the Trojan
War and a steroidal biopic about Alexander the Great; about an updated
feminist spin on Euripides' *Medea* and a romanticized drama about the
Classics scholar and poet A. E. Housman; about a contemporary verse
adaptation, by Sylvia Plath's widower, of a Greek tragedy about a man
who treats his wife badly, and a tendentious popular account of the Pelo-
ponnesian War. As this list suggests, I've generally been less interested
in writing about classical texts or culture per se than in taking a look at
the ways in which popular culture interprets and adapts the Classics—
not least because of what those interpretations and adaptations tell us
about the present, about us. (The Athenians may well have thought
that *Medea* was about language and politics; we think it's about desper-
ate housewives.) Only one of the essays here, in fact, is about a book
that is scholarly in nature, and that book caught my interest precisely
because it attempted to use the Classics as a weapon in a contemporary
political battle. Such attempts to use, and abuse, the classical heritage in
order to influence mainstream political and cultural discussions, from

the conduct of the war in Iraq to the legal status of gay marriage, are the object of more than one judgment in these pages.

A background in the Classics accounts for another, more important and I hope more consistent feature of this collection (which, after all, consists mostly of pieces that have no connection at all to the classical world). When you are exposed for a long time to the astringent beauties of the classical languages—the hard and unyielding grammars, the uncompromising demands of syntax and exigencies of meter, none of which admit of either shoddiness or approximation—you can develop a taste for a certain kind of rigor; you may begin to seek it elsewhere. To my mind, that rigor serves as a kind of template not only for the method that the critic necessarily applies to his subject (art, theater, film, dance, literature, whatever) but also for the qualities to be sought in the works themselves. Those qualities are: a meaningful coherence of form and content; the subtle but precise deployment of detail in the service of that meaning; vigor and clarity of expression; and seriousness of purpose. Since I see no reason why those standards shouldn't be imposed on (and those qualities sought in) the products of mainstream culture—at least those with aspirations to seriousness—as much as on those of high culture, I've attempted to seek, and to impose, accordingly in my own critical writing.

Those conjugations, declensions, and meters can take you away from texts altogether; can give you a taste for what you might call the infinite interpretability of things—not of this or that book or play (with their hidden coherences, turns of phrase, and elegances of poetic diction, which, armed with your paradigms and dictionaries, you eventually learn to decipher) but of whole cultures. These, too, can in their way be reduced to their essential components—to their grammars and vocabularies, so to speak. Civilizations, too, can be "read." (And judged.) It says something significant, for instance, about the Greek conception of the mind and its activities that hidden in the very old verb *oida*, "to know," is a fragment of an even more ancient word, *Fid-*, "to see." (It's the *vid-* in *video*.) And it might well say something meaningful about the

Greeks and their understanding of the complicated and perhaps inevitably tragic relationship between art, which gives meaning to life, and death (which gives meaning to life in a different way) that the name of that shining god of Art, Apollo, is so closely linked to the verb *apollumi*, "to destroy."

This brings me to my title—which, as it happens, has nothing whatsoever to do with the ancient world, although the words in question belong to a writer whom you could certainly characterize as the twentieth century's answer to Euripides: a modern playwright who, like his ancient antecedent, had a particular genius for creating memorable heroines as mouthpieces for universal human emotions.

"How beautiful it is and how easily it can be broken" is a quote from the stage directions to a play by Tennessee Willliams, a great American drama about the victimization of a fragile girl who is tragically in love with beautiful, breakable things: the famous glass menagerie that gives the play its title, and which of course provides a richly useful symbol for the themes of delicacy and brittleness, of the lovely illusions that can give purpose to our lives and the hard necessities that can shatter them. Interestingly, Williams's phrase occurs in a stage direction not about the play's set design but about a certain musical leitmotif he has in mind, one that (he writes, in his typically meticulous directions)

> expresses the surface vivacity of life with the underlying strain
> of immutable and inexpressible sorrow. . . . When you look at
> a piece of delicately spun glass you think of two things: how
> beautiful it is and how easily it can be broken. Both of those ideas
> should be woven into the recurring tune.

I suppose that one reason that this haunting line struck me with such force when I first came across it is that it acknowledges, with perfect simplicity, the inevitable entwining of beauty and tragedy that is

the hallmark of the Greek theater, and is a consistent element in the works that have always moved me the most, from the plays of Euripides to the *History* of Thucydides, from the light comedies of Noël Coward to the films of Pedro Almodóvar. As the Greeks knew well, it's the potential for being broken—which boils down to the knowledge that we all must die—that gives resonance and meaning to the small part of the universe that is our life. The necessity, in the end, of yielding to hard and inexplicable realities that are beyond our control is a *tragic* truth; without that, all you've got is mush—melodrama, and Hallmark sentimentality. That so much of contemporary culture is characterized by this kind of sentimentality, by a seeming preference for false "closures" over a strong and meaningful confrontation with real and inalterable pain, is a cultural *crisis.* That crisis is another theme that runs through many of the essays here.

But to my mind Williams's haunting phrase illuminates not only the nature of certain works that have preoccupied me, but also something about the nature of the critics who judge those works. For (strange as it may sound to many people, who tend to think of critics as being motivated by the lower emotions: envy, disdain, contempt even) critics are, above all, people who are in love with beautiful things, and who worry that those things will get broken. What motivates so many of us to write in the first place is, to begin with, a great passion for a subject (Tennessee Williams, Balanchine, jazz, the twentieth-century novel, whatever) that we find beautiful; and, then, a kind of corresponding anxiety about the fragility of that beauty.

Many of the reviews here are, in fact, judgments about the success of contemporary attempts to interpret, or adapt, or reexamine subjects about which I have deep feelings: the grand and glittering Homeric epics and Virginia Woolf's gossamer *Mrs. Dalloway*; the comedies of Mel Brooks or the tragedies of Euripides; the Classics as a symbol, now being used and abused by this or that faction (the gays, the neocons) to score points in the Culture Wars. And those pieces that are about new work for which there is no original still seek to make use of stan-

dards, of criteria, that like so much of contemporary culture are, in fact, rooted in certain ancient traditions which are themselves beautiful—and fragile. If I mention Aristotle's or Horace's theories of poetry in my review of *Troy*, it's not out of some kind of loyalty to my subject—product placement for the Classics—but because no one has ever stated as crisply and usefully just what it is that epic is supposed to do for its audience.

Respect for the integrity of the original stems, indeed, not from some blind curatorial reflex (hence my conclusion, in one of these pieces, that Aeschylean tragedy is better served by productions that put, say, a bathtub and some circular saw blades onstage than by "authentic" stagings complete with ancient-looking muslin cloaks and sandals), but instead precisely from a sense that the classics of any genre are classic in the first place precisely because they have always been, and will always be, deeply relevant to, and incomparably illuminating of, human experience. That relevance, that ability to enlighten, are themselves rather beautiful; they're the ultimate standards, *kriteria*, by which any work is judged.

Rather than organizing the pieces collected here chronologically or by genre, I've grouped them according to some broad categories. When you first start writing as a freelancer, you're happy to take whatever work you can get; over time, though, it becomes clear both to your editors and to yourself that there are certain subjects you're attracted to, certain motifs you keep finding no matter what you're writing about. Another way of saying this is that however random the assignments you accept, you always end up writing your own intellectual autobiography. As I read over the past fifteen years' worth of my articles and reviews, I was struck by the way in which, however diverse the subjects under review—*The Lovely Bones* and *Brokeback Mountain*, Henry James and *United 93*—I've kept returning to certain general themes. These themes, perhaps not surprisingly, are the same ones that interested me

when I was a graduate student in Classics working on a dissertation about heroines in Greek tragedy and the heroes they often compete with, and sometimes displace, in times of civic crisis or war: the representation of women and men, of femininity and masculinity, in popular culture; gender and sexuality—particularly, since I'm gay, homosexuality; the techniques of tragedy and comedy; the translation and adaptation of classics for general audiences; and the often fraught intersection of literature and war. So I've organized my essays accordingly here, although they can of course be read in any order at all.

—*New York City, October 2007*

PART ONE

Heroines

Novel of the Year

On May 22, 2002, six weeks before the official publication date of Alice Sebold's debut novel, which is narrated from Heaven by a fourteen-year-old girl who's been raped and murdered, the novelist and former *New York Times* columnist Anna Quindlen appeared on the *Today* show and declared that if people had one book to read during the summer, "it should be *The Lovely Bones* by Alice Sebold. It's destined to be a classic along the lines of *To Kill a Mockingbird*, and it's one of the best books I've read in years." Viewers did what they were told, and seemed to agree. Within days of Quindlen's appearance, Sebold's novel had reached the number-one position on Amazon.com, and her publisher, Little, Brown, decided to increase the size of the first printing from 35,000—already healthily optimistic for a "literary" first novel by an author whose only other book, a memoir, was a critical but not commercial success—to 50,000 copies; a week before the book's official publication date, it was in its sixth printing, with nearly a quarter million copies in print.

One week after publication, after *Time* magazine's book critic Lev Grossman had declared the novel "the breakout fiction debut of the year," the book was in its eighth printing, and there were 525,000 copies

in print; two weeks and three additional printings later, the number was just under a million. By the end of September, it had become clear that the book was a phenomenon of perhaps unprecedented proportions: an eighteenth printing of a quarter million copies, itself more than seven times the number originally planned for the first printing, put the number of copies in print at over two million. Such figures suggest that this work may be more than merely the novel of the year: the Barnes & Noble fiction buyer has declared that "a book like this comes around once in a decade." If not, indeed, longer. Little, Brown's marketing director has commented that it's "one of those books that rarely comes along, that reminds you why you chose this business."

Reviews of *The Lovely Bones* have been almost uniformly good, ranging from very warm (Michiko Kakutani, in the *Times*, called it "deeply affecting") to ecstatic (*The New Yorker* called it "a stunning achievement"); but the pattern of the book's remarkable rise to preeminence among novels published during the past year, if not the past few years, suggests that it owes its success to word of mouth. Indeed, it must be remembered that its spectacular rise was achieved without the help of the now-defunct Oprah's Book Club, which floated more than one small first novel onto the best-seller lists.

So there can be no question that the book's popular appeal is deep and authentic. One measure of this is the fact that while the novel has, in its fifth month after publication, finally fallen to the second spot on the *Times* best-seller list, and to the fifth on Amazon.com, it has received a remarkably high number of customer reviews—842, as of this writing—this being perhaps the real measure of reader engagement. By contrast, Ian McEwan's *Atonement* (a best-selling book, according to Amazon, that readers of *The Lovely Bones* are also buying) is number thirty-five in ranking, with less than a quarter of the number of customer reviews that Sebold's book received; *Austerlitz*, by Sebold's near namesake, the late W. G. Sebald, has a ranking of 2,073 and a mere thirty-eight customer reviews. Proust's ranking is 9,315, with fifty-seven reviews.

In an interview with *Publishers Weekly* at the end of July, when the true extent of the book's success was just coming into focus, Michael Pietsch, the publisher of Little, Brown, suggested that the book's appeal lies in its fearless and ultimately redemptive portrayal of "dark material": "grief, the most horrible thing that can happen in a life." The

author herself concurred, suggesting, in an interview on *The Charlie Rose Show* at the end of September, that her first-person approach allowed her to do some serious "truth telling" about the terrible things that happen in her novel. "I mean, there's no bullshit in the fourteen-year-old perspective, and so I think readers are drawn to that. 'Here's something horrible. Let's look at it.'"

Others trying to account for the novel's remarkable popularity have made special mention of Sebold's ability to "tell you the most heartbreaking things with grace and passion," as one Barnes & Noble official put it. As various commentators have noted, one of those heartbreaking things is that dreadful violence is often done to young girls: the novel appeared soon after the national news media widely, even avidly reported a series of horrifying abductions, some of them taking place in broad daylight, of girls who were subsequently murdered. This, of course, is merely a bizarre coincidence—Sebold started work on *The Lovely Bones* in 1995—but one that has made the novel "very timely," as the fiction buyer for the Borders bookstore chain noted in July, and as both Sebold and Rose noted during the course of their discussion.

And yet darkness, grief, and heartbreak are what *The Lovely Bones* scrupulously avoids. This is the real heart of its appeal.

The novel begins strikingly. In the second sentence, the narrator declares that "I was fourteen when I was murdered on December 6, 1973." The few pages that follow, describing Susie's rape at the hands of a creepy neighbor, Mr. Harvey (he builds dollhouses in his spare time), are the best in the book. "As I shook," the dead Susie recalls of the aftermath of the rape, which takes place in an underground chamber that Harvey has constructed in a cornfield near the high school Susie attends, "a powerful knowledge took hold. He had done this thing to me and I had lived. That was all." This has the cold, flat feeling of real life, devoid of self-dramatization or false emotion. The authenticity of this brief scene surely owes something to the fact that the author herself was brutally raped as a Syracuse coed in 1981, an experience that was the subject of her memoir.

And yet the arresting quality of the writing in these few pages almost immediately disappears. Sebold's bold decision to have the dead

girl narrate her story—a device familiar from *Our Town*, a sentimental story with which this one has more than a little in common—at first suggests an admirable desire to confront murder and violence, grief and guilt in a bold, even raw new way. And yet once it's dispensed with that attention-getting preface (the narrative proper consists of Susie's recounting, from her celestial vantage point, of the aftermath of her murder—the faltering search for the killer, the effects of the crime on her family and a handful of her junior high school friends—over the course of a number of years), *The Lovely Bones* shows little real interest in examining ugly things. Indeed, even in the prefatory scene, the ultimate horror that Susie undergoes is one for which the author has no words, and chooses not to represent. In the first of what turn out to be many evasive gestures, the author tastefully avoids the murder itself (to say nothing of the dismemberment). "The end came anyway," she writes, and there is a discreet dissolve to the next chapter.

I use the word *dissolve* advisedly: it is hard to read *The Lovely Bones* without thinking of cinema—or, perhaps better, of those TV movies of the week, with their predictable arcs of crisis, healing, and "closure," the latter inevitably evoked by an obvious symbolism. (In Sebold's novel, Susie's traumatized little brother will, as he grows older, abandon a fort that he has built in the family's backyard for a garden that he decides to plant.) Moments clearly meant to be powerful indications of how the characters are "handling" their grief are presented by means of a mannered shorthand that nowhere feels like real dialogue between living people; the rhythms of Sebold's scenes are the pat, artificial rhythms of television. Here is the scene in which, some time after the murder, Susie's beloved sister, Lindsey, young as she is, learns that only one body part has been found, and demands to learn which part it is:

> Lindsey sat down at the kitchen table. "I'm going to be sick," she said.
> "Honey?"
> "Dad, I want you to tell me what it was. Which body part, and then I'm going to need to throw up."
> My father got down a large metal mixing bowl. He brought it to the table and placed it near Lindsey before sitting down.
> "Okay," she said. "Tell me."

"It was an elbow. The Gilberts' dog found it."

He held her hand and then she threw up, as she had promised, into the shiny silver bowl.

A great many of Sebold's scenes end on little "beats" like this: it's a kind of writing that coyly suggests, rather than vigorously probes, the feelings and personalities of it characters. The resultant tone, throughout the book, is not, after all, grief-stricken, or harrowingly sorrowful, as Sebold's admirers would have it, but a kind of pleasant wistfulness, a memory of pain rather than pain itself. And we just know that, somehow, the pain will make these characters stronger. It comes as no surprise that Lindsey emerges as the toughest, most resilient member of the Salmon clan.

Equally soft-focus are the novel's confrontations with the face of evil that Susie, and Susie alone of all these characters, has looked on directly: the killer himself. Given the glut of literature on sociopaths and serial killers that's available today, it's striking that Sebold's portrait of Mr. Harvey is so perfunctory; the author's sketchy allusions to the origins of Harvey's criminal nature, and the rather offhand details she occasionally throws in, hardly add up to a textured, much less a persuasive, portrait. You're told at one point that Harvey kills animals sometimes in order to avoid killing people; you're told somewhere that the killer's father abused and eventually chased away his wild, rebellious mother, whom the young Harvey sees for the last time, dressed in white capri pants, being pushed out of a car in a town called, none too subtly, Truth or Consequences, New Mexico. But these details, if anything, only make you realize how uninterested Sebold really is in the evil perpetrators in her story, as opposed to the adorable victims.

Consequences, indeed—which is to say punishment, the moral meaning and ramifications of the crime at the heart of her book—are something that Sebold treats as weakly as she does the crime itself. At the end of the novel, in what is apparently meant to be a high irony, Harvey, who has managed for years to elude Susie's increasingly suspicious family and the police, is killed accidentally: as he stands at the edge of a ravine, plotting to attack yet another girl one winter day, he

falls when an icicle drops onto him. This is meant by the author as a grim joke: earlier on, as Susie follows the careers of her sister and some high school friends, there's an episode in which a bunch of gifted kids at a special camp is challenged by their counselor to plot the "perfect murder"; Susie, observing this from Heaven with what can only be called an admirable equanimity, suggests that an icicle would be the perfect murder weapon, because it melts away, leaving no evidence. (This is, as we know, the solution to an old middle-school brain teaser.) The connection between the camp competition and the way that Harvey ends up dying suggests, again with a typical coyness, that a perfect retribution has indeed taken place; but it's a cute, rather than morally satisfying, way to settle the murderer's fate. The real irony here is, if anything, unintended. Without the arch setup of the "perfect murder" competition, Harvey's accidental end would have been interesting, and perhaps suggestive of the operations of a larger cosmic order (or not); with Sebold's laboriously constructed joke, however, the murderer's death becomes one more piece of a narrative puzzle that falls, all too often, rather patly into place.

So having the murder victim be the protagonist offers no special view of evil, or of guilt. I asked myself, as I read *The Lovely Bones*, what could be the point of having the dead girl narrate the aftermath of her death—what, in other words, could this first-person voice achieve that, say, a conventionally omniscient third-person narrator couldn't— and it occurred to me that the answer is that Susie is there to provide comfort: not to those who survive her, to whom (in Sebold's cosmology) she can't really make herself known or felt, but to the audience. Instead of making you confront dreadful things, Sebold's novel, if anything, keeps assuring you that those things have no really permanent consequences—apart from the feel-good emotional redemptions experienced by all of Susie's survivors, and indeed by Susie herself. Susie, we learn, has to be weaned of her desire to linger in the world of the living and "change the lives of those I loved on Earth" in order to progress from "her" heaven to Heaven itself. The cosmology is vague— more shades of *Our Town* here—but that's the point: *The Lovely Bones* is designed not to challenge, but to soothe. The novel's real subject is this process of soothing (which is to say of healing and "closure") as it is experienced by her family and friends.

The latter are a fairly predictable bunch. There is Ruth, the class misfit ("her intelligence made her a problem"), who's "touched" by Susie's spirit as it rushes across the cornfield on that fateful night, en route to Heaven, and who hence develops a special sensitivity to the ghosts of murdered females, which she tends to glimpse while wandering around New York City after she leaves her hometown. And there's Ray Singh, another misfit, a handsome Indian boy who's Susie's great junior high school crush, and who goes on to become a medical student with (again) a special intuition about the souls within the bodies on which he operates. These characters aren't particularly textured or original— it somehow comes as no surprise that buxom Ruth is a latent lesbian and ends up living in a closet-sized room in the East Village—but they are part of milieus that Sebold does have real flair for describing: the suburbs, with their submerged but powerful hierarchies and taboos (Sebold is good on the way Ray's family, to say nothing of Harvey, are quietly marginalized by their more "normal" neighbors); and the abstruse social worlds of high school kids, which the young Susie, in some of the novel's soundest passages, is just learning to navigate when she meets her death.

More important, inevitably, is the healing process that Susie's family must undergo. The novel follows the Salmons over the course of the ten years after Susie's murder, ten years during which her mother, Abigail, has affairs and breaks free of the family, only to return at the end; her father implacably pursues Harvey, whom he knows instinctively to be the killer, and has a heart attack (but doesn't die); her sister, Lindsey, grows up, marries her high school sweetheart, and has a baby; and her younger brother, Buckley, a toddler at the time of the murder, gets to have a climactic, but not devastating, expression of his resentment at their mother for abandoning her family. (He's the one who ends up gardening.) Abigail has returned, by this point, to care for her husband after his heart attack, so that the novel ends with a family reunion.

Even this very brief description should suggest the extent to which this writer likes to stitch improbably neat sutures for some very untidy wounds. And indeed, from that initial evasion of the details of the actual murder and dismemberment to its infantine vision of Heaven as a cross between a rehab program (Susie gets an "intake counselor" when she

arrives) and an all-you-can-eat restaurant (where "all you have to do is desire" something to get it: the dead Susie is delighted to find that peppermint-stick ice cream is available all year round, postmortem), to the final pages in which Susie's family, fragmented for a time after the murder, comes together ten years after her death in a tableau marked by a symbolic redemption and rebirth (her sister's newborn daughter is named after her), Sebold's novel again and again offers healing with no real mourning, and prefers to offer clichés, some of them quite puerile, of comfort instead of confrontations with evil, or even with genuinely harrowing grief.

The most egregious, and the most distasteful, example of the latter is the climax of the novel, a scene in the final pages in which Susie "falls out" of Heaven in order to inhabit the body of Ruth for a while. Why does this happen? The cosmology that underpins this bizarre scene may, yet again, be fuzzy, but the psychology—or perhaps it's the sociology— is not. After the startling scene in which Susie returns to earth, we learn that she has assumed corporeal dimensions once more so that she can enjoy an afternoon of lovemaking with Ray Singh, who even as he is having glorious sex with "Ruth" understands that something is amiss— that the body of his living friend is occupied by the spirit of the dead one. (This is when he starts having a sixth sense about souls—about Things That Science Cannot Know, etc.) Only after Susie gets to know what really good sex is like can she "let go" of her earthly existence.

That a novel with the pretensions to moral, emotional, and social seriousness of this one should end up seeking, and finding, the ultimate salvation and redemption in a recuperative teenage fantasy of idyllic sex suggests that cinema, or television, may in fact be the wrong thing to be comparing it to. Sebold's final narrative gesture reminds you, in the end, of nothing so much as pop love songs, with their aromatherapeutic vision of adult relationships as nothing but yearnings endlessly, bliss-fully fulfilled—or of breakups inevitably smoothed over and healed with a kiss. It is surely no accident that, just after Ray and Susie/Ruth make love, Susie's estranged parents are reunited on her father's hospi-tal bed, weeping and kissing each other.

The level of Sebold's writing, it must be said, does not often rise above that of her moral seriousness. The prose wobbles between a gro-tesque ungainliness ("The time she'd had alone had been gravitation-

ally circumscribed by when her attachments would pull her back") and a nervous tendency to oversaturation with "lyrical" effects. Horror, Susie opines, is "like a flower or like the sun; it cannot be contained"—the kind of nonsense that has the superficial prettiness you associate with the better class of greeting cards. Sometimes it achieves both, as in this description of the lovemaking between Susie's distraught mother and her police detective lover: "I felt the kisses as they came down my mother's neck and onto her chest, like the small, light feet of mice, and like the flower petals falling that they were." (The placement of "falling" and "that they were" was, you suspect, something the author was very pleased with indeed.) Two lines later, Sebold is inspired to find yet a third comparandum for those kisses, likening them to "whispers calling her away from me and from her family and from her grief." The novel's subject may be a killing, but stylistically, overkill is the name of the game.

That Sebold's book does so little to show us a complex or textured portrait of the evil that sets its action in motion, or to suggest that the aftermath of horrible violence within families is, ultimately, anything but feel-good redemption, suggests that its huge popularity has very little, in fact, to do with the timeliness of its publication just months after a series of abductions and murders of girls had transfixed a nation already traumatized by the events of September 11. It is, rather, the latter catastrophe that surely accounts for the novel's gigantic appeal.

For who is Sebold's public, but one that has very recently seen innocents die horribly, one to whom Sebold's fantasy of recuperation and, indeed, an endless, video-like replay has a vital subconscious appeal? ("One of the blessings of my heaven is that I can go back to these moments, live them again," Susie comments, "and be with my mother in a way I never could have been.") A public, moreover, that is now able to see itself as an entire nation of innocent victims? Immediately after the September 11 attacks, Susan Sontag was widely vilified for having called, in *The New Yorker*, for a thoroughgoing examination of the "self-

righteous drivel and outright deceptions being peddled by public fig-
ures and TV commentators" in the wake of the event—a "campaign to
infantilize the public." Our leaders, she went on,

> are bent on convincing us that everything is O.K. America is not
> afraid. Our spirit is unbroken. . . . Those in public office have let
> us know that they consider their task to be a manipulative one:
> confidence-building and grief management. Politics . . . has been
> replaced by psychotherapy.

Confidence and grief management are what *The Lovely Bones* offers,
too: it, too, is bent on convincing us that everything is OK—whatever,
indeed, its author and promoters keep telling us about how unflinch-
ingly it examines bad things. "We're here," Susie's ghost says, in the final
pages of the novel. "All the time. You can talk to us and think about us.
It doesn't have to be sad or scary." The problem, of course, is that it does
have to be sad and scary; that you need to experience the badness and
fear—as Sebold's characters, none more than Susie herself, never quite
manage to do—in order to get to the place that Sebold wants to take
you, the locus of healing and closure: in short, to Heaven.

And what a Heaven it is. In the weeks following September 11, there
was much dark jocularity at the expense of those Islamic terrorists who,
it was said, had volunteered to die in order to enjoy the postmortem
favors of numerous virgins in Paradise. But how much more sophis-
ticated, or morally textured, is Sebold's climactic vision of Heaven, or
indeed of death, as the place, or state, that allows you to indulge a recu-
perative fantasy of great sex?

That for Sebold and her readers Heaven can't, in fact, wait is symp-
tomatic of a larger cultural dysfunction, one implicit in our ongoing
handling of the September 11 disaster. *The Lovely Bones* appeared just
as the first anniversary of the World Trade Center and Pentagon at-
tacks was looming; but by then, we'd already commemorated the ter-
rible day. September 11, 2002—the first anniversary of the attacks, a
day that ought to have marked (as is supposed to be the case with such
anniversary rituals) some symbolic coming to terms with what had
happened—was not a date for which the American people and its press

could patiently wait. Instead, on March 11, 2002, we rushed to celebrate, with all due pomp and gravitas, something called a "six-month anniversary." In its proleptic yearning for relief, and indeed in its emphasis on the bathetic appeal of victimhood, its pseudotherapeutic lingo of healing and its insistence that everything is really OK, that we needn't really be sad, that nothing is, in the end, really scary, Sebold's book is indeed timely—is indeed "the novel of the year"—although in ways that none of those now caught up in the glamour of its unprecedentedly high approval ratings might be prepared to imagine.

—*The New York Review of Books*, January 16, 2003

Not Afraid of Virginia Woolf

At the beginning of the novel in question, it is a fine June day in a great city, and a fifty-two-year-old woman named Clarissa goes shopping for flowers. She is giving a party that evening, and as she walks to the flower shop, a host of thoughts tumble through her mind. Not all of them are about her party. (Her party!) She worries, for instance, that her beautiful teenaged daughter is in thrall to a humorless middle-aged woman who is, somehow, her, Clarissa's, mortal enemy. (The woman's fierce ideological views make Clarissa feel slightly shabby in comparison; and indeed Clarissa supposes that she is, when all is said and done, quite "ordinary.") She is embarrassed to run into someone whom she hasn't invited; she has reveries about a long-ago summer in a house in the country when she and some friends indulged in illicit love affairs. (As she thinks these thoughts she is glimpsed by a neighbor who sternly, but not unkindly, judges her looks: she has aged.) She thinks, often, about death. As she stands in the shop buying the flowers, there is commotion outside—a loud noise—and when Clarissa and the florist go to the window to see what it might be, they get a glimpse of a famous head emerging from a vehicle, someone everyone knows from the papers, from pictures.

The famous head, glimpsed from afar by curious, even prurient crowds, has been placed there by the author of this novel for the purpose of contrast. This head reminds us of the great world out there, and the values by which it measures things: fame, importance, power, rank, distinction—and hence stands in stark contrast to Clarissa's head, filled as it is with a quotidian, haphazard jumble of thoughts that are of no particular importance to anyone except Clarissa herself. Clarissa's life is meant, indeed, to be one of those existences, neither brilliant nor tragic, that moved Virginia Woolf, in *A Room of One's Own*, to ponder what the proper subject and style of an authentic women's literature might possibly be. The values of novels, she argued, reflect the values of life, which novels must mirror; and it was, furthermore, "obvious" that

> the values of women differ very often from the values which have been made by the other sex; naturally, this is so. Yet it is the masculine values that prevail. Speaking crudely, football and sport are "important"; the worship of fashion, the buying of clothes "trivial." And these values are inevitably transferred from life to fiction. This is an important book, the critic assumes, because it deals with war. This is an insignificant book because it deals with the feelings of women in a drawing-room. A scene in a battlefield is more important than a scene in a shop—everywhere and much more subtly the difference of value persists.

Part of the proper work of women's writing, Woolf suggested, was to recuperate for literature "these infinitely obscure lives [that] remain to be recorded." Let men preoccupy themselves with "the great movements which, brought together, constitute the historian's view of the past." As Woolf grew as an artist, she experimented with ways to record and "bring . . . to life" another kind of experience altogether, one hitherto buried in the interstices of those great movements.

One way to do so was, indeed, to focus on the concrete minutiae of women's everyday existences—everything that men's literature, by its very nature, overlooked, an omission that led to yet larger gaps and inaccuracies. "So much has been left out unattempted," Woolf complained. "Almost without exception [women] are shown in their relation to men . . . not only seen by the other sex, but seen only in

relation to the other sex." And so, she told the audiences of the lectures that would become *A Room of One's Own*,

> you must illumine your own soul with its profundities and its shallows, and its vanities and its generosities, and say what your beauty means to you or your plainness, and what is your relation to the everchanging and turning world of gloves and shoes and stuffs swaying up and down among the faint scents that come through chemists' bottles down arcades of dress material over a floor of pseudomarble.

That which men's literature dismissed as trivia must be taken up and forged into a new kind of literature that would suggest how great were the hidden worlds and movements in women's lives; such a literature was long overdue. "There is the girl behind the counter," she wrote toward the end of *A Room of One's Own*. "I would as soon have her true history as the hundred and fiftieth life of Napoleon or seventieth study of Keats and his use of Miltonic inversion which old Professor Z and his like are now inditing."

Hence Clarissa, with her random thoughts of flowers and parties and sewing and old love affairs: she is (for all the differences in social status) that girl, just as the famous head is a reminder of the other world, the world of great movements, of Napoleons and Miltons. And indeed Clarissa is the heroine of the first great example of the literary project that Woolf advocates in *A Room of One's Own*: *Mrs. Dalloway*, first published in 1925, a few years before the essay in which she explicated that project.

And yet the novel I began this essay by describing is not, in fact, *Mrs. Dalloway*. Or, I should say, is not only *Mrs. Dalloway*. It is, rather, Michael Cunningham's *The Hours*, the 1999 Pulitzer Prize winner which is at once an homage to and an impersonation of the earlier work of fiction. (Woolf had long planned to call her novel "The Hours," but decided on *Mrs. Dalloway* in the end.) In it, three narratives about three women, each connected in some way to *Mrs. Dalloway*, are intertwined; in each of the three, numerous elements from Woolf's novel—characters, names, relationships, tiny details of phrasing, individual sentences, whole scenes (not least, the world-famous head poking momentarily

from the big vehicle)—are reincarnated with almost obsessional devotion. But perhaps the most remarkable achievement of *The Hours* is to preserve Woolf's project—to avoid the banal ways in which male novelists often see women, either dramatizing them or trivializing them, and thereby making them more comfortable for consumption by men.

"The design is so queer & so masterful," Woolf wrote in her journal, in June 1923, of the book she was struggling to write; the same words, with additional overtones, could well be used of Cunningham's reinterpretation of it. Cunningham takes his Woolfian donnée and splits it into three narratives, each a kind of riff on some aspect of *Mrs. Dalloway*. Each takes place, as does *Mrs. Dalloway*, in the course of a single day: each focuses on the inner life of one woman. The sections called "Mrs. Dalloway," set in the 1990s, are about a lesbian book editor in New York City named Clarissa Vaughan (whom her best friend and onetime lover, a poet now dying of AIDS, enjoys calling "Mrs. Dalloway"; she's giving a party to celebrate the prestigious literary award he's won). The sections called "Mrs. Brown," set in 1949, recount one fraught day in the life of an L.A. housewife, Laura Brown, who's torn between reading *Mrs. Dalloway* for the first time and planning a birthday party for her husband. And the "Mrs. Woolf" sections envision Virginia Woolf herself on a day in 1923 when she conceives how she might write *Mrs. Dalloway*. In each section, Cunningham ingeniously uses Woolf's novel as a template: like Woolf's Clarissa, each of his three heroines plans a party, has an unexpected visitor, escapes, in some sense, from the house, and tries to create something (a party, a cake, a book).

The central story is the story of Clarissa Vaughan, the woman whose preparations for a grand party, like those of Woolf's Clarissa Dalloway, are the vehicle for a stream-of-consciousness narrative that suggests a contemporary, wryly self-aware Everywoman: "an ordinary person (at this age, why bother trying to deny it?)." While this Clarissa prepares for her party, the dying poet, whose name is Richard (the given name of Mr. Dalloway in Woolf's story) worsens: just as the Great War and the Spanish flu gave poignancy and weight to Clarissa Dalloway's musings about the essential goodness and beauty of everyday existence ("life; London; this moment in June"), AIDS gives substance to the similar

thoughts of Cunningham's Clarissa ("What a thrill, what a shock, to be alive on a morning in June. . . .").

Both Clarissas, for all that they are haunted by thoughts of death, are strong. In Cunningham's novel, as in Woolf's, it is the men surrounding the women who keep falling apart. In *Mrs. Dalloway*, Clarissa's old flame, Peter Walsh, disintegrates in tears when he shows up for an unexpected visit. (He's having an affair with a much younger married woman; sensible Clarissa knows she was right to refuse his offer of marriage, long ago.) In a different part of town, meanwhile, the mad poet Septimus Smith disintegrates and flings himself from a window. Cunningham's novel reproduces these elements while updating them. His Clarissa lives in Greenwich Village with another woman, Sally (the name Woolf gave to the girl her Clarissa once kissed, long ago, in a country house); in his novel, it's an old flame of Richard's—his onetime lover, Louis—who shows up for an unexpected visit and, while Clarissa is preparing for the party, dissolves into tears. Like Woolf's Peter Walsh, Cunningham's Louis is foolish in love: he's having an affair with a male theater student who "does the most remarkable performance pieces about growing up white and gay in South Africa."

And in Cunningham's novel, too, it's a mad poet, Richard (to whom the author gives some of Septimus's lines: both characters believe they hear animals speaking ancient Greek), who spectacularly kills himself toward the end of the book—the kind of theatrical self-immolation that Western literature has typically reserved for women, whose staged disintegrations have long served as the climaxes of so many dramas and novels. In *A Room of One's Own*, Woolf hinted that behind the empire-building noise that men made, women were strong, too; that because of the patriarchal economy, their creations were more often than not children, households, families; but they did create, and could of course create art, too, if they had the means. It was just that no one had written of this strength, this creativity. In *Mrs. Dalloway*, she wrote of it—and of men's weakness; and in *The Hours*, Cunningham does too.

The other two strands of Cunningham's tripartite narrative recapitulate this important if subtle motif of Woolf's story in various ways. His "Mrs. Woolf" section is a fantasy of what might have gone through

Woolf's mind on the day that Mrs. Dalloway took shape. On that summer's day, she wakes up in Richmond (the suburb to which she and her husband, Leonard, had retreated for the sake of her fragile mental health), thinks about her book, entertains her sister, Vanessa Bell, and "Nessa"'s children to tea (they come unexpectedly early), and tries, unsuccessfully, to run off to London, whose noise and bustle she misses. (A frantic Leonard catches up with her outside the train station and fetches her home.) It is no easy or safe thing for a contemporary novelist to ventriloquize a great author who was a novelist herself, but Cunningham approaches his task with great delicacy—and no little erudition: much of the "Mrs. Woolf" section of his book is based on careful reading of Woolf's journals. The "escape" scene, for instance, is based on an episode that Woolf records in an October 15, 1923, diary entry:

> I felt it was intolerable to sit about, & must do the final thing, which was to go to London. . . . Saw men & women walking together; thought, you're safe & happy I'm an outcast; took my ticket; and 3 minutes to spare, & then, turning the corner of the station stairs, saw Leonard, coming along, bending rather, like a person walking very quick, in his mackintosh. He was rather cold & angry (as, perhaps was natural).

Cunningham delicately transforms this, in his novel, into a parable about Woolf's artistry, and her bravery—her yearning to have a full life out of which to create her art, whatever the risks.

But the real delight of the "Mrs. Woolf" portion of Cunningham's *The Hours* is its delicate, detailed, and sometimes witty suggestions about how Woolf might have come up with some of the material that appears in *Mrs. Dalloway*. In *The Hours*, Vanessa Bell's children find a dying bird in the garden, and the youngest, her daughter, Angelica Bell, makes an elaborate bier for it out of grass and roses. Peering at the tiny dead thing in its improbable nest, Virginia thinks to herself that "it could be a kind of hat. It could be the missing link between millinery and death." Readers of *Mrs. Dalloway* will remember that the wife of Septimus Smith is an Italian girl who makes hats; she is, indeed, making one just before her shell-shocked husband flings himself out the window. The hat-like bier gives Cunningham's Virginia an even more important idea: that it

is not Clarissa who must die (she loves life, the world, too much), but the mad poet. "Clarissa," Virginia thinks, "is the bed in which the bride is laid." Clarissa's life, that is to say—and her love of life, the quotidian thoughts and feelings that suggest how good she finds life, and how strong she is—must be the surround, the context, in which the death of the poet, the young man, will stand out as anomalous, impossible to integrate, "other." Another way of putting this is that Virginia will do to her male characters what so many male authors have done to their female characters.

It is the third of Cunningham's three women who has no clear referent in either *Mrs. Dalloway* or the life of its author. But this is not to say that Laura Brown, the housewife whose reading of Woolf's novel, one summer's day in 1949, transforms her life, has no basis in Woolf's work. In *A Room of One's Own*, Woolf wryly comments on the ironic way in which (as was the case in ancient Athens, she thinks; one recalls that she worked on her Greek every day) woman is "imaginatively"— i.e., in the works of male writers—"of the greatest importance," while being "completely insignificant" in real life. Hence what one must do to create a fully real woman is

> to think poetically and prosaically at one and the same moment, thus keeping in touch with fact—that she is Mrs. Martin, aged thirty-six, dressed in blue, wearing a black hat and brown shoes; but not losing sight of fiction either—that she is a vessel in which all sorts of spirits and forces are coursing and flashing perpetually.

In Cunningham's novel, Laura Brown is, in fact, just this combination of prose and poetry. Her life is an ostensibly ordinary one—her day consists of sending her husband, Dan, a former war hero, off to work, and then baking a birthday cake for him with her little son, Richie—but she is not, nor has she ever been, the homecoming queen type. Cunningham goes to considerable lengths to make sure we understand how starkly she stands out against her bland background, "the foreign-looking one with the dark, close-set eyes and the Roman nose," with

her Polish maiden name and her passion for books. Privately Laura thinks she could be "brilliant" herself. Tormented by inner demons, seething with inchoate creativity, striking-looking, she is clearly meant to bring to mind Woolf herself; her tragedy, the author suggests, is that her time, culture, and circumstances provide no outlets for her lurking creativity other than domestic ones. Baking cakes, for instance: as Laura sets about her day's work, "she hopes to be as satisfied and as filled with anticipation as a writer putting down the first sentence."

It's really Laura who's the fulcrum of the novel, a hybrid of Clarissa, with her everyday bourgeois preoccupations, and Virginia, the dark, half-mad high priestess of art. And indeed, in the novel's deeply moving conclusion, we get to see how Laura is the bridge that connects Woolf, in 1923, to Clarissa Vaughan, in the 1990s: little Richie, it turns out, grows up to be Clarissa's friend Richard, the poet. It is Laura who, through her reading of Woolf (she flees to a hotel in order to finish the book in peace and quiet), understands that the life she's living is somehow terribly wrong for her: she feels she's going mad. And it is Laura who finds reserves of terrible strength to preserve her own sanity, her authentic self. By the end of *The Hours* she's decided to abandon her family after the birth of her second child; we learn later that she moves to Toronto, where she becomes a librarian—another position that places her midway, as it were, between literature and life. Throughout *The Hours*, as throughout *Mrs. Dalloway*, it's the women who are strong, who choose life, who survive.

And so Cunningham's novel is a very interesting form of "adaptation" indeed: much more than being merely a clever repository of allusions to its model (although these are many and dazzling, and make *The Hours* a kind of scholarly treasure hunt for Woolf lovers), it transposes into a different key, as it were, the constituent elements of Woolf's novel, for the purposes of a serious literary investigation of large (and distinctively Woolfian) themes—the nature of creativity, the role of literature in life, the authentic feel of everyday living.

Cunningham has, indeed, found just the right equivalents in today's world for many of the elements you find in *Mrs. Dalloway*. Take that famous head, for example—the apparition, in Woolf's book, that serves

as symbol for the world that is made by men, for men's literature and men's values—the great world, with its preoccupation with importance and fame and status. In Woolf's novel, people wonder who that briefly glimpsed head could belong to—"the Queen's, the Prince of Wales's, the Prime Minister's?" In Cunningham's book, the scene is replicated, but this time the VIPs come from a slightly different milieu. "Meryl Streep?" they wonder. "Vanessa Redgrave?"

By a bizarre coincidence that the author of *The Hours* cannot have foreseen, the invocation of Streep's and Redgrave's names invites us to consider another kind of adaptation altogether. As it happens, Vanessa Redgrave was the star of the film adaptation of *Mrs. Dalloway*, which appeared in 1998, the same year that Cunningham's novel was published; while Meryl Streep is the star of the film that seems poised to win this year's Best Picture Oscar, Stephen Daldry's recent adaptation of *The Hours*. Daldry's film is, like its model, a grave and beautiful work, and an affecting one, too; like its model, it goes to great lengths to suggest how literature can change the way we lead our lives. For those reasons, it deserves the acclaim it has gotten. And yet elements of the adaptation suggest that it has done to *The Hours* what *The Hours* would not do to *Mrs. Dalloway*.

———

Stephen Daldry's film adaptation of Cunningham's book shows a good deal more visual imagination than did—which is to say, is a good deal more cinematic than was—his 2000 film *Billy Elliot*, a sentimental Cinderella fable about a working-class boy who dreams of becoming a ballet dancer. The new film is still, essentially, mainstream movie-making; it saves its energies for communicating, as clearly as possible, the shape of its three narratives, which as in the book are interwoven, episode by episode. (You wouldn't want Daldry to make a film of *Mrs. Dalloway* itself, a work that defies cinematic adaptation. Indeed, the adaptation of Woolf's novel that starred Vanessa Redgrave, from a script by the actress Eileen Atkins, who played Woolf onstage in her *Vita and Virginia*, failed to convey the fragmented stream of con-

sciousness that was Woolf's great achievement in the novel—her new way of "bringing to life" the experience of her ostensibly ordinary heroine.) Still, there are many effective, and affecting, visual touches that reproduce, in filmic terms, the tissues in Cunningham's novel that connect its three female figures. I am not talking here so much of the recurrent images—of eggs being broken, of flowers being placed in pots, of women kissing other women—that appear in each of the three narratives in the film, as I am of smaller but very telling touches, such as the ingenious cross-cutting between the Woolf, Vaughan, and Brown narratives. At the beginning of the film, when it is morning in all three worlds, we see Virginia bending down to wash her face; the head that rises up again to examine itself in the mirror is that of Meryl Streep, as Clarissa Vaughan.

Daldry and his screenwriter, David Hare, have, moreover, clearly thought hard about how to represent elements which, in the book, seem not to be of the highest importance, but which in the film convey the book's concerns in sometimes ravishing visual language. Early on in the novel's presentation of Laura Brown, Cunningham describes the young woman's feelings as she allows herself to be swept away by Woolf's fiction:

> She is taken by a wave of feeling, a sea-swell, that rises from under her breast and buoys her, floats her gently, as if she were a sea creature thrown back from the sand where it had beached itself.

Daldry and Hare transpose this minor moment to Laura's visit to the hotel, where it becomes an image that reminds us, in a complex way, just how "carried away" a woman (indeed anyone) can get by literature: in one of the film's most original moments (one spoiled, for the audience, by its inclusion in the theater trailers and television ads, which has resulted in a deadening of its impact in the theater), we see the pale, beautiful Julianne Moore, who plays Laura, lying on her hotel bed when suddenly the rushing waters of a river—the Ouse, surely—flood the room, buoying and then submerging her and the bed. It's just after the striking fantasy sequence involving the river waters that Laura realizes she can't kill herself. (In Daldry's film—but not in the book—the

young mother has brought a number of bottles of prescription pills with her to the hotel, and we're meant to understand that she intends to take her life there.)

More of a problem, inevitably, was the film's representation of Woolf herself. Much has been made of the prosthetic nose used to transform Nicole Kidman into Woolf for the purposes of the film, but while the fake nose has the virtue of making Kidman look less distractingly like an early-twenty-first-century movie star, it also coarsens the Woolf that we do see; the frumpy creature who appears on screen, clumping around in a housedress, breathing heavily through a broad, flat, putty-colored nose, bears little resemblance to the fine-boned, strikingly delicate woman that you see in almost any photograph of Woolf, whose mother was a famous beauty, and who herself was memorably described by Nigel Nicolson, who knew her, as "always beautiful but never pretty." Without the prosthesis, Kidman is pretty without being beautiful; with it, she is neither.

The physical appearance of the film's Woolf is only worth mentioning because it may be taken as a symbol of the ways in which the film's attempts to invoke Woolf herself, or her work, have the effect of flattening or misrepresenting her—not only Cunningham's carefully researched, if idiosyncratically reimagined, character, but also the real person. In Hare's script, for instance, Virginia announces that she's not going to kill off Mrs. Dalloway, as she'd originally intended; instead, she says, she's going to kill off the mad poet. (This is the bit that corresponds to Woolf's insight about the "bride of death" in the novel.) After Vanessa and the children have left, we see Leonard asking Virginia why she has to kill the poet. Because, Virginia announces, "someone has to die in order that the rest of us should value life more. The poet will die. The visionary." It is true that you can go back to *Mrs. Dalloway* and find there a climactic passage in which Clarissa Dalloway muses, on hearing of Septimus's suicide (it turns out that the young man's doctor is a guest at her party, and so she hears, as a piece of idle gossip, what has happened to him), that "she felt glad that he had done it; thrown it away. . . . He made her feel the beauty; made her feel the fun." But this is an implied comment by the author on her character, Clarissa Dalloway, and how she thinks about things; the scene in the film, by contrast, suggests that it's a philosophical statement by Virginia Woolf herself:

that poets must die so that the rest of us will appreciate the beauty of life, and so forth.

It is true that the film, like Cunningham's book, focuses on a small sliver of Woolf's life: the moment in Richmond immediately prior to her return to London. But it's still a serious problem that little about this frumpy cinematic Woolf suggests just why she loves London so much; you get no sense of Woolf as the confident, gossip-loving queen of Bloomsbury, the vivid social figure, the amusing diarist, the impressively productive journalist expertly maneuvering her professional obligations—and relationships. (There's a lot more of the real Virginia Woolf in her Clarissa Dalloway than this film would ever lead you to believe.) If anything, the film's Woolf is just one half (if that much) of the real Woolf, and it's no coincidence that it's the half that satisfies a certain cultural fantasy, going back to early biographies of Sappho, about what creative women are like: distracted, isolated, doomed.

There are other transpositions in the new film that distort the female characters of Cunningham's novel just as drastically, and to similar ends. It is strange, coming directly from the novel to Daldry's movie, to see the central element of Clarissa Vaughan's story—the unexpected visit from Richard's old lover Louis, who bursts into tears; a canny reincarnation, as we've seen, of the scene in *Mrs. Dalloway* in which Clarissa's old flame Peter Walsh comes to see her and weeps uncontrollably—turned inside out. For in the film, it's Clarissa who goes to pieces in front of Louis. "I don't know what's happening," Meryl Streep says as she stands in her kitchen, cooking for her party. "I seem to be unraveling. . . . Explain to me why this is happening. . . . It's just too much." Her voice, as she says these lines, cracks on the verge of hysteria. Cunningham's (and Woolf's) book places Clarissa at the center of her story: she is the subject of ruminations about objects that are male—surprisingly weak or emotionally fractured males. Daldry and Hare's film may look as if it's putting Clarissa at the center of her story—Streep's the star, after all, or one of the three gifted stars—but what the makers of the film are doing, it occurs to you, is exactly what Woolf worried that men did in their fictional representations of women: seeing women from the perspective of men.

In the film these men include, indeed, not only Louis, who in the scene I've just described sympathetically comforts the helpless Clarissa, but Richard too. In Cunningham's novel, there's a passing moment in which Clarissa Vaughan ruefully thinks to herself that she is "trivial, endlessly trivial" (she's fretting because Sally, a producer of documentaries, hasn't invited her along to lunch with a gay movie star); but in the film, she's worried that *Richard* thinks she's trivial. "He gives me that look to say 'your life is trivial, you are trivial,' " Streep says, her voice quavering. For Hare and Daldry, a "woman's story" must, it seems, involve the spectacle of women losing their self-possession in front of their men—men within the drama, and outside of it, too. Their subtle recasting of Cunningham's words makes the character into an object (of Richard's derision, of the audience's pity) when she had, in the original, been a subject.

This shift in emphases is even clearer in the Laura Brown portions of the film. Gone are Laura's darkness, her hidden "brilliance," her foreign looks and last name: here, she is transformed into the exceedingly fair Julianne Moore, who has made a name for herself in a number of films about outwardly perfect young women who are losing their inner balance (as in this year's *Far from Heaven*, and the 1995 film *Safe*). But to make Laura into a prom queen inverts the delicate dynamic of the novel—the structure that makes you aware of Laura's latent poetic qualities, her latent similarities to Woolf. In the book, her madness is that of a poet who has not found a voice; in the film, she's yet another Fifties housewife whose immaculate exterior conceals deep, inchoate dissatisfactions. I found it interesting that in the film, the date for the Mrs. Brown sections has been moved from 1949, as in Cunningham's novel, to 1951; I suspect it's because the latter dovetails better with our own cultural clichés about the "repressed Fifties." Laura's maiden name has been changed, too, from the distinctly foreign-sounding "Zielski," which it is in the book, to the distinctly Anglo "McGrath."

And in the film, we should remember, Laura goes to the hotel for the day not to read, but to commit suicide, whereas in the novel the idea of self-annihilation occurs to her only once she's in the hotel, and then only fleetingly. (That Laura may have more dire intentions is suggested by an abstruse literary allusion on Cunningham's part that has noth-

ing to do with Woolf. Laura checks in to Room 19 at the Normandy Hotel—the same room and hotel where the heroine of Doris Lessing's story "To Room Nineteen" commits suicide.)

And so this Laura, rather than being unusual and complex, is closer to a cliché of domestic repression than she is to Cunningham's character. No wonder that, in a key scene in the film—one that gives away its creators' prejudices, you suspect—this Laura gets *Mrs. Dalloway* so wrong. When she has a visit from her neighbor Kitty (whose vibrancy and seeming good health are intended by Cunningham to suggest those of Vanessa Bell, whom the real Virginia Woolf thought "the most complete human being of us all"), Kitty—clearly not a great reader—asks about the copy of *Mrs. Dalloway* she sees lying on the kitchen counter. Laura replies by describing it as a story about a woman who's giving a party and "maybe because she's confident everyone thinks she's fine, but she isn't."

The problem with this sound bite about *Mrs. Dalloway*, interpolated by the filmmakers, you suspect, for the sake of an audience that may not have read that novel, is that Virginia Woolf's Clarissa *is* fine; as are Cunningham's Clarissa and his Virginia Woolf, and even his Laura, three women who understand, in their different ways, that, as Clarissa Vaughan realizes on the last page of the novel, "it is, in fact, great good fortune" to be alive. "Everyone thinks she's fine, but she isn't" is, on the other hand, a perfect description of Laura as she appears in this film: flawless, the American dream, on the outside, but unraveling on the inside. Which is to say, a character in a film we've seen many times.

At the conclusion of *A Room of One's Own*, Woolf summed up her reasons for thinking that women should have a literature of their own: "The truth is, I often like women," she wrote. "I like their unconventionality. I like their subtlety. I like their anonymity. I like—but I must not run on in this way." I think Michael Cunningham likes women, too; his book's female characters are unconventional and subtle—the "anonymous" housewife more so, if anything, than the others. I also think that, at one level, the makers of the new film of Cunningham's book like women, too. Rarely has a mainstream film offered three more interesting roles for three more accomplished actresses, each of whom makes the most of an admittedly rare opportunity: there are moments—not least, a cli-

mactic encounter in Clarissa Vaughan's apartment between Clarissa's young daughter, Julia, and the now aged Laura Brown—that will make you cry. (I did.)

But I think these filmmakers like women in the way Virginia Woolf feared that male writers like, and use, women: these female figures are, in the end, more conventional, less subtle than what either Cunningham or Woolf had in mind. They are, in other words, more like the women we already know from the books and films that men make about women: the self-destructive, glowering, mad poetess; the picture-perfect Fifties housewife slowly cracking up in her flawless mid-century modern décor; the contemporary lesbian frazzled by the effort of caring for her best friend with AIDS, a woman who goes to pieces on her kitchen floor while wearing rubber gloves.

Still, *The Hours* is a serious and moving film, one that achieves many of its goals; among other things, it will presumably have many, many more people reading *Mrs. Dalloway* than Woolf could ever have dreamed of. That is no mean accomplishment. Perhaps it was inevitable that, of all the elements you find in her great novel, the one that the film should have reproduced most successfully is Clarissa Dalloway's—but not Virginia Woolf's—conviction that what is truly strange, unconventional, and subtle must be sacrificed so the rest of us might feel the beauty, feel the fun.

—*The New York Review of Books,* March 13, 2003

Victims on Broadway I

W hen you look at a piece of delicately spun glass," Tennessee Williams wrote in the stage directions for *The Glass Menagerie*, the 1944 play that made his name, "you think of two things: how beautiful it is and how easily it can be broken." The observation has obvious relevance to that particular drama, which famously features, as one of its symbols, a collection of delicate spun-glass animals owned by one of its soon-to-be emotionally broken characters. (As it happens, the reference to spun glass isn't a bit of pontificating about the themes of the play: Williams is trying to suggest, with typically ample, even novelistic, descriptiveness, the quality of the musical leitmotif he has in mind for his play.) But it's hard not to read that stage direction without thinking of Williams's entire theatrical output: in one way or another, nearly everything he wrote is about beauty and brokenness.

Or, perhaps, about the beauty of brokenness. For Williams, those "two things"—the beautiful and the broken—were always connected. Even if you discount the by now well-known biographical details that seem to overdetermine this recurring theme—the once-distinguished family fallen into decline; the stunted career of the father; the slightly mad, overbearing mother; the institutionalized and then lobotomized

sister—his place, time, and culture seem to have chosen his great theme for him: a recognition that the beautiful (love, romance, "art," the glories of the past) will always remain out of reach or, if briefly achieved, will always be smashed.

He was, after all, a product of the Deep South, where many families, like his, struggled to balance memories of a romanticized past with the realities of a less-than-exalted present; and he was, too, a homosexual living at a time when society still insisted on a certain furtiveness—a time when you couldn't openly acknowledge what it was you found to be beautiful. (Not, as an even cursory perusal of his memoirs suggests, that Williams bothered about secrecy.) In *The Rose Tattoo*, there's a stage direction that calls for two dressmaker's dummies, "a widow and a bride who face each other in violent attitudes, as though having a shrill argument, in the parlor." Although the argument persists throughout Williams's work, you never really doubt that it's the widow who's likely to win. Williams was the great dramatist of the beautiful failure, the poet of the noble defeat.

The sense of inevitability that haunts Williams's most powerful plays is the reason they are not tragedies in the classical sense but rather dramas of pathos. What makes classical tragedy irresistible is the spectacle of a great figure, powerful and competent, brought unexpectedly low by some flaw in himself, some bad decision rooted in his character that leads, with awful irony, to inexorable destruction. In Williams's plays, the bad decisions have already been made by the time the curtain rises; the emotional core of his drama lies not in a critical moment of choice but in the spectacle of abjection, of an already doomed, ruined person struggling to hang on to something beautiful. Greek tragedians tend to be interested in character, which is why the suffering comes at the end of their plays (it's the result of bad choices). Williams is interested in personality, which is why he begins with the suffering, with the poverty or the madness.

This is why his characters, while complex, rarely develop. He prefers, instead, to counterpose characters who represent monolithic and unchanging concepts or values—the raw energies of capitalism or of libido, say (to take the most famous examples, from *Menagerie* and *A Streetcar Named Desire*), and the delicate, even delusional, ideology of beauty and romance, an ideology that is, you could say, both charac-

teristically Southern and characteristically homosexual of a certain period—and then watch the hand play itself out as we all know it must. When you watch *Antigone* or *Bacchae*, you're always haunted by the possibility that things just might have turned out differently, because the characters seem to be independent subjects—seem, however briefly, to be in control of their own choices. When you watch *The Glass Menagerie*, you know from the start that the narcissistic Amanda Wingfield's desperate attempts to find a suitor for her crippled daughter will end up crushing the girl forever; when you watch *Streetcar*, you know, from the minute Blanche DuBois appears outside her sister's tawdry New Orleans apartment dressed in her dainty white garden party outfit, that she will end up in a loony bin.

And yet that same sense of inevitable doom, the spectacle of abjection rather than the drama of choice, is what generates the considerable emotional interest in Williams's best work. The fascination lies in the pathetic tension between the characters' illusions about themselves (the dainty white outfit) and the crushing disappointments that, we know, await them (poverty, the sordid reality of lust). We respond to his heroines not because they are particularly good—they are, if anything, often unattractive; nobody in his right mind would want Blanche DuBois as a houseguest any more than Stanley Kowalski does—but because, since we all have secret fantasies and illusions, we are bound to be moved by the spectacle of characters who can't, or won't, give in to the sordid realities of life.

In his expansive stage directions for *Menagerie*, Williams amplifies his description of the music he wanted. This melody, he said, must be

> like circus music, not when you are on the grounds or in the immediate vicinity of the parade, but when you are at some distance and very likely thinking of something else. . . . It expresses the surface vivacity of life with the underlying strain of immutable and inexpressible sorrow.

Surface vivacity competing with inexpressible sorrow: it would be hard to find a better characterization of Williams's greatest characters. The question is not whether, but rather how long, the vivacity, the beauty, can hold out against the sorrow.

A crucial feature of Williams's dramas of beauty crushed and heroic failure—a feature that does, after all, suggest a certain resemblance between his theater and Greek tragedy—is the playwright's use of female characters to represent both the aspiration toward beauty and the inevitability of defeat. In the time and place and culture that produced him, women could still serve, without irony, as useful vehicles for exploring those qualities. Few dramatists in the Western tradition apart from Euripides have made such memorable and distinctive use of women and even girls—striving, pathetic, relentless, deluded, murderous—as mouthpieces for certain kinds of repressed emotional currents. Like Euripides, Williams was, in his own lifetime, instantly marked, in the eyes of both critics and the public, by a rare imaginative sympathy for his female creations. Like Euripides, he exploited personal and cultural notions of the feminine (soft, poetic, silly, emotional, prone to madness and vengefulness, cunning) to create female characters who transcended them; like Medea and Phaedra and Iphigenia, Williams's women and girls manage to be both memorably, even frighteningly, extreme and sympathetic at the same time. Even when they do repellent things, these characters successfully gain our sympathy by their ability to articulate, or in some way to represent, everything that has been left out of the worldview of the men with whom they come into conflict onstage: delicacy of feeling, spirituality, nostalgia, fantasy, and of course art.

It is for this reason, I suspect, that Williams's plays are themselves rather fragile just now. His dramatic preoccupation with suffering, with madness and desperation, can strike us, in the Prozac era, as excessive; even more, his vision of the feminine as pathetic—which is to say, as liable to *pathos*, as vulnerable, pitiable, as well as hopelessly striving—is likely to strike us, in the post-feminist era, as dated and perhaps even embarrassing. This is why the line between his theater and camp can now seem a blurry one. A young comparative literature professor I know, when he found out I was writing about Williams, wrote an e-mail which he intended to be encouraging. "He pulls off the extraordinary feat," he wrote, "of showing how the camp is—genuinely—tragic: how camp, in fact, is genuine."

But of course Williams didn't write his plays as camp. They only

seem campy if wrenched out of the quite specific social and cultural contexts in which they organically developed. However much it can strike us as outmoded or the product of highly idiosyncratic circumstances—his family history, his homosexuality, the South, postwar sensibilities—Williams's vision of the feminine is as much a part of his distinctive style as his idiosyncratic poetic language is. In his introduction to Williams's collected short stories, Gore Vidal recalls the result of his attempts to edit Williams's prose. "So I reversed backward-running sentences, removed repetitions, simplified the often ponderous images. I was rather proud of the result. He was deeply irritated. 'What you have done is remove my style, which is all that I have.' " If you try to ignore Williams's intellectual and cultural "style," or to update it—to modernize or find feminist issues in it—the plays can't mean what they're supposed to mean, and won't produce the emotions they're supposed to produce.

This, at any rate, is the conclusion you're likely to reach after sitting through the star-studded new productions of *The Glass Menagerie* and *Streetcar* currently enjoying limited runs on Broadway. (I will write about *Streetcar* in a second article.) In each, a failure in sensitivity to the cultural mise-en-scène, to the importance of the feminine pathetic, and above all to Williams's specific requirements for its female and indeed male roles—each production features highly unconventional casting of a major male lead—demonstrates how fragile his work has become.

The Glass Menagerie is, in many ways, Williams's most emotionally delicate work, perhaps because it is his most obviously autobiographical; the characters have not yet hardened into the types, almost the stereotypes (frail belles, abusive men), who inhabit some of the later works. If the play's characters have the unresolved complexity of real life rather than the symbolic power of dramatic and psychological archetype, it's because the relationship between the domineering and manipulative Amanda Wingfield and her two wounded children—the crippled Laura, for whom the once-much-courted Amanda strives to find a "gen-

tleman caller," and the sensitive, rebellious would-be poet, Tom—bears more than a passing resemblance to that between Williams's mother, Edwina, and the playwright and his unstable sister, Rose.

Williams famously refers to *Menagerie* as a "memory play," and he wrote at great length about the "unusual freedom of convention" with which it ought to be presented in order to bring out its dominant qualities of delicacy and fragility. He suggests the use of an onstage screen on which thematically significant "magic-lantern slides bearing images or titles" might be projected ("SCREEN LEGEND: 'OÙ SONT LES NEIGES' ") and insists that the lighting not be realistic, either. ("A certain correspondence to light in religious paintings, such as El Greco's . . . could be effectively used," he goes on to say.) Music, as we know, also plays an important if impressionistic role, with that single, recurring, circus-like tune used "to give emotional emphasis to suitable passages."

Still, however impressionistic Williams wanted stagings of this play to be, it is clear from his further directions (to say nothing of the action of the play) that the design must convey the Wingfields' economic situation, which is both precarious and soul-destroying:

> The Wingfield apartment is in the rear of the building, one of those vast hive-like conglomerations of cellular living-units that flower as warty growths in overcrowded urban centers of lower middle-class population. . . . The apartment faces an alley and is entered by a fire-escape. . . . At the rise of the curtain, the audience is faced with the dark, grim rear wall of the Wingfield tenement. . . .

And so forth.

All this is important because everything that happens in the play— Amanda's obsessive invocations of her more genteel past and her desperate attempts to find her crippled daughter first a job and then a husband; her son Tom's furtive nocturnal escapades, a reaction to his dreary job at a shoe factory—is both fueled by, and made more poignant when considered against, the squalor in which the characters live. Tom's eventual decision, alluded to in a flashback but never actually dramatized in the course of the play, to leave Amanda and Laura in order to find himself as a poet and a man is so dreadful precisely because of its

material rather than merely emotional implications: without the sixty dollars a month that he earns at the shoe factory, the two women will be finally pushed over the line that separates genteel lower-middle-class hardship from true, dire poverty. If the audience does not feel this, the play goes slack—it loses its moral and emotional weight.

So it is dismaying to see the Wingfields, in the ill-conceived and clumsy set design you get in David Leveaux's new staging, inhabiting an airy, spacious, rather comfortable-looking apartment—something you might find in one of the postwar, white-brick buildings omnipresent on the Upper East Side, with a big, new sofa downstage center around which, alas, Leveaux tends to clump his actors. The fire escape that Williams calls for is dutifully represented, but it's an empty gesture, since there's no sense of the claustrophobia that makes this particular fire escape "a structure whose name is a touch of accidental poetic truth," as Williams wrote—no sense of why Tom feels compelled to flee over that fire escape each night en route to the bars (or worse) that he frequents, no sense of what it is he's fleeing from ("the implacable fires of human desperation," as it happens).

What flickerings and gleamings there are to be seen here come, if anything, from the shiny brass-and-glass furniture that the designer Tom Pye has concocted for his set, which hardly suggests imminent economic disintegration. In Williams's text, Laura's glass animals, tiny and glittering in presumed contradistinction to the drabness of the "old-fashioned what-not" that houses them, are the lustrous yet frangible icons of "beauty," of hopes that will never be realized. But in Pye's set, there's so much gleaming metal that you barely notice the play's eponymous fauna. The hideous rectangle of neon (or perhaps fluorescent) white tubing that hovers over the set, occasionally and rather distractingly going on and off, is, I suppose, Leveaux and Pye's nod to Williams's call for "non-realistic" lighting; but it sheds light on nothing in particular, except perhaps the creators' sense that they ought to innovate in some way.

The healthy middle-class polish of the sets is, in a way, reflected in the performances. Thirteen years after her Blanche DuBois received mixed reviews, the beautiful Jessica Lange has returned to Broadway as Amanda Wingfield. It is possible to admire Lange's ambition without

admiring her performance. She has played several unhinged Southern women on screen, in *Crimes of the Heart* (1986), *Blue Sky* (1994), and *Hush* (1998)—and the lobotomized Frances Farmer in *Frances* (1982)—and it may be this that gives to her Amanda a slightly prefabricated quality. (You feel you've met this woman before, somewhere.) But there is nothing in the predictable, cute fluttering, the flirtatiously broad Southern vowels, that corresponds to the playwright's instruction, apropos of this "little woman of great but confused vitality," that "her characterization must be carefully created, not copied from type."

Watching Lange's clichéd impersonation of faded Dixie womanhood, you realize that she, or perhaps Leveaux, has made the mistake of trying to find the appealing "strength" beneath Amanda's desperation—an interpretation that owes more to (and will undoubtedly appeal to) the current popular culture's investment in the bland ideology of personal self-sufficiency, of "wellness," than it does to anything in Williams's troubled text. Lange is, if anything, a big, beautiful woman—she radiates a feline, almost leonine tawniness and self-confidence, and in this production she has been admired by some critics for her "lithe" presence. But for that very reason she has a hard time conveying the "frantic clinging" of Amanda, who, like many other women in Williams's plays, combines a manic repulsiveness with a heartbreaking dreaminess. Far better in the role, last year at the Kennedy Center, was Sally Field, who has the advantage of a poignant physical smallness—just getting around the stage seemed to require a kind of gritty determination, and she used that frenzied doll-like quality to advantage.

But then you never feel in this staging that either the director or the actress was particularly interested in exposing the character's less appealing side: the way in which her Southern charm has putrefied, during a life of hard knocks, into a vanity and ugliness that will destroy her family. During the play's climactic dinner party, Amanda is meant to dither around, grotesquely, in a pathetically outmoded gown from her girlhood; abetted by an obliging costume designer, Ms. Lange manages to look stunning in this scene. This reflected a lot that was wrong here. The actress seems to want to find something to admire even in Amanda's destructive "power"—the way people used to admire Madonna, say, for having "control." But Amanda's domineering isn't admirable, it's pathetic. It's admirable only in its scope, its monstrosity.

Watching Ms. Lange's performance, you are not made unpleasantly aware, as you ought to be, that Amanda is using the search for a gentleman caller for her daughter as a way of reliving her own glorious and more successful young womanhood. Nor, later, do you feel horror at the ugly devil's bargain she makes with the frustrated and unhappy Tom, on which the plot, such as it is, revolves: Amanda promises her son that she will let him leave the house and join the merchant marine, as he longs to do, if he helps to drum up a suitor for his sister. The disaster that follows is largely owing to the fact that he's in such a rush to get away that he doesn't bother to ask whether the young man he drags to dinner is already taken. Both the mother and the son act with unseemly and selfish haste, and the victim is the innocent sister. If you see Amanda as a proto-feminist heroine, as I suspect Lange and Leveaux wanted to see her, the play can't go anywhere, because there is nothing admirable about the results her "strength" produces.

The casting of the female lead has an unfortunate parallel in another choice Leveaux has made, that of the movie actor Christian Slater as the sensitive and tormented Tom—the role that's so closely modeled on the playwright himself. Tom, like Amanda, is a character of extremes, but these extremes don't mean that the character lacks subtlety and even delicacy. He is a dreamy poet who drinks hard and stays out late at night doing things Amanda can't bring herself to imagine; a gentle would-be artist who, presumably in order to set himself free, ends up abandoning the two women after the plan to find a gentleman caller for Laura fails so miserably—largely because of his thoughtlessness.

As with Amanda—as with so much else in Williams—the interest lies in the delicately established juxtapositions, in the tensions between incompatible poles of character and motivation: in Tom's case, both his gentleness and cruelty, both his adoration of Laura and his self-protective egoism. Christian Slater, an actor you rightly tend to associate with wisecracking street toughs, is not someone who conveys gentleness or sensitivity very well (strutting around the set in a leather jacket, he doesn't seem much of a poet, either). What gives Tom three dimensions onstage—what makes his decision to abandon his mother and sister so brutal—is that he is not, in fact, insensitive: he is deli-

cate enough to know what his leaving them will mean, and he does it anyway. Without this sensitivity, he's just a brute, in which case it's not clear why he acts so guilt-ridden in the play's famous epilogue, the short anguished monologue in which a tormented Tom cries out the name of the sister he has abandoned. It's a speech that should devastate you precisely because Tom (like, you're forced to realize, his mother before him) is a delicate soul who has been hardened by life, has been forced by circumstances, rather than character, to be cruel, to hurt people. That's the tragedy of the play, and it's one this *Menagerie* cannot convey.

The lack of delicacy in Leveaux's conception extends, disastrously, to the direction of the play's other characters—Amanda's lame daughter, Laura, and Jim O'Connor, the former high school star on whom Laura once had a secret crush and who, she and we realize with horror, is the well-meaning gentleman caller whom Tom drags back for dinner from the shoe factory one fateful night. Purely in terms of structure, the two roles constitute a brilliant conception: the typically Williamsesque conflict that makes Amanda so fascinating, both repellent and pathetic at once—the conflict, that is, between a hardened optimism and a poignant incompetence—is ingeniously externalized in the disastrous confrontation between Jim and Laura. Yet these are precisely the qualities that fail to come across in Leveaux's production, with the result that the heartbreaking climactic scene, in which Jim's well-meaning attentions to the delicate young woman smash her and her family's illusions forever, becomes pointless.

Of the two performances, that of Sarah Paulson, a fresh-faced and clear young actress, is the more forgivable—you can see what she was up to. Because we know a lot about Williams's life, and in particular because the madness and subsequent lobotomy of his sister, Rose, on whom Laura was to some extent based, are well-known facts of the writer's biography, Laura tends to be presented as a wispy victim—a kind of St. Louis Ophelia. But what makes the character interesting—what gives her the complexity that Amanda, too, ought to have—is that, alone of the Wingfields, Laura is the only realist, the only one who tells the truth. She can admit that she's "crippled," a truth plain to see but which Amanda cannot, until the bitter end, bring herself to acknowl-

edge, and which she covers with the kind of self-deceiving fripperies so beloved of Williams's heroines. ("Why, you're not crippled, you just have a little defect—hardly noticeable, even! When people have some slight disadvantage like that, they cultivate other things to make up for it—develop charm—and vivacity—and—*charm*!")

Laura, I'd argue, is also the only character who deals with the realities of life by resorting to a beauty that is real: art. She not only collects her lovely figurines, which give her great pleasure, but (as we learn) spends her idle time at the art museum, the zoo, the "Jewel-box, that big glass house where they raise the tropical flowers." (Her mother and brother, by contrast, withdraw into drink and delusional fantasies about themselves.) It is precisely because Laura is the sanest of the Wingfields, the one whose interest in beauty is neither morbid nor nostalgic, that the spectacle of her allowing herself to become hopeful about Jim O'Connor is so unbearable.

Still, there's no question that Laura is a victim, and here something is lacking in Paulson's performance. You never feel genuine pathos—you never feel that this Laura is, as she is surely meant to be, ultimately as fragile as her glass animals. The lack of vulnerability in this Laura makes nonsense of the play's principal preoccupation, what Williams always said he thought was the one inexcusable thing: deliberate cruelty by one person to another. (His own guilt about his treatment of his sister, at one point or another, haunts many of his plays.)

Much of the poignancy of the play, its great emotional subtlety, is that the cruelty of which Laura is the victim comes not from the stranger, Jim, but from those who profess to be protecting her—Amanda and Tom. This point is utterly lost because of the misguided performance of Josh Lucas as Jim O'Connor. Lucas, a young actor with toothpaste-commercial good looks, plays O'Connor as a slightly oily slickster who, it's obvious from the moment he swaggers onto the stage, will have no trouble penetrating poor Laura's defenses. This obtuse interpretation misses the point of Jim: he's a heartbreaker not because he's seamy, but because he's simply normal—"an emissary from a world of reality that we were somehow set apart from," as Tom tellingly puts it in his prologue speech. The sudden, mystifying flare-up of feelings that Jim didn't even suspect he could have for someone like Laura, which culminates in an unexpected kiss that is, so typically of Williams, a moment

of utter happiness that is also a moment of destruction, is moving precisely because it's genuine, not put on. That Jim then pulls back and declares that he is, in fact, engaged to another girl is not a malicious act but an acknowledgment of confusion, all too human: that's why it's so devastating. *The Glass Menagerie* can't mean a great deal if Laura is a victim of Jim's narcissism: the far more dreadful reality, which gives the play its characteristic twisted pathos, is that she—and, to some extent, Jim himself—are victims of her mother and brother, pawns of their selfish fantasies. That terrible truth is crushed if you play the scene as an encounter between a crippled girl and a manipulative suitor—a cliché that fails to arouse any feelings at all.

But then, the night I saw this performance I wondered which emotions could be at stake in a *Glass Menagerie* stripped of the nuances of character and sensibility that give the play, give each character, a deep pathos; I wondered what genre the spectacle of a gorgeous, competent mother, her tough, streetwise son, and a smug young hunk ganging up on a feisty crippled girl belongs to. Reality TV, perhaps—those spectacles in which public humiliation has become a source of casual audience amusement. And indeed, the night I saw the play, I was startled to hear people chuckling throughout that most awkward and shame-filled encounter between Jim and Laura. When Jim admits so devastatingly that he is already engaged, when he acknowledges that he's just being nice to Laura, the man next to me laughed out loud.

As the audience at the Ethel Barrymore Theatre—the theater where Williams's *Streetcar* had its New York première in 1948—leapt to its feet for the by now ritual standing ovation at the conclusion of this meaningless production of a play that is, more than almost any other in the Williams canon, about the destruction of beauty and the inevitability of failure, I wondered whether the delicate emotions of such a play are beyond current audiences: whether great drama's demand that we identify with the helpless victims, and with the strident suffering made visible to us onstage, makes us so uncomfortable today that it can only be played for laughs. As I got up to leave, a teenaged girl sitting behind me turned to her parents and said, "But I thought this was supposed to be sad." So did I. The only heartbreak in the theater that night was that there was no heartbreak at all.

—*The New York Review of Books*, May 26, 2005

Victims on Broadway II

The heroine of *A Streetcar Named Desire* is famously alert to the significance of names; "Blanche DuBois," as she flirtatiously points out early on in the play, means "white woods." ("Like an orchard in spring!") But the most meaningful name in the play may be the one that, unlike that of Blanche or her sister Stella—"Stella for star!"—is never parsed or etymologized by the characters themselves.

Throughout the published text of *A Streetcar Named Desire,* the name of the plantation once inhabited by the DuBois family—the "great big place with white columns" that pointedly represents the elevated sensibility to which the white-clad Blanche so pathetically clings—appears as "Belle Reve" (pronounced "bell reeve"). At first glance, the name looks as if it should mean "beautiful dream": *belle* after all means "beautiful" and *rêve* means "dream," and Williams's masterwork is, as we all know, about the tragic destruction of the dreams of beauty to which Blanche, like so many other of Williams's heroines, so pathetically clings. But of course *belle rêve* means absolutely nothing in French. For the French noun *rêve* (the "e" is short) is masculine; if the French Huguenot ancestors of whom Blanche boasts (in the scene in which she translates her name) had wanted to call their estate "beautiful dream," they would

have called it Beau Rêve. What they almost certainly did call it was Belle Rive, "Beautiful Riverbank," which is, in fact, pronounced "bell reeve," and which is a perfectly sensible name for a house in the Mississippi Delta.

The elision of the sensible if rather ordinary "riverbank" in favor of the far more poetic if grammatically illogical "dream" is—whether Williams intended it or not—a deeply symbolic one. On the one hand, it may be said to represent the heroine's approach to life. From the moment she shows up on the seedy doorstep of Stella and her crude husband, Stanley Kowalski, it becomes increasingly clear that Blanche's aim is to replace the mundane, even the sordid—poverty, disgrace, loneliness, encroaching middle age, all the unflattering realities that she associates, in a telling little outburst early in the play, with the naked lightbulb that hangs over Stella's matrimonial bed—with romantic illusions, using whatever means she has at hand: liquor, deceit, costumes, colored paper lanterns. "I don't want realism," she cries during her climactic encounter with her shy, sweet suitor, Mitch, after he's learned that Blanche's affected refinements conceal a dirty past. "I'll tell you what I want. Magic!" The action of the play consists of the process by which Blanche's magic is eroded and ultimately pulverized by contact with hard reality, embodied by her brother-in-law, Stanley. It is no accident that Stanley is a sexual brute who smirkingly boasts of having pulled his plantation-born wife "down off them columns" into, presumably, the mire of sexual pleasure—of having, in a way, retransformed "Belle Rêve" into the muddy "Belle Rive."

But the original metamorphosis, the enhancement of common delta clay into the stuff of illusory dreams, of "Belle Rive" into the impossible "Belle Reve," may be said to reflect another sleight of hand that takes place in the text of *Streetcar*. Here I refer to the character of Blanche herself. In a notoriously vitriolic denunciation of the play composed immediately after its March 1948 New York première, Mary McCarthy derided the "thin, sleazy stuff of this character," the kind of stock figure—the annoying in-law who comes for overlong visits—who, to McCarthy, belongs more properly to the genre of comedy:

. . . thin, vapid, neurasthenic, romancing, genteel, pathetic, a collector of cheap finery and of the words of old popular songs,

fearful and fluttery and awkward, fond of admiration and over-eager to obtain it, a refined pushover and perennial and frigid spinster . . . the woman who inevitably comes to stay and who evokes pity because of her very emptiness, because nothing can ever happen to her since her life is a shoddy magazine story she tells herself in a daydream.

It is, to say the least, difficult to reconcile this rude vision of Blanche DuBois with the iconic status she has achieved in the half century since the play's première: the vanquished but somehow ennobled female victim of male violence, gallantly exiting on the arm of her executioner, the heroically wounded prophetess of art and beauty in the face of crassly reductive visions of what life must be—an emblem, in short, of culture itself. "When, finally, she is removed to the mental home," Kenneth Tynan wrote, "we should feel that a part of civilisation is going with her."

For a production of *Streetcar* to work, McCarthy's and Tynan's wildly opposed characterizations of Blanche must both feel true. Precisely what makes the part so insinuating is the way in which it manages to hold Blanche's awfulness and her nobility in a kind of logic-defying suspension. There can be little doubt that the decision to endow her with both monstrousness and pathetic allure was a deliberate one on Williams's part. As he recalled in his memoirs, Williams began writing bits and pieces of what ended up being *Streetcar* in 1944:

> Almost directly after *Menagerie* went into rehearsals I started upon a play whose first title was *Blanche's Chair in the Moon*. But I did only a single scene for it that winter of 1944–45 in Chicago. In that scene Blanche was in some steaming hot Southern town, sitting alone in a chair with the moonlight coming through a window on her, waiting for a beau who didn't show up. I stopped working on it because I became mysteriously depressed and debilitated and you know how hard it is to work in that condition.

The close relationship between *Menagerie* and *Streetcar* explains a great deal about the later play, and in particular about the special quality of the role of Blanche. The two female leads in *Menagerie* (based loosely on Williams's mother and sister) represent—very roughly speaking—two extremes of theatrical femininity: the manipulative monster and the pathetic victim. It seems quite clear, from the passage in Williams's memoirs, that even at the earliest stages of her creation, the character of Blanche DuBois was meant to be an amalgam in one character of both female leads in the earlier play: the manic, yearning woman who trades in destructive illusions and the tragic, passive victim of those illusions. ("Waiting for a beau who didn't show up" calls to mind both Amanda Wingfield, who as we know was deserted by her husband, and her shy daughter, Laura, whose lameness will, Amanda fears, doom her to spinsterhood.) Desire, Blanche asserts toward the end of *Streetcar*, in part as an obscure justification of her own promiscuous past, is the "opposite" of death; as a figure who represents both desire and death, who embodies that typical Williamsesque grasping at beauty and the equally typical failure to seize hold of it, Blanche fuses within herself the confused, frenetically "desiring" Amanda Wingfield with the almost marmoreally passive and funereal figure of the futile Laura. (Blanche's trajectory from desire to death is famously symbolized by the fact that she's taken streetcars named "Desire" and "Cemeteries" to arrive at the neighborhood called "Elysian Fields.")

This is why, for *Streetcar* to succeed—for the play to evoke the idiosyncratic quality that is so important to Williams's sensibility, the tragic allure of broken beauty, the way in which our illusions can be lovely and destructive simultaneously—Blanche must be convincing as both a monster and a victim. Another way to put this is that she has to delude the audience as successfully as she has deluded herself; must force us, as she forces the other characters (at least for a time), to see her as she wants to be seen, as well as how she really is. It's a fine and difficult line for an actress to walk. If she's played as a delicate neurasthenic, her tragedy has no traction—she's just a loon. She is, in fact, not at all an innocent victim: she's cruel to Stella, irritatingly (and ultimately dangerously) flirtatious with Stanley, manipulative and deceitful with Mitch, her awkward suitor; and as we know, she herself is guilty of the kind of deliberate cruelty to another human being which Williams held to be

particularly reprehensible. (We learn that, years ago, her young homosexual husband killed himself after she humiliated him at a dance.) If, on the other hand, you strip away all the pathos, she's just an alcoholic fabulist—the comic strip figure of McCarthy's vision, the pesky in-law who hogs the bathroom.

It is precisely between the pathological delusions and the unpleasant manipulativeness that the fascination of this character lies. Blanche is enormously appealing, both to the many actresses who yearn to play her and to the audiences who continue to yearn to see her again and again having her nervous collapse, because she has the same kind of outsized, illogical, but nonetheless irresistible character that Medea and Clytemnestra do. None of the three is conventionally sympathetic, since they all do reprehensible things, and yet they are unmistakably heroines, too. Like her Greek tragic sisters, Blanche is caught in a hard world, ruled by aggressive men; however repellent the few tricks women have at their disposal—deception, seduction, "magic"—these characters must somehow evoke our sympathies more than our revulsion.

I've dwelt at some length on the character of Blanche DuBois because she is, in a way, a kind of template for the play itself, which like Blanche suffers from a certain degree of illogic, perhaps even self-delusion. I am not referring to certain aspects of the plot or narrative that other critics have found troublesome, in particular the way in which Williams, for neither the first nor the last time, overloads his characters and action with rather an excess of psychological and historical baggage. (Would our sense of the play, or even its meaning, be radically different if Blanche, in addition to being a drunk, having lost the family estate, and having been run out of town for being a tramp, hadn't also had a gay first husband who'd shot himself at a cotillion? Probably not.)

But it's interesting how this play, like others in the Williams repertoire, never seems to work through a coherent position with respect to the key terms with which it seeks to create its meanings, terms such as *realism* and *beauty* and *lies* and *truth* and *art*. Perhaps its greatest sleight of hand is to have convinced so many people that it's about the losing battle between beauty, poetry, and fantasy, on the one hand, and crassness, vulgarity, and brute "realism" on the other—and convinced them to root for the former—without ever quite engaging the provocative question of why "reality" must always be ugly, and why "art," in these

plays, is always presented as a liar, always has such an aversion to the truth, to reality—which of course good art does not. In a way, the play, like Blanche, succeeds only if it doesn't make you wonder about such internal inconsistencies—doesn't, as it were, make you wonder about "Belle Reve."

The special complexity and richness necessary for a performance of *Streetcar* to succeed on its creator's terms are wholly lacking in the big new production of the play that has just opened on Broadway, starring Natasha Richardson and John C. Reilly. As with the equally vacuous production of *Glass Menagerie* which is running concurrently, the problem lies essentially in a failure by the director and the lead actress to understand the central female part—a particularly costly error when performing Williams. And here again, a concomitant misapprehension about the lead male role makes nonsense of the play's themes.

Precisely because so much of what Blanche actually does onstage is part of the monstrous aspect of her character—her baiting of her sister, her seductive teasing of Stanley, the toying with Mitch, and of course the ceaseless lying—Williams again and again in his script insists on a certain visual and verbal delicacy and flutter, which are expressions of the other Blanche, the vulnerable and wounded creature who must somehow capture our sympathy. Her "delicate beauty," he instructs, "must avoid a strong light. There is something about her uncertain manner, as well as her white clothes, that suggests a moth." Indeed, as we know, from the very earliest stages of writing the play Williams conceived of Blanche as a nocturnal creature; we remember that first image of Blanche, before there was even a play for her to inhabit, "sitting alone in a chair with the moonlight coming through a window on her, waiting for a beau who didn't show up." The nervous fluttering of moth wings is audible in the speeches that Williams wrote for Blanche, too—in her stammering hesitations and anxious repetitions. ("But don't you look at me, Stella, no, no, no, not till later, not till I've bathed and rested! And turn that over-light off! Turn that off!")

These qualities are admirably conveyed in Vivien Leigh's definitive performance in the 1951 film version of the play—a film that every Blanche, and perhaps even more every Stanley, must somehow contend with. It is true that a certain degree of nuance is possible in film, with its close-ups and immaculate sound, that the stage actor must forgo. But even accounting for this, you're struck by the ingenuity and effectiveness of Leigh's performance, from the slightly desperate way she clutches Stella's arm when the two sisters embrace at their first meeting, to the slightly hysterical way her voice hits the word *tired* when she tells Stella, coming off the streetcar, that she's "just all shaken up . . . and hot . . . and dirty . . . and tired." And yet she also uses her slightly worn beauty with just the right degree of aggressiveness in her first scene with Stanley—a reminder that the fragility coexists with a certain hardness.

Neither physically nor temperamentally is Natasha Richardson, the star of the new production, suited for this exquisitely complicated role. Part of the equipment that stage actors, far more than movie actors, must work with in creating a character are the bodies and faces that God (or whoever) gave them, and in this respect it must be said Ms. Richardson has much to overcome, at least when it comes to roles that require confusion and vulnerability. She has the unthreatening, scrubbed, pleasant blond looks you associate with captains of girls' hockey teams; quite tall to begin with, she has inexplicably been given what looked to me to be six-inch heels to wear in this new production, with the result that she clomps around the stage looming over the other actors, exuding the healthy if sexless glow of an Amazon—or, given her coloring, perhaps a Valkyrie. To my mind, the heartiness of Richardson's physique is reflected in her acting. Like Gwyneth Paltrow, another daughter of a famous and gifted actress, Richardson is a star whose performances feel more than anything like the result of an elaborate series of calculations; you feel the will, the determination behind every word and gesture. In this performance, she seemed to be compensating for a lack of natural sympathy with the character by means of exaggerated tics: in particular, her hands shook violently every time she was called upon to suggest anxiety or instability—a caricature rather than a true performance.

And indeed, as I watched Ms. Richardson on two occasions, moving around the enormous and awkwardly designed set (Stella's two-room

apartment is raised on a platform center stage, so the actors are constantly having to step clumsily up or down), I kept trying to think what the awkward bigness, the loping strides, the vague quality of caricature, the fraught avidity reminded me of. It wasn't till I'd left the theater that I remembered what it was: drag performers "doing" Blanche. In this *Streetcar*, you don't get Williams's Blanche, with all her desperate contradictions, so much as a Blanche who's been mediated by the performances we've already seen—not Blanche but "Blanche," the quippy camp queen (Richardson plays for laughs a good many lines—as for instance her remark that "only Mr. Edgar Allan Poe" could do justice to Stella's run-down neighborhood—that, as Leigh's performance makes clear, are all the more telling if downplayed); Blanche the cultural icon of affirmation and determination, qualities we like to admire in women today.

Yet for all the obvious twitching and slurring, Ms. Richardson's Blanche looked like a powerful young woman at the top of her game. Watching her I found it hard not to draw comparisons between this Blanche and Jessica Lange's Amanda Wingfield in *Menagerie*. In both performances, the appalling, neurotic aspects of the characters (hardly mere tics) were being edged out, as it were, by the "strong" side—the side that has greater appeal, in other words, for today's audiences, the side that allows these women to be heroic in a way we want women to be just now.

The big, sexless Blanche of Edward Hall's new production finds her match in sexless, big Stanley Kowalski. An obvious problem of casting this part is the gigantic shadow cast by the remarkable, career-making performance by Marlon Brando, which electrified Broadway audiences and was, no doubt to the chagrin of every actor who's undertaken the role ever since, admirably preserved in the film. Hall clearly believed that the best way to avoid invidious comparisons was to avoid altogether the idea of casting someone straightforwardly sexy (someone like Alec Baldwin, who played Stanley opposite Jessica Lange's Blanche in the 1992 revival on Broadway) as Stanley.

But the perverse casting of the excellent but grotesquely inappropri-

ate John C. Reilly as Stanley, while it makes us aware that we are in the presence of a director who is eager to "rethink" a classic, suggests that this director does not understand the play. Here is what Williams asks for in his Stanley:

> He is of medium height, about five feet eight or nine, and strongly, compactly built. Animal joy in his being is implicit in all his movements and attitudes. Since earliest manhood the center of his life has been pleasure with women, the giving and taking of it, not with weak indulgence, dependently, but with the power and pride of a richly feathered male bird among hens . . . his emblem of the gaudy seed-bearer.

Reilly, who has the physique of a character actor—he's a big, soft-bellied man who slides easily into roles of long-suffering blue-collar husbands, such as the one in the Los Angeles sequences in *The Hours*—fails to suggest any of the qualities Williams seeks. The problem is not that he's rather pleasantly homely, or that he appears to spend less time in the gym than Ms. Richardson does. The problem is that he isn't someone who strikes you as a cocky "seed-bearer," or gives you the slightest impression that "pleasure with women" has been the center of his life from earliest manhood. There are large actors—John Goodman, for instance—who have no trouble convincing you that they're good in bed. Reilly is not one of them.

An intelligent actor, Reilly compensates by giving a performance that emphasizes another much-discussed aspect of Stanley's character, which is the fact that he's a working-class American of Polish descent. His Stanley is loud, bearish, crude—someone who corresponds more or less exactly to what Blanche clearly has in mind when she refers to him, contemptuously, as a "Polack." But the horrible irony of casting Reilly, or of Reilly's understandable default decision to play him as a crass vulgarian, is that the Stanley you end up getting in this *Streetcar* is itself a kind of delusion. As the entire action of the play makes clear, Blanche's harping on the class issue—her insinuations that the "Polack" is an inappropriate match for a DuBois—is a cover for what's really bothering her, which is his raw sexual allure, to which she responds flirtatiously from the very start and which of course comes back to destroy her in

the latter part of the play, when Stanley finally rapes her. ("We've had this date from the beginning," he gloats, and he's right.) To play Stanley as more vulgar than sexy is precisely to shy away from what's at the heart of the play—sex—as determinedly as Blanche, in her delusional mode, does.

It's unfortunate that neither of the leads in the current production is able to convey sexual heat, since there is evidence that Williams himself recognized that it was precisely that energy, flowing across the stage, that could dissolve some of the objections to the play's ostensible inconsistencies. In the memoirs, he tells an amusing anecdote about the 1948 New Haven tryout of *Streetcar*:

> After the New Haven opening night we were invited to the quarters of Mr. Thornton Wilder, who was in residence there. It was like having papal audience. We all sat about this academic gentleman while he put the play down as if delivering a papal bull. He said that it was based upon a fatally mistaken premise. No female who had ever been a lady (he was referring to Stella) could possibly marry a vulgarian such as Stanley.
>
> We sat there and listened to him politely. I thought, privately, This character has never had a good lay.

Wilder's objection arises out of the same critical impulse that fueled McCarthy's. ("She must," she complained of Blanche, "also be a notorious libertine who has been run out of a small town like a prostitute, a thing absolutely inconceivable for a woman to whom conventionality is the end of existence. . . .") But the power of "a good lay"—and, indeed, of desire—explains a lot of what happens in the play, from Stella's connection to Stanley to Blanche's pathetic behavior: her confusion of sex with desire, of desire with love, an emotion to which, in her life, only generic "kindness" has ever come close.

You could, indeed, say that sex is the very core of *Streetcar*'s commentary on illusion, reality, truth, and lies, since it's the object of Blanche's hypocrisy, the vehicle of her undoing. Sex and desire serve the same purpose in this play that poverty and vanity do in *The Glass Menagerie*: they are the solvents that corrode the characters' pretensions, the hard surfaces against which their delusions shatter, leaving the vulnerable

and pathetic interior visible to our shocked, and ultimately sympathetic, gaze. (The final scene of *Streetcar* should leave you with the same almost shamed horror that the final scene of *Menagerie* does.) For the revelation to which this drama leads is that despite her veneer of plantation-bred gentility, Blanche is not as white as her name so famously suggests; she was, we learn, run out of Laurel, Mississippi, for her promiscuity, which culminated in her seduction of an underage boy.

This is why it's important for the actress portraying Blanche to be able to convey the confused sexual avidity that lurks beneath her blurred and desperate gentility. She may denounce Stanley as an "animal," but she herself is all too familiar with the animal pleasures he represents. (Similarly, she chastises her relatives for having bankrupted the family through "their epic fornications"—"the four letter word deprived us of our plantation"—although, as we know, she too is an epic fornicator.) Our desire to see Blanche simplistically, as a heroine of the poetic, has made it easy to forget about her carnality, about the fact that she is, in many ways, not the opposite but the double of Stanley. What's moving about Blanche is what is moving about so many of Williams's pathetic, tortured females: not that she isn't what she claims to be—some kind of virginal "beauty" violated by Stanley's reductive, goat-like "reality" (Stanley, after all, has intense romantic feelings, and waxes poetic about lovemaking)—but that she can still cling to her notions of beauty after wallowing in so much ugly reality herself.

The tortured complexity typical of the play's characters extends to its presentation of sex: the action leads to a climactic sexual encounter between the two that is at once a rape and the inevitable culmination of Blanche's hidden desire. In the film, the sexual energy between Leigh and Brando crackles from the minute she drinks in the sight of him; the fact that Brando—it can be hard to remember this—looked almost shockingly, prettily boyish in the film, despite his muscles, gives texture to the relationship, since we know that Blanche has a special interest in teenagers. At one point, she makes a play for a newspaper boy.

But on the stage of Studio 54, there's no sexual energy, and hence no climax, no provocative complexity—there's just a lot of noise. Reilly in particular compensates for his lack of allure by turning up the volume,

with the result that you feel the potential for violence in Stanley (a character who, as even his wife admits, loves to smash things) but not the potential seductiveness, the thing that got Stella to come down off of them columns. At a certain moment during one of the performances of this *Streetcar*, I realized that Reilly reminded me of Jackie Gleason's Ralph Kramden in *The Honeymooners*—another big galoot who's rough with the women around him. Without the transformative power of sex—the power that for Williams, in so many plays, can effect the metamorphosis of the ordinary into the sublime, a power that is, like so much else in this author's work, like Blanche herself, at once base and exalted—the play had indeed become precisely the play that Mary McCarthy said it was: a simplistic farce about annoying in-laws who outstay their welcome.

Stripped of its key element, stranded between the "daring" pretensions of its director and the subtle text of the play itself, between the tragedy it is meant to be and the comedy into which it can so awkwardly descend, this *Streetcar* doesn't take you anywhere—not to desire, not to cemeteries, certainly not to the blissful Elysian Fields. You leave Studio 54, in fact, with no strong emotions at all—certainly none of the deep feelings that Williams at his best can evoke: the odd and illogical admixture of horror and pity and shamed pathos, those tenderer and more awkward emotions the unflinching exploration of which is his great talent as a dramatist, his great accomplishment as a humanist.

And a *Streetcar* thus denatured, one that leaves you politely tepid, that's about people with no particularly interesting passions, is not only a play Williams wouldn't have written—it's a play he went out of his way not to write. What else, after all, can you conclude from another, final oddity in the text of this play that has to do with the meaning of names, with the way in which verbal conventions can get elided by wishful thinking? I have always wondered why, if Blanche DuBois was indeed married at an early age to a tragic young homosexual—and if she is as invested in social propriety as she claims—she is not known, in the play, by her married name. But then, who would want to sit through a drama about a character named Blanche Gray?

The Women of Pedro Almodóvar

In the 1995 Almodóvar film *The Flower of My Secret*—a work that stands at the chronological midpoint between the director's earliest movies, with their DayGlo emotions and Benzedrine-driven plots, and the technically smoother and emotionally subtler films of the past few years—a successful middle-aged writer called Leocadia (Leo) Macías is caught, as Almodóvar's characters so often are, between the exhausting emotional demands imposed by a complicated life and the equally exhausting demands imposed by what you might as well call Art. Leo is an author of a series of very popular *novelas rosas*, romance novels (literally, "pink novels"), but her life of late has been so tortured—her handsome army officer husband is leaving her, very likely for another woman; her impossible mother is driving her and her put-upon sister nuts—that, as she tells her bemused editor, whatever she writes comes out not pink, but black.

This wry pun is meant by Leo to explain the manuscript she's just submitted, to which the editor, Alicia, has reacted not at all well. As Alicia points out to a weary Leo, the new novel, a violent tale of murder and incest whose female protagonist "works emptying shit out of hospital bedpans, who's got a junkie mother-in-law and faggot son who's

into black men," not only is appallingly inappropriate to the publishing house's "True Love" series, but violates the terms of Leo's contract, which stipulates "an absence of social conscience. . . . And, of course, happy endings." The plot of the new novel smacks less of Barbara Cartland than of Patricia Highsmith; as a sputtering Alicia puts it, it's about

> a mother who discovers her daughter has killed her father, who had tried to rape her. And so that no one finds out, she hides the body in the cold storage room of a neighbor's restaurant . . . !

When Leo, defending the artistry of *The Cold Storage Room*, gently protests that "reality is like that," Alicia launches into an outburst about "reality":

> Reality! We all have enough reality in our homes! Reality is for newspapers and TV. Look at the result! With so much reality, the country's ready to explode. Reality should be banned!

But it's clear that to Leo, the gritty reality of her lower-class characters is far worthier of artistic representation than the rose-hued, gossamer fantasy world of her earlier work. When Alicia glumly asks why Leo's writing has changed, Leo shrugs. "I guess I'm evolving," she says.

Pedro Almodóvar is a director who, over the course of a career that now spans a quarter century, has famously loaded his films with references to mass entertainment, its producers and consumers; his characters tend to be directors, talk show hosts, novelists, *toreros* (and, in *Talk to Her*, a *torera*), actresses, journalists, publishers, dancers, fans—people who are frequently shown in the act of watching dances, plays, television shows, movies, bullfights, concerts. For this reason, exchanges in his films about the nature and merits of popular genres and their ability to represent reality are not to be taken casually. And indeed, it's hard not to think of the argument between Alicia and Leo as one about Almodóvar himself—about his own evolution as an artist, a progress in which *The Flower of My Secret* seemed, as critics at the time and Almodóvar himself have commented, to mark a watershed moment.

Before then, when you talked about "an Almodóvar film," it was pretty clear what you were referring to: something with an exaggerated aesthetic, imbued with the lurid neon glare that you associated more with certain genres of entertainment—radio and TV soap operas, film noir, pop lyrics—than with anything recognizably "real." There was the flash-ily self-conscious penchant for hyperbolic (and sometimes, you couldn't help feeling, ad hoc) plotting: murder, suicide, and hostage-taking were favorite mechanisms to keep the action going (in the 1987 gay stalker melodrama *The Law of Desire*, you get all three). And—as with soap op-eras—hospitals and police stations were favorite settings. There was the hysterical pacing, which only occasionally was intentionally amusing (*Women on the Verge of a Nervous Breakdown*, the director's 1988 breakout hit, was self-consciously constructed as a filmed stage farce). Above all, there were the demimondaine characters—drag queens, transsexuals, prostitutes, junkies—who were handy, vivid symbols of the transgressive themes the then-young Almodóvar, during the heady years of the post-Franco cultural explosion, was clearly eager to explore—and to flaunt.

Such style and such material ideally suited the over-the-top passions that have always been this director's subject, passions that, like those in soaps, were never less than excessive—and, too often, excessively sym-bolic. (In *Matador*, the male and female leads are a former matador and his icily beautiful lover, both of them serial murderers who can achieve orgasm only in the act of killing.) The very titles of the early work have a hysterical or camp edge: *What Have I Done to Deserve This?* (1984), *Tie Me Up! Tie Me Down!* (1990), *High Heels* (1991), and, most famously, *Women on the Verge of a Nervous Breakdown*. It comes as no surprise that the director's earliest champions in the United States were to be found among urban gay men, who were also enjoying, during the mid- and late 1980s, a new-found sense of political power and social visibility—and, of course, were feeling no little anxiety as well just then. Because a kind of hyperactive ebullience mixed with an edge of hysteria was the hallmark of Almodó-var's early style, too, the appearance, back then, of a new Almodóvar film felt to many of us obscurely like a confirmation. This perfect concentric-ity of the films' style and their historical moment no doubt explains why those early films, celebrated as being so gratifyingly "fabulous" at the time, feel today a bit overwrought—a bit dated.

When it came out, *The Flower of My Secret*—a film about an artist's need to outgrow an earlier, insufficiently serious aesthetic—was felt, with no little relief by Almodóvar's admirers, to signal a welcome renewal of creative energies after a number of films (*Tie Me Up! Tie Me Down!*, *High Heels*, *Kika*) in which the deliciously outré boldness or the archly knowing camp fun of earlier work like *The Law of Desire* or *Women on the Verge* had hardened into shtick. Leo, to be sure, is a woman on the verge of a nervous breakdown—her attachment to her wayward husband has a familiarly hysterical edge to it—but what's interesting in this film is the way in which that mad passion fails to lead to the kind of emotional and narrative carnage with which the director had earlier liked to conclude his films.

The Law of Desire, for instance, is also about an obsessed, rejected lover (an ostensibly bisexual young man, played by Antonio Banderas, who stalks and eventually seduces a famous film director and then kills the film director's boyfriend); but whereas the earlier film's melodramatic ending had the stalker shooting himself in his lover's arms—after a police siege and a hostage crisis, no less—*The Flower of My Secret* rejects luridly dramatic death scenes in favor of something subtler and truer. Leo's impulsive suicide attempt is foiled when, having swallowed a bottle of pills, the semiconscious woman hears her crazy mother's voice on the answering machine—at which point she races into the bathroom, forces herself to throw up, and gets on with the painful, messy business of living. The theme of eschewing melodrama for the mundane realities of everyday life is implicit in the film's trick opening, in which we see a distraught woman, whose husband or boyfriend, we are given to understand, is brain-dead, being gently pressured by two doctors to sign a donor consent form: the camera pulls back to reveal that the woman is merely an actress participating in a training exercise for physicians at a transplant clinic run by Leo's best friend.

The self-conscious turning away from hyperbole that seems to be a consistent theme in *The Flower of My Secret*—the transplant clinic feint, the rejection of *The Law of Desire*'s dénouement in suicidal violence, the shift in emotional interest from an erotic, solipsistic obsession with the lover to the dutiful relationship with a mother—looks forward to a larger change that's been in evidence over the past decade or so. Among other things, since 1995 the writer-director has seemed to realize that

invocations of and allusions to pop culture can be more than idle postmodern games or advertisements for one's own cleverness. *All About My Mother* (1999), about a woman seeking emotional meaning (not least, in mothering other people's children) after her adored teenaged son is killed in a car accident, is beautifully organized around a series of echoes of *All About Eve*, with its theme of stolen identities, and of *A Streetcar Named Desire*, with its overriding preoccupation with fragile female psyches. *Talk to Her* (2002), which begins and ends with characters watching performances of Pina Bausch works, contains a brilliantly original set piece in which we get to see scenes from a bizarre 1920s silent film—Almodóvar's invention, amusingly evocative of that era and genre—whose plot comments suggestively on his characters and their motives. (An obsessive, sexually repressed male nurse describes the film—in which a man who's been shrunk to the size of a human finger as the result of a botched experiment enters the vagina of his sleeping mistress—as he himself finally enters the body of a comatose patient with whom he's been obsessed for some time.)

Since then, too, there's been an emphasis in the films on intense feelings that somehow do not lead to seduction, murder, and suicide. (The will to survive, the desire to nurture, and the need to commemorate, for instance.) If the Oscar-winning *Talk to Her*, like *Matador* sixteen years earlier, is about bullfighters and gorings, the tone of the movie, the passions that animate it—that of a journalist for the *torera*, and of the great *torero* who is his rival for her affections—are restrained, almost somber. It's as if Almodóvar were daring himself to make a film about that aesthetically and symbolically loaded cultural institution without going over the top, as he did so gleefully in the earlier movie (which opens with a scene of the sadistic retired bullfighter masturbating to slasher films in which women are dismembered, beheaded, hanged). Indeed one of the sly surprises of the later movie is that the famous *torero* turns out to be rather sweet and nice, and touchingly attentive to his insensate lover—talking to her constantly—as the skeptical journalist, ostensibly the less macho character, does not.

The newfound emotional subtlety and technical restraint that you get in these films seems connected to a deeper appreciation of women

than was previously evident—women not as camp harpies or hysterics or vamps (which is to say women as drag icons), but as something closer to the women of real life. This is so even in *Talk to Her*, where the women are more the objects than the subjects of deep emotions; it's as if his two principal male characters' fraught attention to the comatose women they adore has elicited from Almodóvar some deeper feelings of his own. It is surely no coincidence that the most disappointing film of the director's recent period, the overwrought and overrated *Bad Education*—with its frenetically convoluted temporal layerings, its frantic Highsmithesque plot about a handsome and amoral young man whose masquerade as his own dead brother leads him to seduce both the priest who had once abused the brother and the gay film director who'd had a crush on the brother in school years before—has almost no female characters at all.

Almodóvar's finest film, *All About My Mother*, is in fact exclusively about women, of all kinds: young, old, successful, troubled, confused, strong, weak. The film follows Manuela, an employee at a transplant clinic (here Amodóvar once again recycles a motif from an earlier film) as she tries to rebuild her life after her precocious son's tragic death. The shift from men to women, male homosexual desire to maternal feeling, is signaled by a narrative feint with which the film begins. Early on there is a strong suggestion that the woman's fatherless son—with his fierce attachment to his mother, the prized Truman Capote book he's received for his birthday, and his love of camp classics like *All About Eve*—is on the verge of discovering his homosexuality, or perhaps announcing it to his mother; between those hints and the way in which the camera lingers on the beautiful face of the young actor who plays him, the film looks as if it might be the story of his coming-out.

And yet soon after meeting him, we see the boy being run over by a car after trying unsuccessfully to get the autograph of a famous actress, whose car he chases after in the pouring rain. Here we realize that it's the mother, not the son, who will be our emotional focus; it becomes, so to speak, a story told by him, rather than about him. (Almodóvar has talked about the enormous impact that *L'Avventura* had on him as a young moviegoer, and the narrative dislocation that comes in the first third of *All About My Mother* bears him out.) It's tempting to see the shift from the world of (gay) men to the world of (mostly straight) women

as parallel to another, larger evolution that occurs in the movie, and in the director's work overall—the abandonment of camp melodrama for something at once subtler and more emotionally profound. This shift is evoked by yet another narrative feint: after the boy's heart is transplanted and Manuela (who because of her job has access to confidential records) goes to spy secretly on the recipient, there's a brief moment when you think the movie is going to be about another sentimental cliché: the mother's relationship with the beneficiary of her dead son's organs. But this, too, comes to nothing, and Manuela returns home to rebuild her shattered life

Firmly grounded in reality, then, we follow Manuela over some few years as she becomes a substitute mother to several other characters: the brilliant but emotionally unstable lesbian actress who was the unwitting cause of Manuela's bereavement (played by the handsome Marisa Paredes, who had played Leo in *The Flower of My Secret*), and a young nun (Penélope Cruz) who's been seduced and made pregnant by the father, now dying of AIDS, of Manuela's dead son. (Since his affair with Manuela he's become a transsexual named Lola: even the men in this story aren't completely male.) What's remarkable about the film is that despite the presence of hyperbolic elements familiar from the earlier films—the addicts, the sex changes, the trannies, AIDS, the fatal accident, even the transplant clinic where Manuela works and where, in a horrible replay of the scenario with which *The Flower of My Secret* opens, she is compelled to sign the consent form permitting the extraction and use of her son's organs—the emotional tone is muted, tender, intense yet somehow sober. The film begins and ends with the death of a young person, but there is no question of such death being glamorized, sensationalized, or otherwise cheaply aestheticized; no question that the emphasis is on anything but life. It's as if, once again, Almodóvar were teasing us with elements from his earlier work only to bring us up short—to remind us of how far he'd come.

Looking back at the complex evolution of Almodóvar's style over the past two decades allows you, among other things, to see a secret and symbolic irony at play in Leo's argument with her editor in *The Flower of My Secret*. For Leo, greater artistic seriousness was represented by a commitment to subjects that seemed to her more grittily real, more violent, more working-class—more noir, in every sense—than the rose-

colored fantasy world of her romance novels, with (presumably) their reveries about intense attentions of men to the erotic and emotional needs of women. And yet the director's own progress to greater depth and maturity has moved, if anything, in the opposite direction.

———

The theme of returning to and suggestively recycling old material is at the very core of Almodóvar's new film, the Academy Award–nominated *Volver*, as its title reminds us. The Spanish verb *volver* means not only "to turn"—there is, indeed, a recurrent visual motif here of windmills turning—but "to return" and, with a verbal object, "to do again." Here, as in *Talk to Her*, two women are at the center of connected plots; here, as in *All About My Mother*, the emphasis is on motherhood. Most remarkably, there is here a crucial allusion to the groundbreaking *Flower of My Secret*. For the plot of *Volver* is, in fact, the plot of the very novel that Leo, in her quest for seriousness, had tried and failed to publish in the earlier film. Exactly like Leo's novel, *The Cold Storage Room*, the new movie is about a mother (here called Raimunda), a lower-class cleaning woman, who learns that her deadbeat husband has tried to rape her daughter and, after the husband is murdered, disposes of the body in a freezer in a neighbor's restaurant.

We eventually learn that these crimes—the incest, the murder, the mother's willingness to do anything to protect the daughter—are echoes of, "returns" to, earlier crimes committed by Raimunda's own mother; but this internal return is nowhere near as interesting as the larger one taking place here, which is that of Almodóvar himself once again returning, with delicious self-consciousness, to an old plot—one that sounded hopelessly excessive, too much like his own early work—and reconfiguring it, as he does here even more radically than in his other recent films, in the subtle but provocative manner of his mature style.

Volver dispenses fairly swiftly with two props of the old Almodóvar style: melodrama and men. Indeed, an arresting opening sequence suggestively emphasizes what will be the film's exclusive focus on female experience: it's a shot of the women of a small provincial town vigor-

ously cleaning the tombstones of their relatives (or, in the case of one significant character, her own tomb). It is in this context of death and hard female labor that we are introduced to Raimunda, who lives in Madrid but has come for this ritual visit to her parents' graves (we learn that the couple died together in a fire three years earlier); to her daughter, Paula, a fourteen-year-old nymphet; to her plain-looking sister, Sole; and to their old friend and neighbor Agustina, who has remained in the village and who looks after Raimunda's senile old aunt, also called Paula. A visit to Tía Paula's house is charged—characteristically, as it will turn out—with intense familial emotion and with the specter of the macabre, even the supernatural. For even as the lonely old woman tells her nieces that "the important thing is that you come back [*volver*]," we soon learn that someone else may have come back, too: the two sisters' dead mother, Irene, whose ghost neighbors claim to have seen, and who Tía Paula herself, perhaps not as crazy as she sounds, insists has been doing the housework for her and cooking her meals.

Soon we are back in the big city, Madrid, where the relationships among these women—the supposedly dead mother included, as it will turn out—are the objects of the film's restrained and loving attention. Indeed, the knifing of Paco, Raimunda's husband (a crime committed by young Paula as he tries to rape her), and the disposal of his body are handled with a semi-comical brusqueness; the fact that Raimunda gets away with cleaning up the crime scene and transporting the body from the house to a nearby restaurant freezer and then to a makeshift grave suggests the filmmaker's own desire simply to be rid of the men here, too—they're just a plot mechanism, a way of focusing our attention on the women. In earlier films in which murders occur (*The Law of Desire, Matador*), Almodóvar was clearly intrigued by the high drama afforded by police procedurals; here there are no cops on the murderer's trail, and the only procedure associated with the crime is the almost lovingly filmed sequence in which Raimunda, who cleans vast office buildings for a living, expertly and unsentimentally wipes up the blood with paper towels and then mops the floor. As a cover-up she merely tells everyone that Paco has left her and Paula; when Sole insists that he'll come back (*volverá*), "I don't think so" is the ever-practical Raimunda's opaque reply. To his credit, the director doesn't milk the line for a laugh, as he could well do—as indeed he would have done fifteen years ago.

If anything, when men turn up here, they're soon dismissed; the emphasis repeatedly returns to the bonds that connect these hardworking women. An ongoing joke of the film is the fact that after Raimunda takes over her neighbor's restaurant (typically, he's conveniently gone out of town and we soon forget about him) and makes it thrive, she repeatedly rejects the attentions of the handsome young guy, a member of a film crew, who has hired her to cater for them. The real focus is, if anything, on the way in which a couple of Raimunda's girlfriends, one of whom is a hardworking local prostitute, end up chipping in to help her with her burgeoning business—the way in which these women, without men, start to thrive. Regina, the whore, ends up helping her friend transport and bury the freezer, too—no questions asked. In earlier films, Almodóvar's women were the sort who relied on the comfort of strangers; here, they rely on each other.

It's a tribute to how intensely Almodóvar focuses our attention on female relationships that even after the graphic murder of Paco and the black comedy about the disposal of his body, the only mysteries and the only death we care to solve or to mourn are those involving women. The death is that of Raimunda's beloved Tía Paula, who, she learns after Paco is killed, has died the night before—an event to which, the women of the village insist, Agustina has been alerted by no less a personage than the ghost of Raimunda's mother. A strikingly photographed scene of the old lady's funeral, which shows us, from above, the black-clad townswomen batting their fans and surrounding Sole while we hear the insistent susurration of their prayers, suggests once again—perhaps because it suggests a hive of bees—the theme of feminine emotional solidarity.

Of the two mysteries we are meant to care about, the first has to do with the disappearance of Agustina's mother, a local eccentric who, Agustina tells Paula, had once been the rural town's only hippie, and who disappeared the day that Raimunda's parents perished—a mystery that torments her plain, kindly daughter, who is dying of cancer. (Agustina begs Raimunda to help her solve the riddle before she dies, even if it means appealing to ghosts—a suggestion that an incredulous Raimunda, never one for fanciful solutions to real-life problems, emphatically rejects.) The second mystery concerns the true identity of

the woman who's buried in Irene's tomb. For it soon evolves that the ghost story is another tease, another suggestion of narrative fancy that is soon abandoned in favor of something real. Irene, we learn, is no apparition, and when she finally makes herself known to her daughters and granddaughter, she confesses to a crime that not only explains the disappearance of Agustina's mother, but brings about a violently emotional confrontation on the part of all four women with a crime committed by the dead husband, a crime far more terrible than adultery or murder in self-defense: incestuous abuse of the young Raimunda. Irene's discovery of this crime, along with her knowledge of the husband's affair with Agustina's mother, is, we learn, what led her to set the fire that killed the adulterous couple.

The terrible secrets revealed by a sorrowing Irene explain the cause of the long estrangement between her and her now-grown daughter: the daughter's rage at the mother's failure to see what was happening, the mother's uncomprehending resentment before she did learn the truth. More emotionally significant still, the sensational revelation makes us realize that the two women are poignantly similar to each other: in the daughter the admirable spirit of the mother has, after all, "returned." Each, after all, is a mother who has been willing to incur an awful guilt in order to punish a terrible crime against her daughter: although it's the young Paula and not Raimunda who kills Paco, Raimunda makes it clear that she's willing to take the blame if the crime is ever discovered. (Incestuous abuse by a terrible father is itself a motif to which Almodóvar has returned here: it occurs as an eleventh-hour revelation in *The Law of Desire*, but there it feels gratuitous—it's just another outrageous incident among many, introduced as an attempt to explain a character's erotic life. Here, it has greater narrative significance and a profounder emotional impact.)

The irony of *Volver*'s reenactment of the fictional plot from *The Flower of My Secret* is that the real focus, the real story here, is not in fact what had seemed so repellently sensational to Leo's editor—the murders, the dead bodies, the poverty—but rather a series of subtle, complicated, intense yet finally manageable feelings among female characters, emotions that, in the new film, really do constitute a kaleidoscopic vision of what "True Love" is. The self-wounding anger borne by daughters against their mothers; the subtly etched competitiveness between close

friends and particularly between sisters (Almodóvar and his excellent cast brilliantly evoke the intricate currents that run back and forth between the plain Sole and the beautiful Raimunda, played with great effectiveness by Penélope Cruz, who seems at once more voluptuous and tougher than in her earlier work for Almodóvar, and who has certainly earned her Oscar nomination); the immense and unbearable pain felt by Irene (the great Carmen Maura), a mother who has inadvertently wounded her child by failing to see what was happening to her: these things occupy our attention to the exclusion of virtually everything else, with satisfying results.

This newly exclusive focus on deep emotions among fairly ordinary people has proved a bit disconcerting for many who have come to enjoy the cinematic brand that "Almodóvar film" has long represented. The comparatively subdued reception that *Volver* has received may have much to do with the fact that the film does not deliver the kind of fun we've come to associate for a long time with this director's work—or even with the kinds of extremities of incident and character that his fine, more recent work still revels in: the fantasy silent movies, the miraculous reanimations of comatose girls, the glitter and gore of the corrida.

Here I should mention a "return" of my own. On my first viewing of it, I was fairly unaffected by *Volver*, largely, I think, because what I saw on screen strayed so far from my expectations of it (particularly having read of the murder with which it begins). Gone were the men, the eroticizing of the masculine that to my mind had always seemed to give the director's films either a campy or an erotic traction; gone, too, was the ostentatious appeal to "marginal" elements, gone the elaborate narrative frames created by reference to icons of pop culture, the films within films and plays within films, that gave the earlier work an elaborate and sometimes delicious self-consciousness. The only bit of trashy pop culture you get in the new movie is a scene in which the cancer-ridden Agustina goes on a daytime talk show to appeal to the viewing public for information about her mother; significantly, instead of embracing that tacky form of entertainment, the film rejects it—Agustina walks off the set in disgust, and keeps her stories to herself in the end. The only performance you get here, moreover, is an almost painfully

sincere one: at the wrap party for the film crew, Raimunda, who we learn had once auditioned for a talent show, shyly sings a song called "Volver." (One lyric is "I'm afraid of the encounter with the past that's coming back.") What's interesting here is that this performance itself represents a significant moment of what you might call aesthetic refining: the song in question, familiar to denizens of the Hispanic world as a famous tango from the 1930s—a flashy bit of pop culture if ever there was one—becomes, in Raimunda's tremulous rendition, a deeply soulful flamenco piece. And the only outtake from another director's work is a terribly brief glimpse of the movie that Irene watches as she cares for Agustina: Visconti's 1951 film *Bellissima*, in which a mother goes to poignantly fantastic extremes to make her little daughter a child film star.

In Spanish, *volverse* can mean "to change one's ideas" about something. It wasn't until I myself returned and saw the film a second time—and stayed long enough to confirm the identity of the film clip you see at the very end—that the merits of this subtle new film started to affect me, and I began to see what a great change in ideas it represents. For if *Bellissima* is about a mother whose fantasies of glamour adversely affect her family's ability to live real life (the Anna Magnani character uses up their small funds for grooming little Maria), what's interesting and, finally, moving about *Volver*—what suggests that it's the logical next step from the masterful *All About My Mother*—is that in Almodóvar's new film, motherhood trumps Art. At the very end of the movie, when Raimunda, bidding her mother good night, mentions almost as an afterthought that she wants to tell her about what happened to Paco, Irene is too busy at this point caring for a new daughter-figure, the dying Agustina (shades of *All About My Mother* here), to listen. And so she tells her daughter that the story must wait. This poignant final assertion of the value of life over the allure of overheated narratives suggests that Almodóvar, like the erstwhile romance novelist Leo Macìas, has successfully evolved (a word that shares its root with *volver*). Out of an abandoned melodrama he has fashioned a drama that, in its very restraint, may be the most radical thing its creator has yet attempted.

Lost in Versailles

An unconventional film asks us to imagine a troubled young woman. In one sense, a superficial one to be sure, this is not at all difficult to do: the exterior of this young woman is an appealing one, and tends to attract the eyes of artists. She is, after all, barely out of her teens, blond, attractive if not a conventional beauty—there *is* the question of that lower lip—and has an undeniable grace to which complete strangers seem to respond unusually strongly. This reaction, at once aesthetic and emotional, may have to do with the fact that when her story begins, she is clearly stranded in the dangerous territory between adolescence and true womanhood; even after she grows up, and after we know how her story ends, the feelings she tends to evoke in observers are not unmixed with a certain protectiveness.

Her interior life is more complicated. Although she comes from the ruling class, and has been raised to inhabit a comfortable and predictable milieu, this young woman suffers a transformative crisis. Snatched up and taken very far from the safety of her home, she is set down in a (to her) bizarre and inexplicable world: rigidly hieratic, ruled by arcane conventions of speech and behavior that she, like the audience, finds difficult if not impossible to decipher. (The language spoken in this

place is not hers, for one thing.) Perhaps worse, although this woman, young as she is, is married, she is already aware that her marriage is a difficult, perhaps unsalvageable one; her husband's greatest passion, it would appear, is the complicated mechanical gadgets he likes to fuss with. In an understandable, almost adolescent reaction to all this, there are rebellions: pouty fits, madcap escapades, giddy nocturnal jaunts, flirtations that may or may not be harmless. Such excesses and experimentations, we are meant to feel, are merely means by which this unformed young woman is trying to figure out who she truly is. There is never any real question, in the film, that she is someone worthy of our sympathies and affection.

The foregoing is a fair description of Sofia Coppola's 2003 movie *Lost in Translation*, a surprise art-house success about a naive young American woman who, left alone in a luxurious Tokyo hotel while her fashion photographer husband is on assignment, gets a bittersweet introduction to the complexities of grown-up life—not the least of which is a life-altering flirtation with a world-weary film star old enough (as they are both well aware) to be her father. That it is also largely an accurate description of the director's new film, *Marie Antoinette*, a highly unconventional biopic inspired by Antonia Fraser's sympathetic 2001 biography of the hapless last queen of the ancien régime, tells you a lot about the director and her preoccupations; and explains a lot, too, about the many attractions, and ultimately the fatal weaknesses, of the new movie.

Marie Antoinette is Coppola's third film, and the third of her films to deal with the problems of spirited young women chafing at social restraints. Her moody 1999 debut, *The Virgin Suicides*, was based on the 1993 novel of the same name by Jeffrey Eugenides, whose distinctive "choral" narrator—a first-person-plural voice representing a group of teenaged boys—looks on as the five lovely daughters of the Lisbon family, crushed by narrow-minded parental repression, kill themselves over the course of some months. Merely the choice to adapt Eugenides' novel (which, on the face of it, was unfilmable) told you a lot about the first-time director's offbeat, unemphatic artistic style, so unlike that of her famous father, Francis Ford Coppola. The film itself immediately

established what can now be seen as a signature style: a preference for visual mood-setting over narrative vigor as a means of establishing character and themes, a distinctive and sometimes almost surreal use of certain effects (surprising interruptions; extreme, almost intrusive close-ups; evocative use of slow motion), a game, and gamine, willingness to be playful, even irreverent.

This technique well served her particular interest in representing the inner lives of the troubled young women in that first film—women on the verge of adulthood who had not yet found the words to express their seething, confusing feelings; who rely, as Coppola occasionally does, not without a certain wittiness, on the artifacts of pop culture to get their feelings across. (There's a moving scene in *The Virgin Suicides* where the girls, virtually imprisoned in their parents' meticulous, rather soulless house, communicate with the besotted boys by playing favorite pop albums over the phone to them.) It is, indeed, a striking feature of Coppola's style in that film (and the subsequent ones as well) that the visual is given such preference over the verbal; like that of so many adolescents, the dialogue of her half-grown heroines feels tentative, almost experimental. I have always suspected that you could turn off the sound and watch it with no great diminishment of enjoyment.

This was certainly the case with *Lost in Translation*, whose very title alerts the viewer to the fact that this is the story of people forced to explore their inner lives not least because they have been deprived of their natural linguistic setting. The film makes an ongoing joke of the difficulties that young Charlotte, a callow would-be writer, and Bob, the emotionally exhausted action-picture star who's come to Tokyo in order to make a lucrative if inane liquor advertisement, have in making themselves understood during their sojourn; everything from ordering sushi to taking direction from a Japanese director becomes fraught with unease, even peril. It's as much for this reason, this failure in the ability to communicate, as for any other that the two Americans fall, not without a certain weary relief, into each other's arms. (Or almost fall: as in its model, Noël Coward's *Brief Encounter*, there is never a physical consummation.) Not insignificantly, the moment when their feelings for each other become clear takes place in a karaoke bar, when they are merely mouthing the words of others—a scene noteworthy not least because it's so similar to the record-player scene in *The Virgin Suicides*.

This distrust of language and preoccupation with the limits of what can be communicated in words—the film ends, famously, with Bob whispering something into a tearful Charlotte's ear as he takes his leave of her; we never learn what it is he says, although we see her reacting to it—is compensated for by a powerfully evocative visual style already much evolved from that of *The Virgin Suicides*. Feelings of displacement, loneliness, and emotional disconnectedness are moodily conveyed by Coppola's camera: of particular note (not least because they reappear in *Marie Antoinette*) are jumbled shots of local scenery passing by in an artistic but incomprehensible blur, as if the eye of the observing subject—the frightened young woman—can't quite absorb it all.

These repeated shots of Tokyo skyscrapers whizzing frenetically, confusingly by, the garishly colored neon advertisements and traffic signs flashing their incomprehensible (to Charlotte) seductions and warnings, are beautifully balanced by moments of almost poetic stillness that are equally eloquent in their ability to tell us, even if she cannot, what the heroine is thinking. There is a remarkable scene in which Charlotte, suspecting her husband of infidelity with the vacuous film star he's photographing, flees the crush of Tokyo and silently observes a traditional wedding procession in Kyoto. The slow-motion progression of the bridal party, immaculate in its traditional makeup and dress, and the seemingly random but somehow pointed way that the camera has of lingering in close-up on a hand, a delicately rouged cheek, or an eyelid, tell you more about the tension between the life that Charlotte wants and the life that she's got right now than a long monologue could ever do.

The success of *Lost in Translation* suggested, in retrospect, the limitations of the earlier film. Although striking and often effective, *The Virgin Suicides* suffered from a lack of focus—a problem exacerbated by the director's already impressionistic tastes—that derived, at least in part, from the source material: the sense of diffuseness you felt at the end owed much to the fact that there were, at least in theory, five tragic heroines competing for the filmmaker's, and the audience's, attention. (The most effective bits come in the first third of the movie, which is the story of how the first of the five comes to kill herself; what is meant to be the horrific climax, with the remaining four doing themselves in all at once, feels curiously rushed and flat. Film, with its single eye, is

probably not the right medium for "choral" narration and plots.) In *Lost in Translation*, a film that she wrote as well as directed and over which, therefore, she had total control, Coppola was able to concentrate her distinctive eye on one particular young woman in a particular bit of trouble, with affecting results.

———

The fourteen-year-old Archduchess Maria Antonia of Austria (known by the affectionate nickname Antoine at home but renamed Marie Antoinette with an eye to her French marriage), newly arrived at Versailles from Vienna in 1770, was nothing if not a particular young woman in a particular bit of trouble. She was raised at the court of her mother, the Austrian empress Maria Theresa, which was comparatively relaxed, as such things go: despite the fifteen hundred liveried lackeys who could be made to materialize on state occasions at the Hofburg and at Schönbrunn, family life for the royal Habsburg couple and their sixteen romping children was pleasantly disorganized, full of amateur musicales and sledging parties. The impulsive, good-natured, not terribly bright young girl was betrothed, in a typical bit of matrimonial diplomacy, to the equally young French dauphin. Her mother was eager for an alliance with France.

And so off she went, in an immense and magnificent cavalcade of nearly sixty elaborate coaches—twenty thousand horses were said to have been used, so many were the changes of animals necessary to transport the vast procession from Austria to France—with the results that are, by now, familiar to all. The cold marriage to the well-meaning but emotionally awkward and sexually dysfunctional Louis Auguste, later Louis XVI; the shame that went with not being able to produce a child for a full eight years, while all around her the brittle court ladies gossiped and smirked. (It took the quite explicit intervention of Antoinette's brother, Emperor Joseph II of Austria, to get the French king in sexual working order.) And then, her notorious resort to a frivolous life of nonstop amusement and nonstop spending on a scale that repeatedly brought down the wrath of her sage, disappointed mother, among

many others. "I," wrote Maria Theresa, in one of a barrage of scolding letters that winged their way with brutal frequency from Schönbrunn to Versailles, "who love my little Queen and watch her every footstep, cannot hesitate to warn her of her frivolousness in this matter." To which admonitions Antoinette replied, in a sulky letter to Mercy, the empress's ambassador to France, "What does she want? I am terrified of being bored."

After long-awaited motherhood (and, so the unlikely legend goes, an affair with the dashing Swedish aristocrat Axel Fersen) had mellowed her, she undertook a different kind of flight from the pettiness, repressions, and intrigues of court life, for which she had neither any taste nor—disastrously, as it turned out—any talent. This flight was meant to be the inverse of her earlier emotional escape: an escape not, on the face of it, into material excess, but rather from it—to the relatively private, languorous, unfettered life she cultivated with her "Private Society" at the Petit Trianon, and at the Hameau, the "Hamlet," her model rustic village. Yet even the escapist fantasy of a "simple life" came at a scandalously excessive price; the final bill was nearly two million livres. ("It is likely enough that the Little Trianon cost huge sums of money," the deposed queen admitted at her show trial in October 1793, where the infamous subject of her lavish expenses was among the few legitimate cases that could be made against her, "and perhaps more than I intended, for I gradually became involved in unexpected disbursements.")

In consequence, and rather typically of this well-intentioned but clueless woman, one known for her extraordinary grace of carriage and posture who yet managed to stumble, in all matters of what we today might call PR, with shocking regularity, this second flight from the unnaturalness of the life she was forced to live had the effect of further degrading her reputation. For she alienated not only an uncomprehending, increasingly resentful, and gossip-hungry public, to whom the tales told of private royal gatherings far from the prying eyes of court could mean only one, scandalous thing, but also the social power base of the jealous and excluded court itself; so that by the time the Revolution came, Antoinette was utterly isolated from the people, from her court—from everyone but the few intimates who themselves, eventually, left as well.

It's easy to see how Sofia Coppola, with her artistic interest in the emotional lives of troubled young women forced to choose between inner impulses and external obligations, would have been moved by the sympathetic presentation of the queen's hapless life in Antonia Fraser's somewhat revisionist biography, and would choose it as the subject of her next film—a period film about a subject very much alive for this particular filmmaker. And, it would seem, very much alive to the general public, as suggested not only by the ongoing stream of biographies, novels, films, and documentaries about Antoinette, but by the intense emotional reaction to her most recent avatar, Princess Di—another clueless, well-intentioned teenager married off into a cynical court who found distraction first in spendthrift excess and devotion to fashion, and then in motherhood and an attempt to find some serious and private satisfaction in a life that had to be lived in the public eye; another woman, heedless and foolish at first, who seemed to achieve some real distinction as a person only at the time of her death, in shockingly violent circumstances, in her late thirties.

It's a measure of how greatly this little-girl-lost theme resonates with Coppola that the best parts of her new movie are those in which she frees herself from the conventions of standard film biographies and allows herself to imagine the inner life of a woman whose exterior—her image, her much- (and frequently mis-) reported words and deeds—we have come to know so well. Particularly at the beginning of the movie, there are scenes of great charm and freshness that suggest what it might have been like to be the immature and hapless object of so much imperial pomp. A sequence devoted to the progress of the young archduchess toward Versailles (the grand procession reduced here, no doubt for budgetary reasons, to two coaches) conveys the rather boring reality of that famous journey: you see Antoine looking out the window of her overdecorated coach at the seemingly endless parade of stark, early-spring trees (shades of *Lost in Translation* here); napping; desultorily playing cards with her ladies; gazing hopefully at a rather poignantly flattering miniature of her betrothed; and—best of all—amusing herself by breathing on the windows and doodling in the condensation of her own breath, a childish game as likely to have been played in 1770, you suddenly realize, as in 1970. At one point, in a plaintive child's voice, she asks the child's perennial question: "Are we there yet?" It's a wonderful touch.

These and certain other scenes of memorable visual effectiveness are rendered with a naturalness, a casualness even, rare in movies about great historical personages. A giddily cut montage, rather like something you'd see in a TV advertisement, of endless pairs of elaborate shoes (designed by Manolo Blahnik) nicely suggests the frenetic pleasure of addictive spending. (The sly inclusion of a pair of contemporary hi-top sneakers, in bubble-gum pink, is a visual analogue for the director's surprising but generally effective use of pop rather than period music for the sound track; you're reminded that whatever else these immature royals were, they were, at a certain level, just young people.) Imaginative re-creations of, say, the tedious cleaning-up process following a royal debauch—the unpleasant mess of half-eaten pastries and sticky spilled champagne—suggest a reality of life at Versailles you might not have seen before. Still other images wittily suggest the poor queen's fate: there's one shot of her in a bathtub in which the water comes precisely up to her neckline, and another at the theater in Paris in which her head is framed, again at the neckline, against a balcony.

Such moments nicely capture the interstices in the historical record— the episodes in daily life that must have taken place but of which there is, by now, the merest suggestion of the human reality that informed them. A scene of much charm, set in the Hameau, in which we see the queen engaging in what are clearly unscripted frolics among the flowers with her young daughter Marie-Thérèse, beautifully conveys the happy fulfillment that we know motherhood, and her special retreat, brought to Antoinette. As the little princess ambles about pointing to a little bee that has caught her imagination (*"la petite abeille, la petite abeille!"* the girl keeps crying), there's a telling sense of idle maternal contentment.

Tellingly, the linguistic anomaly of this scene—the American actress playing the French queen is speaking English, the little French actress playing the princess is speaking French—is of no concern to Coppola; the point here, as with so much of this film, is the heady and unexpected beauty of certain images, which so eloquently evoke privileged youth and guileless hedonism—the "sweetness of life" that, we are famously told by Talleyrand, those who did not live before the Revolution can

never know. The teenaged Antoinette's awed first exploration of her fabulous apartments at Versailles (her tentativeness nicely conveyed by the camera, which weaves and meanders as much as she does; never mind that the décor it records is all wrong for 1770); a somehow poignant shot merely of ladies' satin trains as they are dragged through the grass; a scene—at once giddy and strangely, ravishingly languid—in which the young royals, magnificently attired yet utterly youthful, race down a flight of steps in order to witness the sunrise: these linger in the mind long after the movie is over.

A quite different kind of emotion is expressed later on, silently but with equal potency, when the lovesick queen, coming from a final tryst with Fersen, who has to go off to war—perhaps inevitably, Coppola accepts the romantic story—returns to court from the Trianon. In a shot framed from a great distance, we see the tiny figure of the queen slowly, almost painfully ascending a magnificent flight of stone steps toward the palace, virtually dragging herself back to the life from which she cannot escape. Later on, alone in bed, she fantasizes about Fersen, a preposterous image of whom suddenly appears on screen: grimed with the dirt of battle, wrapped in an enormous billowing cloak, he sits astride a stallion that rears in slow motion—a hyperbolic picture that looks for all the world like the cover of a romance novel. Both times I saw the film the audience laughed nervously at this over-the-top image, but I thought it was right on target. Fersen, after all—so good-looking that he was known in London as "the Picture"—was described by contemporaries as looking like the hero of a novel, and Coppola has found the right imagery to convey his melodramatic allure. She has clearly done some homework.

One of the two great problems of the film is the sense you often get that she'd done her homework rather too faithfully: the languid freshness and visual originality of many scenes that seem evocative of Marie Antoinette's inner life stand in vivid contrast to the impression often given here, as it is in so many film biographies, that the narrative is often impatiently ticking off the Big Moments in the well-known life.

Here Coppola's film falls apart, because her special gift is for convey-ing emotional and psychological states suggestively, allusively, and im-pressionistically, by means of collocations of images; she has less talent for telling a straightforward tale. The movie suffers when you feel, as you often do, that she's read Fraser's biography thoroughly and is duti-fully reproducing incidents of her subject's life. Do we really need the story, which Fraser tells in great detail and which Coppola obligingly includes here, of how the dying Louis XV was forced to send away his mistress, Mme. du Barry, in order that he might receive Communion on his deathbed? The episode, hastily sketched in and, I suspect, in-comprehensible to anyone unfamiliar with the sorry story of the awful death of the *Bien-aimé*, adds absolutely nothing to our understanding of the film's subject, and ends by being a confusing distraction.

So too many of the episodes taken from the latter parts of Antoi-nette's life—which is to say, the part of her life that took place after the crisis that is of real interest to Coppola, which is the crisis of a young girl torn from her natural setting and forced to stay afloat, willy-nilly, in a strange and foreign place. Coppola's apparent lack of interest in anything outside of the cocooned and photogenic private world of the doomed queen is evident in the desultory quality of the many stilted moments designed to convey what's going on in the world beyond Ver-sailles—the kind of clanking scene in which someone says to the king at a meeting of his council, "The Americans are asking for help with their revolution," or, worse, when we see someone rush up to the king and announce, "The Bastille has been stormed!"

The director tries to cover over her lack of real interest in "His-tory" with some catchy tricks (there's a little montage in which we see some portraits of the queen bearing scribbled labels that say things like "Madame Deficit," and so forth), but it seems an afterthought; such mo-ments are mere chronological signposts, and the film loses its appeal whenever we're forced to rush by them. *Marie Antoinette* would have succeeded better purely on formal terms if it had never attempted to include this material—if it had been what I suspect Coppola always wanted it to be, a reverie on what it might have been like to be the very young Marie Antoinette, rather than a straight account of her life. In the end, it's too little of either.

But then—and this is the second and fatal problem with Coppola's movie—could you, indeed *should* you really make a film about Marie Antoinette the victimized young woman as if she were the private person she apparently wished, at times, she'd been? There is, if anything, something Marie Antoinette-ish about the director's impatient disdain for the outside world, for the history that was going on all around her sensitive and troubled heroine. (And not just around her, but right in front of her: when the Estates General finally met in May 1789, it was at Versailles—the first great intrusion of the coming Revolution into that enclave—although you'd never guess as much from this movie.)

There's nothing wrong with being interested in the inner life of a queen who was, in the end quite tragically, nothing more than the "average woman" to which the subtitle of Stefan Zweig's 1932 biography alludes, an all-too-ordinary person placed by fate in extraordinary circumstances. But this particular life, the rather unexceptional personality whose contours Coppola is interested in delineating here—and which she does delineate so effectively at times—had an enormous impact on history, on real events and persons. That this was already clear to the queen's contemporaries is evident from the concerns about the young queen's behavior expressed by her brother Joseph (no slouch himself when it came to hectoring letters), which are, in hindsight, particularly significant. "In very truth I tremble for your happiness," he wrote his sister, "seeing that in the long run things cannot go on like this . . . the revolution will be a cruel one, and perhaps of your own making."

The provocative relationship between personality and history in the case of Marie Antoinette has indeed been clear to subsequent generations. Writing thirty years after the Revolution, the comtesse de La Tour du Pin, by then a fifty-year-old émigrée, who had been presented at court as a young woman and whose glamorous mother had been a lady-in-waiting to the queen ("the queen liked my mother, she was always captivated by glitter and my mother was very much the rage"), ruminated on the inevitable lessons to be gleaned from the queen's life:

> My earliest visit to Versailles was in 1781, when the first Dauphin was born. In later years, when listening to tales of Queen Marie-Antoinette's sufferings and shame, my mind often went back to

those days of her triumph. I was taken to watch the ball given for her by the Gardes du Corps in the Grande Salle de Spectacle at Versailles. She opened the ball with a young guardsman, wearing a blue dress strewn with sapphires and diamonds. She was young, beautiful and adored by all; she had just given France a Dauphin and it would have seemed to her inconceivable that the brilliant career on which she was launched could ever suffer a reverse. Yet she was already close to the abyss. The contrast provides much cause for reflection!

But the contrast has apparently provoked no such reflection in Coppola, who in her new film gives you, as it were, the dress but not the abyss. To be so unreflective, to want to make a film about Marie Antoinette that ignores who she was in history, seems shockingly naive, intellectually; it's like wanting to make a film about what it's like to be a starving artist and deciding to have your hero be the young Adolf Hitler.

And so Coppola's movie, which works so hard and with such imagination to include in its portrait much that has been ignored, ends up leaving out much that cannot be ignored. Most egregiously, it fails completely to convey in any way why it was that this particular queen aroused the loathing of many in her country. You get absolutely no sense from the new *Marie Antoinette* of the immense and combustible loathing that was for the queen outside her circle of intimates as the years went by, while she was languishing in her unstructured muslin *lévites* among the soft pillows of the Petit Trianon, among the bits of dress and décor to which Coppola's swooning camera gives an almost erotic allure. The irony is that this willed ignorance of the admittedly less photogenic outside world disserves Coppola's artistic and emotional purpose, her desire to explain and, you suspect, defend the queen: had she included points of view and voices other than the queen's, she'd have only found material to underscore some of her subject's sympathetic qualities. (There is little question that while she could make gross mistakes of judgment, nearly all of the calumnies heaped on Marie Antoinette, including the notorious Affair of the Diamond Necklace, were absurd and vicious misrepresentations, when not downright inventions.)

The result of all this is a film that is ultimately, like its subject, horribly, fatally truncated. Stefan Zweig, a far more tart and critical biographer than is Antonia Fraser, wrote of the queen that "though but little inclined to reflection, she was quick of perception, her tendency being to judge all that happened in accordance with her immediate personal impressions—for she saw only the surface of things." It would be unfair to say that Sofia Coppola sees only the surface of things—she sees a great deal more, sees what surfaces can be the reflections of, and renders what she sees with artful ingenuity—but in this film, at least, it's as if she's been so bewitched by the fabulous beauties of what she sees, the silks and satins and shoes and frosting on the bonbons everyone always seems to be eating, that she's lost track of crucial events and the inescapable larger significance of her subject's life.

Indeed, the final silent image in this movie, so filled as it is with striking and suggestive images, tells you more about Coppola, and perhaps our own historical moment, than it could possibly tell you about Marie Antoinette. It's a mournful shot of the queen's state bedchamber at Versailles, ransacked by the revolutionary mob the night before the queen and her family were forced to leave for Paris and, eventually, death (the end point to all the frivolity which, tellingly, Coppola cannot bring herself to narrate): the camera lingers over the opulent room, its glittering chandeliers askew, its exquisite boiseries cracked and mangled. You'd never guess from this that men's lives—those of the queen's guards—were also destroyed in that violence; horribly, their severed heads, stuck on pikes, were gleefully paraded before the procession bearing the royal family to Paris. But Coppola forlornly catalogs only the ruined bric-a-brac. As with the teenaged girls for whom she has such sympathy, her worst imagination of disaster, it would seem, is a messy bedroom.

—*The New York Review of Books*, November 30, 2006

Looking for Lucia

In February 1834, Gaetano Donizetti, whom the première of his *Anna Bolena* four years earlier had made a star of the Italian opera world, accepted with joy an invitation by Rossini to compose an opera for the Théâtre-Italien in Paris. As the vehicle for his entrée into the Parisian music world, the composer cannily chose an adaptation of a popular French play about a murdered Venetian doge; and yet the run of *Marin Faliero*, as the new opera was called, was both unspectacular and short, closing after five performances. Partly this had to do with the fact that the opera premièred late in the season, a serious disadvantage particularly since it had been preceded by Bellini's hit *I Puritani*; partly it was because of practical aggravations of the kind amusingly familiar from the performance histories of early-nineteenth-century opera. (The Parisian fire marshals had insisted on testing their new safety system the day after the *prima*, a routine that involved, among other things, flooding the theater.)

But if *Marin Faliero* was waterlogged, at least one contemporary account suggests that the reason had less to do with the material production than with something intrinsic to the work itself—a work remarkable, as operas about Venetian doges can be, for its preponderance

of strong male roles. Two months after the Paris run, when the opera was produced in London, the critic Henry Chorley wrote that

> despite the great beauty of the bass, baritone, and tenor roles, *Marin Faliero* languished, in part from the want of interest in the female character—a fatal fault to an opera's popularity.

It is tempting to think that Donizetti himself might have secretly, or at least unconsciously, shared this assessment of his work's fatal flaw. After all, soon after he returned to Italy, a month after *Faliero*'s truncated run, in order to begin work on the first of three new operas he'd agreed to compose for the Teatro San Carlo in Naples, he settled on a subject that seemed impervious to any possible objection that its heroine lacked "interest."

That subject was a hugely popular 1819 novel by the recently deceased Sir Walter Scott—a work whose suitability for the theater, despite the author's odd assertion that it didn't lend itself to the stage, had already been demonstrated by the fact that when Donizetti set his sights on it, it had already been dramatized by librettists for three other composers (and been adapted in verse by Hans Christian Andersen for a concert performance, with musical accompaniment, in 1832). The novel—which not coincidentally has been considered the leanest and dramatically tightest of Scott's historical fictions by readers from E. M. Forster to Thomas Hardy, the least encumbered by swags and poufs of "history"—was *The Bride of Lammermoor*. During six weeks in the summer of 1835, Donizetti wrote his new opera to a libretto by Salvatore Cammarano (who would go on to provide Verdi with the texts to four operas, including *Il Trovatore*) that drastically pared down Scott's novel, stripping away everything but the bare bones of its Romantic tragedy: the tale of a young girl who, after being forced by her insensitive family to give up her true love and marry a husband of their choice for the sake of their political and financial advantage, is driven to madness and murder.

The madness instantly became the new work's most famous element, and it has remained so ever since. For the climactic moment in Act 3—when Scott's Lucy Ashton, here redubbed Lucia, having lost her mind and stabbed her husband to death on their wedding night,

appears before the horrified wedding guests—Donizetti memorably gave his heroine an extended scene in which the young woman's derangement is represented with brilliant musical ingenuity. In this great mad scene, the fragmentation of Lucia's thoughts is suggested by the fragments of earlier tunes running through the scene; her inarticulate longing and terror (earlier on, she'd sung of "joy that can be felt but not spoken") are made plain in the flights of wordless vocal pyrotechnics that slither and explode between the more articulate moments. The spooky inarticulateness comes straight from Scott's novel: in it, when the blood-covered Lucy is finally discovered, she doesn't speak but instead "gibbered, made mouths, and pointed at them with her bloody fingers, with the frantic gestures of an exulting demoniac."

Because of the ingenuity of Donizetti's achievement in this scene, it soon became the best known of a number of operatic representations of female insanity, many of them to be found in the bel canto repertoire of the early nineteenth century. Donizetti's breakthrough work, *Anna Bolena*, has one; the rather paranoid Bellini, always rivalrous when it came to the slightly older Donizetti, gave *Puritani* two. The popularity of such scenes, and the iconic status particularly of the Mad Scene in *Lucia*, make you wonder whether they represent something essential about opera itself—a genre that, like Greek tragedy, seems to take special pleasure in representing extremes of feminine suffering. The paradox of so much opera—that is to say, the genre's celebration of female power (that marvelous voice) and what you might call its punishment of female action (however spectacularly they sing, sopranos tend to die equally spectacularly, and in far greater numbers than, say, their tenor lovers do)—has led some scholars to see in opera, as indeed they have seen in Greek tragedy, the ambivalent operations of a male-run society that simultaneously desires women and seeks to constrain them. Typical of this school of thought is the French critic Catherine Clément, who has observed that opera

is not forbidden to women. That is true. Women are its jewels, you say, the ornament indispensable for every festival. No prima donna, no opera. But the role of the jewel, a decorative object, is not the deciding role; and on the opera stage women perpetually sing their eternal undoing. . . . From the moment these women

leave their familiar and ornamental function, they are to end up punished—fallen, abandoned, or dead. The "fair sex" indeed.

This reading of opera has a particular resonance when you think of *Lucia*, a work that was invoked throughout the nineteenth and early twentieth centuries in novels whose heroines, repressed and thwarted by their societies or husbands, themselves explode into climactic acts of violence (or are simply killed off): Donizetti's opera makes memorable and rather pointed appearances in *Madame Bovary*, *Anna Karenina*, *Where Angels Fear to Tread*, and other works.

Whether you agree with the feminist reading or not, you still have to wonder why it's the mad scenes that grip our imaginations so. ("These onstage collapses are fascinating to watch," as an article in the playbill for the new Metropolitan Opera production of *Lucia* puts it.) Which is to say, why "want of interest in the female character" is fatal to an opera—and why that "interest" so often takes the form of virtuoso singing that expresses abjectness, madness, and violence. On its opening night in September 1835, at any rate, *Lucia* proved a triumph. There was certainly no want of interest in its female character.

As it happens, Donizetti and his librettist, Cammarano, took great pains to bring out, to the exclusion of virtually all else, the qualities of feminine pathos present in their source material. For starters, they gutted pretty much all of the late-Stuart intrigues that in the novel serve as the fraught background for the internecine maneuverings between Lucy's family, the Ashtons, and their rivals, the Ravenswoods (the family to which, inevitably, her beloved, Edgar, belongs). A recent academic critic of Scott's novel has written of what you might call the tension between "history" and "fiction" in *The Bride of Lammermoor*, a novel in which history

> is a mélange of blood feuds, economic necessity and coercion, class enmities, religious intolerance, political rivalry, superstitious lore, and the menace of violence. . . . Critics who condemn as unwise or misplaced the love between Lucy and Ravenswood

miss the point. Without fidelity in love, there is nothing worth-
while in the novel's world.

Donizetti, however, was famously unmoved by politics. (In 1831, after
his triumph in Milan with *Anna Bolena*, he returned to a Rome afflicted
by civic upheavals inspired by the July Revolution in Paris. His reac-
tions are recorded in a letter to his father: "I am a man whom few things
disturb, or rather only one: that is, if my opera goes badly. For the rest,
I do not care.") What did interest him—what had interested him from
the start of his career, when as an ambitious young composer he was
already chafing at the constraints imposed by the glittering Rossinian
style and the happy endings invariably imposed by the censors—was
what was interesting to many artists and composers and writers just
then, which was "fidelity in love." And of course the dreadful conse-
quences when that love failed.

Hence while today's Walter Scott scholars may argue that in *The
Bride of Lammermoor*, "the tragic erotic theme" functions "as a caution-
ary parable about the necessity for the Union," the operatic version re-
verses those priorities: what references to the original historical setting
remain (there are a couple of lines about William and Mary and the
French, and so forth) serve merely to intensify a drama that is essen-
tially domestic and erotic. When we learn, in the opera, that Lucia's
brother, Enrico Ashton, finds that he has allied himself to the wrong
political party, we're interested not in the Stuarts but rather in the awful
dramatic result of Enrico's predicament: his decision to trick his sister
into marrying a man she doesn't love, but who can help restore his own
fortunes. (This intense domestic crisis flares most poignantly in the Act 2
duet between the two siblings, when to Enrico's repeated declarations
that only Lucia's marriage to the rich and well-connected Arturo Buck-
law can save him, Lucia pathetically replies, *Ed io?*: "And what of *me*?")

The most significant alteration on the part of *Lucia*'s composer and
librettist of their source material lies not, however, in their treatment of
politics, but rather in the way they approach an issue having to do with
gender. For in Scott's novel the villain of the story, the character who
drives Lucy to madness and violence, is not in fact the heroine's brother
(as those who know the story from the opera are likely to suppose),

but rather her mother, Lady Ashton, a "proud, vindictive, and predominating spirit," a "bold, haughty, unbending" virago who is compared by the narrator to Lady Macbeth (!). This harridan has of course been dispensed with in Cammarano's adaptation: we're told in the first scene of *Lucia* that the girl's mother has recently died, and indeed the ongoing references to the daughter's grief are meant to suggest that Lucia's mental instability had been triggered by this terrible shock. During one of her Lincoln Center master classes, Maria Callas, a great Lucia, told a student that "you must make the public feel that this girl is ill from the beginning." (She also referred to Enrico as a "snake.")

The creators of *Lucia* have, then, very pointedly isolated their fragile heroine in a world that consists almost exclusively of men. Indeed, at a moment when Italian composers were exploring the rich musical and dramatic possibilities of intense pairings between two sopranos, or sopranos and mezzos, in Romantic melodramas—Bellini's Norma and Adalgisa in *Norma* (1831), Donizetti's own Anne Boleyn and Jane Seymour in his breakthrough *Anna Bolena*—it's striking that Donizetti has worked so hard to deprive his Lucia of significant female companionship. (The role of her confidante, Alisa, is so shallow and negligible that even in the nineteenth century, not long after Lucia's triumphant première, people were likely to talk of the great "quintet" in Act 2, which is in fact a sextet.) More, the men with whom he and Cammarano have surrounded her—Edgardo included—are scarily self-involved and prone to violent emotions. (They talk a great deal about their *rabbia*, their rage.) They are, if anything, as proud, vindictive, and predominating as Scott's Lady Ashton ever was.

Here, comparison not with *The Bride of Lammermoor* but with another predecessor is instructive. Lucia is just as top-heavy with male roles as the failed *Marin Faliero* was; but in the later, successful work, the fact that the heroine is surrounded by strong men was not an oversight but a carefully considered plan—not so much an abandonment on the part of the composer as a purposeful imprisonment, one that makes us think of her vulnerability, her suffering. Her "interest."

The effect produced by all this textual maneuvering is one to which we have become so accustomed, which feels to us so natural, that it's easy

to forget that it was the result of self-conscious and quite canny craft: the insistent, ever-growing emphasis, throughout *Lucia*, on qualities of abandoned pathos, of a feminine suffering that begins in an oppression symbolized by an act of sexual intrusion (the forced marriage), and ends with an explosion of spectacularly aggressive and finally self-destructive energies. That shift, from sacrificial victim to avenging harpy, reminds you of the Greek tragedies that were the ancestors of early-nineteenth-century dramas like *Lucia*.

That it's easy to take those archetypes for granted is plain in our reactions to the opera today. In an assessment of the notoriously post-modern, heavily (heavy-handedly, to some) symbolic production of Donizetti's opera by the director Francesca Zambello, which debuted at the Met in 1992 to a chorus of boos from the audiences and disdain from most critics, a *New York Times* writer referred to the "perhaps gratuitous feminist spin" that Zambello put on the opera in her director's note (where she referred to *Lucia* as "a tale of psychological terror, of emotional blackmail, and of sexual politics set in the half-seen realm of the unconscious"). And yet, as so carefully constructed by Donizetti and Cammarano, *Lucia di Lammermoor* is the story of an isolated young girl, the only female in a violent family, who's tricked by her ambitious brother into marrying a man she doesn't know—and by "marrying" we mean, necessarily, having sex with him; Cammarano's text is not shy about referring to the *talamo*, the "marriage-chamber," into which Lucia is forced—in order to save her brother and his money and position. She must suffer, that is, to save the man. If to see such a story as having feminist overtones is "gratuitous," it would be very nice to know what an ungratuitous feminist spin might look like.

———

This work ought to have been an ideal vehicle for demonstrating the much-advertised priorities of the "new Met"—the institution that, under the leadership of Peter Gelb, has made a great deal in the press of its commitment to dramatically meaningful productions, directed by eminent people of the legitimate theater. This emphasis, I think, is

part of the larger and very admirable aims of the new general manager to popularize grand opera, to bring it to a new audience: the drama in opera, you're meant to feel, is the element that anyone, even those who aren't (yet) in love with operatic music, could be moved by. The *Lucia* that premièred last month, in a new production by the Tony Award–winning stage director Mary Zimmerman and featuring the appealing French soprano Natalie Dessay (who, the promotion reminds us, started out as an actress and only then segued into singing) is, quite literally, the poster child for this new regime and its ambitious program. At the beginning of the autumn, it was impossible, if you lived in New York City, to wait for a bus without being greeted by the stark image of Ms. Dessay's gamine face, eyes wide with simulated madness, her mascara running, plastered on the side of the bus stop.

All the more strange, then, that this important new production is such a bore. Despite a strong and committed cast and a director who could be counted on to make much of the dramatic aspects of a work whose ravishing music is often considered sufficient cause to perform it, this *Lucia* failed to add up—failed, most egregiously (and most surprisingly) of all, to make anything meaningful or memorable out of what you might not at all gratuitously call the "feminist" element: the very element, you'd think, that should give it particularly contemporary interest.

A big problem here is the direction. You could see why Donizetti's opera, with its elemental Romantic plot and Every-Madwoman heroine, might have appealed to Mary Zimmerman, a writer and director who has always been interested in the possibilities of starkly dramatizing archetypal, even mythic material: the *Odyssey* of Homer, the *Thousand and One Nights*, and Ovid's compendium of erotic disaster stories, the *Metamorphoses*. In staging these works, Zimmerman often has striking "concepts": her *Metamorphoses* was set in a big, shallow swimming pool; her *Arabian Nights* ended in present-day Baghdad. Still, the problem with concepts is that most great works are too elastic, too polyphonic, to be squeezed into a single notion: just where those impressive-looking concepts get you, intellectually or indeed emotionally, isn't always clear. I loved the idea of putting Ovid under water, not least because Ovid loved it, too: *Metamorphoses* begins with the watery chaos of creation, a perfect medium, you realize, for the corporeal transformations that

follow. But Zimmerman never really made the water mean anything: it was just the stuff in which the actors splashed around as they acted out, fairly conventionally, the various stories.

A lot of the new *Lucia* has the same high-concept feel. There is, to start with, the mise-en-scène, which here has been inexplicably updated from the late seventeenth to the late nineteenth century. (If you squint, you might think you're watching a dramatization of Trollope's *The Eustace Diamonds*—at least as far as the costumes go: Zimmerman hasn't filled the Met's vast stage with much decor, perhaps intending for the airplane-hangar-like stage to dwarf the characters and thereby emphasize their isolation.) Updatings of operas can be controversial, but shouldn't necessarily be so: there is, at the very least, an argument to be made for updating the action of many operas to the time of composition, the moment whose intellectual and cultural climate can explain a great deal about the work itself. This would certainly be the case of *Lucia*, composed during a period of a decade and a half that showed a particular fascination with female madness—the period of the Brontës, of the "madwoman in the attic." Why Zimmerman should have chosen the late 1870s rather than the 1830s was anybody's guess: it seemed not only against the grain (the end of the nineteenth century, with its bold heroines, jars as a milieu in which to set a pathetic Romantic tragedy) but gratuitous, a decision never explained.

And—worse—never capitalized on, never followed through. We hear again and again in *Lucia* that the girl is still in mourning for her mother; you'd have thought that Zimmerman would make something of this fact, given that few cultures have fetishized grief and mourning as much as the late-Victorian one in which she has chosen to set her production. A Lucia weighted down by the trappings of deep mourning would have presented a striking and psychologically suggestive picture—a visual reminder of the trauma that haunts her from the start. But Zimmerman doesn't excavate the possibilities of her own concept.

A rigorously coherent use of the setting that she's imposed on this *Lucia* would have given resonance to other clever but ultimately unrealized notions. During the great Act 2 sextet, when a furious Edgardo interrupts the wedding between Lucia and the wealthy Arturo and all the major characters sing of their various impressions and reactions at once, Zimmerman "opens out" this usually static moment in a sugges-

tive way. As the principals sing, a wedding photographer fusses at them, nudging them into a wedding-day pose—a conceit that nicely communicates the dreadful tension, so common in operatic drama, between the crushing demands of the outside world and the interior turmoil that torments the characters. But like too much else in this staging— not least, an enchantingly pretty fall of snow that's a perfect visual analogue to the descending harp arpeggios that introduce Lucia's first aria (in which she describes seeing the ghost of a girl murdered by her lover's ancestor)—this one is just a "moment" that comes and then, like the photographer's flash at the end of the sextet, goes up in a puff of smoke.

Occasionally, Zimmerman's concepts do serious damage to the carefully constructed meanings of the numbers. In the new production, as Lucia narrates her Gothic tale of ghosts and murdered maidens, the ghost itself, in the form of an all-too-corporeal, white-powdered dancer, flops around the heroine as she sings, and then glides away, writhing and beckoning, before disappearing a bit awkwardly into the fountain. Although this is visually arresting and certainly novel, to make the ghost concrete—to make it real—seems a very serious misapprehension of the meaning of the text here. Cammarano begins with this hysterical narrative of ghosts and visions because he wants, from the start, to underscore the girl's mental fragility (as Callas understood so well). If the ghost is real to *us*, the audience, then our sense of the heroine's delicate emotional state is inevitably diminished—as is, just as inevitably, our sense of the final murderous madness as a culmination, rather than an aberration.

Such novelties, so effortfully contrived (Zimmerman wants us to believe that the images of skeletal tree branches on the show curtain before each act represent "the human vascular system in the brain"), stood in stark contrast to the director's inexplicable abandonment of the actors. Both times I saw this *Lucia*, I found my eyes wandering all over the stage (and sometimes the house) during even the most dramatic moments; there was nothing happening on the stage to hold the attention. Certainly nothing to do with the chorus, in which Zimmerman shows no interest: again and again they simply stood around in big clumps, bizarrely unresponsive to anything that was happening around them. The latter is a particularly serious problem, needless to say, in the Mad Scene. I recently

watched a DVD of a 1967 *Lucia* with Renata Scotto and Carlo Bergonzi, filmed in Japan, as well as a couple of performances by Joan Sutherland from the mid-1980s: what struck me was how each of the chorus members seemed to have been directed, to have been given a "character" to play, horrified, appalled, sympathetic, whatever. This is crucial: their reactions to the unfolding tragedy help cue the audience's reactions.

That level of detail is, even in Zimmerman's direction of the principals, often absent—and when it's present, it's misguided. Her approach to directing opera singers can be strangely amateurish; often she simply moves her principals downstage to sing, and then they stand there singing, and that's it. (She must be a conductor's dream.) This important director from the "straight" theater showed little concern for using the actors and their bodies (and the spaces between those bodies) to delineate character, to express something about the drama of the plot—or, indeed, the drama of the music. This is a particularly serious failing in early-nineteenth-century Italian melodrama, in which the decisive gesture, always indicated by the score, the arc of an aria, or the strong declamatory force of a piece of recitative, is everything. Recalling the Lucia of Maria Callas, in a 1955 Berlin performance conducted (and largely directed) by Herbert von Karajan, the Italian director Sandro Sequi spoke shrewdly of the importance not of "realism" but of high stylization, the starkly meaningful gesture, for performances of bel canto opera—a stylization that, as classical actresses know well, paradoxically releases, rather than constrains, emotional realism:

> For me, [Callas] was extremely stylized and classic, yet at the same time human—but a humanity on a higher plane of existence, almost sublime. Realism was foreign to her, and that is why she was the greatest of opera singers. After all, opera is the least realistic of theater forms.

Years after Callas's 1955 Berlin *Lucia*, people remembered the starkly stylized way in which she used just her arms in the mad scene "like the wings of a great eagle, a marvelous bird. When they went up, and she often moved them very slowly, they seemed heavy—not airy like a dancer's arms, but weighted. . . . There was a continuous line to her singing and movements, which were really very simple."

That Renata Scotto was also an heiress to that high tradition is clear even in the grainy and amateurishly recorded Japanese television performance from 1967. Every line of Donizetti's music is accompanied by a telling movement, or by an equally telling stillness: this singer may have been small and plump, but she knew how (and was unafraid) to use her body. In her performance, when Lucia reads the (forged) letter meant to convince her of Edgardo's faithlessness, she crumples a little (and why not? The word used of her at this moment is *vacilli*, "totter"); when Edgardo prepares to tell her, in Act 1, that he must leave for France and she says *Che dici?*, "What are you telling me?," she turns away in a small but vivid movement of quiet pain. Of such small things are memorable performances made.

No one seems to have explained any of this to Natalie Dessay, whose bride of Lammermoor was, if anything, the greatest example of the curious inertness that characterized the show. Her benumbed, almost anesthetized Lucia was the product of an interpretation that all too clearly had been carefully considered; but it was, too, an interpretation wholly at odds with both Donizetti's music and Cammarano's text— with, that is to say, the work's style.

I suspect that this failure might, paradoxically, actually have something to do with what the Met is interested in these days: "serious" acting, taking the theater "seriously." Much has been made of Dessay's training as a modern stage actress (the playbill informs us that she'll be appearing in a Thomas Bernhard play in 2010, in Paris). But as admirable as such preparation is, it doesn't necessarily have much to do with the operatic stage of nearly two hundred years ago—which is to say, the stage for which Donizetti wrote the music that, whatever your directorial interpretation, still has to be played at every performance of *Lucia*. Dessay, whose lithe and adorable stage presence is paralleled by a coolly agile voice very much in the French tradition, seems to have worked very hard to create a Lucia at odds with the singer's own well-known persona. (She was a fun Zerbinetta and a fine, flirty Manon.) Hence her subtle, realistic, traumatized, "psychological" interpretation of Donizetti's crushed heroine.

But in bel canto opera, with its post-classical high stylization, the

kind of subtleties that Dessay wants to telegraph simply don't register—they're at odds with the music. Her Lucia enters in a kind of numbed fog—a nice idea, except for the fact that her music here is filled with foreboding, agitated and anxious in the ghost-story cavatina and, in the cabaletta, tinged with hysteria. So Dessay's physical demeanor on stage, intended no doubt to convey a bruised psyche, merely came across as indistinct, inexpressive. (When this Lucia reads the forged letter, she shows virtually no physical reaction at all; she could have been reading a Chinese takeout menu. No *vacillando* here.) The same quality of dissociation characterized the singing, which although technically expert on the part of all three leads (particularly the ferocious Enrico of Mariusz Kwiecien, a role you hope he gets to reprise in a more congenial production), was curiously devoid of any sense of real engagement. This problem was not helped by the conducting of James Levine, who has always seemed indifferent to the bel canto repertoire. The effect of all of this was to muffle rather than amplify the heroine's tragedy.

There were, in fact, three gestures in this *Lucia* that I particularly remembered after the show was over, all of them illuminating in some way the fatal flaws of this production. The first, a cheap and vulgar one, showed the emptiness of the "concepts" that plagued the direction. During the furious duet between Lucia and her brother in the first scene of Act 2—the "you must save me"/"and what of *me*?" duet—Zimmerman has her Enrico reaching suggestively along Lucia's leg at one point. This was not only wholly inappropriate to the drama but wholly unnecessary as well: Cammarano's libretto and Donizetti's music make Lucia's victimization amply clear without any need for the now-fashionable invocation of incest. Like so many of the conceits here, this one went nowhere—just another flake of falling snow.

The second deeply falsified the text. In Act 2, Zimmerman has Lucia, in a Tosca-like moment, sneak a knife off her brother's desk, apparently in preparation for the mayhem of Act 3. But if Lucia is already premeditating violence in Act 2, the Mad Scene falls apart—it's not as "mad" as we might think. (It's *Medea*.) This gratuitous insertion makes a hash of the libretto's carefully orchestrated sequence, as each act progresses, from isolated fragility, to desperation, to explosion.

The third gesture tells you pretty much everything you need to know about the larger misconceptions that lay behind Dessay's perfor-

mance, acclaim for which, both in the press and in the audience, reveals a lurking embarrassment about the "high" style typically, and rightly, associated with this kind of opera. During her mad scene—the scene by which any Lucia will inevitably be judged; a scene that Ms. Dessay has said she considers "the easiest part" of this opera to sing—there was a moment when Dessay stood stock still and simply screamed: a real, shivery, horror-movie scream. This is the kind of thing that makes an impression. On the first night I saw the opera, a woman in back of me murmured to her husband, "Now *that's* scary."

The problem, of course, is that the scariness is already in the text, in the music. We know how hard Donizetti and Cammarano thought about their text, how hard they worked to put their broken heroine's suffering and dissociation in the music, in the words (or lack of words). That Natalie Dessay and Mary Zimmerman thought that this scene needed the addition of "real" scariness merely reveals the extent to which they neither comprehend nor trust the creators of the work they're staging. That staging, needless to say, is a hit. Whether it has "interest" is another matter altogether.

—*The New York Review of Books*, November 22, 2007

Not an Ideal Husband

By now, we have all heard the story. Like so many tragedies, this one begins with a husband and his wife. The husband seems a happy man, preeminent among his contemporaries, affable, well liked, someone whose weaknesses are balanced by a remarkable gift for inspiring affection and loyalty. (His relatives, on the other hand, are thought to be cold and greedy.) The wife, whose fiery inner passions are belied by a conventional exterior—she exults in the small routines of domestic life—is intensely, some might say madly, devoted to him. They have two small children: a boy, a girl.

Then something goes wrong. Some who have studied this couple say that it is the husband who grotesquely betrays the wife; others, who consider the wife too intense, too disagreeably self-involved, dispute the extent of the husband's culpability. (As often happens with literary marriages, each has fanatical partisans and just as fanatical detractors—most of whom, it must be said, are literary critics.) What we do know is that directly as a result of her husband's actions, the wife willingly goes to her death—but not before taking great pains to guarantee the safety of her two children. Most interesting and poignant of all, the knowledge of her impending death inspires the wife to previously unparalleled

displays of eloquence: as her final hours approach, she articulates, with thrilling lyricism, what she knows about life, womanhood, marriage, death—and seems, as she does so, to speak for all women. It is only after her death, many feel, that her husband realizes the extent of his loss. She comes back, in a way, to haunt him: a speaking subject no longer, but rather the eerily silent object of her husband's solicitous, perhaps compensatory, ministrations.

This is the plot of Euripides' *Alcestis*. That it also resembles, uncannily in some respects, the plot of the life of Ted Hughes—whose final, posthumously published work is an adaptation of Euripides' play—may or may not be a coincidence. Because Hughes's *Alcestis* is a liberal adaptation, it cannot, in the end, illuminate this most controversial work of the most controversial of the Greek dramatists. (Scholars still can't decide whether it's supposed to be farce or tragedy.) But the choices Hughes makes as a translator and adapter—what he leaves out, what he adds, what he smoothes over—do shed unexpected light on his career, and his life.

As Ted Hughes neared the end of his life, he devoted himself to translating a number of classical texts: a good chunk of Ovid's *Metamorphoses* in 1997, Racine's *Phèdre* in 1998 (performed by the Almeida Theatre Company at the Brooklyn Academy of Music in January 1999), and Aeschylus's *Oresteia*, commissioned by the Royal National Theatre for a performance in 1999 and published posthumously in that year. Hughes had translated one other classical text: Seneca's *Oedipus*, for a 1968 production by the Old Vic starring John Gielgud and Irene Worth. But with the exception of that work, the fit between the translator and the texts was never a comfortable one.

Hughes made his name as a poet of nature, and excluding the translations (he also translated Wedekind's *Spring Awakening* and Lorca's *Blood Wedding*) and the self-revealing 1997 *Birthday Letters*, addressed to his late wife, the poet Sylvia Plath, he rarely strayed from the natural world, for which he had extraordinary imaginative sympathy (and which in turn inspired his fascination with Earth-Mother folklore and animistic magic). A glance at his published work reveals the following titles: *The Hawk in the Rain, Crow: From the Life and Songs of the Crow, Flow-*

ers and Insects, Wolfwatching, Rain-Charm for the Duchy, Cave Birds, The River. "They are a way of connecting all my deepest feelings together," Hughes told an interviewer who'd asked why he spoke so often through animals. Yet the poet's appreciation for—and artistic use of—the life of birds, fish, insect predators, of barnyards and wild landscapes, was anything but sentimental. As Helen Vendler observed in a review of the 1984 collection *The River*, Hughes, who liked to represent himself "as a man who has seen into the bottomless pit of aggression, death, murder, holocaust, catastrophe," had taken as his real subject "the moral squalor attending the brute survival instinct." In Hughes's best poetry, the natural world, with its dazzling beauties and casual cruelties, served as an ideal vehicle for investigating that dark theme.

It was a theme for which his tastes in language and diction particularly well suited him. Especially at the beginning of his career, the verse in which Hughes expressed himself was tough, vivid, sinewy, full (as Vendler wrote about *The River*) of "violent phrases, thick sounds, explosive words," the better to convey a vision of life according to which an ordinary country bird, say, can bristle with murderous potential. "Terrifying are the attent sleek thrushes on the lawn / More coiled steel than living—a poised / Dark deadly eye . . . ," goes the violent beginning of "Thrushes," from the 1960 collection *Lupercal*, hissing suggestively with alliterative *s*'s, exploding with menacing *t*'s and *d*'s, thick with cackling *c*'s and *k*'s. It was, indeed, Hughes's "virile, deep banging" poems that first entranced the young Plath; she wrote home to her mother about them. (At the end of his career a certain slackness and talkiness tended to replace virile lyric intensity; few of the *Birthday Letters* poems, for instance, achieve more than a documentary interest. Hughes himself seemed to be aware of this. "I keep writing this and that, but it seems pitifully little for the time I spend pursuing it," he wrote to his friend Lucas Myers in 1984. "I wonder sometimes if things might have gone differently without the events of '63 and '69 [Plath's suicide in 1963 and, in 1969, the suicide of Hughes's companion Assia Wevill, who also killed the couple's daughter]. I have an idea of these two episodes as giant steel doors shutting down over great parts of myself. . . . No doubt a more resolute artist would have penetrated the steel doors.")

A taste for violence in both theme and diction is undoubtedly what drew the younger Hughes to Seneca's *Oedipus*. The rhetorical

extravagance of the Stoic philosopher and dramatist's verse, the sense of language being pushed to its furthest extremes, the famously baroque descriptions of the violence to which the body can be subjected: these have long been acknowledged as characteristic of Seneca's style. In his introduction to the published version of the *Oedipus* translation, Hughes (who in works such as his 1977 collection, *Gaudete*, warned against rejecting the primordial aspect of nature in favor of cold intellectualism) commented on his preference for the "primitive" Senecan treatment of the Oedipus myth over the "fully civilized" Sophoclean version. Seneca's blood-spattered text afforded Hughes plenty of opportunities to indulge his penchant for the uncivilized, often to great effect: his renderings of Seneca's dense Latin have an appropriately clotted, claustrophobic feel, and don't shy away from all the gore. The man who, in a poem called "February 17th," coolly describes the aftermath of his decapitation of an unborn lamb *in utero* ("a smoking slither of oils and soups and syrups") was clearly not fazed by incest and self-mutilation. "My blood," Hughes's Jocasta says, ". . . poured on / into him blood from my toes my finger ends / blind blood blood from my gums and eyelids / blood from the roots of my hair . . . / flowed into the knot of his bowels . . .," etc.

Hughes's Seneca was good, strong stuff because in Seneca, as in Hughes's own work, theme and language are meant to work at the same pitch—the moral squalor was nicely matched by imagistic, prosodic, and linguistic squalor. Hughes was much less successful when, a generation later, he returned to classical texts—especially the dramas. You could certainly make the case that classical tragedy (and its descendants in French drama of Racine's *siècle classique*) is about nothing if not the moral squalor that attends the brute survival instinct—not least the audience's sense of moral squalor, its guilty pleasure in not being at all like the exalted but doomed scapegoat-hero. But it is an error typical of Hughes as a translator to think that you can extract the squalid contents from the highly stylized form and still end up with something that has the power and dreadful majesty of the *Oresteia* or *Phèdre*. Commenting on *The River*, Professor Vendler observed that "Hughes notices in nature what suits his purpose": the same is true of his approach to the classics.

It's not that Hughes's translations of Racine and Aeschylus can't convey with great vividness the moral and emotional states of the characters; they can. "I have not drunk this strychnine day after day / As an idle refreshment," Hughes's besotted Phèdre tell her stepson, with an appropriately astringent mix of pathos and wryness. His Clytemnestra has "a man's dreadful will in the scabbard of her body / Like a polished blade"—lines that Aeschylus never wrote, it's true, but that convey the poet's preoccupation particularly with the threateningly androgynous character of his monstrous queen. But what Hughes's classical translations (and so many others, most notably the very uneven new Penn Greek Drama Series edited by David Slavitt and Palmer Bovie) lack—disastrously—is grandeur. And the grandeur of high tragedy arises from the friction between the unruly passions and actions that are represented (incestuous longings, murderous and suicidal violence—moral squalor, in short) and the highly, if not indeed rigidly, stylized poetic forms that contain them: Racine's glacially elegant alexandrines, or the insistent iambic trimeters of the Greek dialogue alternating at regular intervals with choral lyrics in elaborate meters. William Christie, the leader of the baroque music ensemble Les Arts Florissants, has spoken of "the high stylization that releases, rather than constrains, emotion": this is a perfect description of the aesthetics of classical tragedy.

Hughes—never committed to strict poetic form to begin with, and increasingly given to loose, unrhythmical versification—is suspicious of the formal restraints that characterize the classical. Like so many contemporary translators of the classics, he mistakes artifice for stiffness, and restraint for lack of feeling, and he tries to do away with them. In his *Oresteia* the diction is more elevated than what you find in some new translations (certainly more so than what you find in David Slavitt's vulgar *Oresteia* translation for the Penn Greek Drama series, which has Clytemnestra pouring a "cocktail of vintage evils" and addressing the chorus leader as "mister"); but still Hughes tends too much to tone things down, smooth things out, explain things away.

Few moments in Greek drama are as moving as the chorus's description, in the *Agamemnon*, of Iphigeneia, about to be sacrificed at Aulis by Agamemnon, pleading for her life "with prayers and cries to her father" and then, even more poignantly, after she has been brutally gagged,

"hurling at the sacrificers piteous arrows of the eyes." But Hughes's rather suburban Iphigenia cries, "Daddy, Daddy," and simply weeps ("her eyes swivel in their tears"). Such choices remind you of how much the extreme figurative language that Aeschylus gives his characters has regularly confounded, not to say embarrassed, translators. The Watchman at the opening of the *Agamemnon* is so terrified of the adulterous, man-emulating queen that he can't even talk to *himself* about it: "A great ox stands upon my tongue," he mutters ominously. The line has tremendous archaic heft and power, something that cannot be said for Hughes's "Let their tongue lie still—squashed flat."

No doubt because of the many opportunities Ovid's *Metamorphoses* affords for crafting images of the animals into which so many characters are transformed, the most successful of Hughes's late-career translations is his *Tales from Ovid*. But even here the poet fails to realize how important Ovid's form is. In his Introduction, Hughes makes due reference to the Hellenophile poet's "sweet, witty soul," but he's clearly far more interested in what he sees as the *Metamorphoses'* subject: "a torturous subjectivity and catastrophic extremes of passion that border on the grotesque." He manages, in other words, to find the Seneca in Ovid. And yet the pleasure of Ovid's epic lies precisely in the delicate tension between all those regressive, grotesque, nature-based metamorphoses and the "fully civilized" verses in which they are narrated: a triumph of Culture over Nature if ever there was one. Hughes's Ovid is often very effective, but it is not sweet and witty.

======

It's tempting to think that Hughes found Euripides' *Alcestis* interesting precisely because this work—the tragedian's earliest surviving play—presents so many problems of both form and content. With its unpredictable oscillations in tone and style, it seems positively to invite abandonment of formal considerations altogether. "A critic's battlefield," the scholar John Wilson wrote in his introduction to a 1968 collection of essays on the play. The war continues to rage on.

Alcestis was first performed in 438 B.C. in Athens at the Greater

Dionysia, an annual combined civic and religious festival, including a dramatic competition, that must have resembled a cross between the Fourth of July, Thanksgiving, and the Oscars. The drama was presented as the fourth play in a tetralogy—the final spot, that is, in which amusingly bawdy "satyr plays" were normally presented, presumably to alleviate the pity and fear triggered by the three tragedies that had preceded it onstage. (The three that preceded *Alcestis*, two of which seem to have dealt with the sufferings of passionate women, are lost.) And yet, this fourth play—in which Queen Alcestis voluntarily dies in place of her husband, King Admetos, when the appointed day of his death is at hand, only to be brought back from Hades by Herakles in the play's bizarre finale—unsettlingly mixes elements of high tragedy with its scenes of comic misunderstandings, elaborate teasing, and drunken hijinks.

The first, "tragic" half of the short drama begins with a somber expository prologue by Apollo, followed by a debate between Apollo and Death, who has come to claim Alcestis and who is warned that he won't, in the end, get his way. We are then plunged into the mortal world and a mood of unrelenting gloom: a heartrending scene of Alcestis's slow death; her farewells to her children (whom she relinquishes to her husband on the condition that he not neglect them) and to her husband (who vows never to remarry); her impassioned outburst, addressed to her marriage bed, as she sees death approaching; her funeral procession, which is interrupted by a violent argument between Admetos and his aged father, Pheres (who along with his elderly wife refused to die in his son's place when given the chance to do so); and a grief-stricken Admetos's return to his empty house after the funeral.

The second, "comic" half presents the spectacle of the rambunctious Herakles' arrival at the house of mourning (he is en route to yet another of his Labors); Admetos's excruciatingly diplomatic efforts to keep up his reputation as a good friend and legendary host (he doesn't want Herakles to know Alcestis has died lest his guest feel unwelcome); a drunken, feasting Herakles' discovery of the truth, and his subsequent vow to bring his friend's wife back; and the hero's rescue of Alcestis after a wrestling match with Death himself, which takes place beside Alcestis's tomb. The play ends with the eerie spectacle of a triumphant Herakles, like the father of a bride, handing over the veiled and silent

figure of Alcestis to Admetos without, at first, telling Admetos who the woman is—teasing him in order to prolong the suspense. She never speaks again during the course of the play.

The hodgepodge of moods, styles, and themes suggested by even this cursory summary has made interpretation of this strange work particularly thorny. To cite John Wilson further:

> Even the genre to which the play belongs is disputed—is it a tragedy, a satyr play, or the first example of a tragicomedy? Who is the main character, Alcestis or Admetos? And through whose eyes are we to see this wife and this husband? Is Alcestis as noble as she says she is? And is Admetos worthy of her devotion, or does he deserve all the blame that his father, Pheres, heaps upon him? And is the salvation of Alcestis a true mystery, a sardonic "and so they lived happily ever after," or simply the convenient end of an entertainment?

These questions continue to puzzle classicists, despite radical shifts in the way we read classical texts. Since Wilson wrote in the 1960s, no literary-critical school has influenced classical scholarship so much as feminist studies has; and the *Alcestis* has proved an especially rich vehicle for scholars interested in demonstrating the extent to which literary production in classical Greece reflected the patriarchal bias of Athenian society during its cultural heyday. "The genre of the *Alcestis*," the classicist Nancy Sorkin Rabinowitz has written in a stimulating if perhaps too ideologically rigid study of Euripides' handling of female characters, ". . . depends on gender. On the surface, it is comic: death leads to life, and a funeral resolves into a wedding. But is it a happy ending for Alcestis as well as for Admetos? Although funeral and wedding may seem to be opposites, they come to much the same thing for this woman."

You don't have to be a feminist hard-liner to have your doubts about Admetos. Even at the very beginning of the drama, as Alcestis lies dying within the house, the king's self-involvement takes your breath away. It is true that the laments he utters in his exchange with the dying Alcestis

are all fairly conventional ("Don't forsake me," "I am nothing without you"), and yet their cumulative effect is unsettling: gradually, it strikes you that for Admetos this domestic disaster is all about him. Alcestis's death, he cries, is "heavier than any death of my own"—an appeal for sympathy that's a bit much, considering that she's dying precisely because he was afraid to. He's Periclean Athens's answer to the guy in the joke about the classic definition of chutzpah—the one who murders his parents and then throws himself on the mercy of the court because he's an orphan.

Admetos makes the dying Alcestis several somewhat excessive promises: among them, a vow to ban all revelry for a full year, and an oath never to take another woman into his house. Yet by the end of the play he will have broken both: first when he allows Herakles to be feted with wine and music, and then when he accepts, as a man might accept a new bride, the anonymous veiled woman into his household—before he knows she's Alcestis. Most bizarrely, he declares that he will have an artisan fashion a statue of Alcestis, which he will take to bed and caress as if it were she—a "cold pleasure," to be sure, but one that will help to assuage his loss. For some critics, this has a fetishistic, doth-protest-too-much quality; whatever you make of it, it's striking that, having promised to mourn Alcestis forever, her husband begins, before she even dies, to seek comfort (however cold) for himself.

So the husband is a weak man in the first part of the play. But he must be so, since whatever "tragic"—or, for that matter, dramatic—development Euripides' play has depends on Admetos's evolution—on his starting out as a less than admirable man who comes to realize that the existence he has purchased with his wife's life isn't worth having precisely because he has lost her. "Now I understand," he exclaims at the play's climax, right before Herakles enters with the resurrected Alcestis. Even so, this king is no hero: Alcestis's miraculous return from the grave yanks her husband back from the brink of truly tragic self-knowledge, the kind he'd have acquired if he had had to live with his loss, as characters in "real" tragedies do. (When they don't kill themselves, that is.)

As it is, Admetos gets to eat his cake and have it, too. "Many readers will feel [his grief] does not change him enough," the Harvard classicist Charles Segal tartly observed in one of several penetrating essays he

wrote on this play. Richmond Lattimore, who translated the *Alcestis* for the University of Chicago Greek Drama series nearly half a century ago, was moved, similarly, to question Admetos's character, using the bemused rhetorical-question mode into which those who have grappled with the *Alcestis* keep falling, no doubt because the work's violent wobbling between genres makes any definitive pronouncement seem foolhardy. "If a husband lets his wife die for him," Lattimore asked, "what manner of man must that husband be?"

===

Hughes's *Alcestis* adaptation invites us to believe that this is, in fact, the wrong question to be asking. His version is wholly unconcerned with Admetos's flaws, not least because in his version, Admetos has no flaws. Everything in Euripides that suggests we ought to question the husband's character has here been excised; instead, it's God who gets the rough treatment. It's a striking alteration.

The cleanup job begins early on. In Euripides' play we learn that Apollo, in gratitude for being well treated *chez* Admetos, has promised the mortal king that he will be able to avoid his death if he can find someone to die in his place; Admetos tries all his loved ones in turn until finally his wife agrees to die for him. But in Hughes's version, Admetos is spared the embarrassing (indeed, damning) task of begging his relatives—and wife—for volunteers; here, it's Apollo who "canvasses" for substitutes. In fact, Apollo doesn't even have to ask Alcestis, as in Euripides' play Admetos most certainly does: she just volunteers. (It's interesting that Hughes's heroine is more faithful to her counterpart in the original than his Admetos is; and when he gives her lines that Euripides didn't—as when, in her farewell to her daughter, she pathetically exclaims, "She will not even know what I looked like"—the drama is enhanced.)

Similarly, Hughes smoothes away any sign of what Charles Segal calls the "unthinking self-centredness of the husband." He erases the solipsistic whininess from Admetos's laments at the beginning of the play. The breathtakingly self-involved utterances that Euripides

puts in Admetos's mouth, well translated by Lattimore—"sorrow for all who love you—most of all for me / and for the children" and "Ah, ['good-bye' is] a bitter word for me to hear, / heavier than any death of my own"—here become the considerably less galling "Fight against it, Alcestis. / Fight for your children, for me" and "Good-bye!—don't use that word. / Only live, live, live, live." (For American readers, at least, the latter will have an unfortunate Auntie Mame-ish ring.)

Most strikingly, Hughes eradicates any sense of the strange excessiveness of Admetos's promise to build a replica of his wife, which in the new version becomes a dismissive, indeed incredulous, rhetorical question: "What shall I do, / Have some sculptor make a model of you? / Stretch out with it, on our bed, / Call it Alcestis, whisper to it? / Tell it all I would have told you? / Embrace it—horrible!—stroke it! / Knowing it can never be you . . ." Hughes's subtle rewriting inverts the whole point of the scene. The original hints disturbingly at the husband's readiness to accept a substitute for the dead wife; the new version emphasizes the husband's steadfast fidelity. (To further deflect blame from Admetos, Hughes makes his father, Pheres, particularly disgusting. Here the old man not only refuses to die for his son, but "screeches" and "wails" at the younger man to "Die . . . clear off and die.")

Hughes's alterations, ostensibly minor, ultimately sap the strength of Euripides' dramatic climaxes. In the original, the culminating scene in which a veiled, voiceless Alcestis returns home to her husband on Herakles' arm owes much of its eeriness precisely to Admetos's deathbed promise, which has prepared us for the idea, however odd, that the king will settle for an inhuman facsimile of his dead wife; and lo and behold, at the "happy" ending we see him holding hands with something that could well be such a dummy. But since Hughes has dispensed with Admetos's vow, the climax loses all of its creepy potential. Once again, the translator's embarrassment about the grand, bizarre qualities that so often characterize tragic action and diction takes its toll in dramatic effectiveness.

In the original, what leads us to a fleeting suspicion that Her-

akles' companion is, in fact, nothing more than a statue is the figure's total silence during a lengthy exchange between Admetos and Herakles—a muteness that clearly disturbs the other characters and, precisely because we're afraid the silent woman might be just a simulacrum, a revenant, ought to disturb us, the audience, too. In Euripides, an agitated Admetos turns to Herakles and demands: "But why does she just stand there, voiceless?" Fred Chappell's rendering for the Penn Series, otherwise marred by gimmicks (each scene is introduced by musical directions in Italian, as if it were an opera: *"allegro calmando; poi accelerando"*), nicely conveys Admetos's agitation: "But why does my Alcestis stand so silent?" In Hughes's version, an ever-polite Admetos blandly murmurs, "Will she speak?" You wonder whether he cares.

On the face of it, at least part of the reason for Hughes's shifting of emphasis—and any suspicion of moral weakness—away from Admetos is that he wants his adaptation to be a grand dramatic and poetic statement about the triumph of the human spirit, about mortality and the victory of love over death. The husband and wife are idealized, whereas there's a lot of complaining about "God" and his pettiness and cruel indifference to human suffering ("As usual, God is silent"). To bolster this cosmic interpretation of the original, Hughes adds, in the Herakles scene, elaborate riffs on Aeschylus's antiauthoritarian *Prometheus Bound*, with its questioning of Zeus's justice, and on Euripides' own profoundly antireligious *Madness of Herakles* (in which the hero, freshly returned home from his labors, is temporarily maddened by a vengeful goddess and in his delusion murders his wife and children). And Hughes's dark mutterings about "nuclear bomb[s] spewing a long cloud / of consequences" and the accusatory descriptions of God as "the maker of the atom" who is served by "electro-technocrats" suggest as well that the poet had not given up his preference for primitive Nature over cold Culture.

Yet even as Hughes ups the thematic ante in his adaptation, formal problems seriously undercut his ambitions. Perhaps inevitably when dealing with *Alcestis*, the translation is, even more than his others, marred by the poet's inability to find a suitable tone. In what looks like an attempt to convey the tonal variety of Euripides' hybrid drama, Hughes experiments more than previously with slangy, playful diction.

The results can be odd, and often betray the dignity of the original where it is, in fact, dignified. "You may call me a god. / You may call me whatever you like," Hughes's Apollo says in his prologue speech, which in the original is crucial for setting the mournful tone of the entire first half. It's a bizarre thing for Apollo to say: characters in Greek tragedies get zapped by thunderbolts for far less presumptuous haggling with divinities. (*Alcestis* begins, in fact, with a dire reference to Zeus's incineration of the hubristic Aesculapius, Apollo's son, who dared to raise the dead—the first allusion to the all-important theme of resurrection.) Apollo goes on: "The dead must die forever. / That is what the thunder said. The dead / Are dead are dead are dead are dead / Forever. . . ." You suspect Hughes is trying here to convey the thudding infinite nothingness of death, but bits like this are unfortunate reminders that the translator was also a prolific author of children's books. The intrusion of comic informality is hard enough to adjust to in Euripides' *Alcestis*, where the biggest moral problem is a husband's gross inadequacies; but it's a disaster in Hughes's *Alcestis*, where the big moral problem is God's gross inadequacies.

Hughes, it should be said, wasn't the first widower poet for whom the opportunity to translate the *Alcestis* served as the vehicle for a corrective shift in emphases. In Robert Browning's long historical poem *Balaustion's Adventure* (the subtitle is "Including a Transcript of Euripides"), which was composed after the death of his wife, Elizabeth, a poetess comes to Athens from Rhodes to meet Euripides, and then sets about adapting *Alcestis*. But her version—and, by extension, the Browning version—turns out to be a redemptive one. In it, "a new Admetos" rejects out of hand Alcestis's offer to die in his place: "'Tis well that I depart, and thou remain," he tells his wife, with whom, indeed, he gets to enjoy a fairy-tale posterity. ("The two," Browning writes, "lived together long and well.") Hughes's adaptation renovates Euripides along comparable lines. If the ancient dramatist's *Alcestis* forces us to ask, "If a husband lets his wife die for him, what manner of man must that husband be?" then the contemporary poet's *Alcestis* asks, "If God lets people die, what manner of god must He be?" In Hughes, as in Browning, there are no guilty husbands—no profound delving into the emotional (if not moral) squalor that often goes with being the survivor. There are just guilty abstractions.

Disturbing silences like the one with which Euripides' *Alcestis* concludes are a leitmotif in the drama of Plath and Hughes. In *Bitter Fame*, her biography of Plath, Anne Stevenson describes a tiff between Plath and Hughes's sister, Olwyn, that took place during the Christmas holidays in 1960: depending on whose side you're on, the episode demonstrates either Plath's irrationality or Olwyn Hughes's coldness. In response to a remark of Olwyn's that she was "awfully critical," Plath "glared accusingly" at her sister-in-law but refused to respond, keeping up her "unnerving stare" in total silence. "Why doesn't she say something?" Olwyn recalled thinking. (*That* would have been an excellent translation of Admetos's climactic line, conveying vividly the frustration and unease of someone faced with this particular brand of passive-aggressiveness.) As recently as a few years ago, Olwyn Hughes, in a letter to Janet Malcolm, was clearly still smarting from what Malcolm, in her book about Plath and Hughes, *The Silent Woman*, called Plath's "Medusan," "deadly, punishing" speechlessness.

But if Plath was, like Alcestis, the "silent woman," Hughes himself was the silent man—aggressively, punishingly so, at least in the eyes of those who wanted to know more about the characters in this famous literary/domestic "tragedy," the passions of whose "characters" only the language of Greek myth and classical drama, it sometimes seems, can capture. ("They have eaten the pomegranate seeds that tie them to the underworld," Malcolm wrote; "I go about full with the darkness of my flame, like Phèdre . . . ," Plath herself wrote.) When Hughes's *Birthday Letters* appeared in 1997, it met with a variety of reactions: horror, joy, shock, surprise, anxiety, enthusiasm, etc. But what everyone agreed on was that it was, in essence, a relief: finally, Hughes was speaking.

And why not? "Ted Hughes's history seems to be uncommonly bare of the moments of mercy that allow one to undo or redo one's actions and thus feel that life isn't entirely tragic," Malcolm wrote. *Birthday Letters* was viewed by many as a kind of second chance, an opportunity to undo, or perhaps to redo, his public image with respect to his dead wife. (The same is true of the personal effects—passports, letters, photographs, manuscripts—that had belonged to Hughes, and which appear

to have been the bases for several of the "Letters." "He is thought of by critics as being so self-protective and so unrevealing of himself," said Stephen Enniss, the curator of literary collections at the Robert W. Woodruff Library at Emory University. "I think the archive will make him appear more human, more sympathetic than the detached voice and aloofness we had known.")

Writers—even those who appear aloof and voiceless about their private lives—can reveal themselves inadvertently. Reading Malcolm's description of the trapped Hughes, I found it hard not to think of Euripides' *Alcestis*, a play that notoriously allows a flawed man to undo and redo the fatal past. The undoings and redoings you find in Hughes's almost inadvertently moving adaptation of that work—the elisions, omissions, and reconfigurations—suggest that the poet's most revealing public utterance with respect to Plath may not have been *Birthday Letters* after all. In her way—her "veiled" way—the most eloquent figure, among so many strange and tragic silences, has turned out to be Euripides' silent woman.

—*The New York Review of Books*, April 27, 2000

PART TWO

Heroics

A Little Iliad

W ho, contemplating the vast catalogue of vanished works of literature from the ancient world, really regrets the lost epics about the Trojan War known as the *Cypria* and the *Little Iliad*? To have just one more complete poem by Sappho (bringing the grand total to two); to have any of the seventy-five lost plays of Aeschylus, the hundred and sixteen by Sophocles, the seventy by Euripides; to recover Ovid's lost *Medea*, or even a single one of the much-admired love elegies of Vergil's friend Cornelius Gallus, which once comprised four whole books and of which a single line now survives; to have the crucial missing books of Tacitus's *Annals*—for any one of these, there is very little that even the most upstanding classicist wouldn't do. Any one of these, after all, would add immeasurably to our understanding of classical civilization; any one of these would, indeed, add unimaginably to the treasure house of world literature.

But for the *Cypria* and the *Little Iliad*, I suspect, no one apart from the most scrupulous philologue sheds a secret tear. These were just two of what was once a grand cycle of eight epic narratives in verse, composed at some point in the preclassical Greek past, which together comprised many tens of thousands of lines and at least seventy-seven "books," or

papyrus scrolls, and which narrated pretty much everything having to do with the Trojan War, from its remotest prehistory (the wedding of Achilles' parents, Peleus and Thetis) to the final bizarre ramification of its furthest, attenuated plotline (the murder of Odysseus, in his old age, by his son Telegonus, his child by the witch Circe). Of these eight, of course, only two survive: the *Iliad* and the *Odyssey*. But later summaries, paraphrases, and even quotations in learned commentaries on classical works that have survived give details about the other six. We know that the eleven books of the *Cypria*, for instance, made for rather an everything-but-the-kitchen-sink affair, covering all the action from the nuptials of Peleus and Thetis to the Judgment of Paris to the abduction of Helen, all the way through to the first nine years of the war—right up to the moment when Homer's *Iliad* begins.

And we know that at some point after the *Iliad* came the so-called *Little Iliad*—also something of a laundry list of a poem, from the sound of it, narrating as it did much of the action after the death of Achilles, from the suicide of Ajax and the mission to fetch Philoctetes to the construction of the Trojan Horse, from the deceitful embassy of the Greek soldier Sinon (who convinced the Trojans to take the wooden horse, falsely asserting that the Greeks, fearing plague, had returned home), to the Achaeans' terrible entry into Troy. Various other poems filled in the blanks: the *Aethiopis* narrated the deaths of ancillary characters like the Amazon queen Penthesilea and Memnon, an Ethiopian ally of the Trojans (hence the poem's name); another, called the *Nostoi*, or "Returns," narrated the arduous homecomings of the Greek heroes after the war, particularly that of Agamemnon. It was presumably adjacent to the *Nostoi* in the epic cycle that the *Odyssey* once stood.

One reason that we don't hugely regret the absence of most of the lost epics is, in fact, the greatness of the two surviving Homeric works: each is a masterpiece that stands easily on its own, needing neither a prequel nor a sequel. Another reason is that much of the content of the lost epics was recapitulated in later Greek tragedies, to say nothing of Vergil's *Aeneid*, the second book of which provides as harrowing and satisfying an account of the Fall of Troy as anyone could want. But there's

another reason that we shouldn't mind too much the loss of poems like the *Cypria* or the *Little Iliad*. Apparently, they weren't all that good.

In the twenty third chapter of his *Poetics*, Aristotle suggests why. In this section, he somberly warns about some potential pitfalls in constructing the plots of epic poems; as examples of what can go wrong, he uses, as it happens, both the *Cypria* and the *Little Iliad*. "With respect to narrative mimesis in verse," he writes (by which he means epic poems),

> it is clear that the plots, as in the tragedies, ought to be made dramatic—that is, concerning one whole and complete action having a beginning, middle, and end; clear, too, that its structures should not be similar to histories, which require the exposition not of one action, but rather of one period and all the events that happened during it to one person or more; and how each and every one of those things that transpired relates to every other. . . . But most of the poets, more or less, do just this. Which is why (as I have already said) in this, too, Homer may be said to appear "divinely inspired" above the rest, since he did not attempt to treat the [Trojan] war as a whole, although it had a beginning and an end; for the plot was bound to be too extensive and impossible to grasp all at once—or, if kept to a reasonable size, far too knotty in its complexity. Instead, taking up just one section, he used many others as episodes, such as the "catalogue of ships" and other episodes with which he gives his composition diversity. But the other poets construct one composite action about a single man or period, as for instance the poet of the *Cypria* and the *Little Iliad*.

For those who think that "epic" merely means "big" or "long," it's worth emphasizing that by "action" Aristotle clearly does not mean a long string of events—such as, for example, the suicide of Ajax, the Greeks' attempt to lure Philoctetes and his magic bow back to Troy, the construction of the wooden horse, Sinon's ruse, and the penetration of the Trojan walls by means of the hollow horse, all of which, as we know, went into the *Little Iliad*. Such events are, in Aristotelian terms,

merely linked together but do not form what he thinks of as a "plot," a single action—what he calls a *praxis*, a word derived from the Greek verb *prattein*, "to do." For Aristotle, a poem consisting of lots of little doings nominally linked by chronology ("everything leading up to the Trojan War," say, or "everything that happened after Achilles died") was one that, as even a brief summary of the *Cypria* or the *Little Iliad* suggests, was little more than a boring catalogue.

A plot, by contrast, is what the *Iliad* has. For all its great length, the poem is precisely about what is proposed, in its famous opening line, as its subject matter: the wrath of Achilles, its origins, its enactment, its consequences. (So too the *Odyssey*, whose concomitant episodes all refract what it, in its equally famous opening line, purports to be about: the "man of many turnings who wandered wide": no part of the poem does not illuminate his cleverness, his yearning for home, his humanity.) To be sure, Achilles' rage, as it plays itself out through the poem's twenty-four books, sheds light on a vast host of issues: the meaning of heroism, the nature of war and of peace, the sweetness and bitterness of human life. But the *Iliad* is able to illuminate so much precisely because of its searing focus on one *praxis*, which is what gives it its awesome weight and terrible grandeur. Which is to say, what makes it truly big, truly "epic."

We do not, of course, possess either the *Cypria* or the *Little Iliad*, but what we know about them suggests that they have much in common with another failed epic: this summer's big blockbuster movie, Wolfgang Petersen's *Troy*, a film that falters hopelessly for precisely the same reasons that those lost, bad poems did. *Troy* claims, in a closing credit sequence, to have been "inspired" by the *Iliad*, but however much it thinks it's doing Homer, the text it best illuminates is Aristotle's.

———

What the makers of *Troy* have is not a single unifying action, but a single unifying notion: that the Trojan War was a war like any other. "This is about power, not love," the Trojan prince Hector (Eric Bana, an Australian actor who recently played the comic-book character "The

Incredible Hulk," and who looks not very different from someone you might see on the subway) declares early on to his new sister-in-law, Helen (Diane Kruger, a pretty blond cheerleader type). Such tough pronouncements are clearly meant to demonstrate that Petersen and his screenwriter, David Benioff, are going to give us an epic for our times, and have, accordingly, stripped from *Troy* all traces of the supernatural, the mythic, and even the heroic. Gone are Homer's mischievous gods and goddesses; gone, too, the elaborate shame-culture codes of honor, reciprocity, gift-giving, and booty-apportioning that inform every action taken by every character in Homer.

Benioff has exiled Homeric heroics in favor of something that modern audiences will feel more comfortable with: global geopolitical Realpolitik. Here Agamemnon (played by a scenery-devouring Brian Cox, much given to wicked cackling) is driven not by considerations of family honor (after all, it's his brother, Menelaus, who's been cuckolded by the Trojan prince Paris) but by a desire for world hegemony: an opening title informs us that, having already subdued the cities of Greece, he lusts for Troy, the only city that stands between him and Aegean domination. It's made quite clear that neither he nor any of the other characters, with the exception of the old Trojan king Priam (Peter O'Toole), believes in the Greek gods: during the first day of battle, when Achilles (Brad Pitt) and his Myrmidons storm the Trojan shore (a sequence shamelessly lifted from Steven Spielberg's *Saving Private Ryan*), he blithely desecrates a shrine of Apollo, slicing the head off the god's golden cult-image. Back in Troy, meanwhile, Hector, responding to his father's pious declaration that Poseidon will protect their city, snaps back, à la Stalin, "And how many battalions does the sea-god command?"

There is nothing at all wrong with toying with Homeric or epic characters and story lines. The classical canon is full of works that do just that; indeed if, out of some fussy curatorial reverence for "the classics," we were to dismiss wholesale reconfigurations or adaptations of Homer, we'd have to start by junking, among much else, Aeschylus's *Oresteia*, Sophocles' *Philoctetes*, *Electra*, and *Ajax*, and Euripides' *Iphigenia at Aulis*, *Iphigenia Among the Taurians*, *Electra*, *Orestes*, and *Trojan Women*. This is why, although Benioff makes some startling innovations to myth as we know it—beginning with the deaths of both Menelaus and Ajax during the first major engagement between the Greeks and Trojans, and ending

with the murder of Agamemnon during the Sack of Troy, all of which demises wreak havoc with the extant tragic canon—it's pointless to criticize *Troy* on the grounds that it's not "faithful" to the text of Homer, as so many critics have done. Most of the action of the film, at any event, is not based on the *Iliad* but instead recapitulates almost in its entirety the narrative once related by those lost epic poems of Troy, filling its nearly three hours with everything from pretty Paris's abduction of Helen to the wide-screen destruction of the Trojan citadel itself.

The real objection to Petersen and Benioff's reductive ideological updating of the epic story they tell is structural, not pedantic: the "realism" they've opted for goes against the grain of the genre they're working in. For one thing, the authors' jettisoning of Homeric codes of behavior makes a hash of much of the characters' actions. In Homer, Agamemnon's seizure of Achilles' property, the slave girl Briseis, represents a catastrophic affront to Achilles' sense of himself; his subsequent withdrawal from the war is the hinge of Homer's plot, setting in motion awful consequences unforeseen by Achilles himself. (And, indeed, Agamemnon's action is motivated by a similar desire not to lose face: he only takes Achilles' girl after he's told he has to give up one of his own.) But Benioff's bitter and disillusioned Achilles doesn't really believe in anything, and so you don't really know why he bothers. A lot of the action of *Troy*, which blindly follows much of the epic cycle's plot while providing none of the epic motivations, feels similarly hollow.

Or, indeed, downright ridiculous. What sets the climax of the *Iliad* in motion is the killing of Achilles' beloved companion, Patroclus, at the hands of Hector—another loss, but this time one that propels the sulky hero back into vengeful action. Fueled, you suspect, by a desire to expunge the vaguest hint of homoeroticism from the proceedings—by classical times, the question wasn't so much whether Achilles and his beloved Patroclus were doing it, as it was (for instance, in Plato's *Symposium*) who was doing just what to whom—Benioff makes Patroclus Achilles' "cousin." Particularly today when family ties have never counted for less, this bit of whitewashing has increasingly hilarious results as the action progresses. Watching *Troy*, you'd think that there was no higher value for the Bronze Age Greeks than cousinage. "He

killed my *cousin*!!" Achilles shrieks at Priam when the latter comes begging for his son's body at the end of the story. "You've lost your cousin, now you've taken mine," a mournful Briseis (in this version, Hector's cousin) tells Achilles. "When does it end?" This film's notion that entire civilizations were destroyed because of excessive attachment to one's collateral relations is, surely, a first in world myth-making.

There are here, to be fair, incessant references to one bona fide Homeric value: the premium placed on the glory heroes derive from being celebrated in song through the ages. And yet here again, the gritty twenty-first-century realism favored by those responsible for *Troy* makes nonsense of a genuinely Bronze Age element they have nonetheless retained. For the endless references to immortality through future fame ("men will write stories about you for thousands of years to come," one character says, blissfully innocent of the fact that there is no writing yet) are undercut both by the pervasive cynicism and by the grim modern character of the milieu Benioff works so hard to establish. There's no reason to believe that men as disillusioned and irreligious as those we keep seeing here would ever believe in anything so fuzzy as "immortality" in the first place. Anyway, if the Trojan War was really no more than a territorial affair—"about power, not about love," as one character puts it—you have to wonder just what about it, precisely, is worth celebrating at such great length in all those epics—epics which clearly include this movie itself?

And so, in the end, Benioff successfully ascribes convincing motivation to precisely one character—Agamemnon, with his lust for world hegemony—while neglecting the other 49,999 Greeks whom we constantly see in computer-generated battle scenes. Had *Troy* featured just one shot of the men gathered enchantedly around a blind bard who's singing of someone's great martial prowess, much of the movie would have made more sense; such a scene would have given depth and complexity to his otherwise monotonously hard-bitten warriors. But clearly this isn't gritty enough for the creators of *Troy*: as with many genuinely Homeric elements alluded to here, the filmmakers slavishly invoke the idea of immortal fame while failing to be able to account for it, to integrate it.

But then, they're making the wrong kind of movie for the message they want to convey. The notion of a deconstructed, antiwar Trojan War

story, a grittily realistic story about men with cousins rather than codes of honor, a fable about the emptiness of heroic illusion, is of course one that the ancients themselves entertained—not, however, in epics, but in tragedies. (*The Trojan Women*, for example.) The Greeks knew enough to realize that if you're making an epic, the potency and grandeur of the epic action, the magnificence and scope of the genre itself, would undercut any attempts to subvert it from within. This is as true for epic movies as it is for epic poems. We go to films like these precisely to be overwhelmed by the bigness and wonder of it all, and it's confusing to be told—even as we're invited to attend a film like *Troy* because it's a (I quote the recent ads for the film) "magnificent, opulent, passionate" and "sensational" "action spectacle"—that all the magnificence and opulence and spectacle are really worthless.

It's telling that the few critics who have really liked *Troy* are those who fail to perceive that the movie's form works so disastrously against its "message"—which is to say, they think that Homer is, essentially, antiwar and anti-epic, too. In *Slate*, David Edelstein confidently announces that "the story" of *Troy*

of course, comes to us largely from Homer's *The Iliad*, and while artists over the centuries have added their own gloss, the thrust remained unchanged: For all the heroics of these legendary warriors, the Trojan War was a grotesque and needless waste of lives.

"The picture," he goes on to say, "stays surprisingly true to its grim inspiration. The little stuff is often haywire, but the big themes are on the money." Writing in a similar vein in *The New Yorker*, David Denby found *Troy* "both exhilarating and tragic, the right tonal combination for Homer." Denby goes on to describe how, by the end of Petersen's film, we see that at Troy "the Greeks don't win anything worth winning":

The Greek heroes and generals, showoffs with eagle pride, tell one another that poets will someday celebrate their exploits. But the bitterness of loss is what they will sing of.

This, he declares, honors the intentions, if not the style or the means, of the poets.

It would be difficult to find more lopsided mischaracterizations of the *Iliad* and its themes than these. Whatever else war is in Homer, it's anything but a "grotesque waste": among other things, it's the occasion for the song that Homer has composed, which in turn is the vehicle for the perpetuation of the fame of those who died—the thing Benioff keeps having his characters talk about without ever suggesting what it really means. For the characters (and, very likely, the audience) of Homer's great songs, the celebration of one's exploits in the song of poets, immortal fame or *kleos*, is the very linchpin of the heroic code; it is precisely the prospect of commemoration in song that makes the bitterness of war, and even more the horror of death, worth enduring. Those who have read the *Iliad* closely know that a standard adjectival epithet for battle is, in fact, "bringing-glory-to-men."

Those who have read Homer's great poem carefully know, too, that as terrible as war can be in it, battlefield violence is something that heroes are eager for, rejoice and exult in, something they enjoy wholly apart from considerations of the glory it will bring them. Homer's warriors are, as it were, professionals, and they enjoy a job well or even elegantly done: a memorable simile from Book 16, the book in which Patroclus is killed, likens the Greek warrior, who has driven a spear into the head of an enemy soldier, cantilevering the poor man out of his chariot, to an angler who, "perched / on a jutting rock ledge, drags some fish from the sea, / some noble catch, with line and glittering bronze hook." As the classicist Bernard Knox reminds us, in his splendid introduction to Robert Fagles's supremely fluent and elegant translation of the *Iliad*, from which I have just quoted, "one of the common words for combat, *charmê*, comes from the same root as the word *chairô*—'rejoice.' " In Homer, war can be hell, but just as often it's sheer heaven. If you don't get this, you don't get Homer—and you don't, really, get epic either, a genre whose amplitude and grandeur are reflections not of the number of events that take place in it, but rather the splendor of its subject, which is as beautiful as it is terrible.

One thing that does follow—fatally—from the filmmakers' decision to strip from the Trojan War the "heaven" implicit in its Greek epic donnée—the exultation of war, the grand and rigid notions of honor and glory and heroism that motivate real heroes, the golden-hued and sometimes rather charming Olympian interludes—is a disastrous failure in tone. It's one thing to try to show the characters of myth as believable human beings, but quite another to vulgarize them, and vulgarize is what this film inevitably does again and again as it seeks, but never finds, an appropriate register for its unholy hybrid of contemporary cynicism and mythic plot. Some of the dialogue is in a mode perhaps best described as faux-legendary—the kind typically accompanied by much clasping of forearms ("May the gods keep the wolves in the hills and the women in our beds!")—whereas a good deal of it seems to have been airlifted from southern California. ("I'm making you another seashell necklace, like the ones I used to make you when you were a boy," Thetis, Achilles' mother, announces, clad in what appears to be a tie-dyed housedress.) It's bad enough having both in the same film; when they clash in the same scene, it's excruciating. "You are a Princess of Troy now!" Hector admonishes Helen. "And my brother needs you tonight!"

Visually, too, Petersen's film is awkward—yet another instance in which the ideology of the filmmakers goes against the genre of the film. For a movie that cost $170 million, this one looks shoddy and, apart from a few impressive computer-generated action shots (not least, the rather thrilling first glimpse of the Greek armada sailing to Troy, which appears to number at least a thousand ships), surprisingly sparse. The sets look cheap and are, to boot, inauthentic: there's a scene in Menelaus's palace that looks like a party at a Turkish-themed restaurant, and Troy itself is a bizarre hodgepodge of Egyptian, Assyrian, and Mycenaean motifs. As I watched *Troy*, I kept wondering why, given his Olympian budget, Petersen couldn't have paid some nice classicist a heroic sum of money to tell him what these Bronze Age cities ought to look like. (There are a lot of gaffes which could easily have been avoided: one portentous title indicates that the seaside palace we're looking at is in "the Port of Sparta," which, given Sparta's actual location, is a bit like setting a movie in the "Port of Tulsa"; another scene depicts a confrontation between the armies of Agamemnon and those of the king of Thessaly in central Greece, whose subjects are, hilariously, repeatedly referred to

not as "Thessalians" but—in a skip north to an entirely different region of Greece that no doubt owes much to the writer's vague memories of the letters of St. Paul—as "Thessalonians.") Worse, the battle scenes lack clarity and impact, and the crowd scenes are messy and unconvincing. Petersen's fall of Troy appears to devastate about thirty people.

Petersen became famous with the 1981 film *Das Boot*, about life aboard a German U-boat during World War II, and it may be that tight spaces bring out the best in him; he brings to *Troy* none of the visual panache that makes even the most imperfect of old Hollywood epics fun to watch. In Joseph Mankiewicz's 1963 *Cleopatra*, overblown, underrated, and not at all unintelligent, there's an over-the-top sequence portraying the Egyptian queen's entrance into Rome, and it's a breathtaking showstopper not least because the director knows how to build up to a big moment; he doesn't show you Cleopatra until you've had to sit through an endless parade of acrobats and fan-wavers, so that by the time Elizabeth Taylor appears (on a gilded palanquin atop a rolling pyramid-thing), you're as impatient as a Roman. In *Troy*, the entrance of the fabled horse into the city—a moment that should evoke an almost macabre poignancy, given that the Trojans think the fatal object is a peace offering—falls flat: Petersen shows you the horse first, and then a few people desultorily doing a line dance below, like grown-ups at a bar mitzvah reception. Then, anxious as ever to get to the next scene, he cuts away.

Virtually every big moment in Troy is sapped of impact in this way. Petersen either doesn't know how to frame a scene (the final encounter between Achilles and Hector, which should feel overwhelmingly climactic, is particularly lifeless) or he beautifully establishes a shot or a tableau that he doesn't allow to sink in: a creepy glimpse of a panting Achilles, the first day of slaughter behind him, hunched on a parapet and looking, you suddenly realize, more leonine than human, a terrific Homeric touch; an impressive-looking sequence showing the Greeks burning their dead at night; a macabre nocturnal funeral for Hector, with the royal womenfolk draped in black, sitting on an impossibly high dais. Just as I had begun to relish each of these, Benioff's skittish script and Petersen's anxious camera zipped along to the next scene, desperate to tick off the next Big Epic Moment, unaware that the real impact of epic lies precisely in the moments this director and screenwriter keep abandoning, the moments that further our understanding of the action, the *praxis*.

Not surprisingly, given Petersen's directorial strengths, the only scene that has even a frisson of genuine feeling is one that takes place in extremely close quarters. Toward the end of the film, old Priam sneaks into Achilles' tent in order to try to persuade the implacable hero to surrender the battered body of his son so that the Trojans might give it a proper burial. Priam keeps trying to get close to Achilles, who keeps sliding away, at once repelled and embarrassed. The awkward physicality of this brief scene efficiently and quite movingly conveys some real emotions (whether they're Archaic emotions is another matter): the old king's humiliated but necessary self-abasement, Achilles' sudden, grief-stricken realization that the only people he can admire are the Trojans, his enemies—and that the only father figure he can admire is the father of the man he's just killed. (It's the only scene in the movie in which Brad Pitt warms up as an actor; you can tell that here, finally, he's dealing with something he can understand.) The dynamic between a fatherless young hero and a bereft older man in particular is a genuinely powerful motif that could have been the basis of a valid rewriting of Homer, had Benioff and Petersen been interested in creating a coherent action instead of ticking off a list of events to be covered. Such a rewriting would, moreover, have been entirely Greek: the theme of unexpectedly riven loyalties in a young Greek hero looking for a father figure is, in fact, what shapes Sophocles' *Philoctetes*.

And so *Troy* goes, skidding from one event to the next, from one undernourished conceit to another, anxious simply to get to the inexorable end. But in the end, there's nothing to hold *Troy* together, apart from that lumbering momentum to the narrative finish line. The movie manages to be (literally) a textbook example of everything an epic shouldn't be, which is to say both tedious and overstuffed at the same time. Or, to use the correct Aristotelian diction (for of course Aristotle could have predicted all this), "too extensive and impossible to grasp all at once," but also "far too knotty in its complexity."

Three hundred years after Aristotle committed his thoughts on epic to paper, the Roman poet Horace addressed a verse epistle to a would-be littérateur from a wealthy and well-connected family. Although technically known as *Epistles* 2.3, this witty but quite canny verse handbook

on the writer's art has since been known as the *Ars poetica*, the "Art of Poetry," and it contains a piece of advice about how to construct epic plots that is so famous that, like certain other Roman expressions—*caveat emptor*, for instance—we can utter it in the original and be confident of being understood. Here is the passage in which it occurs, in David Ferry's 1997 translation:

> And don't begin your poem the way the old
> Cyclic "Homeric" poets saw fit to do it:
> "I sing of the famous war and Priam's fate."
> What's to come out of the mouth of such a boaster?
> The mountain labored and brought forth a mouse.
> Ridiculous. He does much better who doesn't
> try so hard to make such grandiose claims. . . .
> He goes right to the point and carries the reader
> Into the midst of things, as if known already;
> And if there's material that he despairs of presenting
> So as to shine for us, he leaves it out;
> And he makes his whole poem one.

"Into the midst of things": *in medias res*. Whatever its claims to Homeric inspiration, however much it (inadvertently) invokes the lost "cyclical epics," the only ancient texts that Petersen's *Troy* ends up shedding light on are those works of criticism, very old but clearly still valuable, whose caveats the makers of this flaccid film have so powerfully if unintentionally proved valid. The ancients, who were less apt than we are to confuse size with import, knew that an epic without a focus—without a single action, a coherent plot, a single terrible point to make—was just a very long poem. Petersen's very long movie boasts a budget of many millions, a cast of thousands, and a duration of several hours; but despite those "epic" numbers, the movie looks and feels small. You could say, indeed, that mountains of money, time, and talent have labored and brought forth a $170 million mouse. In more ways than one, this *Troy* is a Little Iliad.

—*The New York Review of Books*, June 24, 2004

Alexander, the Movie!

Whatever else you say about the career of Alexander the Great— and classicists, at least, say quite a lot; one website that tracks the bibliography lists twelve hundred items—it was neither funny nor dull. So it was a sign that something had gone seriously wrong with Oliver Stone's long, gaudy, and curiously empty new biopic about Alexander when audiences at both showings I attended greeted the movie with snickering and obvious boredom. The first time I saw the picture was at a press screening at a commercial theater, and even from the large central section that was (a personage with a headset informed us) reserved for "friends of the filmmaker," you could hear frequent tittering throughout the film—understandable, given that the characters often have to say things like "from these loins of war, Alexander was born." A week later, at a matinee, I got to witness a reaction on the part of those who were unconstrained by the bonds of either duty or amity: by the end of the three-hour-long movie, four of the twelve people in the audience had left.

This was, obviously, not the reaction Stone was hoping for—nor indeed the reaction that Alexander's life and career deserve, whether you think he was an enlightened Greek gentleman carrying the torch

of Hellenism to the East or a savage, paranoid tyrant who left rivers of blood in his wake. The controversy about his personality derives from the fact that our sources are famously inadequate, all eyewitness accounts having perished. What remains is, at best, secondhand: one history, for instance, is based largely on the now-lost memoirs of Alexander's general and alleged half-brother, Ptolemy, who went on to become the founder of the Egyptian dynasty that ended with Cleopatra. At worst, it's highly unreliable. A rather florid account by the first-century A.D. Roman rhetorician Quintus Curtius often reflects its author's professional interests—his Alexander is given to extended bursts of eloquence even when gravely wounded—far more than it does the known facts. But Alexander's story, even stripped of romanticizing or rhetorical elaboration, still has the power to amaze.

He was born in 356 B.C., the product of the stormy marriage between Philip II of Macedon and his temperamental fourth wife, Olympias, a princess from Epirus (a wild western kingdom encompassing parts of present-day Albania). His childhood was appropriately dramatic. At around twelve he had already gained a foothold on legend by taming a magnificent but dangerously wild stallion called Bucephalas ("Oxhead")—a favorite episode in what would become, after Alexander's death, a series of increasingly fantastical tales and legends that finally coalesced into a literary narrative known as the Alexander Romance, which as time passed was elaborated, illuminated, and translated into everything from Latin to Armenian. While still in his early teens, he was at school with no less a teacher than Aristotle, who clearly made a great impression on the youth. (Years later, as he roamed restlessly through the world, Alexander took care to send interesting zoological and botanical specimens back to his old tutor.)

At sixteen he'd demonstrated enough ability to get himself appointed regent when his father, a shrewd statesman and inspired general who dreamed of leading a pan-Hellenic coalition against Persia, was on campaign. The young prince used this opportunity to make war on an unruly tribe on Macedon's eastern border; to mark his victory he founded the first city he named after himself, Alexandropolis. At eighteen, under his father's generalship, he led the crack Macedonian cavalry to a brilliant victory at the Battle of Chaeronea, where Macedon crushed an Athenian-Theban coalition, thereby putting an end to

southern Greek opposition to Macedonian designs on hegemony. At twenty, following the assassination of Philip—in which he (or Olympias, or perhaps both) may have had a hand—he was king.

That, of course, was just the beginning. At twenty-two, Alexander led his father's superbly trained army across the Hellespont into Asia. Next he liberated the Greek cities of Asia Minor from their Persian overlords (i.e., made them his own: the governors he appointed were not always champions of Hellenic civic freedoms), staged his most brilliant military victory by successfully besieging the Phoenician island fortress of Tyre (part of his famous strategy to "defeat the Persian navy on land" by seizing its bases), and freed a grateful Egypt from harsh Persian suzerainty. While in Egypt, he indulged in one of the bizarre gestures that, wholly apart from his indisputable genius as a general, helped make him a legend: he made an arduous and dangerous detour to the oracle of Ammon in the desert oasis of Siwah, where the god revealed that Alexander was in fact his own son—a conclusion with which Alexander himself came increasingly to agree. While in Egypt he also founded the most famous of his Alexandrias, a city that eventually displaced Athens as the center of Greek intellectual culture, and where his marvelous tomb, a tourist attraction for centuries after, would eventually rise.

Although Alexander had, apparently, set out simply to complete his father's plan—that is, to drive the Persians away from the coastal cities of Asia Minor, which for centuries had been culturally Greek, ostensibly in retaliation for a century and a half of destructive Persian meddling in Greek affairs—it's clear that, once in Asia, he began to dream much bigger dreams. Within three years of crossing the Hellespont, he had defeated the Persian Great King, Darius III, in a series of three pitched battles—Granicus, Issus, and Gaugamela—in which he triumphed against sometimes dire odds. It was in the rout that followed Issus that Darius fled the field of battle, leaving his wife, children, and even his mother behind in the baggage train. Alexander, with characteristic largesse and fondness for the *beau geste*—like most extravagant personalities, he had a capacity for generosity as great as his capacity for ruthlessness—honorably maintained the captives in royal state. His brilliant victory on the plain of Gaugamela in Mesopotamia in October 331 B.C., made him the most powerful man the world had ever known,

ruler of territories from the Danube in the north, to the Nile valley in the south, to the Indus in the east. He was also the world's richest person: the opulent treasuries of the Persians at Babylon, Susa, and Persepolis yielded him the mind-boggling sum of 180,000 silver talents—the sum of three talents being enough to make someone a comfortable millionaire by today's standards.

After Gaugamela, Alexander, driven by a ferocious will to power or inspired by an insatiable curiosity (or both), just kept going. He turned first to the northeast, where he subdued stretches of present-day Afghanistan, Uzbekistan, and Tajikistan, and there took as a wife the beautiful Roxana, daughter of a local chieftain, much to the consternation of his xenophobic aides. Then he moved to the south, where his designs on India—he believed it to be bordered by the "Encircling Ocean," which he longed to see—were thwarted, in the end, not by military defeat but by the exhaustion and demoralization of his men, who by that point, understandably, wanted to head back to Macedon and enjoy their loot. Himself demoralized by this failure in support, Alexander relented and agreed to turn back.

The westward return journey through the arid wastes of the Macran desert toward Babylon, which he planned to make the capital of his new world empire, is often called his 1812: during the two-month march, he lost tens of thousands of the souls who had set out with him. That tactical catastrophe was followed by an emotional one: after the army regained the Iranian heartland, Alexander's bosom companion, the Macedonian nobleman Hephaistion—almost certainly the king's longtime lover, someone whom Alexander, obsessed with Homer's *Iliad* and believing himself to be descended from Achilles, imagined as his Patroclus—died of typhus. (The two young men had made sacrifices together at the tombs of the legendary heroes when they reached the ruins of Troy at the beginning of their Asian campaign.) This grievous loss precipitated a severe mental collapse in the king, who had, in any event, grown increasingly unstable and paranoid. Not without reason: there were at least two major conspiracies against his life after Gaugamela, both incited by close associates who'd grown disgruntled with his increasingly pro-Persian policies.

Within a year, he himself was dead—perhaps of poison, as some have insisted on believing, but far more likely of the cumulative effects

of swamp fever (he'd chosen, foolishly or perhaps self-destructively, to pass the summer in sultry, fetid Babylon), a lifetime of heavy drinking, and the physical toll taken by his various wounds. He was thirty-two.

There can be no doubt that the world as we know it would have a very different shape had it not been for Alexander, who among other things vastly expanded, through his Hellenization of the East, the reach of Western culture, and thus prepared the soil, as it were, for Rome and then Christianity. But as extraordinarily significant as this story is, little of it would be very interesting to anyone but historians and classicists were it not for a rather curious additional factor: what the Greeks called *pothos*—"longing." The best and most authoritative of the ancient sources for Alexander's career are the *Anabasis* ("March Up-Country") and *Indica* ("Indian Affairs") by the second-century A.D. historian and politician Arrian, a Greek from Nicomedia (part of the Greek-speaking East that Alexander helped to create) who was a student of Epictetus and flourished under the philhellene emperor Hadrian; throughout his account of Alexander's life, the word *pothos* recurs to describe the emotion that, as the historian and so many others before and after him believed, motivated Alexander to seek far more than mere conquest. The word is used by Arrian of Alexander's yearning to see new frontiers, his dreamy desire to found new cities, to loosen the famous Gordian knot, to explore the Caspian Sea. It is used, significantly, to describe his striving to outdo the two divinities with whom he felt a special bond, Herakles and Dionysos, in great deeds. An excerpt from the beginning of the final book of Arrian's *Anabasis* nicely sums up the special quality that the *pothos* motif lends to Alexander's life, making its interest as much literary, as it were, as historical:

> For my part I cannot determine with certainty what sort of plans Alexander had in mind, and I do not care to make guesses, but I can say one thing without fear of contradiction, and that is that none was small and petty, and he would not have stopped conquering even if he'd added Europe to Asia and the Britannic Islands to Europe. On the contrary, he would have continued to

seek beyond them for unknown lands, as it was ever his nature,
if he had no rival, to strive to better the best.

What Alexander's psychology and motives were, we are in a particularly poor position to judge, the contemporary sources being absent. But there can be little doubt that the quality that Arrian describes here— the restlessness, the burning desire to see and to know new things and places for (it seems) the sake of knowing—is what captured the imagination of the world in his own time and forever afterward.

Particularly striking was his openness to the new cultures to which his conquest had exposed him—not least, because it showed a king who had clearly outgrown the notoriously xenophobic ways of the Greeks. This new sensibility expressed itself in some of Alexander's boldest and best-remembered gestures, all of which have the touch of the poetic, even the visionary about them: his courtly behavior toward the family of the defeated Darius (the Persian emperor's mother became so close to the man who defeated her son that on hearing that he had died, she turned her face to the wall and starved herself to death); his creation of a vast new army of 30,000 Iranian "Successors," meant to replace his retiring Macedonian troops (a plan that provoked mutiny among the Macedonians); the grand mass wedding he devised the year before he died, in which he and nearly a hundred of his highest officers were married, in the Eastern rite, to the cream of Persia's aristocratic women as a symbol of the unification of the two peoples.

Yet however much it resulted in a desire to form a new hybrid culture, the appeal of Alexander's *pothos* is precisely that it seemed to be an expression of something elementally Greek. Travel for the sake of knowing, a burning desire to experience new worlds at whatever cost, and the irreversible pain that results whenever a Western "anthropologist" makes contact with new civilizations: these are, of course, themes of another famous Greek text, although not the one Alexander associated himself with. For while he may have seen the *Iliad* as the blueprint of his life, what gives his life such great narrative and imaginative appeal for us is, in fact, that it looked so much like the *Odyssey*. Indeed, he was, perhaps, Tennyson's Odysseus as much as Homer's. Without

pothos, Alexander is just another conqueror. With it, he's the West's first Romantic hero, and possibly its first celebrity.

———

Many of the problems with Stone's movie arise because *Alexander* is torn between the facts of its subject's life and the romance of his personality—between showing you all the research that's been done (there are fussy re-creations of everything from Alexander's tactics to Darius's facial hair) and persuading you of Alexander's allure. Between these two horses the movie falls, and never gets back on its feet.

A great deal has been made in the press of the scrupulousness with which the director endeavored to remain true to the known facts: "historical accuracy" was heralded as a hallmark of this latest in a string of big-budget Hollywood treatments of classical material. Stone retained a retired Marine captain as his military adviser; and engaged Robin Lane Fox, the author of a popular biography of Alexander, as a historical consultant—in return, apparently, for allowing Fox, an expert horseman, to participate in a big battle scene. (A remunerative strategy that, I fervently hope, will not recur in the cases of classicists called on to advise the directors of future toga-and-sandal epics.) There is no denying that a lot of the film is richly detailed, despite some inexplicable gaffes—why a mosaic wall map in the Greek-speaking Ptolemy's Egyptian palace should be written in Latin is anybody's guess—and absurd pretensions. (The credits are bilingual, with awkward transliterations of the actors' names into Greek characters: to whom, exactly, is it necessary to know that Philip II was played by "OUAL KILMER"?) Research has obviously gone into matters both large and small, from the curls in Darius's beard to the layout of the Battle of Gaugamela, which at thirty minutes makes up one-fifth of the entire film, and which has been dutifully re-created in all its noise and confusion, right down to the clouds of orange dust, which, we are told, obscured the field of battle. Even in the much-discussed matter of the accents the actors are made to assume, there is in fact a certain method: Stone has all the actors who portray Macedonians speak with an Irish (and sometimes a

Highland) brogue, the better to suggest the cultural relationship of the back-country Macedonians to their lofty Greek counterparts. (To poor Olympias, played with scenery-devouring glee by Angelina Jolie, he has given a peculiar Slavic drawl.)

And yet the matter of accents, however admirably motivated, also helps to illuminate a weakness that is characteristic of the film in general. For the director's clever notion ends up being an empty gesture, since there are virtually no Greeks in his film for the Macedonians to be contrasted *with*. Apart, that is, from a two-minute appearance by Christopher Plummer as Aristotle, who is shown lecturing to his pubescent charges among a pile of (inexplicably) fallen marble columns, describing the differences between the beneficial and the deleterious brands of same-sex love—a scene patently included in order to prepare audiences for the fact that little Alexander and Hephaistion will grow up to be more than just wrestling partners. (Provided with this Aristotelian introduction, we are supposed to breathe easy in the assumption that they're the kind who, as the great philosopher puts it, "lie together in knowledge and virtue.") The absence of Greeks in the movie is more than structurally incoherent: it's a serious historical omission, given that Alexander's troubles with the Greeks back home were a critical problem throughout his career.

The narrative of much of *Alexander* has, indeed, a haphazard feel: it's not at all clear, throughout the three hours of the film, on what basis Stone chose to include, or omit, various events. Vast stretches of the story are glossed, with patent awkwardness, by a voice-over narration by the aged Ptolemy (who's shown, in a prologue sequence set in his palace in Alexandria, busily writing his history forty years after Alexander's death). But in lurching from Alexander's youth to his victory at Gaugamela, the film misses many crucial opportunities to dramatize its subject: there is nothing about Egypt, no oracle at Siwah—an event of the highest importance and certainly worthy of visual representation—and no double sacrifice at Ilium, which would have nicely suggested the intensity of Alexander's attachment both to the Achilles myth and to Hephaistion, certainly more so than the silly dialogue about "wild deer listening in the wind" that Stone puts in the lovers' mouths. (As with many an ancient epic, this one veers between a faux-biblical portentousness and excruciating attempts at casual-

ness: "Aristotle was perhaps prescient.") Even after Gaugamela, there are inexcusable omissions. Where, you wonder, is Darius's mother; where, crucially, is the mass interracial wedding pageant at Susa? And what about the story of the Gordian knot, a chestnut that illustrates, with brilliant concision and in an eminently filmable way, Alexander's approach to problem solving?

What does get packed into the film, on the other hand, is often treated so perfunctorily as to be meaningless to those who don't already know the life; a better title for this film would have been *Lots of Things That Happened to Alexander*. Famous tidbits of the biography—a reference to his tendency to cock his head to one side; another to an embarrassing episode in which his father mocked his fondness for singing—are awkwardly referred to *en passant* to no purpose other than to show that the screenwriters have studied hard and know about these details. Much that is of far greater importance is similarly poorly handled: the conspiracies against his life, the mutiny in India, and above all his ongoing and ultimately failed efforts to impose the "prostration," the Persian ritual obeisance to the king, on Macedonians and Persians alike are either so briefly alluded to or so hurriedly depicted as to leave you wondering what they were about. Historical characters are similarly paraded across the screen, often without being introduced, again merely to show that the filmmakers have done their homework. The beautiful Persian eunuch Bagoas, who our sources tell us was presented to Alexander as a peace offering by a surrendering satrap, and who seems to have remained faithful to his new master for the rest of his life, suddenly appears, in this version, as little more than an extra in the harem at Babylon, and the next thing you know he's giving Alexander baths. Something, you suspect, got left on the cutting-room floor.

There is little mystery, on the other hand, about why other episodes are prominently featured. The courtship and marriage to Roxana, for instance, get a disproportionate amount of screen time—not least, you can't help feeling, because Stone, whatever the loud claims that here, at last, was a film that would fearlessly depict Alexander's bisexuality, was eager to please his target audience of eighteen-to-twenty-six-year-old males. Hephaistion and Alexander occasionally give each other

brief, manly hugs, whereas a lengthy, stark-naked wedding-night wrestling match between Alexander and Roxana makes it clear that they, at least, were not going to be lying together in knowledge and virtue. (The sexual aspect of Alexander's relationship with his longtime lover is, in fact, entirely relegated to Ptolemy's voice-over: you don't envy Anthony Hopkins having to declare that Alexander "was only conquered by Hephaistion's thighs," one of the many clunkers that evoked snickers from the audience.)

The perceived obligation to cram in so much material affects Stone's visual style, which—apart from some striking sequences, such as a thrilling and imaginatively filmed battle between the Macedonians on their horses and the Indians on their elephants—is often jumbled and incoherent. There's a famous story about how, when the captive Persian royals were presented to the victorious Alexander, the queen mother, mistaking the taller and handsomer Hephaistion for the King, made obeisance to him. "Don't worry, Mother," Alexander is reported to have said, "he, too, is Alexander." This crucial encounter, so rich in psychologically telling detail, is filmed so confusingly in *Alexander* that it's impossible to tell, among other things, that the Persian lady (here, for no reason at all, it's Darius's wife rather than his mother) has made a mistake to begin with, and so the entire episode disintegrates into nonsense.

What all this betrays is a problem inherent in all biography, which is that a life, however crammed with dazzling incident, does not necessarily have the shape of a good drama. The reason it's exhausting, and ultimately boring, to sit through *Alexander*—and why the movie started disappearing from theaters so soon after its release—is that while it dutifully represents certain events from Alexander's childhood to his death, there's no *drama*—no narrative arc, no shaping of those events into a good story. They're just being ticked off a list. To my mind, this failing is best represented by the way in which the action of Stone's movie suddenly and inexplicably grinds to a halt three-quarters of the way through in order to make way for an extended flashback to Philip's assassination a decade earlier. It seemed to come out of nowhere, was lavishly treated, and then disappeared, as the filmmaker scrambled to get to the next historically accurate moment. A lot of *Alexander* is like that.

Even this wouldn't necessarily have mattered if the movie had managed to convey Alexander's unique appeal. From the very beginning of his film it's clear that Oliver Stone has succumbed to the romance of Alexander, and wants us to, too. "It was an empire not of land or of gold but of the mind," the aged Ptolemy muses aloud as he shuffles around his palace, which itself is a fairly typical mix of the scrupulously accurate and the inexplicably wrong. (The scrolls piled in the cubbyholes of his library rightly bear the little identifying tags that were the book jackets of the classical world; on the other hand, the tacky statuary on Ptolemy's terrace looks suspiciously like the work of J. Seward Johnson Jr.) "I've known many great men in my life, but only one colossus," he drones on, as a put-upon secretary scurries after him with a roll of papyrus. (He would, for what it's worth, have been writing on an erasable wax tablet; costly papyrus was only for fair-copying.)

You can't help thinking that one reason you have to be told so explicitly and so often about the greatness of Alexander the Great is that the actor Stone has chosen to portray Alexander is incapable of conveying it himself. Colin Farrell is an Irishman with a sly, trickster's face that betrays nothing of what may be going on behind it; in films like *Phone Booth*, in which he plays a sleazy PR executive, he has a skittish authenticity. It's true that he shares certain physical characteristics with Alexander: like the Macedonian, the Irishman is small, a bantamweight who looks fast on his feet. (Alexander himself was such a good runner that for a while he was considered a candidate for the Olympic games, until he protested that he would compete only against kings.) But he simply doesn't have the qualities necessary to suggest Alexander's remarkable charisma. As he trudges through the film, earnestly spouting lines that describe what we know Alexander was thinking ("I've seen the future . . . these people want—need—change"), he looks more and more like what he in fact is: a Hibernian character actor with a shaggy-browed poker face trapped in a glamorous leading man's part.

The void at the center of this biopic must be especially embarrassing to the filmmakers, given how much fuss they made about another aspect of the film's attempts at capturing "historical accuracy": the grueling

boot-camp training that Farrell and the actors playing his troops had to go through in order (presumably) to lend his on-screen generalship authenticity. The night before the press screening I attended, the Discovery Channel aired a documentary entitled *Becoming Alexander*, which showed Farrell jogging under the hot Moroccan sun with the loyal extras and talking about the bond that had grown up between him and the men whom he would be leading into cinematic battle. A military expert hired to advise the filmmaker opined that, as a result of this earnest process, Farrell had been transformed from "an Irish street kid" into a "leader of men."

Whatever else it illuminates, the patent fatuity of this hype—if the actor hadn't attended the boot camp, would the extras have disobeyed his orders at Gaugamela?—suggests that *Alexander* gets at least one thing across successfully: the vanity of the filmmakers. With its dramatically meaningless detail and almost total failure to convey the central allure of its subject, the film at least betrays its creators' satisfaction with their own effort and expense—with, that is to say, their ability to outdo other classical epics that have sprung up since *Gladiator* was a hit a few years ago. (Or betrays, perhaps, their own biographical agendas: it occurs to you that Stone, who an early autobiographical novel reveals was the product of a rocky union between a wealthy, powerful father and a rather unstable, alluring mother, may really have been making a movie about himself.)

But the reason *Gladiator* was successful was not that its characters sported historically accurate togas and lolled about in Roman orgies, but that it had an irresistible *story*: a noble and innocent hero betrayed by an ostensible friend, a long, tormented imprisonment where the hero nonetheless acquires the arcane skills and resources that will make his vengeance possible, and then the elaborately staged, long-awaited comeback, the climactic revenge. (It's essentially a remake of *The Count of Monte Cristo*.) For all the talk of authenticity and of identification with the ancients on the part of the director and actors responsible for *Alexander*, no one seems to have paused to wonder, while they spent months and millions on re-creating the Battle of Gaugamela with earsplitting, eye-popping verisimilitude, whether the "accuracy" of such a reconstruction of the classical past actually adds anything to our understanding of that past—whether it helps tell the story or enhances

our appreciation of why Alexander may be more worth making a movie about than other ancient conquerors are. To my knowledge, there are no medieval romances in Armenian about Julius Caesar.

If the above sounds disappointed, it is. I became a classicist because of Alexander the Great: at thirteen, I read Mary Renault's intelligent and artful novels about Alexander, *Fire from Heaven* and *The Persian Boy* (the latter told from the point of view of Bagoas the eunuch), and I was hooked. Adolescence, after all, is about nothing if not *pothos*; the Alexander story's combination of great deeds and strange cultures, the romantic blend of the youthful hero, that Odyssean yearning, strange rites, and panoramic moments—all spiced with a dash of polymorphous perversity which all the characters seemed to take in stride—were too alluring to resist. From that moment on all I wanted was to know more about these Greeks. Naturally I've learned a great deal since then, and know about, and largely believe, the revisionist views of Alexander, the darker interpretation of the events I read about thirty years ago in fictional form; but I will admit that a little of that allure, that *pothos*, still clings to the story—and to the Greeks—for me.

At the age of sixteen, soon after I read Renault's novels (from which, I couldn't help noticing, a good deal in Stone's film is borrowed without credit, not least a Freudian scene illuminating the sources of Alexander's hatred of his father, and perhaps of his indifference to women), I wrote the author a fan letter, which I concluded by shyly hoping that she wouldn't reply with a form letter. Her response, which was the beginning of a correspondence that lasted until her death ten years later, and which inspired me to go on and study Classics, came to my mind when I was hearing Colin Farrell described as a "leader of men" in *Becoming Alexander*. "I wonder," Miss Renault wrote to me in April 1976,

> whoever told you I'd send you a "form letter" if you wrote to me. Are there really writers who do that? I knew film stars do. You can't blame them, really . . . about half the people who write to them must be morons who think they really are Cleopatra or whoever. . . . Writers, though, write to communicate; and when someone to whom one has got through takes the trouble to write and tell one so, it would be pretty ungrateful to respond with something off a duplicator.

Because narcissistically deluded filmmakers are now as addled as starry-eyed fans, this new fictionalized *Alexander* isn't getting through to many people. I certainly doubt that it will inspire a young bookish boy somewhere to be a classicist, or a writer, or both.

—*The New York Review of Books,* January 13, 2005

Duty

Duty

————

Although the exact size and composition of the vast Persian horde that invaded mainland Greece in 480 B.C. continues to be the subject of debate—Herodotus, eager to underscore his overarching theme of imperial hubris, puts the number of Persian land forces alone at nearly two million, although modern historians suggest it was likely to have numbered only a tenth as many, at the most—it is probably safe to say that the teeming Asiatic multitudes of the Persian emperor Xerxes did not include a corpulent, nose-pierced mutant humanoid with lobster-like claws in place of hands. Nor, as far as we know, did the barbarian host include bald giants, their teeth filed into points, who were kept in chains by their Persian masters until released, like antique weapons of mass destruction, on the unsuspecting Greeks; nor, at least as far as our ancient sources indicate, was Xerxes himself an androgynous, eight-foot-tall, shaved-headed Brazilian with a penchant for cheek piercings and a weakness for metallic eye shadow.

Such fanciful creatures are, however, likely to be indelibly associated henceforth with the Persian Wars in the minds of the millions of moviegoers around the world who have spent over $400 million to see 300 since its release in March. This hugely popular new movie, adapted

from the cartoonist Frank Miller's short 1999 comic book of the same name, takes as its Herodotean subject a historically pivotal and culturally loaded episode from the Persian Wars. In 480, as Xerxes' *grande armée*, having crossed from Asia over the Hellespont (which the grandiose monarch famously lashed for its recalcitrance), was inching its destructive way south through upper Greece, the ever-fractious coalition of Greek city-states, uneasily led by Athens and Sparta, decided to send a force to hold the enemy at a choke point in central Greece called Thermopylae—the "Hot Gates" beyond which lay easy access to the region of Attica, Athens, and the whole of Greece to the south. Not untypically, some of the perennially parochial Spartans had pressed to abandon the pass in favor of defending the Isthmus of Corinth much further to the south—a strategy that would have guaranteed the destruction of Athens while ensuring a more cogent defense of the Spartan homeland in the Peloponnese, below the Isthmus.

In August 480, the two armies met. Xerxes did nothing for three days, in order to let the comparatively puny coalition forces get a good look at the immense enemy they were to face; then he sent the first wave of troops in. (The Persian emperor had the canny idea of including in that first batch of warriors relatives of the Persians who'd been killed by the Greeks at Marathon, during the first Persian invasion ten years earlier.) The Greek forces, numbering around seven thousand, among them just three hundred Spartans under their king, Leonidas—the full Spartan army, numbering some eight thousand citizen-warriors, had declared itself unable to attend, since a religious festival was taking place back at home—held the pass with surprising success during two days of intense fighting.

But after the location of an alternate route around the pass was betrayed by a local man to the Persian command on the evening of the second day of battle, Leonidas realized that the Greek position was doomed and decided to make a suicidal last stand with his three hundred Spartans—and, it should be said, about two thousand others: four hundred Thebans, seven hundred Phocians from central Greece, and nine hundred Helots, the serfs on whose forced labor the Spartan economy depended. The time purchased by this small Hellenic force at the cost of their own lives made possible the retreat of the remaining Greek soldiers, and gave Athens more time to prepare for the great

naval battle at Salamis that would, the following year, decide the course of the war in favor of the Greeks.

The suicidal bravery of the tiny Spartan-led force against overwhelming odds has stood ever since as a model of military heroism—and, often, of the moral and political superiority of free Western societies over Eastern despotisms. In a 1962 film about Thermopylae called *The 300 Spartans*, which starred Richard Egan as Leonidas and Ralph Richardson as the crafty Athenian leader Themistocles, the Greco-Persian conflict became a convenient metaphor for the Cold War: in it, there's a lot of talk about how the Greek states are "the only stronghold of freedom remaining in the then known world," while Xerxes dreams of "one world—one master," and so forth.

Herodotus himself notably casts the Greco-Persian conflict as a battle between the forces of slavery (motifs of lashing and punishment are consistently associated with the Persians in his account) and those of liberty. But apart from a couple of shouted references to Greek "freedom," neither Miller's comic book version of Thermopylae nor Zack Snyder's film version shows much serious interest in matters ideological. The primary emphasis of the book (which begins with the Spartans under Leonidas bravely marching off to Thermopylae and ends, more or less, with images of their arrow-pierced bodies) and also, to a large extent, of the film (which adds a bit of a subplot concerning Leonidas's queen, Gorgo—a decision made by the filmmakers, we're told, in order to enhance their product's appeal to women), is on the mechanics of the battle itself: the three successive days of intense fighting, followed by the culminating self-immolation.

Miller's book, which like many comic books revels in stylized tableaux of violence, captioned with inarticulate grunts ("AARR"), has a lurid, looming feel: much of the action—and there is little besides action—is strikingly conveyed in images that are, essentially, silhouettes. Snyder's film has its own eerily distinctive look. As with the comic book, the emphasis is on imaginatively realized images of violence. The director's wife and producing partner, Deborah Snyder, told an *Entertainment Weekly* reporter that she and her husband wanted to give the film's violence the stylized look of "a ballet of death"—a choreographical task

to which Snyder's previous Hollywood experience, as the director of a remake of the blood-spattered horror classic *Dawn of the Dead*, admirably suited him.

And yet—surprisingly for the filmmakers, we are told—it's the political implications of the Battle of Thermopylae that have caused trouble since the release of *300*. In particular the film's representation of the Persians as subhuman monstrosities has been seen as tapping into deep and unattractive cultural biases. (To say nothing of wreaking gleeful havoc with historical details. Not the least of the latter sins is the movie's suggestion that the only Greeks who stood up to the Persians were the macho Spartans: you occasionally glimpse a Phocian or two, but you'd never guess, from *300*, that there were brave Greeks other than Spartans present at this history-making engagement. The tag line that appears in the print ads for the movie is "See the Movie That Is Making History": "making history up" would be more precise.) It's a measure of the international atmosphere at present that the cartoonish excesses of Snyder's film adaptation of Miller's comic book—the effete or monstrous Persian grotesques no less absurd, to be sure, than the hypertrophied bodybuilder types meant to represent the Greeks—have been taken with considerable seriousness in certain quarters. In Iran, where the film was immediately banned by the indignant government, an adviser to President Ahmadinejad called *300* "part of a comprehensive US psychological warfare aimed at Iranian culture"—a comment notable, perhaps, for its assumption of a coherence in U.S. war policy that is sadly unapparent to less fervent eyes.

In the United States, even more moderate spokesmen for Iranian interests have seen in the film's representation of the Persians symptoms of a cultural anxiety stemming, ultimately, from the September 11 attacks. Here is the judgment of Ahmad Sadri, a professor of Islamic world studies at Lake Forest College, in *Payvand*, an online journal of Iranian news and culture:

> To my mind, Snyder's *300* drinks deeply at the cauldron of rage that is still boiling over in the United States six years after that bloody Tuesday. Two invasions, a trillion dollars in smoke and three thousand dead Americans have not sated the Achellian [*sic*] anger in a remote part of the American psyche. The movie

300 unleashes that abiding desire to curse, brag and rave at "end-less Asian hordes."

In a similar vein, a critic for *Slate* referred to the film as "a textbook example of how race-baiting fantasy and nationalist myth can serve as an incitement to total war."

To a certain extent, this is a tempting thesis. Railing against endless Asian hordes is, after all, a time-honored tradition in Western entertainment—one that goes back, as it happens, to the Greeks themselves. The stereotype of the decadent, despotic, effeminate, inscrutable, untrustworthy, servile, fawning, irrational, sexually ambiguous "Oriental" makes its first appearance in Greek literature, particularly in tragedy. The Eastern "barbarian"—whether in the person of the protagonist of *Medea* or of *Bacchae*'s seductive Dionysus—often stands as the negative image of the idealized Greek self, which is presented as masculine, rational, and self-controlled. In this light, both Miller's comic book and Snyder's movie, with their scenes of hypermasculine posturing on the part of the well-muscled Spartans, and their consistent representation of the Persians as effete (and, strikingly, nonwhite—a portrayal that might have come as a surprise to the fair Persians), may be seen as quite faithful to a very old tradition indeed.

And yet it's hard to believe, as many of the film's critics do, that these cultural stereotypes, even coming at a tense moment in U.S. relations with the Middle East, are the reason for its enormous popularity. Among other things, the sheer hyperbole of the film's style—the monsters and freaks, the stilted, semaphoric visuals, the Tom of Finland physiques, the clanking, Cecil B. DeMille dialogue—militates against taking it too seriously; or, at any rate, against taking it more seriously than you'd take a comic book. I have seen *300* twice at enormous cineplexes, and I wasn't particularly aware of any anti-Asian sentiment roiling among the boisterous, hooting, applauding audiences at those showings. If anything, the audiences' expressions of derisive amusement, when presented with the images of Xerxes, for instance, seemed to suggest that people understood quite well that they were in the presence of an over-the-top, highly stylized representation that had little pretension to any kind of historical or even cultural verisimilitude. I somehow suspect that, despite the suspiciously burqa-like garb of some Persian sol-

diers, few of the audience members found themselves inspired by the experience of watching *300* to change their feelings about Iranians or anyone else.

For this reason, it seems to me that indignant concerns about the film's covert politics or apparent cultural prejudices can be dismissed— just as we can dismiss the indignant repudiation of the film by some historians and classicists around the world who have denounced it on the grounds of historical inaccuracy. "We don't know that much about the Spartans," one Australian film critic huffed, "but we have a fair idea of what they wore in battle, and it included leg and chest plates for protection." In view of the presence of lobster-clawed mutants, it seems a bit beside the point to quibble over the precise details of Peloponnesian couture.

———

Far more worrying, to my mind, was what the tremendous popularity of the new movie suggested not about the current state of international politics, but about the current state of popular entertainment, and of cinematic art. It's true that for Frank Miller, the creator of *300*, the story he wants to tell is a deeply political and even moral one. "I've always loved this story," he told an interviewer for an online film site:

> It's the best story I've ever got my hands on. I was a little boy of seven when I saw this clunky old movie from 20th Century Fox called *The 300 Spartans*. I was sitting next to my brother Steve, who's two years older than me. We were seven and nine so we were too cool to sit with our parents. Our parents were in a row behind us and toward the end of the thing, I went, "Steve, are the good guys going to lose?" He went, "I don't know. Ask Dad." So I jump back over and sat down next to my Dad and said, "Dad, are the good guys going to die?" "I'm afraid so, son." I went and sat down and watched the end of the movie and the course of my creative life changed because all of a sudden the heroes weren't

the guys who get the medal at the end of *Star Wars*. They're people who do the right thing, damn the consequences.

As you flip through Miller's work, however, you wonder whether the key phrase in that impassioned statement isn't so much "do the right thing," with its admirable ethics, as "damn the consequences," with its macho swagger. Until the release of *300* Miller was famous primarily for *Sin City*, a series of self-consciously noir graphic novels which traces, among other things, the solitary and very bloody quest for justice by a hulking, overmuscled, much-scarred loner named Marv as he makes his way through a profoundly corrupt urban jungle called Sin City. Marv is given to cynical, Philip Marlowe-esque utterances that everywhere betray—with what degree of tongue-in-cheekness can only be guessed—a gleefully regressive indulgence in a vision of hard-bitten masculinity that, predictably, harks back to the dour heroes of the noir films of the 1940s.

This is evident not only in the stark and often strangely beautiful graphics, but in the dialogue that Miller gives his hero. Here's Marv as he tells a female friend about his thirst for vengeance against the mobsters who killed a prostitute he'd slept with:

> There's no settling down. It's going to be blood for blood and by the gallons. It's the old days. The bad days. The all-or-nothing days. They're back. There's no choices left and I'm ready for war. . . . Hell isn't getting beat up or cut up or hauled in front of some faggot jury. Hell is waking up every god damn morning and not knowing why you're even here.

A similarly gleeful defiance of PC attitudes colors virtually the entire novel, from its adolescent vision of its female characters as either helpless damsels or busty dominatrices to its offhand references to—well, the barbarian East. "Sin City falls away behind me," goes one of Marv's reveries. "Noisy and ugly as all hell. The Mercedes hums and handles like a dream. She may look like some Jap designed her, but the engine's a beauty."

To be sure, Miller is working here within a well-defined noir tradition and taking it to an extreme. But it's hard not to feel that the defi-

ant swagger he so admired as a boy, on seeing *The 300 Spartans*, has been internalized and then expressed in heightened aesthetic terms in his work—and not only in the Thermopylae-themed *300*, which everywhere betrays the same heated investment in exaggerated masculinity and, ostensibly, heterosexuality. (The Athenians are ridiculed by the Spartans as being effete "philosophers" and "boy-lovers"; in the case of the latter, given what the historical record indicates, this is demonstrably an instance of the pot calling the kettle black-figured.) The emotional core of the book—more, even, than of the movie, in which the character of the Spartan queen has been enhanced—lies in this relentless celebration of the defiant, strutting, physically superb Spartan male. Miller and Snyder might be startled to learn that Aristotle, in his *Politics*, describes the Spartans as *gynaikokratoumenoi*, "ruled by women."

The film's pubescent preoccupation with magnificent male musculature becomes, indeed, a crucial plot-point in its retelling of the old story. In Herodotus, we learn that the man who betrayed the secret back route to the Greeks' position was a local named Ephialtes, who like many other residents knew the location of the path, and who expected to be rewarded for his betrayal of his fellow Greeks. In the Miller/Snyder version, Ephialtes is, significantly, a grossly deformed, hunchbacked Spartan who betrays his countrymen because they won't let a physically inferior specimen fight for them. Given the film's overwhelmingly young, male audience, it is hard not to feel that this fetishizing of masculine posturing and masculine physiques, rather than its representation of the Persian enemy, is where a good part of its appeal resides.

And even this may not be the real key to understanding why *300* is the biggest movie of the year. Critics who have disdained it as bloody and visually cartoonish have gone out of their way to deride it as (unsurprisingly) the cinematic equivalent of a comic book: flat, episodic, lurching from one visually explosive moment to the next. But what's really striking about the film is that it doesn't even have the aesthetics of a comic book, to say nothing of a graphic novel—the best examples of which, at least, show considerable concern for subtle narrative rhythms. Apart from the awkwardly larded-through story of Ephialtes and the equally clanking, meanwhile-back-at-the-ranch subplot about Gorgo

(who in this version uses her considerable rhetorical and sexual wiles to manipulate the Spartan senate into sending reinforcements to her husband's outnumbered band—*gynaikokratoumenoi*, indeed), *300* consists primarily of consecutive scenes depicting the Spartans mowing down the ever more scary-looking Persian antagonists who keep coming at them. First there are the ordinary Persian foot soldiers; then the so-called Immortals, here inexplicably represented as wearing metallic, vaguely Kabuki-like masks that conceal grotesque mutant faces and slobbering, fanged mouths; then the freaks and elephants and monsters, all culminating in a last defiant stand in which Leonidas wounds Xerxes himself before being annihilated in a shower of Persian arrows.

As I sat watching this progression during my first viewing of *300*, I was reminded of something, but it wasn't comic books. It was only a few days later, when I was playing video games with my kids, that I realized that the experience most closely approximated by a viewing of Snyder's movie was not even that of reading a comic book, but that of playing one of the newer, graphically sophisticated video games. In such games—for instance, *Star Wars Jedi Knight II: Jedi Outcast,* a favorite of mine—the player is often an embattled warrior, charged with making his way through enemy territory in order to reach a certain goal (a spaceship, a treasure, etc.). In order to reach the goal, of course, you have to eliminate vast numbers of enemies—aliens, robots, freaks, whatever. These latter are, with each successive "level" of the game, increasingly powerful, scary, and difficult to defeat; the game gets harder as you progress through its imaginary world. There's no plot or overarching structural dynamic involved; the only meaningful activity is killing a sufficient number of enemies to get to the next level. It's true that there's usually some background, some history that seems to provide a kind of "plot" for the proceedings, which comes in the form of a narrative voice-over that plays before each new level of the game begins. (In *Jedi Outcast,* for instance, you're told that your mission is to prevent the villains from decimating the Jedi Academy on planet Yavin 4.) But these token narratives, such as they are, are discrete elements detachable from the experience of playing the game itself—indeed, you can just skip over them and go right to the slaughter that is the real point of the game.

All this is as good a description as any of what *300* is like. Whatever

its intermittent and feeble preliminary invocations of noble sentiments such as "freedom" for the Greeks and the importance of "reason" as opposed to Eastern unreason (neither of which notions, it must be said, would likely have had much appeal to the historical Spartans, members of a slave-based and deeply, almost stupidly superstitious culture), *300* is wholly lacking in nearly every element we normally associate with drama in even its most debased popular forms. Gone are the distractions of motivation or character—or even dialogue, apart from posturing slogans. ("This is SPARTA!!!!!" Leonidas screams as he pushes some Persian envoys into a well, a line that got a huge laugh both times I saw the film.) Gone, too, is any sense of a plot more rudimentary than the one you get in the setup for *Jedi Outcast*. Herodotus's narrative of the Second Persian War does have grand and overarching plots, although these clearly weren't interesting to either Miller or Snyder. For Herodotus there is, on one level, the great organizing moral dynamic, as predictable as physics or mathematics, of overweening pride laid low: in Darius, in his ancestors, in his son Xerxes, all of whom trust foolishly to wealth, size, power, the things that, as time and experience teach the wise person, are ultimately evanescent. And on the Greek side, the plot, indeed the drama, resides in the craftily, excruciatingly drawn-out uncertainty whether the perennially quarreling Greek city-states will ever become a coalition capable of repulsing Xerxes' army—a plot that is not only suspenseful but also deeply political.

What gives structure to *300*, by contrast, is not so much an evolving narrative as simply an increase in the number and ugliness of the combatants who keep pouring toward the Spartans, who blast their way through greater and more savage onslaughts of freakish enemies until the final, gory extermination takes place—all of it punctuated occasionally by slogans about freedom and so forth. But just to talk about "freedom" and "reason" is not, of course, the same as dramatizing the importance of freedom and reason. Snyder's film, like Miller's comic, lingers on the avenging violence while giving only the most superficial nod to the concepts that, we are constantly told, motivated that violence. For that very reason the violence, of which there is a great deal, isn't exhausting or affecting, because it has the candy-colored, hallucinatory, stylized quality that the violence in video games has; it hasn't been contextualized, it's not tethered to anything that we might feel.

It's just the colorful stuff that happens to the cardboardy figures on the screen before they disappear and new cardboardy figures need to be dealt with. And then—GAME OVER.

Something, indeed, seems to be over, if the extraordinary success of this movie is to be taken seriously. A curious part of the story of Thermopylae—a part that didn't make it into Miller's *300*, perhaps because it has to do with those boy-loving, philosophizng Athenians rather than the manly Spartans—concerns the origins of the tragic theater. There is a long-standing tradition that when Xerxes abandoned his forces and returned in humiliated defeat to Susa, he left behind his opulent tent, which was among the spoils taken from his general, Mardonius, when the Greeks finally vanquished the invaders at Plataea in 479. According to some sources, this fabulous trophy came to be used as the backdrop in the theater of Dionysus at Athens; the Greek word *skênê*, from which we derive the word *scene*, in fact means "tent." Another fascinating, if perhaps apocryphal, story holds that timber from the Persian ships destroyed at Salamis was used in the construction of yet another theater.

The presence of Xerxes' tent on the Greek tragic stage—a visible (if eventually fraying) trophy snatched from a hubristic imperial overlord—would have constituted a remarkable material symbol of the interweaving of history, politics, and art that you got in the then-new genre that came to be known as tragedy. At the very least, it would certainly account for a number of striking references in early Greek tragedy to opulent Eastern cloths and weavings. In Aeschylus's *Agamemnon* (458 B.C.), for instance, the returning Greek king's hubristic decision to tread on a sumptuous carpet—fit, as the text reminds us, for an Eastern potentate—heralds his imminent demise; in the same playwright's *Persians* (472 B.C.), there are repeated allusions to the soft, lush, ornate fabrics with which the Persians adorn themselves. All such references would, of course, have taken on powerful additional meaning for the original audience if the very artifacts of Persian hubris were visibly present in the theater.

This is merely a way of saying that it's quite possible that the battle that inspired Frank Miller's comic book, and now Zack Snyder's movie version of the same, was intimately tied to the origins of the Western

theater itself. If so, the connection was not merely a superficial, material one (the tent, the broken planking) but rather something larger. For the grand themes that seemed to inhere in the lived history of the Persian Wars—the foolishness of overweening arrogance; the way in which moral conviction can be a match for sheer power; the dangers inherent in underestimating a disdained "other"—were to provide tragedy with its own grand themes over the seventy-five years of its magnificent acme: a period that began with the end of the Persian Wars and ended with the exhausted conclusion of the Peloponnesian War, the conflict in which, as Herodotus seems to have foreseen, the Athenians themselves eventually came to resemble the blustering, despotic Persians of old. To better serve its themes of spectacular rises and terrible falls, the tragedians honed and perfected the array of elements and techniques that became the cultural inheritance of the Western theater: the organically coherent plot, which suggests that endings are the logical and necessary outcomes of beginnings; character development as expressed in both monologue and dialogue; the meaningful dynamics of entrances and exits, of visual spectacle counterpointed by lyric rapture.

To various degrees, these elements have provided the underpinnings for every kind of theatrical entertainment ever since, from Venetian opera to soap opera, from Shakespeare to *Star Wars*. That Zack Snyder's flatly stylized *300*—which invokes the dramatic history of the Persian Wars but which has no quality of drama, no serious interest in history whatsoever—has packed some of the largest audiences in movie history into our theaters makes you wonder whether the tradition that began at Thermopylae might well have ended there, too.

—*The New York Review of Books*, May 31, 2007

It's Only a Movie

K ill Bill: Volume 1, the fourth movie to be written and directed by Quentin Tarantino, is about a number of things, but violence isn't really one of them. This isn't to say that it is not a violent film. Of the various controversies that have surrounded the movie since it began shooting—the first over the surprise announcement by the producers that they were going to cut what was to have been one movie into two parts (*Volume 2* will open in February)—none has been as fierce as the one that has raged about the extent of the movie's graphic gore. In *Kill Bill: Volume 1*, you get to see (among other things) a fight to the death between two young women, one of whom ends up impaled by an enormous kitchen knife before the wide eyes of her young daughter; a pregnant woman being savagely beaten and then shot in the head at point-blank range on her wedding day; a man's tongue being pulled out; a graphic decapitation with a samurai sword; torsos sliced open; impalings with various instruments; and, in a scene that you'd be tempted to call climactic if the movie had any kind of narrative arc whatsoever, a twenty-minute-long pitched battle between a lone American female and dozens of Tokyo gangsters, in which the limbs of a great many of the latter get lopped off. It's saying something about the sheer amount

of battery and bloodletting that Tarantino works into this film that the final act of killing comes almost as something of a relief, and strikes you as being almost dainty: a young woman in a kimono has the very top of her head sliced off, quite neatly, in a tranquil, snow-covered Japanese garden.

A good deal of intense brutality is, of course, nothing new to Tarantino fans. *Reservoir Dogs* (1992), the first feature that he both wrote and directed, contains an almost unwatchably savage torture scene that, at the time, seized the imagination of audiences and critics and has become infamous ever since: in it, a sociopathic petty criminal slowly cuts off a young policeman's ear, to the accompaniment of some upbeat pop music, and afterward, he douses the cop with gasoline, meaning to burn him alive. This was a harbinger of things to come; since then, all the films that Tarantino has either written or directed are characterized by scenes of a sadistic and quite graphic violence, set in the context of random and, sometimes, unmotivated crime.

True Romance, the first commercial feature that Tarantino wrote (in 1987; it was directed by Tony Scott and released in 1992), features a stabbing with a corkscrew and the prolonged beating of a young woman; both *True Romance* and Tarantino's breakout popular success, *Pulp Fiction* (1994), show men being kicked and shot in the genitals; *Pulp Fiction* ends with a scene of S&M torture and homosexual rape. (It also famously depicts a man plunging a syringe full of adrenaline into the chest of a woman who has OD'd on heroin.) *Natural Born Killers*, written in 1989 and directed by Oliver Stone, was about an amoral young couple on a crime spree; *From Dusk Till Dawn* (1995) is a gory vampire extravaganza set in a Mexican cathouse, in which an unsuspecting pair of criminal brothers—one's a bank robber, the other's a sexual predator played by Tarantino—are waiting to meet an associate. All of Tarantino's movies are, in fact, about low-level criminals involved in complex crimes that get fouled up, and it's not hard to see why: double-crossed thieves and drug dealers tend not to have many scruples about observing the Sixth Commandment.

What has upset many people about the violence in Tarantino's movies isn't the violence per se—as bloody as they are, they're no more brutal than, say, the typical *Terminator* movie, and no more repellently graphic than any of the *Alien* films, which are far more popular—but

rather the offhand, occasionally even comic fashion in which the violence in his films is presented. To many critics of Tarantino's work, the violence—like the ear-cutting in *Reservoir Dogs*—has too often seemed gratuitous, included not so much to further the plot or illuminate character, as to punish the audience—to see how much it can tolerate. This notion may seem outlandish, but it gets support from Tarantino himself. "The audience and the director," he recently asserted in a *New Yorker* profile that was timed to coincide with the release of *Kill Bill*, "it's an S&M relationship, and the audience is the M. It's exciting!" Both the content ("the audience is the M") and the tone of the remark ("it's exciting!") are revealing: watching Tarantino's films, it's hard not to wonder whether the "S" is not somehow compensatory, betraying the kind of anxieties about masculinity and, indeed, about sexuality that you associate with high school locker rooms. In *Reservoir Dogs*, one of the thieves is vexed to learn that his alias will be "Mr. Pink"; *True Romance* and *Pulp Fiction* feature telling scenes in which male characters react violently to homoerotic teasing. (The latter is the film whose climax is a homosexual rape.)

Because of a violence that is presented without any apparent moral comment, because of the embarrassment about adult sexuality in his films, Tarantino—who was born in 1962 and is thus of the first generation of directors to have been raised on cable television and video recordings, with their promise of endless repetition—has become, in the minds of many, the poster boy for a generation of Americans—mostly male—whose moral response to violence, it is feared, has been alarmingly dulled by too much popular entertainment.

Hence it's easy to see why *Kill Bill* has aroused enormous controversy and attracted an unusual amount of attention in the press: it's been taken as a kind of culmination, the most violent film yet by a filmmaker with a known penchant for violence. Nearly all critical comment about the film, whether laudatory or disapproving, has focused on the moral and aesthetic implications of the film's martial-arts sequences and its scenes of baroque bloodletting. (Tarantino has often asserted that, for him, the violence in crime movies is analogous to the dance sequences in musicals.) In general, the critics have fallen into two camps. In the

first are those who see the film's lavishly choreographed scenes of violence as a symptom of a cultural malaise. Anticipating a defense of the film based on the fact that its violence is too stylized to be taken seriously, David Denby argued, in his review in *The New Yorker*, that there is a "little problem" with this position, which is that a

> filmed image has a stubborn hold on reality. An image of a rose may be filtered, digitally repainted, or pixilated, yet it will still carry the real-world associations—the touch, the smell, the romance—that we have with roses. Tarantino wants us to give up such associations, which means giving up ourselves.

This is, essentially, a Platonic argument—one that worries about the tortured relationship between sophisticated imitations of reality and reality itself. It is an argument that the film historian and critic David Thomson also advanced, in a long and ambitious piece in the *Independent*, when Tarantino's film first came out. In that article, Thomson explored, in considerable detail and with unconcealed anguish, the relationship between the violence to which young consumers of popular culture are regularly exposed and the violence of the society in which we now live:

> I don't mean to suggest that film is the source and model of all that is wrong in modern society. But I do think that the world of film, which includes those people who are madly enthusiastic about any film, need to examine very carefully what happens in our minds when we watch endless violent imagery and feel no wound or repercussions. For one, I am no longer confident that a message has not been passed down to several generations, in their bloodstreams, in their nervous systems and in their trigger fingers.

The moral argument inevitably fuels the aesthetic objections: Thomson makes the point that while all of Tarantino's films were violent, at least the earlier ones were "about people"; he goes on to bewail the way in which, in the new movie, Tarantino has chosen to "ignore character and conversation" in favor of what he calls " 'pure' cinematic violence."

This allows Thomson, in turn, to dismiss the new movie as "a stream-lined version of a kids' video game."

To these old-fashioned arguments, another, perhaps hipper group of critics has objected that it is precisely as a game that we should see *Kill Bill*; that, because the movie's violence is, as the author of the *New Yorker* profile put it, so "stylized and funny," so over-the-top, so cartoonish, its rivers of blood so obviously fake, its killings so unrealistically elaborate, we can't really take it seriously. So, for instance, Richard Corliss in *Time* observed that the film is

> really about the motion, the emotion, the very movieness of movies . . . an effusion of movie love by the prime nerd-curator and hip creator of cult action films. *Kill Bill* is his thank-you note to the Hong Kong kung-fu epics, Japan's *yakuza* gangster dramas and '70s Italian spaghetti Westerns and horror films that shaped his sensibility.

There is some truth in this; a well-documented aspect of Tarantino's biography is that he worked for five years as a clerk in a California video store, where he acquired the dazzlingly encyclopedic knowledge of genre films—Asian, Mexican, American—that has influenced all of his work, which is full of intricate allusions to, and direct quotations of, other films. It's no accident that the characters in his films talk obsessively, even manically, about popular movies, TV shows, and songs. *True Romance* begins with its boyish hero making an impassioned paean to both Elvis and the Japanese martial-arts star Sonny Chiba (who appears in *Kill Bill* as a master sword-maker). *Reservoir Dogs* opens with a group of thieves arguing about the meaning of the lyrics to Madonna's "Like a Virgin." *Pulp Fiction* features a crucial scene set in a restaurant whose waiters impersonate Marilyn Monroe and Buddy Holly (the maître d' is, appropriately enough, Ed Sullivan); *Jackie Brown* (1997) starts out with a gun dealer, played by Samuel L. Jackson, discussing the influence of "Hong Kong flicks" on his clients' buying habits. "The killer [in a movie] had a .45," he observes, "they want a .45."

And yet it's possible that the "movieness" of Tarantino's work, the endless invocations of other motion pictures, is itself a far greater problem than its violence. Indeed, if you forget for a moment about the con-

tent of Tarantino's latest film, about the violent acts that it so ornately represents, you're forced to wonder what it is, precisely, that his movies' endless reflections on, and references to, the culture of popular entertainment give you—apart from an appreciation for Tarantino's inexhaustible ability to quote from and allude to the thousands of movies that he has seen and seen again. The answer to that question is more troubling by far than the sight of a few heads lying on the floor.

———

Certainly *Kill Bill* offers few of the traditional satisfactions of drama—even genre dramas such as martial arts or spaghetti Westerns. This is strange, given that it takes the form of that most satisfying of narratives, the revenge saga. (A title that appears just after the opening credit reads "Revenge is a dish best served cold.—Old Klingon Proverb." The reference to the villainous alien race in the *Star Trek* series will remind cognoscenti that this proverb was quoted by a character in the second of the *Star Trek* feature films.) Its heroine is a young woman known only as The Bride, a former member of a squad of female assassins that's called the Deadly Viper Assassination Squad (DiVAS)—the kind of girl gang that certain Seventies TV shows, like *Charlie's Angels*, celebrated. In *Pulp Fiction*, a drug dealer's moll, played by Uma Thurman, who here plays The Bride, tells another character that she'd once appeared in the pilot episode of a series called "Fox Force Five," which was about "a bunch of foxy chicks" who are a "force to be reckoned with": one blond, one Japanese, one black, one French, one who specializes in knives, etc. DiVAS, which consists of just such an assortment, is, therefore, in the way of an in-joke, an elaborate self-reference for Tarantino fans.

For reasons never explained in *Volume 1*, perhaps because of the tardy division of the film into two parts, The Bride has abandoned her life of professional crime, and presumably because of that decision is gunned down, along with her husband-to-be and the rest of her bridal party, on her wedding day by the other DiVAS and their ringleader, Bill. (We know this because, in a flashback, we see their bodies on the ground.) Although she's been shot in the head at point-blank range by

Bill, The Bride survives, awakes after a four-year coma, and plots her terrible revenge.

The action of *Kill Bill* covers two of these retributive murders. (At least two: when The Bride wakes up from her coma, she first kills the corrupt hospital orderly who, as she overhears, has been renting out her immobile body for sex.) Tarantino is famous for his temporal scrambling—he often shows you something happening, and only later provides a flashback that illuminates why it's happened—and *Kill Bill* is no exception: the second of the revenge killings to take place is actually the first one you see. At the beginning of the film, The Bride enters the home of one of her former colleagues, Vernita Green (code name: Copperhead), played by Vivica A. Fox, and after a brutal hand-to-hand fight ends by knifing Vernita as her young daughter mutely watches. We then see what has preceded this: The Bride journeying to Tokyo in order to track down and kill another of the DiVAS, O-Ren Ishii (a.k.a. Cottonmouth, played by Lucy Liu), who now reigns as the boss of all bosses in the *yakuza* underworld. (Her surname, in another bit of Tarantino film-buff allusiveness, is a tribute to two Japanese filmmakers: Teruo Ishii, who directed *yakuza* films in the Sixties, and Takashi Ishii, who directed the female revenge movies *Black Angel Volume 1* and *Volume 2*.) The Japanese portion of the film features a flashback, done in the style of Japanese anime cartoons, to O-Ren's traumatic childhood: her parents were killed by a *yakuza* boss before her eyes when she was seven, and at the ripe old age of eleven she dispatches him in a suitably grisly manner.

At this point Tarantino's story gets rather Homeric, whether he realizes it or not. In order to defeat this most fearsome adversary, The Bride—like the *Iliad*'s Achilles preparing at last to confront Hector—needs a suitable weapon: in this case it's not new armor forged by an obliging god, but a legendary samurai sword forged by the master swordsmith Hattori Honzo. (The character is borrowed from Japanese films, where he was played by Sonny Chiba, who plays him again here.) Using this fearsome blade, The Bride eventually dispatches, in that climactic confrontation, hordes of O-Ren's colleagues before slicing off the cranium of O-Ren herself. First, however, The Bride dismembers O-Ren's closest associate, whose still-living trunk she deposits, after the slaughter is over, at the emergency entrance of a Tokyo hospital, as a warning to Bill. Then the movie is over.

What few critics have remarked on is how boring all this actually is—how random the action seems, how incomplete the narrative feels, how tedious, for all their color and noise, the scenes of violence are. If the feeling you leave with is one of flatness, it's because Tarantino has lavished his attention on (as it were) the choreography while neglecting the story. We never do learn why (or, for that matter, who) The Bride married, why she reformed herself and left the DiVAS, why they assault her, what her relationship with Vernita and O-Ren was, why they are the first (if they are) to be dispatched, why Bill seeks her death: these are questions that Tarantino either isn't interested in or is leaving for the second part of his film. The result is that the violence, however artfully enacted, never feels climactic—never feels as if it's accomplishing anything moral or emotional, which is precisely what violence can do in serious literature. (If you took everything out of the *Iliad* but the battle sequences, you'd have a work that approximates the feel—and, for what it's worth, the significance—of *Kill Bill*.) The final gruesome tableau of *Kill Bill* has, in fact, the same emotional impact—which is to say, none—as the brutal catfight with which it begins; either one could come at any point in the film, with pretty much the same effect. In this, Tarantino's film differs from its genre models, in which, however artlessly, the culminating tableaux of brutality are meant to feel, and often do feel, satisfying.

Indeed, in this respect *Kill Bill* may be said to differ radically even from Tarantino's own earlier films, in which (you could argue) the violence has a kind of point, either thematic or stylistic. When the hitman played by James Gandolfini in *True Romance* methodically beats a gamine young woman, prior to his planned shooting of her, and her increasingly bruised and bloody face keeps filling the screen, we know that he's just doing his job. By the same token, killings that are presented to get big laughs, like the accidental shooting of a minor character in *Pulp Fiction* (which precipitates a manic bout of car-cleaning) or the offhand gunning down of an extremely annoying young woman in *Jackie Brown*, could be said to illustrate something about the world in which those characters live, one in which casual violence is a quotidian affair. Even if you were reluctant to ascribe to Tarantino any moral sensibility whatsoever, you could still argue that the violent acts had a

kind of aesthetic point—they were just the commas and semicolons of Tarantino's cinematic vocabulary, ways of punctuating the progress of the narrative. And indeed, the blazing gunfights and orgies of extermination with which nearly all of the films that Tarantino has been involved in end may be said to function as triple exclamation points, an emphatic means of calling our attention to the fact that the story is now over. (The DVD of *True Romance* features the chapter titles of the various scenes; two that come toward the end are entitled "Room Full of Guns" and "Room Full of More Guns.")

The violence in *Kill Bill* feels different—or, rather, it doesn't feel like anything at all, and not merely because Tarantino hasn't bothered to give it any emotional resonance. Whatever you thought of *Reservoir Dogs*, the torture scene was unbearable—which is to say, it affected you; the same is true for those comical killings in the other movies I've just mentioned, which affected you in a different way. (The sheer randomness of the killings reminded you that the criminals who performed them lived in a moral universe so alien to your own that the only response was to laugh.) But as you watch the limbs flying off in *Kill Bill*, the heads spinning across restaurant tables, the kitchen knives sticking out of people's chests, you look at it with the same sense of detachment with which you watch those carefully orchestrated shows on the Food Channel—you just admire the professional's expertise. After The Bride kills Vernita in her neat suburban kitchen at the beginning of the film, she turns around to find that Vernita's young daughter has witnessed the whole thing. But—as The Bride apologizes to her—the girl says nothing at all, shows no reaction. Neither does the audience.

This lack of affect, the protective distancing arising from an awareness of the "movieness" of what we're witnessing, is what Tarantino's admirers use to defend him. ("See? It's so artificial that no one takes it seriously.") But it's not clear that Tarantino wants you to feel nothing at all. In the *New Yorker* profile, the director asserted that what fills in the blanks of his cartoonish characters, what provides the "backstory," is what the audiences already know, as movie audiences, of the actors themselves. "Robert Forster's face is backstory," Tarantino said, referring to the actor who plays the middle-aged hero of *Jackie Brown*:

That was so with both him and Pam Grier [the film's female
lead]. If you've been an actor in this business for as long as they
have, you've seen and fucking done it all, all right? They've had
heartbreaks and success and failure and money and no money,
and it's right there. They don't have to do anything.

For Tarantino, the movie fan who knows everything about the actors
in the films he loves, it's unnecessary to write psychology or motivation
into the movies; he's assuming that, like him, you'll be able to fill in the
blanks. This goes for plot as well as character: he assumes that you, too,
have seen enough kung fu movies and bad old Westerns (to say noth-
ing of bad Seventies chick-cop shows) to know why these characters do
what they do, why they're seeking revenge, and so on. He thinks, in
other words, that he can devote an entire film to choreographing scenes
of kung fu violence because you already know the story, in effect, and
are willing merely to sit back and enjoy the fight sequences that he's
hung on a tenuous plotline.

The problem with this—and, ultimately, with the "movieness" ar-
gument in general—is that the writing and the actors do "have to do"
something. What, after all, if you don't know who Pam Grier or Robert
Forster is? Tarantino's devotion to his B-movie idols is touching, but
it shows up the flaw in the argument that (as the admiring *New Yorker*
writer put it) the reason that "Tarantino is as good a filmmaker as he is
is that he is an audience member first and a director second." But audi-
ences are necessarily passive, whereas directors must transform what
they have seen into a new vision. Tarantino certainly ingests, but it isn't
clear that he digests. Watching Tarantino's films—and none more than
Kill Bill—is like being stuck in a room with someone who, like so many
of this director's characters, can't stop talking about the really neat parts
in the movies he's seen. This is entertaining if you share his mania, but
if you don't, he ends up being a bore.

Here it's worth mentioning that Tarantino emphatically rejects the
notion, advanced by some critics, that his paraphrases and quotes of
other films are meant to be ironic. "I mean this shit," he has said. "I'm
serious, all right." Tarantino, in other words, has absorbed whole all

of the movies he has seen, from the vampire flicks to the Douglas Sirk melodramas he so admires; in his filmic allusiveness, there is no "take," no postmodern frame—no point of view. He just loves these movies without judgment, without critique. "It's hard to pin down Tarantino's taste," the *New Yorker* writer commented, "because he likes nearly everything." Another way of saying this, of course, is that he has no taste at all.

The lack of a sense of intellectual process, or of judgment, that characterizes Tarantino's approach to his movie influences helps explain the ultimately vacant quality of so much of his work, no matter how clever it often is. This is certainly true of *Kill Bill*, but it also goes for the earlier films—the ones "about people." When they first came out, I enjoyed the structural cleverness of *Pulp Fiction*, the comfortable plot machinery of *Jackie Brown*, the taut, depraved claustrophobia of *Reservoir Dogs*. And yet when I saw them again recently, I was surprised to find myself bored by all three. In the end, they feel wholly disposable—they're not in any significant way *about* any of the elements of which they're made up (crime, guilt, race, violence, even other movies). You realize that Tarantino doesn't have any ideas about them at all; he just thinks they're neat things to build a movie around.

This, in the end, is the most troubling thing about Tarantino and his work, of which *Kill Bill* may well be the best representative: not the violence but the emptiness, the passivity, the sense that you're in the presence not of a creator but of a member of the audience—one who's incapable of saying anything about real life because everything he knows comes from the movies. It occurred to me, after I left the *Kill Bill* screening, that Tarantino may actually think that "revenge is a dish best served cold" really *is* an "Old Klingon Proverb." People worry about Tarantino because they think he represents a generation raised on violence; but it's as a representative of a generation raised on television reruns and video replays that he really scares you to death.

—*The New York Review of Books*, December 18, 2003

Nailed!

Ever since 405 B.C., when Aristophanes, in a comedy entitled *Frogs*, hit upon the sublime idea of staging a literary contest in the Underworld between two dead writers who loathe each other's work (Euripides and Aeschylus), the best literary criticism has often been a form of sadistic entertainment—one that uses comedy's tools (humiliation, ridicule, exaggeration) to comment not on society but on art. There is, of course, an equally long tradition of critics who don't strive to score belly laughs as they illuminate great texts; that tradition, in fact, begins with Aristophanes' near contemporary Aristotle, to whose *Poetics*, written sometime in the middle of the fourth century B.C., we owe the first full-scale, intellectually sophisticated attempt to analyze the nature of aesthetic pleasure and to systematize the mechanisms by which literary texts produce that pleasure. Aristotle's own text is, it must be said, not the most fun to read: it would be hard to find a less humorous explanation of humor than "Comedy is (as we have said) an imitation of inferior people—not, however, with respect to every kind of defect: the laughable is a species of what is disgraceful. The laughable is an error or disgrace that does not involve pain or destruction," etc., etc.

If a work like *Frogs* is more fun for audiences than the *Poetics* is, it's

probably because the comedy, with its ruthless send-ups of the well-known weaknesses of each of the two contestants, satisfies a primitive pleasure that lies at the heart of all comedy: the Schadenfreude-laden enjoyment of the spectacle of someone else's humiliation and, ultimately, defeat. After a long verbal duel in which each playwright enumerates his opponent's flaws with devastating accuracy, Aristophanes provides a brilliant climax that hilariously conflates a literal and a figurative "weighing" of one poet's work against the other's: each approaches a scale and utters a line from his work, and the onlookers peer to see whose words are, literally, weightier. Aeschylus—whose diction is famously more ponderous ("bundles of blast and boast," his antagonist spits) than that of Euripides (who prefers airy *vers libre*)—naturally wins, and so Euripides must remain in the Underworld, while Aeschylus is restored to the world of the living.

It is worth noting that the comic contest between the two writers is repeatedly referred to in Aristophanes' text as a *krisis*, a word that can mean anything from "dispute" to "decision" to "judgment"; the verb it's related to is *krinô*, "to judge." Those shades of meaning help illuminate the nature of another derivative from *krinô*: the English word "critic." As the culminating scene from *Frogs* reminds us, disputes about the values of an artist's work are decided by a kind of weighing, which leads to a judgment. The person who performs this weighing, this judging, is the critic.

Critics, of course, are also judged, either explicitly or implicitly: you somehow suspect that most people would much rather see a performance of *Frogs* than plow their way through the *Poetics*. It's not that Aristotle doesn't make exacting judgments; it's just that they're too polite to be much fun. ("An example of inconsistency is the *Iphigenia in Aulis* . . . in characterization, just as much as in the structure of events, one ought always to look for what is necessary or probable.") Great popular criticism, on the other hand, acknowledges and exploits the cruelty inherent in any critique, which is why we're still reading *Frogs*, and still giggling at Aeschylus's attacks on Euripides. "You, you jabber-compiler, you dead-beat poet, / you rag-stitcher-together, you say this to me? / . . . I won't stop, until I've demonstrated in detail / what kind of one-legged poet this is who talks so big."

Talking big—to say nothing of Aristophanic hyperbole, comic brio, and the guilty pleasure to be had in witnessing the humiliation of others—is on offer in a new work of literary criticism by a contemporary writer, the novelist Dale Peck. The book's title, *Hatchet Jobs*, tells you a lot about its author's style. In the summer of 2002, Peck created what he proudly refers to, in the introduction to the twelve essays in his new book, as a "ruckus in the publishing world." The cause of the ruckus was an annihilating review he'd written of a memoir by the novelist Rick Moody—to whom Peck, in an opening salvo more or less typical of his critical modus operandi, referred as "the worst writer of his generation." Peck himself is happy to chronicle the notoriety his review garnered soon after its publication:

> Let me be honest: my review was scathing. . . . Cocktail party gossip soon yielded pieces in *New York* magazine and the *Observer*, online at *Salon* and *Plastic.com* and at least a dozen blogs. Most of the commentary denounced me, not so much for what I'd written as for the vehemence with which I'd phrased it. . . . The backlash reached its nadir in March 2003, in a massive essay Heidi Julavits wrote for the debut issue of *The Believer*. In the piece . . . Julavits called for a literary culture that . . . resists the urge to indulge in "snarky" book reviewing.

He does not exaggerate: I happened to be staying with friends in Italy early that summer, and I can attest that even there the phone lines and Internet connections were humming with news about *l'affaire* Moody. Peck claims, in the introduction to *Hatchet Jobs*, that his initial pleasure in his article's impact "faded as I realized that people were less interested in what I (or the writers I'd reviewed) had to say than in the possibility of a brawl," but you can't help thinking he's being a tad disingenuous. Anyone who begins a review by stating that someone is the worst writer of his generation is someone who's interested in the possibility of a brawl.

The notorious Moody review ("The Moody Blues") has now been collected with eleven other "writings on contemporary fiction," which Peck has written for *The New Republic*, *The London Review of Books*, and *The Village Voice*. The surprise of the book is that its outré title (to say

nothing of its cover, a photograph of the brawny, bald-headed Peck wielding an axe) does it a serious injustice. Whatever its rhetorical excesses—and there are many—and its cramped aesthetic vision, it is an extremely intelligent book, and clearly the work of a potentially note-worthy critic—although, to be sure, one working in the Aristophanic, rather than the Aristotelian, mode.

Hatchet Jobs is not, at first glance, the book that you'd have predicted Peck would end up writing, back when his career first began. In 1993 he published a much-acclaimed debut novel called *Martin and John*, which was really a collection of short stories connected by the conceit, which you learn toward the end (and sometimes suspect that Peck came up with at the end, too), that one of the characters has written them all. It was a clever book—the work of a young man, to be sure, but sur-prisingly sophisticated both emotionally and formally. (Although the stories are all about different people in different places and of differ-ent classes, the main characters are always named Martin and John, and the secondary characters are always Bea and Henry.) Peck's formal gamesmanship was evident again in his second novel, *The Law of Enclo-sures*, whose title derives, in part, from the way in which the first and second halves of this fiction (about a drearily unhappily married couple named Bea and Henry) enclose a starkly written autobiographical sec-tion in which Peck suggests the origins of certain themes and subjects that recur in his fiction: domestic alienation and violence, psychological cruelty, alcoholism, spousal abuse, child abuse, homosexuality, prema-ture death.

As it turned out, *The Law of Enclosures* was a kind of road map for Peck's subsequent career. His next book was another novel, *Now It's Time to Say Goodbye* (1998), a sprawling affair about race and sexual-ity set in a rather suggestively named town ("Galatea") in Kansas, the state where Peck grew up. It was a book whose cast of characters—an artist, an academic, a black hustler named Divine, an albino black man, a black preacher, and a white Southern belle—suggested tremendous allegorical ambitions. But after that it was as if the startling central sec-tion of *The Law of Enclosures* had exerted a kind of tug on its author, and Peck returned to nonfiction family memoir with *What We Lost* (2003),

which focused on his father's grim childhood, where once again alcoholism, child abuse, psychological abuse, and poverty were the subjects at hand. Dale Peck Sr. is, indeed, the figure who connects all of his son's writing: a powerful, frightening, tormented, and punishing father is never very far away in both his fiction and his nonfiction—and, I suspect, his criticism as well.

I am not a great admirer of Peck's fiction, which I find (perhaps because of the artificial, almost willed quality of its formal and rhetorical schemes) always to be straining rather too hard for effect. This was certainly the case with *Now It's Time to Say Goodbye*, which collapsed under the weight of its overladen allegorical structures. But even the much-acclaimed first novel seemed to me to seesaw between a strained "lyricism" ("the world accumulated history as each second passed, but I sloughed it off as though my body were coated in wax") and cliché: "I look at him, confused, staring full on into the bottomless tranquility of his eyes." Equally conventional, it seemed, was the affected affectlessness of the prose Peck used to describe the traumas his characters suffered—a stylistic tic you found in lots of young gay male writing during the late 1980s and early 1990s. ("I lost my virginity to my stepfather on my mother's double bed during the afternoon's heat while she was at work.") For someone who, in his critical writings, seems to value "passion" highly, Peck hasn't put a lot of it in his fiction.

These bad habits were more in evidence in the second novel. Critics have raved about the beauty of Peck's prose, but in his fiction, at least, the diction has only gotten more portentous with time ("this drifting was his only dream, his earliest desire; it was his desideratum"), the writing more overwrought ("the shriek of the alarm had skinned him like an onion, layer by layer"), and the symbolism ever more heavyhanded. In *The Law of Enclosures*, the unhappy couple are having a new house built, and each one has a different idea of what it should look like, so that in the end it is—*like the marriage itself!* (as Peck, who is much given in his criticism to caustic italics, might put it)—"an eccentric amalgamation; inside, it looked like two jigsaw puzzles forced together." Worse, in this novel Peck indulged even more a penchant for what I think of as bossiness: he never trusted his story (let alone dialogue) to illuminate his characters, but instead not only kept telling

you what his characters were thinking at every moment, which is wearying, but had them think things that no one actually thinks, except of course for characters in novels, who need to think them so that we realize that they're doomed or vulnerable, etc.:

> The bandana splayed at Henry's feet as though it were a parachute tied to the body of a toy soldier, and as he looked at it he remembered that even though those parachutes never worked, the soldiers tied to them, plastic, invulnerable, always survived their falls.

Looking back, I see that Peck's bullying tendency to hog the microphone was a kind of clue to where his talent really (or so it seems to me) lay, which is nonfiction—memoir, criticism. The only really authentic writing in his first two books is the brilliant central section of *The Law of Enclosures*, where Peck the scathing critic takes over from Peck the affected novelist. Here there is total authority, as opposed to mere pushiness. And real invention, too. (There is a remarkable chapter in which he imagines inhabiting—entering, really—the body of his father, whom he wishes to understand, orifice by orifice.) In this central section, too, the emotions—above all, grief for the author's mother, who died when he was three—seem authentic rather than learned or (as with much of the AIDS material in *Martin and John*) obligatory, and for that reason achieve genuine lyricism:

> But only when she is forgotten, and I am forgotten, and everyone who has ever read this is forgotten, only then will the wound of her loss be closed and the world be, once again, whole.

That's something you don't mind being told.

There's a line in *Hatchet Jobs* in which Peck lambastes the critic Sven Birkerts (the object of particularly devastating ferocity) for being too controlling: "Birkerts," he writes, "wants to do more than merely bring books to readers. He wants to tell readers how they should be reading them." But this is precisely what Peck himself has kept doing in his fiction, where the impulse doesn't belong; it was only when he'd relaxed

into nonfiction that he found a style that was natural to him, a voice that was truly strong.

===

The urgent need to control—to make sure you see what he sees, with no room for dissent—coupled with a desire to seduce are, of course, the traits of a comedian as well as those of a critic, and the hallmark of Peck's style is a ferocious sense of humor that, in its wildness, its parodic ferocity, and its machine-gun willingness to hit or miss is indeed Aristophanic. This style is present on every page of *Hatchet Jobs*, which features essays not only on Moody and Birkerts, but on a fair range of novelists both established and fairly young: David Foster Wallace, Philip Roth, Colson Whitehead, Stanley Crouch, Julian Barnes, Jim Crace, Kurt Vonnegut. There are also omnibus essays on genre fiction: gay epics, novels about black women.

Given the dourness of Peck's fiction, the humor comes as a welcome surprise. He likes to open his pieces with an outrageous statement guaranteed to grab your attention—"the worst writer of his generation" (Moody), "in a word, terrible" (David Foster Wallace's *Infinite Jest*), "it is so bad that I began to suspect he might actually have talent" (Jim Crace's *The Devil's Larder*)—and, having done so, rewards you with a stream of zippy bons mots for the rest of the essay. During much of the time I was reading *Hatchet Jobs*, I was laughing out loud. The wit is rarely gratuitous, providing as it does a vivid (if often nasty) sense of what it feels like to read this or that author:

> Reading Birkerts, especially when he writes about contemporary novelists or the Internet, I feel like I'm watching an old man tapping his foot to a phat beat, maybe even letting himself lip synch. . . . And when he's writing about his beloved early-twentieth-century moderns, it's as if the channel has switched to a polka station and the old man gets up and parties.

Only occasionally does the humor fall flat: "With friends like this, literature needs an enema. Ooh, that was probably a bit much, huh?" (Well, yes.) There is, too, a rangy imaginativeness to Peck's critical prose that allows him to illustrate the points he wants to make far more vividly than most critics can. For instance, he very astutely describes the main character in *The Intuitionist*, Colson Whitehead's debut novel, as "weirdly emotionless, simultaneously three-dimensional but without substance, like a figure half materialized on the transporter deck of the Enterprise."

The humor and stylishness would be worth little without intelligence and acuity, and of each Peck has a great deal. *Hatchet Jobs* has much of interest to say about both individual authors and certain fashionable trends. ("Let's face it, cancer has become, in narrative terms, less a fatal disease than a gift, a learning experience, a personal triumph.") He gets the feel of Kurt Vonnegut's cult-figure popularity just right ("Writers who are merely great—writers such as Mailer and Bellow and Roth and Updike—write stories which become part of our dreams, but cult writers are themselves dreamed about"). The famous takedown of Rick Moody's narrative self-indulgences is as deadly accurate as it is amusing. "Moody," he writes,

> starts his books like a boxer talking trash before the bout, as if trying to make his opponent forget that the only thing that really matters is how hard and how well you throw your fists after the bell rings.

This is not only vivid, but true.

I respect Peck's intelligence and talent too much to reduce him to a "gay writer," but *Hatchet Jobs* offers every evidence that what you might call an "outsider" sensibility has informed his reading of certain authors, even those he considers to be "great" (as, for instance, he does Philip Roth). The results are often both stimulating and searching. Peck liked Roth's *American Pastoral* a good deal less than I did—as often, he can't seem to see anything positive in books in which he's found anything negative—but it's hard to deny the brilliance of the critique that he offers, in his essay "The Lay of the Land," of the misogynistic current in

Roth's fiction. He achieves this critique, in part, by ingeniously teasing out the implications of Roth's title, noting that the earliest American writing consisted of settlers' "pastoral" descriptions of the virgin land. Then he goes on to observe that

> the land-woman had to be subdued, and subdued it was, both physically by its colonists, and figuratively, in the three and half [*sic*] centuries of literature that have been produced here [in which] a feminized landscape is traversed, mapped, contained. In our country, the pastoral is a false tradition, an invention, a written convention, a way of writing about a subject originally designed to woo money from investors who had no knowledge of what was being written about; similarly, Roth's pastoral is equally faked, a lost paradise that never existed but nevertheless had to be invented so it could be eulogized in his novel.

It's a stark point that comes across all the more powerfully for lacking any whiff of special pleading.

That Peck's criticism is blissfully free of political (or politically correct) agendas is just as evident, and even more striking, in "Stop Thinking: The (D)evolution of Gay Literature." This essay contains what is, to my mind, the single best critique of the curiously flat quality of much of the "gay-niche" fiction that has appeared in recent years. "A novel which aspires to social criticism," Peck observes of Ethan Mordden's *How Long Has This Been Going On?*,

> ought to depict the society it criticizes. . . . If as a novelist, exposing homophobia is your mission, then it seems worthwhile to point out that there's only so much one can learn about homophobia by looking at gay people; eventually you have to examine the homophobes, and that means looking at straight people. Think of the interaction between Jews and Gentiles in Saul Bellow, between blacks and whites in Toni Morrison . . . [but] Mordden's characters are reduced to wailing and flailing their way through an Us-Against-Them world in which They are unusually absent. As a strategy, it seems a bit like playing rac-

quetball in a court with no walls, and that same image could describe the progress of Mordden's narrative: each scene gets one good whack, and then it rolls off into the distance.

Here as in so many of these essays, Peck takes on a potentially tricky subject, but precisely because he's a brawler—temperamentally unafraid to take aim and swing—more often than not he scores a palpable hit.

================

And yet as much sense as Peck so often makes, there is something awry with this collection, and it's something his detractors have intuited, too, even if they haven't articulated it particularly well. (None, it must be said, are as much fun to read as he is.)

There is, to begin with, the problem of overkill. I have no strong opinion either way of Sven Birkerts, and I too thought Rick Moody's *The Black Veil* was a sodden mass of pretentiousness and self-indulgence, but as I made my way through Peck's lengthy excoriations of these authors, it occurred to me that perhaps it might be wasteful to expend many thousands of words on the complete annihilation of writers who are, when all is said and done, not of the first tier. But here and elsewhere, it's as if Peck can't stop himself—there's something manic about the way he pounces on something trivial, something like a misused metaphor (he does go on about one involving the game of horseshoes), and shakes it like a cat shaking a dead mouse. This excess often has the effect of diminishing, or sometimes even eclipsing, the substantive points Peck wants to make. There's a fascinating passage in which Peck, who thinks very ill of Julian Barnes's *Love, Etc.*, criticizes the author's plotting:

> In between these two plot points is what appears to be the traditional scenic connective tissue, but even though it clearly delineates the route from there to here . . . it omits, like a road map, the mountain ranges, out-of-date billboards, and fleeting eye

contact with the blonde in the Lexus that distinguish an actual journey from a line on a piece of paper: the traffic jams, the overpriced gas, the toll booths and speeding tickets, the rickety crosses with faded flowers commemorating a highway fatality, the good and bad weather, the good and bad coffee. . . . For all Barnes' mechanical delineation of Oliver's seduction . . . the key question of attraction is never addressed, and in the end the only discernible reason Gillian invites Oliver in is because Barnes programmed her to do it.

This is a wonderful bit of writing, but two things strike you: first, that by the middle of the passage you (and, you suspect, Peck) have temporarily forgotten just where this metaphorical road trip is headed, and second, that what's really going on here isn't so much criticism as a kind of performance—it's as if Peck wants to show you not what's wrong with Barnes, but how good a writer he, Peck, is.

The pervasive sense of an underlying competitiveness can sometimes be invigorating, but too often leads to cheap ad hominem attacks. "Need somebody to slog through a second-rate translation of Mandelstam's journals or *The Radetzky March*," he scoffs, "and produce two thousand words to fill that big slot in the middle of the book—for not very much money to boot? Birkerts is your man." What Sven Birkerts (or anyone else) gets paid for his literary journalism has nothing whatsoever to do with the quality of his criticism; "not very much money" is snotty, and has no place in serious criticism. Peck claims at the end of his book that he wants his reviews to be "some kind of dialogue with my generation," but what kind of dialogue can you have, really, with someone who's shouting—and kicking?

Indeed, construction, as opposed to destruction (however entertaining), is not one of Peck's fortes. It must be said that after twelve chapters of hacking away with his hatchet, he doesn't leave much standing, and you start to wonder just what it is he does think is worthwhile. Peck says again and again that he thinks it all went wrong with Joyce: "*Ulysses* is nothing more than a hoax upon literature, a joint shenanigan of the author and the critical establishment." On Joyce he blames what he sees as the current debased state of the novel, stranded (as he believes

it to be) between a naive realism, on the one hand, and a postmodern formal gimmickry "that has systematically divested itself of any ability to comment on anything other than its own inability to comment on anything." As far as Peck's concerned, "both of them, in my opinion, suck. . . . I think the modes need to be thrown out entirely." But what he wants to replace them with isn't clear. Although he does occasionally betray certain tastes ("the traditional satisfactions of fictional narrative—believable characters, satisfactory storylines, epiphanies and the like"), and occasionally mumbles something about a "new materialism," he refuses to say what a new "mode" would look like:

> My goal was never to offer an alternative model to the kinds of writing I discuss here, because it's precisely when a line is drawn in the sand that people begin to toe it and you fall into the trap of reification, of contemporaneity, an inability to react to changing circumstances.

This is cagey and, you can't help thinking, disingenuous. All criticism derives, ultimately—whether explicitly or implicitly—from precisely the kind of model that Peck won't, or can't, provide here: a standard, a criterion, the intellectual, formal, or generic touchstone by which he evaluates the worth of whatever work he's considering. The critic's job is, if anything, to draw lines in the sand, to demarcate the good from the bad, the authentic from the inauthentic; given the authority and vehemence of Peck's attacks on what he thinks is bad, his coyness about "toeing the line," his unwillingness to be explicit about what he thinks is good, to describe and justify what his criteria are, is noteworthy.

You wonder, if anything, whether "inability to react to changing circumstances" may be said to characterize Peck's own position (as much as it's possible to figure out what it might be). Like his former colleague at *The New Republic*, the estimable and excellent James Wood, Peck seems to want more novels like the great nineteenth-century novels: serious, impassioned, fat, authoritative. But you can't write nineteenth-century social novels about twenty-first-century global culture, because the form and preoccupations of the nineteenth-century novel are different from those that might properly interpret the twenty-first century:

whatever you think of the self-referential gamesmanship of authors like David Foster Wallace and Dave Eggers, their desire to write books that reflect their own inability to comment on anything but their own inability to comment on anything is a reflection of the anxieties—and realities—of the world in which we actually live. You can call all you want for a return to what is, essentially, a Victorian "materialism," but to do so is an expression of sentimentality, ultimately; it's like calling for the return of sixteenth-century Venetian opera or Greek tragedy.

Or, for that matter, Greek comedy. Peck seems, indeed, to be aware of the underlying unsoundness of his aesthetic ideology, because he prefers to do the Aristophanic thing: focusing less on working through a coherent aesthetic than on his showing off his own dazzling performance—while, of course, getting rid of the wrongdoers. He dreams breathlessly of "the excision from the canon, or at least the demotion in status, of most of Joyce, half of Faulkner and Nabokov, nearly all of Gaddis, Pynchon, DeLillo." This fantasy again betrays a surprising intellectual naïveté. Canons aren't drawn up like shopping lists; they grow organically, just as genres and styles do, out of the soil of the culture that produces them.

———

Together with his failure to provide a positive picture of what he wants writing to be, the critical metaphors to which Peck resorts—of excision, expulsion, and humiliation ("demotion in status")—suggest what is, in the end, incomplete about his criticism. For if criticism is, as the word's etymology suggests, essentially an act of judgment, it seems to me that Peck's critical writings, for all their intelligence and brio, focus, instead, on what comes after judgment: punishment. There is, indeed, something punitive about his reluctance to let any flaw pass, no matter how trivial it (or the author in question) might be; his words and sentences fall like the blows of a lash.

Or, as he himself put it, of a hammer. In *The Law of Enclosures* there's a remarkable passage in which he discusses his relationship with his

frightening, powerful father, and the psychological dynamics at play are interesting enough to make the passage worth quoting in full:

> Your gifts are fists and curses, your punishments kisses and ca-resses, and I have grown bitter with your love and sweet with your hatred. You are my god, my father, but I am your bible: I turn your flesh into words, and words have always outlasted the gods who fathered them. I have built you up and I have torn you down, and I can do either again, or neither, or both. Words are my wrenches, words my hammer and nails. Words are my fists, my liquor, my food, and words are my women. With my words I will protect you. I will save you as you have saved me. I save you forever, and for everyone, and for eternity. Dear father, I am saving you now.

Dynamics of power, punishment, and pain between a younger and an older man have recurred in Peck's work from the beginning: *Martin and John* contains two arresting descriptions of S&M sex, one of which ends with the younger man begging the older to penetrate him with a shotgun. It is difficult not to see, as the origins of this fascination, the extreme Oedipal tensions at play in the passage from *The Law of Enclosures*, too: the obsession with power (Peck's as well as his father's), the son's fantasy of being able to punish or save, the constant threat of physical violence both by and against the father ("fists" occurs twice).

All this is worth noting only because of its implications for Peck's criticism. It's hard not to feel, in his book reviews, a ferocious kind of acting-out going on. The "hammer and nails" Peck mentions in the passage above seem intended not so much for constructing something— the way you're tempted at first to read this passage—as for crucifying someone; and indeed, you sense that what Peck the critic really wants to do when he picks up a book to review isn't so much to judge the writer as to *nail* the guy. (In this context, it is surely interesting that the writer he singles out for unambiguous praise, meant to serve as a kind of capstone to the collection, is a woman, Rebecca Brown, who wrote a memoir of her mother's death.)

There's no denying that all that hammering yields a lot of pleasure for Peck's readers; but it's not the road to serious critical work—if, of

course, that's what Peck wants. (Two pages into *Hatchet Jobs*, he declares that he "will no longer write negative book reviews"—"I am throwing away my red pen"—a showy gesture which suggests that his foray into criticism wasn't much more than a performance after all.) Even Aristophanes—who was, we should remember, a comedian and not a critic—seems to have been made uneasy by the sadistic aspects of criticism. "I cannot judge them any more," his Dionysos apologizes when the word-weighing is over. "I must not lose the love of either one of them. / One of them's a great poet. I like the other one." The lines remind you that loving and liking are as much a part of criticism as are hating and hacking; and that the impulse underlying good criticism ought to be affection for literature rather than animus toward writers. After his novels, after his memoir, and especially after *Hatchet Jobs*, we know pretty well whom Peck has hated, and why. Now it's time to say goodbye. The serious critic, after all, is measured—and judged—as much by what and how he praises as by what and how he blames; and he should be as stimulated by the pleasure he gets from his reading as he is by the pain.

—*The New York Review of Books*, July 15, 2004

The Way Out

At the beginning of Philip Roth's 1979 novella *The Ghost Writer*, the twenty-three-year-old narrator, Nathan Zuckerman, tremulously approaches the secluded New England home of a famous but reclusive Jewish writer, E. I. Lonoff. Of this Lonoff we are told that he has long ago forsaken his urban, immigrant roots—the cultural soil from which, we are meant to understand, his vaguely Bashevis Singeresque fiction sprang—for "a clapboard farmhouse . . . at the end of an unpaved road twelve hundred feet up in the Berkshires." Long out of circulation, he is considered comical by New York literary people for having "lived all these years 'in the country'—that is to say, in the *goyish* wilderness of birds and trees where America began and long ago had ended." Still, young Nathan, an aspiring novelist, admires Lonoff extravagantly, not only because of "the tenacity that had kept him writing his own kind of stories all that time," but because

> having been "discovered" and popularized, he refused all awards and degrees, declined membership in all honorary institutions, granted no public interviews, and chose not to be photographed,

as though to associate his face with his fiction were a ridiculous irrelevancy.

A young man's admiration; a young man's perhaps self-congratulatory idealization of a figure who, it is all too clear, he would like one day to be.

If, thirty years ago, readers felt safe in identifying the ingenuous, ambitious, hugely talented Newark-born Nathan Zuckerman with his creator—Zuckerman indeed went on to become the hero of an impressive number of subsequent novels focused on the sexual, artistic, cultural, and moral life of the American Jewish male—anyone familiar with Roth's recent biography will find it difficult not to identify the author today with Lonoff. Like the fictional writer, Roth is a novelist whose work is profoundly rooted in Jewishness (however much Jewishness may be questioned, berated, and rejected in it); like Lonoff, Roth has ended up living "in the country"—not far from the Berkshires, in fact (whither the elderly, ailing Nathan Zuckerman also eventually repairs, in a much later novel); as with Lonoff, the recent biography suggests an aversion, if not to honors and awards (of which Roth has many), then to the whirl of New York literary life, to the ridiculously irrelevant ephemera of being a major figure in the culture. A recent profile of Roth in *The New York Times*, timed to coincide with the publication this month of the short novel *Everyman*, his twenty-seventh book, makes a point of noting that the new book is one of the rare ones in which Roth has permitted an author photograph to appear.

And as with Lonoff, there is a sense of the literary lion become, suddenly, the lion in winter. There is, to my mind, a kind of caesura in the Roth corpus that falls exactly in the middle of the 1990s. The first half of the decade saw the publication of two novels that, between them, embody the major themes of Roth's work. In 1993 Roth published the dazzling *Operation Shylock*, a brilliant parable about the meaning of identities Jewish, artistic, and cultural: in it, the narrator, ostensibly Roth himself, sets out to find and confront a Philip Roth impersonator who is also a prophet of something called "Diasporism," an ideology promoting the return of Israelis to their European countries of origin. (All this, to raise the stakes even higher, is set against the trial of the concentration camp guard John Demjanjuk, charged with being Ivan

the Terrible, "the butcher of Treblinka.") The connection between eros and art, always a crucial one in Roth's fictional world, was subsequently explored, with equally outré gusto, in *Sabbath's Theater* (1995), whose protagonist is a onetime puppeteer and self-described "dirty old man." The former book won the PEN/Faulkner Award, the latter, the National Book Award for fiction.

Since then—starting in 1997, when Roth, then in his mid-sixties, published his Pulitzer-winning *American Pastoral* (the first installment of a nostalgic trilogy, largely about the failure of the American Dream, which also included *I Married a Communist*, a look back at the Fifties, and *The Human Stain*, in part a sour indictment of political correctness)—the roiling, libidinous energies and aggressive intellectual dazzle of what could be described as Roth's middle period, the period that culminated in *Operation Shylock* and *Sabbath's Theater*, have yielded more and more to a distinctly elegiac mode. It's not that the books necessarily have any less vivacity, any less imaginative brilliance (the latter amply demonstrated by the publication, in 2004, of his counterhistorical Nazified America fantasy *The Plot Against America*); it's merely that they seem, suddenly, to be written by someone who's closer to the periphery than to the center of things, who's looking back in resignation, or anger, or both. However vivid its depiction of the tumult of Sixties political fervor, the dominant note sounded in *American Pastoral* was one of idealized nostalgia—hardly untypical for this author—for the Depression-era work ethos recalled from his childhood, the ethos that was frayed during the decade the novel depicts. Similarly, in *The Human Stain* there was a tension between grouchy disdain for the novel's present-day fictional setting (politically correct academia, circa 1990) and a golden-toned reverie about the solid values of the past: in this case, the values of an aspiring black railway porter, father to the protagonist, values that have been upended and mocked by the sanctimoniousness of the present.

It occurred to you, as you read these novels and those that followed—particularly *The Dying Animal* (2001), which finds a recurrent Roth hero, the libidinous cultural critic David Kepesh, "nearing death" and, even worse, appalled to realize that the voluptuous Cuban-American student with whom he carries on an obsessive affair is mortal, too—that they were the work of an author facing his seventies. An autumnal frost had set in.

Roth himself has been outspoken, of late, about his preoccupation with death. In the *Times* profile he talked at length about the "gigantic shock" of finding himself at an age when his friends are dying, it would seem, en masse (in the book, he indeed describes old age as a "massacre"):

> This book came out of what was all around me, which was something I never expected—that my friends would die. If you're lucky, your grandparents will die when you're, say, in college. Mine died when I was a schoolboy. If you're lucky, your parents will live until you're somewhere in your 50's; if you're very lucky, into your 60's. You won't ever die, and your children, certainly, will never die before you. That's the deal, that's the contract. But in this contract nothing is written about your friends, so when they start dying, it's a gigantic shock.

That the subject is one of great urgency to the author just now is made clear by the fact that this heartfelt sentiment closely echoes a passage from *The Dying Animal*:

> The loveliest fairy tale of childhood is that everything happens in order. Your grandparents go long before your parents, and your parents go long before you. If you're lucky it can work out that way, people aging and dying in order, so that at the funeral you ease your pain by thinking that the person had a long life. It hardly makes extinction less monstrous, that thought, but it's the trick that we use to keep the metronomic illusion intact and the time torture at bay: "So-and-so lived a long time." But Consuela had not been lucky.

The repetition is oddly moving—as of someone dazed by a sudden blow, walking around in circles. According to the *Times* profile, the worst of the blows suffered by Roth was the death of his old friend and mentor, Saul Bellow. The author disclosed that it was on the day after Bellow's burial that he sat down to write something that would, more directly than any of its predecessors, confront the specter of death itself—as the new book's title, with its allusion to the medieval morality play about

a visit by Death to a nameless "everyman," makes clear. "I'd just come from a cemetery," Roth said, "and that got me going."

"Got me going" can, of course, mean "started me on my way"; but it can also mean "worked me into a frenzy." The latter, I suspect, is the more apt here. For although what we know of Roth and how he came to write *Everyman* promises that here is a book in which we will get to witness a great novelist facing, head-on, the great subject, the book itself is surprisingly thin—in every way. This is not to say it lacks intensity: every page of this account of an ordinary man's physical disintegration and eventual death bears witness to a bitter outrage, constantly reiterated in that same dazed way, against the simple but devastating fact that the body, eventually, fails—that, in time, people's "personal biographies . . . become identical with their medical biographies." But although the bitterness is a sentiment few would argue with, it is not clear that this powerful emotion has translated here into a powerful work of fiction.

Like the late medieval work with which it shares its title, *Everyman* proceeds episodically. In the play, the ordinary mortal, referred to simply as Everyman, is called to account for his life before the seat of Judgment. There he finds that he has been abandoned by Fellowship, Kindred, and Goods in rapid and rather depressing succession; but he is saved, in the end, by the intervention of Good Deeds, Knowledge, Confession, Discretion, and so on. The drama, unsurprisingly, ennobles the abandonment of material goods and ephemeral ties (friends, family) in favor of more abstract, spiritual values.

The ruthless, almost sadistic stripping away of material goods and common pleasures, at any rate, is replicated in Roth's book. *Everyman* self-consciously seeks to rewrite the premodern dramatization of a stark and terrifying confrontation with Death but without the moralizing and Christianizing—which is to say, the comforting and redeeming—elements. "It's told from the Christian perspective, which I don't share," Roth remarked while explaining how he came to write the book; "it's an allegory, a genre I find unpalatable; it's didactic in tone, which I can't

stand." Still, like its medieval model, this tale begins with the demise of its hero—in this case, a thrice-divorced retired advertising executive—and thereafter seeks to account for his life in a series of scenes from the dead man's past, episodically presented. But because of its relentless rejection of spiritual abstractions and its compensatory emphasis on the failure of the corporeal self, these vignettes, in Roth's *Everyman*, are in every case connected to either a medical crisis or a funeral. Hence, for instance, a narrative of the hero's early childhood is pinned to a description of a hernia operation he had at the age of nine; the collapse of his second marriage is pegged to his mother's death; and so on.

The structural relationship between everything that happens in the book and scenes of illness, hospital stays, medical procedures, and deaths is meant to underscore a glumly reductive theme: "Up and down the state that day, there'd been five hundred funerals like his. . . . It's the commonness that's most wrenching, the registering once more of the fact of death that overwhelms everything." And indeed, to underscore the universality of his subject, the author presents us with an ostensibly common person: his hero, never named, is all too clearly meant to be generic. We're told, for instance, that he always thought he was "square," that "he never thought of himself as anything more than an average human being."

It must be said that the pose of ordinariness, crucial to Roth's intentions, is none too persuasive, not least because, try as he might to be ordinary, the hero of this book inevitably starts to sound as interestingly tormented and complex as are the heroes of Roth's other books. This everyman is, like so many of the men you meet in Roth's novels, a talented Jewish boy from the Newark area who enjoyed an idyllic childhood complete with a revered brother and hardworking parents who, themselves the children of immigrants, embody the thrifty American values of the Depression era. As often in Roth's fiction, the father in particular is idealized and heroized; what tenderness there is here—and there isn't much—is, unsurprisingly, reserved for the hero's father, the owner of a jewelry store in Elizabeth called "Everyman's Jewelry Store."

This protagonist is, also like those others, a man who struggles, on the whole unsuccessfully, to balance a strong libido with the demands of family connections. Particularly vexed are his relationships with his

two sons (one of whom is moved by his emotions, at his father's funeral, to an intense physical reaction almost like regurgitation—a recapitulation of a connection between filial emotion and vomiting that appears as well in *The Dying Animal*). There is the usual collection of females: vaguely nice mothers, somehow never as sharply etched as the fathers; ex-wives who are inept or grasping or inappropriate or, as one is here, appreciated by her wayward husband only after the marriage has ended. And there is, too, an encounter with a tiny, young, frizzy-haired sexpot who ends by humiliating the hero—a female type, and a scene, that we have encountered before in Roth's fiction. (She turns up, memorably, in *American Pastoral*.) The one successful relationship this well-heeled New Jersey Jewish everyman has is with his daughter by the worthy second wife, but there's something sketchy and abstract about the way this relationship is drawn—you feel it's there primarily for the sake of a tenuous allusion to King Lear, a father who also has three children, only one of whom is "good."

There are, indeed, so many ghostly reincarnations in this book of earlier characters that it occurred to me at one point that the title might have been meant as a kind of inside joke: for just as *Everyman* replays its hero's life, it seems, too, to replay quite self-consciously motifs and characters from Roth's other works, and its pages sometimes seem like a rather hastily assembled waxworks display of Characters from the Novels of Philip Roth.

The familiar vividness, if not the uniqueness, of the characters in *Everyman* ends up being a problem. Little of what we know about this everyman comes across as generic or "average"; that the character feels oddly unfinished is surely the result of a struggle between the author's desire to write about an everyman and his natural talent for creating a very specific kind of man, a seethingly interesting male character. The occasional tirades about, say, people who dote on their grandchildren— a sentiment surely more prevalent than not among the population of real-life everymen—feel odd coming from the mouth of a supposedly average person. (Other fraught asides, characterized by a kind of elegiac exhaustion, for instance one about the "corpse-strewn *anni horribiles*

that will blacken the memory of the twentieth century," are equally unpersuasive.) The result is a character whose component parts seem somehow fragmented, unintegrated.

The sense of authorial overdetermination—that certain elements here too transparently serve a preordained theme—persists in another way. From that hernia operation in 1942, when he is nine (the character, like the author, was born in 1933) to his final cardiac arrest, Roth's everyman strikes the reader as a person who seems, if anything, to have enjoyed bizarrely—or perhaps it's "suspiciously"—poor health throughout his life. First the childhood surgery, then, in his thirties, a near-fatal brush with peritonitis following a ruptured appendix; then the onset of heart ailments, the quintuple bypass surgery, followed by the arterial cleanings, the stents, the defibrillators, and so on. A typical passage looks like this:

> The year after the three stents he was briefly knocked out on an operating table while a defibrillator was permanently inserted as a safeguard against the new development that endangered his life and that along with the scarring at the posterior wall of his heart and his borderline ejection fraction made him a candidate for a fatal cardiac arrhythmia. The defibrillator was a thin metal box about the size of a cigarette lighter; it was lodged beneath the skin of his upper chest, a few inches from his left shoulder, with its wire leads attached to his vulnerable heart, ready to administer a shock to correct his heartbeat—and confuse death—if it became perilously irregular.

It's as if, in order to hammer home his theme that each of us is, ultimately, nothing more than a body that fails, the author has abused this one fictional body to unlikely—or at the very least, unusual—extremes. Extremes of physical failure, that is to say, as debilitating as are the extremes of the emotional failure to which we are told this supposedly "average" man has doomed himself. Even the good daughter, with whom at the end of his life he dreams of living, ends up living with her mother instead. At the end of his life, this man is utterly, if somewhat artificially, improbably, alone.

Roth is so eager to leave his allegedly average hero with nothing to hold on to by the end of his story—no body, no family—because his mission here is reductive in every sense of the word: for him, we're nothing but bodies, in the end, and we know what happens to those. (At one point the hero sourly declares that if he were to write an autobiography, it would be called *The Life and Death of a Male Body*.) The final third of the book is little more than a catalog of health crises, both the hero's and his friends': in rapid succession, you hear about the dreadful demises or debilitations of three of his former colleagues and the nice ex-wife. The relentless and ultimately numbing repetition again suggests a wounded outrage on the part of the author; and yet the character is so undefined that the awful departures of his onetime wives, relations, and friends (of "Kindred," that is to say, and "Fellowship") carry little emotional weight. But then, the author's denial to his character of the solace of emotional ties serves his larger, bleak theme. A closing and climactic confrontation with a gravedigger—*Lear* has been abandoned for *Hamlet* here—places great emphasis on the hero's desire for the comfort not of intangible abstractions but of "concreteness": knowing how a grave is dug, knowing what happens down there.

The opposition between concreteness and abstraction (and, naturally, between everything those two could be expected to stand for in a novel: the material and the spiritual, the body and the soul, the profane and the sacred) informs a suggestive if underdeveloped subplot, a passage of a few pages that hints at how interesting this book might have been if it had told us more. In his retirement, the hero, a skilled amateur painter, decides to teach an art course in the retirement community, located on the Jersey Shore, to which he's moved. Here, his overeager but naive students dream of painting glorious abstract paintings—a genre in which he himself is skilled, we learn, although he eventually abandons it, having lost confidence in his talent; they resent the still lifes he requires them to paint. "I don't want to do flowers or fruit," a student says, "I want to do abstraction like yours." (It's hard here not to recall the French term for still life: *nature morte*, "dead nature.")

To such students our everyman approvingly repeats a remark made by the painter Chuck Close, that "amateurs look for inspiration; the rest of us just get up and go to work." As if to drive home the notion that

only concrete objects and solid values—flowers, fruit, hard work—matter in the end, we learn that the one pupil who has any talent ends up killing herself, unable to cope with her chronic back pain—something that isn't abstract at all. So much, it would seem, for the triumph of art over life.

The pervasive, strangely intense, almost angry insistence that the abstractions with which we normally comfort ourselves—emotional, spiritual, artistic—amount to little in the face of our common and none-too-pleasant fate, which is the bitter failure of the flesh of which we are made, flies, of course, in the face of the redemptive action of that other, antique drama called *Everyman*. In Roth's book the hero is someone who "put no stock in an afterlife and knew without a doubt that God was a fiction and this was the only life he'd have," and so is left, at the end, with nothing but bones, which as he sees it is all that survives of us in the end. "The flesh melts away but the bones endure," he thinks during a final visit to the graves of his parents, with whom he carries on a moving silent conversation:

> His mother had died at eighty, his father at ninety. Aloud he said to them, "I'm seventy-one. Your boy is seventy-one." "Good. You lived," his mother replied, and his father said, "Look back and atone for what you can atone for, and make the best of what you have left."
>
> He couldn't go. The tenderness was out of control. As was the longing for everyone to be living. And to have it all all over again.

That this flare-up of emotional intensity is directed at what the character knows to be nothing more than hard, white bones is no accident: throughout the book he has yearned for something that is truly concrete, something that will last. "Imperishable," indeed, is a word we're told he loves. At one point he asks his Danish mistress, soon to become the disastrous third wife, to translate it into her native tongue; more significantly, we learn that his father loved using that very word of the small diamonds he once sold to his working-class clientele. "A piece of

the earth that is imperishable, and a mere mortal is wearing it on her hand!" The contrast between the mortal and the immortal, the perishable flesh and the imperishable piece of earth, which recurs with greatest effect in the cemetery scene, is meant to be a poignant one.

But in the end, Roth's relentless reduction of his hero to nothing but failed relationships and failed flesh doesn't move—and worse, doesn't persuade. For all the novel's intensity—and despite the chillingly clinical descriptions of what happens when "eluding death" becomes the "central business" of one's life—you don't really believe it. The fact that Roth's anonymous hero ends up "lost in nothing" both emotionally and, finally, physically says more about the way this particular narrative has been manipulated, and about the author's bitterness about mortality just now, than it does about the condition of being a human being. The vast preponderance of evidence, after all, suggests that in the face of death people do, in fact, cling happily and successfully to the familiar abstractions—love, family, art, religion. *The Dying Animal* claimed to look death in the face, but wriggled out of the confrontation: its aging-satyr hero was saved while his voluptuous young mistress got breast cancer. (Another victory for the boys.) *Everyman* claims to look death in the face as well, but, by concentrating too narrowly, only on the physical, only on the materiality of our passage from life, he ends up drawing an equally unfinished picture of what it's like when Death comes calling.

And indeed, just as his allegedly ordinary hero can't help being a vividly Rothian type, it's hard not to see, creeping into Roth's annihilating pessimism here, an irrepressible sentimentality. What, after all, does it mean to commune with the bones of one's parents in a cemetery—a communication that involves not only the hero talking to them, but them talking *back*—if not that we like to believe in transcendence, believe that there is, in fact, something more to our experience than just the concrete, just the bones, just the bits of earth? If the scene is moving, I suspect it's because of the nakedness with which it exposes a regressive fantasy that seems to belong to the author as much as to his main character: once again, Roth reserves his best writing and profoundest emotion for the character's relationship with his parents. This reversion to the emotional comforts of childhood seems to me to be connected to the deep nostalgia that characterizes this latest period of Roth's writing

(it's at the core of *The Plot Against America,* too); it seems to be something that Roth himself is aware of, too, and which, in a moment that is moving in ways he might not have intended, his everyman articulates. "But how much time could a man spend remembering the best of boyhood?" the protagonist of *Everyman* muses during a sentimental trip to the New Jersey shore town he visited as a boy. It's a question some readers may be tempted to ask, too.

As it happens, the culminating scene in the graveyard also recalls a sentiment—a redemptive one—expressed in the original *Everyman.* There, in a triumphant concluding passage, Knowledge suggests that out of death can come beauty—and art. "Now hath he made ending. Methinketh that I hear angels sing, and make great joy and melody. . . ." Roth's new book, as imperfect as it is impassioned, spends a lot of time arguing violently against such sentimentality, such aesthetic abstraction; but ends up suggesting in spite of itself that, whatever else is true, it's the ending that everyone, himself included, prefers.

—*The New York Review of Books,* June 8, 2006

Mighty Hermaphrodite

Those Greeks and their hermaphrodites! Teiresias, the seer who futilely haunts so many Greek tragedies, was one. Having enjoyed the special privilege of living as both a male and a female, he was asked by the gods to settle an argument about which of the two sexes had more pleasure from lovemaking; on asserting that the female did, he was struck blind by prudish Hera—but given the gift of prophecy by Zeus as a compensation. The minor deity Hermaphroditus, of course, was another, appearing in religion (there is evidence of dedications to the god as early as the third century B.C. in Attica), in literature (Ovid, in the fourth book of the *Metamorphoses*, elaborates the mythic narrative in which this son of Hermes and Aphrodite was joined in one body with the nymph Salmacis), and in art, where the opportunities for imaginative representations of this strange creature proved irresistible, predictably enough, to Hellenistic sculptors, with their penchant for the extreme.

The most famous of these sculpted hermaphrodites is a Greek one from about 150 B.C., which survives in Roman copies such as the one to be found in the "Hermaphrodite Room" in the Uffizi. At first glance, the figure seems to be that of a sleeping woman. She lies facedown, and

is quite voluptuous: her breasts, pressed against the couch on which she reclines, are full, as are her hips. Her hair is carefully, fashionably coiffed. On closer inspection, however, it becomes clear that this is no ordinary female. For there, peeking out of the voluminous folds of her gown, is a penis, as modest and perfectly formed as any of the unassuming members familiar from countless classical nudes. Male nudes, that is.

To this catalogue we may now add another Greek, Calliope Stephanides, the heroine—and later the hero ("Cal")—of Jeffrey Eugenides' second novel, which is slyly entitled *Middlesex*. The title ostensibly refers to the name of the street in Grosse Pointe, Michigan (a state that is itself a "middle"), where much of the novel is set; but of course, it's really about another kind of middle altogether. For adorable little Callie turns out, by the novel's end, to be a boy—one who suffers from a rare genetic disorder that causes a type of male pseudohermaphroditism. Although chromosomally male (she has both an X and a Y), she has no real penis, but instead a kind of extended clitoris which she will refer to as "the crocus"; she has testes, but they remain undescended. As a result of this she is misidentified at birth as being a girl and is raised as a girl by her amusingly neurotic, upper-middle-class Greek-American parents. Until puberty, that is, when her male hormones kick in and it becomes increasingly evident that she is no ordinary female. (For one thing, she doesn't menstruate, although she tries mightily to fake it: "I did cramps the way Meryl Streep does accents.") It is only after a road accident lands her in an emergency room that Callie and her bewildered family realize how extraordinary she really is. *Middlesex*, then, is a *Bildungsroman* with a rather big twist: the *Bildung* it describes turns out to be the wrong one—a false start.

From Ovid to Gore Vidal, hermaphroditism and bisexuality have provided writers with irresistible occasions to comment on both Nature and Culture. Eugenides—whose small, nearly perfect first novel, *The Virgin Suicides*, reflected a Greek tragic sensibility, with its chorus-like first-person-plural narration and its self-immolating young heroines, like something out of Euripides—is well aware of the opportunities his choice of subject has afforded. (In the new novel, the author's allusions to the—his—Greek literary heritage tend to be on the jokey side, consisting of mock-epic invocations of the Muses: "Sing, Muse, of Greek

ladies and their battle against unsightly hair!" and so on.) The tension between who Callie is raised to be and who Cal ends up being, between his early life as a girl and his subsequent life as a man, is clearly an occasion for musing upon all kinds of bimorphisms and dualities. Among these are: the ironies of being a "hyphenated" American of recent vintage ("In America, England is where you go to wash yourself of ethnicity": so observes a sardonic Callie, the big-nosed, dark-haired child of first-generation Greek-Americans, who ends up attending a Waspy private girls' school); the horrors of racial conflict (a major set piece of the novel takes place during the 1967 Detroit race riots); and, indeed, the entire global geopolitical picture. Reminiscing about his family's reaction to the 1974 Cyprus crisis, the adult Cal, who ends up a career diplomat stationed in Berlin, remarks knowingly that now Cyprus was "like Berlin, like Korea, like all the other places in the world that were no longer one thing or the other." Elsewhere, he ruefully observes that both he and the once-torn city are seeking "unification . . . *Einheit*."

And yet *Einheit* is what *Middlesex* itself ultimately lacks. Eugenides' novel seems itself to be composed of two distinct and occasionally warring halves. One part has to do with hermaphrodites—with Callie's condition, and how she comes to discover what she "really" is. The other, far more successful part has to do with Greeks—and, in a way, Greekness. Far more colorful than the story of what Callie is, is the story of how she came to be that way—the story of why this child came to inherit the exceedingly rare and fateful gene that ends up defining her indefinable life. This story, the real heart of the novel, is an old-fashioned family saga—as full of incest, violence, and terrible family secrets that make themselves felt from one generation to the next as anything you find in Sophocles, a junior high school performance of whose *Antigone* plays, indeed, a crucial role in the plot. Needless to say, Callie gets cast as Teiresias.

Everything in *Middlesex* that has to do with the (to say the least) eccentric Stephanides clan is lively and original, fulfilling the promise of *The Virgin Suicides* nearly a decade ago. It's a measure of Eugenides' self-confidence that he spills the novel's most sensational secret—that Callie's paternal grandparents, Desdemona and Eleutherios ("Lefty")

Stephanides, are actually brother and sister—early on. To his credit, if the incest theme holds your attention, it's not so much because it's the key to Callie's genetic inheritance as because of the unusually understated way that the author handles it. The opening pages of Eugenides' book, with its description of the young Desdemona's and Lefty's claustrophobic lives in a tiny Anatolian village near Smyrna in the early 1920s, are so tenderly rendered as to make this strange love seem natural. Orphaned during the Greco-Ottoman violence that culminated in the 1922 Turkish massacre of the Greeks of Smyrna, the voluptuous, fiercely proper Desdemona and her jaunty younger brother (who uncomprehendingly warbles American pop tunes as he gets dressed in the morning) are left alone to tend the family's silk farm on the slopes of a mountain overlooking Bursa, the ancient Ottoman capital. With considerable delicacy and not a little humor—Cal's narrative voice is rather jaunty throughout—Eugenides explores the ferocity that can characterize the feelings that siblings living in isolated places have for each other. ("Lefty was one year younger than Desdemona and she often wondered how she'd survived those first twelve months without him.")

Here as elsewhere in the novel—and here more successfully than elsewhere—Eugenides weaves one family's story into that of a whole nation. As the brother and sister try to resist the storm of passion that has seized them, the storm clouds of war gather around them. Their efforts at resisting each other are, occasionally, comic: an increasingly desperate Desdemona futilely gives beauty tips to the only other marriageable girls in the village, hoping they'll look more attractive to a disdainful Lefty, who spends his time in the brothels of Bursa, choosing girls who have his sister's dark braids and full figure. But incest turns out to be the least of their worries. In these vivid opening pages the author recalls, not without a wry bitterness that is almost a genetic inheritance of many younger descendants of certain Greek immigrants, the Greek government's ill-fated plan to reclaim its ancient Anatolian territories—the scheme known as the *Megali Idea*, the "Big Idea." That scheme notoriously ended in disaster for the Hellenes: it helped the triumphant rise of Ataturk and, in 1922, culminated in the Turkish army's burning of Smyrna and the murder of over one hundred thousand of that city's Greek inhabitants—an event that provides this first of the novel's four main sections with its unforgettable and brilliantly narrated set piece.

The carnage of the Smyrna cataclysm is, moreover, skillfully woven into the Stephanides saga: for it becomes a cover for the two orphaned siblings to consummate their long-burning lust for each other, and to emigrate as man and wife.

Many of the pleasures to be had from Eugenides' book are the pleasures to be had from any good immigrant family novel. For the first two hundred of Eugenides' five-hundred-plus pages, you're so absorbed in the saga of the Stephanideses' attempt to establish themselves in their new country that you're tempted to forget that this is all, in its way, preamble—an elaborate explication of how Callie came to inherit her special gene. These richly emotional—and, often, richly comic—pages move, in classic European immigrant–literature fashion, both geographically westward and economically upward. Interwoven with sardonic, fashionably postmodern commentary by the grown-up Cal, the plot follows Lefty and Desdemona from their arrival at Ellis Island ("A least it's a woman," Desdemona says, warily eyeing the Statue of Liberty. "Maybe here people won't be killing each other every single day"), to their journey west to Detroit. There, their first cousin Sourmalina, a thoroughly Americanized young woman with some secrets of her own—she was kicked out of the village after being found in a compromising position with a married woman—awaits them. She is the only person to whom they ever confess their terrible secret, using her own past as leverage.

Eugenides' sprawling narrative continues on from the birth of Desdemona and Lefty's son, Miltiades (Milt), who will become Callie's father, through the Depression (Lefty's brief career as a gangster ends when Prohibition ends and he becomes a popular barkeep). It gradually shifts focus to Milt and his youth and young adulthood during the Second World War, lingering on his fanciful courtship of Sourmalina's daughter Tessie, whom he eventually marries (he charms her with his clarinet-playing, and then with his clarinet itself, which he places against various parts of her body as he plays); then it shifts from the loss of Milt's first business during the 1967 Detroit race riots to his founding—partly by means of an insurance settlement after the riots—of a successful restaurant chain that brings him thoroughly American success while

invoking his ethnic past. (The chain is called "Hercules Hot Dogs.")
And so the story goes on, shifting finally to Callie herself, as she grows
up and, during yet another Turkish invasion—the 1974 Cyprus crisis—
discovers the mystery of her own identity. (Not all of the author's at-
tempts to pin family history to national history work: two long sections
about the Stephanides family's dealings with blacks—and, by exten-
sion, about America's race problems—come off as preachy and rather
nervous. The seven-year-old Callie's observations that the 1967 riots are
"nothing less than a guerrilla uprising. The Second American Revolu-
tion" stretch credulity to the breaking point.)

It's hard not to feel, as you make your way through this often en-
grossing and fluently narrated saga, that the Stephanideses' story is
the story that Eugenides really wants to tell—a story of Greek immi-
grants as only one who has hungrily absorbed such stories from birth
can retell them. This narrative is populated by memorable characters
who have all the hard, unexpected contours of real people: Lefty, struck
dumb by a stroke, meticulously translating Sappho every day, smoking
hashish and listening to *rebetika* albums in his attic room while com-
municating with his family by means of a chalkboard; the ferocious
and self-consciously "self-made" Milt, arguing politics with the Marxist
girlfriend that Callie's older brother brings home from college during
the Sixties ("Well, if giving somebody a job is exploiting them, then I
guess I'm an exploiter"); Uncle Mike, the Orthodox priest who's mar-
ried to Milt's sister but loves Tessie; Tessie herself, anxious and ever
hopeful that her daughter will finally start menstruating. Eugenides
gives these characters authentic voices that rescue them from being
adorable caricatures—always a danger with immigrant stories. Indeed,
perhaps because they are voices the author has heard, these ring true in
a way that Callie's, and Cal's, never does.

This author has a remarkably good ear for the rhythms not only of
immigrant speech, but of immigrant thought. The elderly, bleakly fa-
talistic Desdemona's pleasure in commercials for detergents, with their
"animating scrubbing bubbles and avenging suds," tells you more about
her particular brand of grim Puritanism—the prudishness of a woman
who has lived most of her life burdened with secret guilt—than five
pages of earnest psychologizing could. You have no problem believing
that this is a woman who, when vexed by a family member—as when,

for instance, her son, Milt, decides that he won't have the infant Callie baptized—starts fanning herself furiously with one of the very special fans that she collects:

> The front of the fan was emblazoned with the words "Turkish Atrocities." Below, in smaller print, were the specifics: the 1955 pogrom in Istanbul in which 15 Greeks were killed, 200 Greek women raped, 4,348 stores looted, 59 Orthodox churches destroyed, and even the graves of the Patriarchs desecrated. Desdemona had six atrocity fans. They were a collector's set. Each year she sent a contribution to the Partriarchate in Constantinople, and a few weeks later a new fan arrived, making claims of genocide. . . . Not appearing on Desdemona's particular fan that day, but denounced nonetheless, was the most recent crime, committed not by the Turks but by her own Greek son, who refused to give his daughter a proper Orthodox baptism.

It is at the baptism—for of course Desdemona eventually gets her way—that Callie, whose abbreviated, penis-like member is so well hidden by the folds of skin around her genitals that Tessie's obstetrician thinks the infant is a girl, urinates on the priest, the stream "ris[ing] in an arc," much to the atheistic Milt's delight. An arc? "In all the commotion," the adult Cal dryly remarks, "no one wondered about the engineering involved."

===

The engineering involved brings us to the other part of *Middlesex*: the hermaphrodite's tale, the material that gives this classic immigrant saga its special, au courant twist. Ironically, this ostensibly more sensational material turns out to be the flatter, less interesting half of Eugenides' hybrid book.

The literary interest of a novel with this subject lies, inevitably, in the author's obligation to create a uniquely doubled, and mixed, voice.

What would a voice that had been both male and female—the voice of Teiresias—really sound like? And yet the author's feel for hermaphrodites isn't nearly as sure as his grasp on Hellencs: throughout *Middlesex*, you feel that he's evading what he should be confronting, both stylistically and intellectually. For one thing, he gets around the problem of having to invent a new kind of voice—even the problem of having to ventriloquize convincingly a young midwestern Greek-American girl—by narrating his hybrid story in the voice of the adult, and decidedly male, Cal. How much more stylish and persuasive this book would have been had he constructed the narrative as something other than a flashback, so that the voice of the girlish Callie could have sounded different—interestingly, meaningfully different—from the voice of the male adult she becomes.

One result of this tonal problem is that Callie always feels like a cipher: surprisingly—given her remarkable predicament—she's not nearly as colorful or interesting as her less problematic relatives. She's a notion rather than a character, someone you're constantly being told about rather than someone whose mind, as in the greatest fiction, you actually get to inhabit. It's not that Eugenides can't persuasively do unusual voices: in *The Virgin Suicides*, he invented a plural narrator to better articulate the inchoate and intense yearning peculiar to adolescence. All the more strange, then, that the lengthy section of the new novel devoted to the event that awakens Callie's sense of being "different"—a fierce crush on a junior high school classmate identified throughout the novel as "the Obscure Object" (a moniker that the author laboriously goes on to explain, giving a plot summary of the Buñuel film)—feels so uninspired and predictable. If so, I suspect it's because Eugenides—which is to say, Cal—isn't quite comfortable in Callie's skin. The "chorus" that made up his first book's collective narrator was so convincing because of the poignant tension between their adult hindsight and the boyish yearning (for the dead girls whom they desired) that was still evident in that collective voice. None of this textured quality emerges in Cal's description of Callie's infatuation with the "O.O.," which is a fairly standard narration of a fairly ordinary adolescent crush. (It's true that efforts have been made to suggest the atmosphere of adolescent girlhood: there's a lot about the feverish social

politics of Callie's all-girl school—the misfits, the "Charm Bracelets," and so on—but unlike virtually everything about *The Virgin Suicides*, this material, like so much of what we learn about Callie, feels studied, learned.)

The failure of this central character to feel authentic hampers the larger effects the novel wants to make. Not the least of these is the emotional impact it's meant to have. Toward the end of *Middlesex*, Callie starts doing some research on some terms she's seen in a doctor's report about her, and (after looking up some words in an encyclopedia) notes, with understandable grief, that one synonym for what she is is "MONSTER." The scene is meant to be moving—climactically moving, even—but it doesn't work because you've never really gotten to know this monster intimately; you know about her what you might have guessed anyway just from having heard what the basic plot is. (The scrim of the narrator's sardonic, postmodern sensibility, fashionable just now among writers in their forties, doesn't help matters.) The scene may put you in mind of another famous monster, but only briefly; Mary Shelley was canny enough to know that in order to sympathize with her creature, you had to get inside its head, let it speak for itself.

If Callie doesn't really persuade, neither does the adult (and male) Cal, who is equally opaque: he has surprisingly little personality, given all he's been through, as if having been both male and female has depleted, rather than enriched, his (as he might say) *Weltanschauung*. You finish the novel without knowing much about him, apart from his penchant for saying sardonic things about Berlin and *Einheit* and for making vaguely postmodern narrative gestures ("which brings me to the final complication in that overplotted year"). Speaking of overplotting: a tenuous subplot, set in the present and concerned with Cal's tentative courtship of an Asian-American artist, feels artificial, constructed solely to give an overarching shape to the novel's four big sections.

The failure of the author to provide an authentic voice and personality for his creature presages much more serious failings—failings not of tone or characterization, but of comprehension of the issues underlying the primary subject matter of the novel itself. It's probably safe to say

that a novel whose main character—whose *narrator*—is someone who's lived as both a female and a male has to justify itself by providing some kind of rare or remarkable insight into sex and gender. Eugenides himself acknowledges as much when he has Callie observe that "latent inside me . . . was the ability to communicate between the genders, to see not with the monovision of one sex but in the stereoscope of both." And yet that special stereoscopic vision is not in evidence here—or rather, the privileged information you get from Callie and Cal never strikes you as being that special. There is, if anything, something cliché about the insights into gender that the author comes up with. Indeed, whatever claims the novel may make to exploring subversively a "middle sex," it everywhere proclaims the unthinking assumptions of a quite conventional male heterosexual. When Callie finds she likes reading the *Iliad*, she wonders whether it's the male hormones "manifesting themselves silently inside me"; so too when she finds herself falling in love with (as she thinks) another girl. Similarly, when she sees through a plan by a couple of boys to get her and the Obscure Object to take a walk to an abandoned cabin in the woods, she wonders whether she does so because she's really a boy herself.

But such characterizations—not least, of all boys as inherently oversexed and violence-loving, traits that Callie, as she becomes a teenager, finds she shares, and that appear meant to justify her feeling that she is "really" a boy—are hardly nuanced; if anything, they're the product of what you could safely call cultural monovision. To declare that "desire [for a girl] made me cross over to the other side"—i.e., to being a boy— seems awfully naive in this day and age, positing a kind of essentialism about sexuality and erotic affect that is equally unsubtle. (Why is it the case that Callie's attraction to girls "means" she's a boy? What if she's just a gay girl?) We may not know much about Callie by the end of this book, but we certainly get a glimpse into how Eugenides thinks. "Breasts have the same effect on me as on anyone with my testosterone level," the adult Cal boasts, a claim that will surely come as a surprise to Eugenides' gay male readers who (it seems safe to say) have as much testosterone as the next fella.

I suspect that Eugenides has fallen back on such unthinking clichés for the same reason that Callie and Cal remain so unformed: in the end,

he hasn't really figured out what might go on inside the head of some-one who's had Callie's experiences. This vacuum at the very center of his book accounts for a general sense of deflation toward the end, when some weighty climactic aperçus start racking up. But do you really read a 529-page novel that sets out to explore the most profound realm of human experience merely to find out, in its closing pages, that "normal-ity wasn't normal" or that "what really mattered in life, what gave it weight, was death"?

And so, in the end, *Middlesex* fails because its author doesn't really believe in the premise to which his title so cleverly alludes—in the rich possibilities afforded by being truly in, and of, the "middle." After the fateful automobile accident that results in the revelation of Callie's special nature (she runs into the street while escaping the embraces of the O.O.'s amorous brother, and is rushed to the ER, where an astute doctor diagnoses her condition), the fourteen-year-old is taken by her confused and incredulous parents to a sex disorders clinic at a New York hospital. Here, she is interviewed by a renowned sex researcher, who slants the results of his research into her case in order to bolster his own view that nurture, rather than nature (i.e., genetics), determines a child's gender.

When Callie sneaks a look at his report, which recommends re-constructive surgery on the (genetically male) teenager's abbreviated organ in order to preserve her female identity, she runs away from the clinic, from New York, and from her—now his—parents, because he's decided that, as he writes in a farewell note to his parents, "I am *not* a girl! I'm a *boy*." (Like his grandparents before him, he deals with his terrible secret by going west: cutting his hair, donning boy's clothes, he hitches his way to—inevitably—San Francisco, where he works as a freak in a sex show for a while before the novel's final, and least plau-sible, bit of overplotting—a frantic car chase involving Milt, a fake kid-napping, and ransom money, the sole purpose of which is to bring the wayward Callie back home for a climactic funeral and reconciliation.) The author may think he's writing about the unique double viewpoint, the stereoscopic sensibility, the sense of special access to two worlds at once, but the novel he's written is, finally, about the far less interesting

search for who Callie "really" is—which is to say, one thing rather than another, instead of both things at once. It pretends to be about being in the middle, only to end up suggesting that you have to choose either end.

The unpersuasive, approximate quality of Eugenides' handling of the hermaphrodite material and the questions it raises, in contrast to the verve and authenticity of its Greek family saga, suggests that, with *Middlesex*, we are indeed in the presence of a strange hybrid; it's just not the one Eugenides was aiming to create. There's no way to prove it, but I have a feeling that *Middlesex* began its life as two novels: a Greek immigrant story, based to whatever extent (one hopes not too great) on the author's family history; and a novel about the alluring subject of bimorphic sexuality (based, perhaps, on the sensational case, much publicized a few years ago, of a Midwestern girl who turned out, like Callie, to be genetically male). At some point, I suspect, the author had, or was given, the intriguing idea of fusing the two. And why not? Like some other recent sprawling novels—Michael Chabon's *The Amazing Adventures of Kavalier and Clay* and Jonathan Franzen's *The Corrections*, to pick two outstanding examples that took the form of personal and family epics that doubled as epics of American life, too—Eugenides' *Middlesex* clearly wants to graft the political onto the personal, the abstract onto the particular, a nation's saga onto a family's.

But the graft didn't take. They may inhabit the same narrative body, but when you think about it, the immigrants and the hermaphrodite inhabiting this book really have nothing to do with one another. There's nothing about Greekness per se that helps you understand this hermaphrodite, and there's nothing about hermaphroditism that helps you understand these particular Greeks. Indeed, the thematic potential that's implicit in the figure of the hermaphrodite—bimorphisms, dual identities, deep divisions within the self—is never fully realized: the author doesn't provide enough about the immigrant dilemma of divided identity to make Callie's condition a cogent metaphor for her family's status, and because the sections in which the Stephanides clan interacts with its black neighbors in Detroit feel merely dutiful, constructed rather than organic, the connections that Eugenides seems to want to make in those scenes—between his hermaphrodite protagonist and, say, America's divided self—don't persuade. The only reason that

this particular hermaphrodite is Greek is that Eugenides happens to have a Greek story to tell as well as a hermaphrodite's story.

And so, in the end, *Middlesex* itself is stranded in the middle, somewhere between either of the two books it might have been. Or, perhaps, it has extremes but no "real" middle, no place where the two parts connect. Like that statue in the Uffizi, it has a surfeit of distinct characteristics that, properly speaking, belong to different realms. Eugenides' ambitious but malformed novel may not end up shedding much light on what it means to be in that middle, but there's no question that it's a bit of a hermaphrodite itself.

—*The New York Review of Books*, November 7, 2002

PART THREE

———

Closets

The Passion of Henry James

For a while, during the Gay Nineties of their respective centuries, the American writer Henry James and the Irish writer Colm Tóibín—whose remarkable new novel is about James—were faced with the same embarrassing problem. It was a problem that touched both their personal and professional lives; to both writers, it seemed to be a problem that fiction alone could solve.

Early in 1895, James had been asked by his friend Mrs. Daniel Sargent Curtis, a great American hostess who lived in a great Venetian palazzo, to write an appreciation of the writer John Addington Symonds, the aesthete, Italophile, and early crusader for the rights of homosexuals, who had died a couple of years before. Mrs. Curtis had appealed to James not out of any awareness (or, at least, any conscious awareness) of his own deeply submerged sexuality, but rather because James and Symonds famously had another passion in common: Italy. (More than a decade earlier, James had sent to Symonds a copy of an essay he'd written about Venice, with a note declaring—the phrasing strikes you now as almost comically suggestive—that "it seemed to me that the victims of a common passion should sometimes exchange a look.") In his reply to Mrs. Curtis, James was careful to distance himself from that other,

unmentionable, passion, what he called Symonds's "strangely morbid and hysterical nature," even as he acknowledged that to write about the dead author without referring to it would be "an affectation; and yet to deal with it either ironically or explicitly would be a Problem—a problem beyond me."

All the more interesting, then, that the subject matter that was an insoluble problem for James the critic and essayist had already proved to be a godsend to James the master of fiction. In his notebook entry for March 26, 1884, James, who was fascinated by gossip about Symonds's unhappy marriage to a prim woman who detested his writings, wrote down the framework of a short story about a similarly unhappy couple: "the narrow, cold, Calvinistic wife, a rigid moralist, and the husband impregnated—even to morbidness—with the spirit of Italy, the love of Beauty, of art, the aesthetic view of life." A few months later, James published the short story "The Author of 'Beltraffio,' " a small masterpiece of delicate luridness in which the conflict between the aesthete (whose book, like Symonds's essay in defense of homosexuality, had provoked a scandal) and his disapproving wife for possession of their small, "extraordinarily beautiful" son ends with the mother allowing the boy to die rather than belong to his father.

Almost exactly a century after James, acting out of a profound discomfort at the possibility of self-exposure, turned down the occasion to write explicitly about homosexuality, the Irish journalist and novelist Colm Tóibín did more or less the same thing, for more or less the same reasons. In the preface to the British edition of his 2001 collection of essays about gay writers and artists, *Love in a Dark Time: And Other Explorations of Gay Lives and Literature,* Tóibín describes how he recoiled after being invited in 1993 by an editor at *The London Review of Books* to write about his homosexuality. "I told him instantly that I couldn't do that," Tóibín recalls. "My sexuality . . . was something about which part of me remained uneasy, timid and melancholy. . . . I told him I couldn't do it. I had nothing polemical and personal, or even long and serious to say on the subject." Not to be discouraged, the editor simply resorted to another method of—the language is suggestive—"enticing" Tóibín: he started sending him books by or about gay writers, some of which Tóibín found "too interesting to resist." Because of his own timidity and melancholy, he goes on to say, the figures to whom he was

attracted were not contemporary authors like Edmund White and Jeanette Winterson, "whose novels had done so much to clear the air and make things easier for gay people," but rather "other figures from an earlier time, whose legacy was ambiguous, who had suffered for their homosexuality."

And yet the writer from an earlier time whose legacy is, famously, perhaps the most ambiguous of all with respect to the vexed issue of secret sexuality, of how "silence and fear" can affect an artist's life and work, is the one artist whom Tóibín chose not to include in his collection. This is not to say that Henry James isn't present in *Love in a Dark Time*: a large part of the introductory chapter is, in fact, devoted to James. But for Tóibín, James stands as the negative example—a figure who, because of his self-repression, not only didn't have a "gay life," but had no life at all. At the end of a discussion of James's great story "The Beast in the Jungle" (1903), which is about a man who spends his life convinced that some "rare and strange, possibly prodigious and terrible" destiny awaits him, only to realize that he's missed what life has had to offer while he's been waiting, Tóibín argues that the story "becomes much darker when you know about James's life. . . . You realize that the catastrophe the story led you to expect was in fact the very life that James chose to live, or was forced to live. . . . In 'The Beast in the Jungle,' James's solitary existence is shown in its most frightening manifestation: a life of pure coldness."

For Tóibín, this coldness, this evasiveness, cripples rather than enhances notoriously ambiguous works like "The Author of 'Beltraffio,' " whose coded implications of unnamed moral dangers he finds frustrating rather than (as with many readers and critics) tantalizing. James, he writes, "left himself with no opportunity to dramatize the scene he imagined since he could not even make it clear." This failure to be clear seems to have frustrated Tóibín when he was preparing *Love in a Dark Time*, and so he didn't include James in the collection itself. For him, it would seem, James as both a man and an artist was something prodigious and terrible—something, in a word, of "a Problem."

It now appears that the problem Tóibín couldn't solve in nonfiction prose is one that he, like James, has labored to resolve in a work of fiction: *The Master*. (The title refers to the nickname that the rather overpoweringly impressive and oracular James acquired from a reverential

younger generation; it should be said at the outset that Tóibín's novel, with its crisp, almost tactile scene-setting, is anything but overpowering or heavy in the way many people think James's work is.) As with James in "Beltraffio" and, indeed, "The Beast in the Jungle," Tóibín in *The Master* has grafted a novelist's imaginative sympathy and human insight onto the armature of real-life events. As with James, the result is both aesthetically and psychologically potent—and weakened only, perhaps, by certain limitations that tell us more about the author than they do about his ostensible subject, which in this case is, in fact, the "pure coldness" that for Tóibín was James's life.

Whatever Tóibín's literary-critical and ideological interest in James, *The Master* is unquestionably the work of a first-rate novelist—one who has for the past decade been writing excellent novels about people cut off from their feelings, or families, or both. Of these, *The Blackwater Lightship*—a finalist for the Booker Prize that was made into a film for television early in 2004—is the best known, although *The Heather Blazing* (1992), whose protagonist is an emotionally remote Irish judge, has, until now, best expressed Tóibín's preoccupation with the theme of tragic lack of self-awareness.

Like some of the earlier novels, *The Master* seeks to build its portrait of an emotionally hobbled person by moving back and forth between a crisis in the character's present to illuminating episodes from his past. In the new novel, the present consists of the "treacherous years" in England (so described by Leon Edel, James's greatest biographer): which is to say, from January 1895, the month when *Guy Domville*, the historical drama in which James had placed his hopes for commercial success, resoundingly flopped, to October 1899, when James's competitive older brother, the philosopher William James, came with his family for an extended visit that is meant to provide a final, poignant illumination of the "coldness" at the heart of James's writing. In each of the novel's eleven chapters, some incident triggers a memory in Henry (as Tóibín refers to James throughout); this oscillation between past and present allows the author to paint a detailed portrait not only of the claustrophobic anxiety of the late 1890s (not least the paranoia engendered by the trial of Oscar Wilde) but also the whole of James's life, from his supremely

privileged Yankee childhood to his Atlantic-hopping young manhood right up until his late middle age, a period of crisis that turned out to be the threshold of his richest, densest work: *The Ambassadors*, *The Wings of the Dove*, *The Golden Bowl*.

Tóibín, of course, has more on his mind than just painting a novelistic portrait of Henry James. What he seeks to illuminate is the opacity, the failure of passion, that he sees at the core of James's work, as well as of his life. In each chapter, the present-day incidents and the memories they evoke are linked ingeniously to the genesis of Henry's art. There is, for instance, a scene that takes place early on in *The Master* in which Henry listens attentively to a remark made by the archbishop of Canterbury's son, about a pair of children he'd once heard of, abandoned on an old estate; this was, in fact, the real-life genesis of *The Turn of the Screw*. Tóibín faithfully re-creates this scene, but also makes it the stimulus to a flashback about Henry's early life, his invalid sister Alice, and their childhood seesawing between Europe and America. For Tóibín, this was the beginning of James's "coldness" as well as of Alice's hysterical hypochondria. "Both of them," Tóibín's Henry muses, "had somehow been abandoned as their family toured Europe and returned, often for no reason, to America. They had never been fully included in the passion of events and places, becoming watchers and nonparticipants." And yet even as Henry realizes he failed Alice, now dead, he starts to toy with the idea of how she might become part of the story he has begun thinking about: "Now, as he began to imagine a little girl, it was his sister's unquiet ghost which came to him."

Similarly, a visit from Henry's boyhood acquaintance Oliver Wendell Holmes Jr. leads to recollections of his cousin, the pretty and spirited Minny Temple, whose early death traumatized not only James but many other young men of his circle, including Holmes and the Harvard jurist John Gray. By the 1890s, James had already reincarnated Minny as Isabel Archer in *The Portrait of a Lady*, and a decade later would summon her once again from the dead, even more powerfully, as Milly Theale in *The Wings of the Dove*. A post–Civil War idyll in the countryside, peopled by Minny and Henry and the other youths, is beautifully evoked by Tóibín in the course of a long and richly detailed section of the book that captures the lost Minny—surely one of the most important if unwitting muses of nineteenth-century fiction—far

better than any biographer has been able to do. Here again, we see the process by which sentimental memory is alchemized into art in James's ever-churning mind:

> During the time since Holmes's visit and in the midst of all his worry and suffering, his interest in the picture of a young American woman slowly dying, which he had noted down, had intensified. It was the story of a young woman with a large fortune on the threshold of a life that seemed boundless in its possibilities.

And so *The Master* proceeds, wending its delicate way between the middle and end of the nineteenth century, offering rich, darting, almost impressionistic glimpses of the moments of James's life that made him "the Master." The most extended, and most tragic, of these shimmering episodes is, inevitably, the flashback to James's friendship with the novelist Constance Fenimore Woolson. A grandniece of James Fenimore Cooper and a woman of great intelligence and uncommon independence of mind and habit, Woolson was in many ways James's most intimate friend; her suicide in 1894, in Venice, could well have been the result of his inability to respond to her desire for a greater intimacy. (She killed herself during a particularly bleak Venice winter after it became clear that James wasn't going to be joining her there, as he had indicated he might.) As Colm Tóibín's Henry James faces the twentieth century, it is clear that he must come to terms with the losses, and failures, of the nineteenth; the author's evocation of an artist confronting his inadequacies as a man is, for much of the novel, delicate, complex, and moving.

The Master is not, of course, a novel about just any man, but rather a novel about a figure from the past about whom we know an extraordinarily great deal, through both his own and others' memoirs, books, and letters. As Tóibín well knows, ventriloquizing the past is a dangerous affair for a novelist who wants to be taken seriously: just to remind you, he has an indignant Henry tell his supercilious and critical brother (who has suggested he write a novel about the Puritans) that he views "the historical novel as tainted by a fatal cheapness." Tóibín himself gets around this pitfall in two ways. First, he avoids the obvious trap of trying to make his Henry James sound Jamesian: to try to "do" James would inevitably end up sounding comical. (See, for instance, Gore

Vidal's hilarious send-up of James in one of his own historical novels, *Empire*.) From this novel's haunted and haunting first line—"Sometimes in the night he dreamed about the dead"—*The Master* is wholly of the present, and stylistically belongs to Tóibín alone, who achieves a new level of terse economy here both in his descriptive passages and, particularly, in the dialogue. Everything you need to know about the real Henry James's disdain for Oscar Wilde (whom, predictably, he detested: a "fatuous cad," he told Henry Adams's wife, Clover) is summed up in a laconic remark about Wilde's mother, who was said to be jubilant about his trial, that Tóibín puts in the mouth of his fictional Henry James: "It is difficult to imagine him having a mother."

The "fatal cheapness" of many historical novels lies in the way they show off their own hard-won verisimilitude, as overrich detail congests the narrative. Of meticulous detail *The Master* lacks none: nearly every page bears witness to a prodigious amount of research, from passing references to the appearance of James's room in Mrs. Curtis's palazzo, with its "pompous painted ceiling and walls of ancient pale green damask slightly shredded and patched"—almost a verbatim quotation of James, as it happens—to the way Henry complains to himself, after the failure of *Guy Domville*, that he'd failed to "take the measure of the great flat foot of the public"—another verbatim quotation. And yet while this dazzling embedding of bona fide Jamesian nuggets throughout his narrative will delight James scholars, they never obtrude into the smooth and elegant flow of the novel's movement. (Tóibín's major departure from the known facts is temporal: a number of events that occurred after 1900 are shepherded into the preceding decade.)

The deft wielding of the facts by (as it were) Tóibín the journalist and critic would be mere window dressing without the acute psychological perceptiveness that informs the author's portrait of his subject. This intelligent sense of the bigger picture enables Tóibín to come up with sensible solutions to some famous conundrums in James scholarship. I am not as persuaded as Tóibín was by the assertion, in Sheldon M. Novick's 1996 biography, *Henry James: The Young Master,* that the young James had a homosexual affair with Oliver Wendell Holmes Jr. when Holmes returned from the Civil War—a scenario supported in Novick's book by a reading of the existing documentary evidence that has the same relationship to rigorous scholarship that Monet's

water lilies do to high-resolution digital photographs. (Much hangs on a Freudian reading of an allusion by James to an "obelisk" that occurs in proximity to a description of the Holmes residence.)

Tóibín, however, finds the story "oddly convincing"—and indeed makes it much more convincing in his novel, where it provides a scene of almost unbearable tension between the two young men, the one blandly curious, the other immobile with a desire he is too terrified to act on. (Or perhaps not: it seems appropriately Jamesian to be confronted by a scene that you can read again and again without being able to determine just what, if anything, has happened.) What's important is the way Tóibín the novelist uses such scenes to suggest the sources of James's distinctive creative vision—to show why he is the father of the psychological novel: "He wondered at how, every day, as they moved around each other, each of them had stored away an entirely private world to which they could return at the sound of a name, or for no reason at all."

The Master will inevitably be compared to another recent novel about a great writer: *The Hours*, by Michael Cunningham, which was, at least in part, about Virginia Woolf as she set out to write *Mrs. Dalloway*. But Tóibín's book is concerned less with the creation of a single work than with something at once much bigger and much more elusive: the nature of an entire artistic consciousness (and a very great consciousness at that). Here is where *The Master* is both most suggestive and most problematic.

For as you make your way through *The Master*, with its impression-istic ambling between past and present, a distinctive and perhaps too repetitive pattern begins to emerge. Each memory that is triggered or captured may lead to the creation of a work of literature by Henry the artist, but each memory tends also to lead you by the hand to a scene of moral failure on the part of Henry the man. There's a passage early on in which the young Henry, working up one of his first short sto-ries, uses an incident from his home life and finds himself enthralled by the "feeling of power" that a "raid on his own memories" can produce when they are transformed into art; what we are clearly intended to understand as a kind of artistic parasitism (and a corresponding aver-sion to "real" living) is increasingly held up to ruthless scrutiny—and judgment—by both the author of *The Master* and its characters. One

friend suggests quite blatantly that Henry's shrinking from Constance Woolson's needy affection drove her to self-destruction; Henry's use of the Symondses' marriage as fodder for "'The Author of 'Beltraffio' " shocks another friend, the writer Edmund Gosse. ("He insisted that writing a story using factual material and real people was dishonest and strange and somehow underhand.") And Holmes flatly accuses Henry of responsibility for the death of Minny Temple, who'd hinted to James that she'd have loved to join him for a healthful vacation abroad; he didn't respond. By the end, remembering Minny, Tóibín's Henry shocks even himself. "He felt a sharp and unbearable idea staring at him, like something alive and fierce and predatory in the air, whispering to him that he had preferred her dead rather than alive, that he had known what to do with her once life was taken from her, but he had denied her when she asked him gently for help."

This emphasis on James's alleged responsibility for Minny's death is, as it happens, one of Tóibín's rare departures from the documentary record about James's life: although he cites part of a letter that the real-life Minny wrote to James ("Think, my dear, of the pleasure we would have together in Rome"), he doesn't cite the postscript she added, in which it's clear she knows her fantasy of traveling with him in Europe was just that: "I am really not strong enough to go abroad with even the kindest of friends." Tóibín can't acknowledge that James may have been "the kindest of friends," because it interferes with his larger vision of James the cold fish, the artistic vampire living off the lifeblood of his innocent and truly suffering victims. *The Master* is, of course, a novel, and Tóibín isn't bound by the facts; but the way that he's loaded the dice against James here suggests what is, to my mind, a larger failure of sympathy.

This is strange, because sympathy is something Tóibín the critic, the chronicler of gay lives, has thought a great deal about. "The gay past is not pure," he writes in *Love in a Dark Time*, referring to the way in which the homosexuals of an earlier generation were forced to lead double, lying lives. "It is duplicitous and slippery, and it requires a great deal of sympathy and understanding." But *The Master*, Tóibín's fifth novel, made me wonder whether he fully understands only a certain kind of suffering, and has only a certain kind of sympathy. For Oscar Wilde, with his extravagant public sufferings and real physical abasement, for the scholar F. O. Matthiessen, with his tortured closetedness

and eventual suicide, Tóibín—who has acknowledged what he feels is the "abiding fascination of sadness . . . and, indeed, tragedy"—clearly has great sympathy in his essays. And it is for this nineteenth-century, operatic suffering that he has sympathy in the new novel, too: Minny and Constance and Alice James, with their Pucciniesque anguishes, their illnesses, premature death and suicide.

But it may be that Tóibín's very nature, his own fascination with high tragedy and his admirably fierce moral objection to the kind of se-cretiveness and closetedness that once ravaged him, as it did so many of us, makes him unable to get to the deep opaque heart of Henry James—the elusive and frustrating thing that got him going about James in the first place. For it's possible that James just didn't suffer in the way Tóibín understands suffering. From everything we know, he was indeed quite a happy person (by his own standards, rather than ours) for most of his life—productive, sociable, well loved, and remarkably kind. And, of course, a very great artist for whom art was the highest satisfaction. Yet Tóibín never explores what it might feel like to be satisfied by art alone (in the way that most of us want to be satisfied by love and sex); he just keeps showing you the damage that art causes without really suggest-ing what its compensatory value might be—for James or, indeed, for us. There is an early story of James's in which a young American asks him-self whether "it is better to cultivate an art than to cultivate a passion"; for James in real life, at least, it seems clear what the answer was—just as it seems clear what Tóibín thinks, too. The last page of *The Master* provides one final memory, one final illumination of why James was "cold," why for him there was a kind of emotion in art that nothing in "life" could match. A closing image of the lone artist, anxiously culling moments from life to be preserved in art, is meant, I suspect, to come off as melancholy, if not tragic.

But what if James wasn't tragic? That a life without passion as most of us understand it could still be a fulfilled life is one paradox that Tóibín's artful, moving, and very beautiful novel doesn't seem to have consid-ered; and so he doesn't dramatize it because it isn't clear to him. What we get in *The Master* is, instead, the intricate and wrenching drama of James's "victims." In the end, the Master himself remains, ultimately, unknowable—a problem that perhaps no artist could ever solve.

—*The New York Times Book Review*, June 20, 2004

The Two Oscar Wildes

At the climax of Oscar Wilde's comic masterpiece, *The Importance of Being Earnest*, we learn that a baby has been mistaken for a book. Until that improbable revelation, the play—Wilde's wicked exposé of the artificiality of conventional morality, and his one unequivocally great work—is concerned less with procreation than with recreation. *Earnest* follows two fashionable young heroes, Algernon Moncrieff and Jack Worthing, as each leads an elaborate double life, complete with false identities and imaginary friends, that allows him to seek unrespectable pleasures while presenting a respectable face to his local society at home: London for Algy, whose fictional invalid friend, Bunbury, provides frequent excuses to escape to the countryside; Hertfordshire for Jack, whose assumption of a false identity of his own (that of an invented ne'er-do-well brother named "Ernest") allows him to misbehave in town.

Those artificial façades start crumbling when both men fall victim to natural impulses. Jack has fallen in love with Algy's cousin, Gwendolen Fairfax, and Algy becomes besotted with Jack's young ward, Cecily Cardew, during a mischief-making visit to Jack's house in the country. (He arrives pretending to be the made-up black-sheep brother, Ernest—

which is just as well, since Cecily, like Gwendolen, has always yearned to marry a man named Ernest—and Jack, although irritated, can't expose Algy without exposing himself.) Jack's matrimonial aims, however, are seriously impaired by the fact that he has no pedigree. As he sheepishly reveals during an interview with Gwendolen's mother and Algy's aunt, the formidable Lady Bracknell, he was discovered, as an infant, in a large handbag in the cloakroom in Victoria Station, and subsequently adopted by the kindly gentleman who found him, Mr. Worthing.

Just how the baby got into the handbag is revealed in the play's final moments, when it evolves that Miss Prism, the tutor currently employed by Jack to educate Cecily, was once a nursemaid in the employ of Lady Bracknell's sister (Algy's mother)—the same nursemaid who'd gone for a promenade with Algy's elder brother twenty-eight years ago and subsequently disappeared, along with her charge. As the shocked company looks on, Prism describes how, "in a moment of mental abstraction," she had switched the baby she was taking care of and the manuscript of the novel she was writing, placing the former in her handbag, which she deposited in the railway station cloakroom; and the latter in the pram, which she took for a stroll. On realizing that she'd lost the baby, Miss Prism fled London and never returned.

Miss Prism's inability to distinguish between a human being and a work of fiction may have been the result of mental abstraction, but for Oscar Wilde, the conflation of life and art was always deliberate. The result, for us, is that it has never been easy to separate how Wilde led his life—particularly his personal craving for notoriety—from his aesthetic and creative impulse to subvert. As early as the 1870s, before he'd left Oxford for London, the Dublin-born student of both Pater and Ruskin was playing the young *artiste* with a flair for self-promotion that caught the attention of the wide world. The character of Bunthorne in the Gilbert and Sullivan operetta *Patience* was based on him; his postcollegiate debut as a public figure was at the splashy opening of the new Grosvenor Gallery, which the twenty-two-year-old Wilde attended in a coat cut to look like a cello.

Not everyone was seduced by the precocious youth and his attention-getting shenanigans. "What has he done," the actress Helen Modjeska

complained, "this young man, that one meets him everywhere? . . . He has written nothing, he does not sing or paint or act—he does nothing but talk." Nonetheless, Wilde had become sufficiently famous as a proponent of Aestheticism by his mid-twenties that he went on a two-year lecture tour of the United States, during which he gave tips to the colonials on how to make life more aesthetic. "The supreme object of life is to live," went Wilde's refrain. "Few people live."

By "living," Wilde in his Aesthete mode meant living beautifully, down to the last detail. Despite its apparent superficiality—or indeed, because of its apparent superficiality—the insistence that every aspect of lived life be exquisite and unconventional was part of a philosophical and artistic project of subversion; the emphases on surfaces, appearances, and style flew in the face of conventional middle-class Victorian sensibility, with its leaden earnestness and saccharine sentimentality. This creed was intended to be a red flag waved in the face of bourgeois society, and was understood as such by those sophisticated enough to see what he was up to. "So much taste will lead to prison," Degas murmured while Wilde visited Paris just before *Earnest* opened early in 1895.

Wilde's life was intended to be a demonstration of his artistic philosophy—was intended, that is to say, to seem like a work of art. The self-consciously dandyish clothes, the flowing locks that he wore provocatively long, the promenades down Piccadilly holding a lily, the unconventional all-white décor in the house at 16 Tite Street, where he eventually lived with his wife, Constance, and their two children, and which, like the famous blue china that adorned his Oxford rooms, was the subject of much comment; the polished epigrams he kept in a notebook at the ready ("you have a phrase for everything," a disapproving Walter Pater scolded him): all these suggested that there was not a little truth in that famous remark to Gide, one that—typically of Wilde, for whom "a truth in art is that whose contradictory is also true"—assumed a distinction between art and life even as it sought to blur that distinction. "I have put my genius into my life," he declared. "I have only put my talent into my works."

The statement was probably true of everything except *Earnest*. Even at Oxford, where he showed extraordinary promise as a Classics student, it was clear that Wilde saw his intellectual gifts as a passport to

celebrity; that he happened to be brilliant enough to earn fame in any number of honorable ways was merely a means to an end. "God knows," the young Magdalen graduate replied, when asked what he wanted to do after university. "I won't be a dried-up Oxford don, anyhow. I'll be a poet, a writer, a dramatist. Somehow or other I'll be famous, and if not famous, I'll be notorious."

He got everything he hoped for. Like many Victorian youths who had a literary bent and a restless nature, Wilde set out to be a poet. His early efforts were not without some success: he won the prestigious Newdigate Prize at Oxford with a poem called "Ravenna." Yet for all their surface dazzle and facility, and despite a patent eagerness to shock with "decadent" material—in "Charmides," a youth makes love to a statue of Athena, who takes predictably humorless revenge— Wilde's verse was always studied, and now seems dated, lacking the epigrammatic crispness and fluency of his prose, which by contrast seems surprisingly modern. (*Punch* dismissed his first volume of poems as "Swinburne and water.") Pater had sensed early on that Wilde's real voice was the sound of speech, not song: "Why do you always write poetry?" he chided Wilde. "Why do you not write prose? Prose is so much more difficult." One reason was that it was as a poet that the young Wilde thought he could garner the most attention; his early career strongly suggests that he loved posing as a littérateur as much as he loved writing itself. "*Pour écrire il me faut du satin jaune,*" he announced. He insisted on writing the draft of his early play *The Duchess of Padua* on fabulously expensive stationery.

It was in prose that Wilde found his real voice, which was clearly that of a critic. The provocative titles of some of the essays—"The Truth of Masks," "The Decay of Lying," "The Critic as Artist"—suggest, *in ovo*, the scope and character of his future artistic and philosophical project, which Wilde's biographer Richard Ellmann succinctly characterized as "conducting, in the most civilized way, an anatomy of his society, and a radical reconsideration of its ethics." The most ambitious prose vehicle for that project was *The Picture of Dorian Gray*, which, for all its haphazard construction, still suggests—with its almost prurient and (whatever his post facto demurs) never quite unadmiring portrait of beauty wholly divorced from morals—why Gide could have thought of Wilde as "the most dangerous product of modern civilization." That

judgment may seem excessive to our modern ears, but in the wake of Dorian—and of Wilde's French-language drama *Salomé*, written at the same time and characterized by the same self-conscious desire to shock by means of decadent sexuality—it would have seemed quite justifiable. "Since Oscar wrote Dorian Gray," Constance Wilde sighed in 1890, when her husband's novel was being denounced as decadent and immoral, "no one will speak to us."

Five years later, people weren't only speaking to Wilde, they were begging for him. By then, it was evident that even *Dorian Gray*, with its famous inversions of substance and reflection, of life and art, hadn't been the ideal vehicle for his gifts; Wilde himself knew perfectly well he wasn't really a novelist. "I am afraid it is rather like my own life—all conversation and no action," he said of *Dorian Gray*. But what is a weakness in a novel can be a strength in a play. Helen Modjeska had been prescient: Wilde was, at bottom, a great Irish talker, and his true métier, as the course of his career would soon demonstrate, was dialogue—real dialogue, rather than the rococo verses he'd put in the mouths of his early characters. It's the voice of Wilde the brilliant talker—amusing, incisive, economical, wicked, feeling, fresh, contemporary, right—that you hear in the plays. (And in the letters, too, which have the same quality of intellectual vivaciousness and delightfulness of expression that his best dialogue has.) It wasn't until he allowed that real-life voice to be heard in his work that Wilde achieved true distinction in art as well as life, however briefly. "Talk itself is a sort of spiritualised action," he declared in May 1887, at a time when he'd begun writing down narratives and dialogues as a kind of training for his mature dramatic work, of which *Earnest*—with its razor-like epigrams and perfect inversions of the natural and the artificial, of life and art, of babies and books—was the most exquisite, and devastating, expression.

———

Typically, the creative breakthrough marked by Wilde's great comedy was deeply entwined with another, personal watershed: his authentic artistic self emerged into view at the same time that his authentic emo-

tional self was being revealed. After being initiated into homosexual sex by the precocious Robbie Ross in 1886—Ross was seventeen, Wilde thirty-one—Wilde became increasingly involved in enacting the Greek love to which he'd always enjoyed alluding, even when he didn't actually practice it. (He'd scandalized his fellow Oxford undergraduates by observing, of a school athlete, that "his left leg is a Greek poem"; but back then he really was all talk.) Wilde's marriage had begun to unravel after his wife's second pregnancy, which left him physically repelled: "I . . . forced myself to touch and kiss her . . . I used to wash my mouth and open the window to cleanse my lips in the open air." By the late Eighties and early Nineties, he was spending his free time first with Ross, and then, after their fateful 1891 meeting, with the pale-skinned, fair-haired Lord Alfred Douglas—"Bosie." And, soon after, with the telegraph boys and rent boys and other lower-class youths of the homosexual demimonde, whose company gave Wilde—the gay among straights, the Irishman among Englishmen—the delicious, gratifying thrill of danger: "like feasting with panthers."

Wilde's consummation of his Hellenic urges, after such a long courtship, put an end to all kinds of unresolved tensions. The art/life dialectic that Wilde made the basis of so many of his on- and offstage pronouncements was just one of many that structured his life and work; temperamentally, he preferred to hesitate between such poles rather than commit to either one. Just as he had hovered endlessly on the verge of conversion to Catholicism as an undergraduate, just as he could never quite choose between Ruskin's moralistic aesthetics and Pater's pagan "gem-like flame," he had vacillated, from his earliest youth, between the classical and the medieval, the Greek and the Gothic. Between, that is to say, the form, the style, the profane "sanity" of his beloved Greeks, on the one hand, and religious feeling combined with Romantic exaltation, on the other. One of the things that "Ravenna" is about, indeed, is the keenly felt tension between the Hellenic and the Gothic. Its narrator wobbles between ecstatic apostrophes of Greece ("O Salamis! O lone Plataean plain!") and invocations of Gaston de Foix and "huge-limbed Theodoric, the Gothic king." "To be Greek one should have no clothes: to be mediaeval one should have no body: to be modern one should have no soul," he wrote. But it was to the Greeks that he eventually returned.

It is tempting to read Wilde's "anatomy of his society"—his "radical reconsideration of its ethics" by means of a playful reordering, even deconstruction, of key terms—as the product of his Greek rather than his Gothic side: Hellenism was the rubric under which his intellectual and emotional passions could, for once, coexist in peace. In an essay he wrote at twenty-five for the Oxford Chancellor's Prize, he entwines style, illicit sexuality, and the classical exaltation of form above all things:

> The new age is the age of style. The same spirit of exclusive attention to form which made Euripides often, like Swinburne, prefer music to meaning and melody to reality, which gave to the later Greek statues that refined effeminacy, that overstrained gracefulness of attitude, was felt in the sphere of history.

Wilde identified the Greek aesthetic as "essentially modern," and inasmuch as he, in his Greek mode, became the first popular modern writer to attempt to divorce aesthetics from morality, he was accurate. The Wilde we love, the Wilde of the epigrammatic wit, the Wilde who so devastatingly skewers puffed-up convention by turning his fictive worlds inside out, is the pagan, the Greek Wilde. The forms with which we identify him today—epigram, satire, the conventionalized situational comedy—are classical forms. The Romantic Wilde, the deeply nineteenth-century Wilde, the Wilde of the cloying sonnets and the highly perfumed blank verse of early plays like *Véra, or The Nihilists* and *The Duchess of Padua*, we tend to ignore. It was—significantly—only after his disgrace, in the bitter, belated paroxysm that was eventually published as *De Profundis*, that Wilde (who'd once remarked that the chief argument against Christianity was the style of Saint Paul) championed spirituality in its traditional "medieval" forms, emphatically rejecting his erstwhile allegiance to classical style, to

> the dreary classical Renaissance that gave us Petrarch, and Raphael's frescoes, and Palladian architecture, and formal French tragedy, and St. Paul's Cathedral, and Pope's poetry, and everything that is made from without and by dead rules, and does not spring from within through some spirit informing it.

Indeed, even in the Wilde that we do treasure, particularly the three English-language plays that precede Earnest—*Lady Windermere's Fan* (1892), *A Woman of No Importance* (1893), and *An Ideal Husband* (1895)—it's clear that the author belonged as much to the dying century as he did to the one that lay ahead. The spirit of these works, which seek to subvert stuffy conventions, may look forward to the twentieth century, but the plays themselves are, essentially, clanking nineteenth-century melo- dramas, with their illegitimate births suddenly revealed, their plots that hinge on stolen jewels and letters, their eleventh-hour revelations. Even Wilde's contemporaries were able to see this. After attending a 1907 revival of *A Woman of No Importance*, Lytton Strachey described the play to Duncan Grant as "a complete mass of epigrams, with occasional whiffs of grotesque melodrama and driveling sentiment. . . . Epigrams engulf it like the sea." In almost every dramatic work but *Earnest*, we feel the two Wildes—the sentimental, "Gothic" Wilde, and the crisp, classical Wilde—at war. It was only in *Earnest*, with its architectural symmetries, its self-consciously toy-like, artificial characters, its bejew- eled style, that he achieved the ideal "Greek" harmony in which form and content were entirely at one.

Still, if *Earnest* is a perfect vehicle for the expression of Wilde's intel- lectual and aesthetic concerns, it can also be read as an allegory for the writer's life—one that was torn between a hunger for acceptance and a flair for subversion. (*"Le bourgeois malgré lui"* was Whistler's canny description of his onetime friend.) Like the drama of his life, much of the drama that Wilde wrote was concerned with the tension between the public masks we wear and the messy private impulses that they often hide; with sudden reversals of fortune and last-minute recogni- tions; with true natures—and true identities—ruefully revealed at the last minute. This is particularly true of the two works whose debuts early in 1895 marked the apogee of his professional life and the onset of his personal disintegration: *An Ideal Husband* and *The Importance of Being Earnest*. The former premièred to delirious reviews in January 1895; the latter, on Valentine's Day of the same year. Four days later, the mar- quess of Queensberry, Bosie's father, left his famously misspelled call-

ing card, which referred to Wilde as a "somdomite"; two months later, Wilde had been condemned for "gross indecencies."

Unsurprisingly, both plays use the same structural devices (switched identities, long-buried secrets) and both treat identical themes (the catastrophic tensions between public and private selves), and yet they are radically different in tone, temperament, and style. *An Ideal Husband* seems, indeed, to belong to the nineteenth century, and looks backward to what we may call the "Gothic" Wilde. Its interest lies, if anywhere, in its imperfections: the famous epigrams ("To love oneself is the beginning of a life-long romance") sparkle brightly, but are at odds with the melodramatic structure and patent sentimentality—and with overwrought passages in which the playwright seems to be using his characters as mouthpieces for personal concerns. When the play's tortured main character, a man revealed to have a terrible secret in his past, addresses a series of lengthy, impassioned, and nakedly illogical pleas for sympathy to his wife—a woman whom he goes on to chastise for having insufficient sympathy for his flaws—it is impossible not to think of Wilde himself.

Earnest, on the other hand, has the high aesthetic elegance and irrefutable mechanical efficiency of a theorem: in this case, a theorem about art and society. Here, significantly, all emotion, all feeling—all real "life"—have been purposefully pared away. With its nihilistic inversions of surface and content, attitude and meaning, triviality and seriousness, the play flashes and gleams dangerously like the scalpel it was meant to be, the instrument with which Wilde dissected Victorian ethics, thereby making twentieth-century aesthetics—an aesthetics divorced from false sentiment—possible.

The story of the paradoxical process by which Wilde evolved from a poseur who put life before art into a real artist, from the composer of florid poems on ostentatiously lofty themes into the author of comedies whose flippancy concealed a serious intellectual and critical purpose, is a fascinating one. So it is a great irony that Wilde's life story has come to overshadow his work in a way that has blunted our understanding of just what it is that made him an interesting artist. Today we think of Wilde as an icon of martyrdom in the cause of sexual freedom; and yet our seeming familiarity with him—our sometimes too-hasty sense

that we know what he's about, which happens to be something we're interested in today—has dulled our appreciation of his creations. This is nowhere more apparent than in the recent film version of *The Importance of Being Earnest*. It was directed by the Englishman Oliver Parker, who also directed the 1999 film version of *An Ideal Husband*; in both films, a knowing familiarity with Wilde the icon has all too frequently transformed his artistic creations into the opposites of what they were intended to be.

To get *The Importance of Being Earnest* right—to convey the danger, as well as the delight, inherent in those artfully constructed double lives; danger and delight that Wilde himself knew so well, and which ultimately destroyed him—you need to maintain its artificiality, the self-conscious conventionality of form that the playwright uses to highlight his ideas about the artificiality of social and moral conventions. In Anthony Asquith's flawless 1952 film version of the play, the director emphasizes the theatrical nature of his material: the movie opens with an image of people being seated at the theater, followed by the appearance of a title card reading, "Act 1. Scene 1. Ernest Worthing's Room in the Albany." The performances themselves—particularly those of the incomparable Joan Greenwood as Gwendolen and Dorothy Tutin as Cecily—are shaped to be as robotic as possible. The young women tinkle their slyly nonsensical lines ("Mamma, whose views on education are remarkably strict, has brought me up to be extremely short-sighted") like the windup toys they are.

In his new film version of *Earnest*, by contrast, Oliver Parker does what many filmmakers do when translating plays onto celluloid, which is to attempt to "open out" the work. This allows him to present many splendid images: of the grotesquely ornate residence in which Lord and Lady Bracknell live; of Jack's impressive country seat, where Algy arrives by means of a hot-air balloon; and of Lady Bracknell's awesome hats, which appear to have decimated more than one aviary. But film's inherent tendency to naturalize what it shows us works, if anything,

against the grain of the play—as does the inevitable tendency of film to translate into images motifs and ideas that are conveyed onstage by means of words. The latter is particularly unfortunate when treating the work of a great talker; the visual temptations of film make nonsense of some of Wilde's sharpest and best-known lines. "I never travel without my diary," Gwendolen famously says with glacial sweetness on meeting Cecily at Jack's country house. "One should always have something sensational to read in the train." Parker's film makes you wonder just when she gets to read that famous document, since in this version she prefers to motor down from London in a clanking automobile which she can barely keep on the road. This makes for visual interest, but destroys the comic point.

It may be that the purpose of showing Gwendolen's perilous drive is to demonstrate her independence of mind. (Parker writes in a scene in which we see her having the name "Ernest" tattooed on her derrière—a vulgar and otiose intrusion.) But, of course, Wilde's Gwendolen has no "mind," or at least not in the sense Parker thinks she does. The most salient aspect of Gwendolen's character is, if anything, her artificiality of mind: it is her and Cecily's inane, lifelong yearning to marry men named "Ernest" that drives the perverse action of the play, forcing both Jack and Algy to maintain their elaborate double lives as Ernests. Indeed, Parker's eagerness to give his characters inner lives often means that his direction is at odds with the directions Wilde provides. Like all of *Earnest*'s females, young Cecily is as tough as nails beneath an elaborate, doll-like politesse; this is part of Wilde's satire of contemporary expectations that high-born girls be hothouse flowers. Jack understands his creator's important point, and goes so far as to articulate it—one of the rare moments in the play when a character says, and means, something that happens to be true: "Cecily is not a silly, romantic girl, I am glad to say. She has got a capital appetite, goes on long walks, and pays no attention at all to her lessons." Parker, however, has ideas of his own. His Cecily is the opposite of Wilde's—a dreamy young thing who, during long, beautifully photographed fantasy sequences, imagines herself as a misty Burne-Jones heroine, decked out in medieval gowns while tied to a tree awaiting rescue by hunky knights. Wilde's point is that contemporary artistic fantasies of young maidenhood run counter to some tough natural truths; Parker's joke is that—well, there is no joke.

Of course, the two young women are merely embryonic versions of the most artfully constructed of all of Wilde's females, Lady Bracknell, that epigram-breathing dragon of self-assurance. Like all great humor characters, she is utterly without a past or future, without motivation or reason of any kind: like the mandarin systems of class and taste and privilege that she represents, she merely, monstrously, is. Parker, however, gives her a sordid past as a lower-class showgirl who (as we see in a flashback) entrapped Lord Bracknell into marriage by getting pregnant—a scenario as unlikely as it is, ultimately, unilluminating. However clever, such details undermine the entire project of Wilde's dramaturgy, which always proposes as being quite "natural" that which is the most artificial of motivations, and vice versa.

Parker's failure to understand the structures and meanings of Wilde's play is clearest in his direction of the final scene—the dénouement in which Miss Prism tells all, and all ends happily. At the end of the play, after it is established that Jack is the long-lost child of Lady Bracknell's sister—and hence is Algy's brother—there is a frantic scrambling to find out what his real given name had been. (Remember, Gwendolen will only marry an "Ernest.") All that Lady Bracknell can recall was that the child was named for its father, the late General Moncrieff, whose first name she can no longer remember. Jack eagerly consults the Army Lists, where he triumphantly discovers thay his dead father's name had, in fact, been Ernest John, and hence that both his real and his assumed names are, indeed, "true": so that Jack has been both Ernest and "earnest" all his life. "It is a terrible thing," he declares at this revelation, "for a man to find out suddenly that all his life he has been speaking nothing but the truth." It is this discovery that prompts his newfound aunt's withering final observation: "My nephew, you seem to be displaying signs of triviality." The disdain she evinces for the discovery of this authentic "Ernest" mirrors Wilde's disdain for all that is "earnest."

Bizarrely, Parker contorts this concluding moment, with its typically Wildean condemnation of earnestness, into its exact opposite. In his cinematic *Earnest*, we see Jack's finger going down the list of entries in the Army Lists and landing on the name "Moncrieff," but the first name here, as we can all too clearly see, is simply "John." Nonethe-

less—in order to win the hand of Gwendolen—Jack announces to everyone that his late father's name was Ernest. Lady Bracknell sees and comprehends the deceit, but still goes on to make her disdainful closing remark about her nephew's "signs of triviality": the result is that in this version, her barb is directed not at Jack's "earnestness," but at his deceitfulness, which she alone has glimpsed. For her to condemn deception rather than sincerity doesn't merely miss the point, it inverts it: Parker's film ends up implicitly endorsing the conventional morality that the play—a drama, let us not forget, by the author of "The Truth of Masks" and "The Decay of Lying"—so hilariously lampooned.

———

The reasons for Parker's failure—the reasons his *Earnest* is cute rather than lethal—are not hard to locate, and may best be understood by comparing two other films having to do with Wilde. Like the two film versions of *Earnest*, one dates from the Fifties and the other is very recent; both are biographies of Wilde himself.

The 1959 Ealing Studios picture *Oscar Wilde*, starring Robert Morley as the corpulent Wilde and Ralph Richardson as his forensic nemesis, Sir Edward Carson, dwells on Wilde's tragedy. Nearly a third of this movie—which came out when *Regina v. Wilde* was still a living memory for some people—is devoted to the trials, the almost Greek-tragic climax of which was one small comment made by Wilde during the course of his cross-examination. Asked whether he'd kissed a certain boy, Wilde disdainfully replied that he had not, as the boy in question was "singularly plain." This, we now know, was the turning point of the trial: by suggesting that Wilde would have kissed the boy had he been pretty, it gave Wilde's foes the ground they needed to condemn him. (The organizers of the British Library exhibition "Oscar Wilde, 1854–1900: A Life in Six Acts," which opened late in 2000 and subsequently traveled to the Morgan Library in New York City, also realized this point: the exhibition featured a copy of the official court transcript of Wilde's trial, opened to the page on which this crucial remark appears. Queensberry's calling card was also on display.) And so, in a final, terrible fail-

ure to distinguish between reality and art, Wilde's need to perform, to amuse the spectators, came at the cost of his freedom—and, eventually, his life.

The film ends, as Wilde's life did, ignominiously, with a drunken Wilde drinking absinthe in a French bar, cackling dementedly to himself. If the film focuses on the tragic repercussions of Wilde's actions ("Why did I say that to Carson?" he cries: it's a good question), it does so no more than Wilde did himself. "I thought life was going to be a brilliant comedy," Wilde wrote from prison to Bosie in the immensely long, tortured letter of recrimination (and self-recrimination) that became *De Profundis*. "I found it to be a revolting and repellent tragedy."

Brian Gilbert's 1997 film *Wilde*, by contrast, ends not in defeat but in erotic victory. By the time Gilbert made his film, anyone who remembered the sordid reality of Wilde's humiliation and defeat had died; living memories had been replaced by a political and cultural need to see Wilde purely as a martyr—not as a self-destructive hero-martyr, in the Greek-tragic mold that Wilde would have well understood, but as a wholly passive victim, a role that erases everything about what happened to him that is interesting from a moral and psychological point of view. (You wonder how many people recall that it was Wilde, in a moment of monumental delusion, who sued Queensberry for libel; it was during this prosecution that it was revealed, in a way that the earlier film showed but the more recent one does not, that the marquess's "libel"—"somdomite"—was in fact all too true.)

Gilbert's biopic is intended above all as a celebration of "the love that dare not speak its name"; only a few moments are devoted to the trials—presumably because we all take for granted that Wilde was simply the hapless victim of Victorian sexual hypocrisy. This film ends not with the end of Wilde's life, but with his reunion with Bosie in Italy after his release from prison. As Wilde stands in a sunlit piazza, the beautiful face of Jude Law, who plays Bosie, comes into view, smiling ecstatically. Freeze-frame, then credits. This puerile moment isn't so much misleading as dishonest. In real life, as we know, the grossly mismatched love between what Auden called "the underloved and the overloved" failed miserably to conquer all, and the awful squabbles between Wilde and the dreadful Bosie continued, as did the terrible arguments about money.

You can't understand why Wilde was important, and you certainly can't understand why *Earnest* is great, without recognizing the aspect of danger and tragedy that lurked beneath the glittering surface of his best comic creation—and of his life. Wilde the classicist understood that the flip side of *Earnest*, with its misplaced baby and last-minute recognitions between near relations, was *Oedipus Rex*. The stylistic master of dualities, of truths that were also their own opposites: in order to do justice to Wilde, to both the life and the art, we must always strive to see not only the exaltation but the humiliation, not only the pathos and suffering but the hubris and arrogance, not only the dazzling clarity of vision about the flaws in his society but a penchant for self-deception that suggested a profound self-destructiveness; not only the beauty but the peril. Wilde himself saw it all too clearly, if too late. An intricate appreciation of the complex and often deceptive relationship between things as they really are and things as we wish them to be is, after all, the whole point of his final work for the stage.

The recent film biography's failure to understand what Wilde's life was about is mirrored, in Parker's film of *Earnest*, by a failure to understand what his art was about. Both movies are characterized by a certain familiarity, a certain presumptiveness, about who Wilde was and what he meant. It's significant that Parker's direction constantly underscores the most famous witticisms and inversions of the normal ("her hair has gone quite gold with grief") with intense close-ups—the cinematic equivalent of winking. Parker isn't doing Wilde; he's doing "Wilde." Our own need to see Oscar Wilde as one thing only—as a cartoon martyr, as the poster boy of a modern-day movement—has dulled our vision, and reduced Wilde both as a man and as an artist. In an irony that Wilde himself would have appreciated, we have all become too earnest to do *Earnest*.

—*The New York Review of Books*, October 10, 2002

The Tale of Two Housmans

Tom Stoppard's play about A. E. Housman opens with a perceptive bit of shtick. As the curtain rises, the eminent Cambridge Latinist and author of *A Shropshire Lad* has just died at the age of seventy-seven—the year is 1936—and is waiting to be ferried across the Styx. Charon, the infernal ferryman, is waiting, too: he keeps peering over "Professor Housman's" shoulder, looking for the other passenger he thinks he's supposed to be picking up:

> CHARON: He's late. I hope nothing's happened to him. . . .
> AEH: Are you sure?
> CHARON: A poet and a scholar is what I was told.
> AEH: I think that must be me.
> CHARON: Both of them?
> AEH: I'm afraid so.
> CHARON: It sounded like two different people.
> AEH: I know.

Stoppard wastes no time, then, getting to the heart of the Housman conundrum—the "psychological puzzle," as C. O. Brink, in his 1986

history of English classical scholarship, puts it, that even today makes the poet-scholar someone who can arouse "attention, admiration, fear, irritation, criticism, evasion, or downright detestation" in those who study him. For to all appearances, Housman *was* two different people. To study his life and work—and Stoppard clearly has studied them; his play is filled with knowing citations of Housman's letters and published writings—is to confront again and again the stark divisions, rigid distinctions, and odd, almost schizoid doublings that characterize nearly everything about him.

Housman himself set the tone. Sundering, separation, and halving are motifs in several of his best-known and most striking verses. "I shook his hand and tore my heart in sunder / and went with half my life about my ways," goes one posthumously published poem, presumably about his farewell to Moses Jackson, the hearty, heterosexual Oxford companion for whom he had a disastrously unrequited passion that was the pivotal emotional experience in his life. Demarcation and bifurcation are themes in his scholarly writing as well: hence his lifelong insistence, impossible to take seriously any longer, on divisions between intellect and scholarship, on the one hand, and emotion and literature, on the other. "Meaning is of the intellect, poetry is not," goes one typical aphorism. Occasionally, the poetic and the scholarly came together: "The stars have not dealt me the worst they could do: / My pleasures are plenty, my troubles are two. / But oh, my two troubles they reave me of rest, / The brains in my head and the heart in my breast." "He very much lived in water-tight compartments that were not to communicate with each other," his sister Kate Symons observed after his death. She was referring to Housman's homosexuality, which forced him, as it did many homosexuals of his era, to live a "double life"; but duality is the leitmotif of his entire existence, professional as well as personal.

Who were the "two" Housmans? The "two different people"—a poet, a scholar—for whom Stoppard's clueless Charon waits are particularly apt symbols for the two discordant halves into which Housman's personality seemed, even to his contemporaries, to fall. (The title of W. H. Auden's review of *A.E.H.*, a 1937 memoir of Housman written by his brother Laurence, who was a popular and prolific poet and playwright in his own right—his *Victoria Regina*, starring Helen Hayes, was a huge Broadway hit—was "Jehovah Housman and Satan Housman.") There

was the heavenly poet of *A Shropshire Lad*, first published in 1896, the elegy on dead or soon-to-be-dead youth which was so loved in its time that its author was, in George Orwell's words, "the writer who had the deepest hold upon the thinking young" in the years immediately before and after World War I; and yet there was also the devilishly forbidding classics scholar who, in the damning words of a contemptuous 1939 sonnet by Auden, "Deliberately . . . chose the dry-as-dust":

> *In savage footnotes on unjust editions*
> *He timidly attacked the life he led*
> *And put the money of his feeling on*
> *The uncritical relations of the dead.*

Auden knew his classics, and the "dry-as-dust" criticism wasn't a casual bit of Philistinism: Housman devoted thirty years of his professional life to producing a five-volume critical edition of an obscure verse treatise on astronomy and astrology called the *Astronomica*, by the minor first-century A.D. poet Marcus Manilius.

And there were also the tender Housman, whose sympathy for the doomed young men he wrote verse about—the soldiers marching off to die in wars not of their making, the forlorn, possibly homosexual suicides, the prematurely dead village athletes, the petty criminals about to be hanged—was apparently limitless; and the vindictive Housman, whom the ineptitude of other scholars could rouse to bursts of famously annihilating—and, it must be said, quite funny—contempt. One eighteenth-century edition of Manilius, Housman dryly wrote, "saw the light in 1767 at Strasburg, a city still famous for its geese." (Luckily, the editor responsible for the offending Strasburg edition was long dead: Housman went on to write that his "mind, though that is no name to call it by, was one which turned as unswervingly to the false, the meaningless, the unmetrical, and the ungrammatical, as the needle to the pole.")

Finally, there was the man whom friends recalled as "an admirable raconteur," the bon vivant who loved good food and wine and (as Housman once slyly hinted to some High Table companions) was perfectly willing to fly to Paris for lunch, the tablemate whose "silvery," "boyish,

infectious" laughter made an impression on all who heard it, the kind and surprisingly sensitive colleague who, as his friend the classicist A. S. F. Gow noted, took pains, in the everyday business of academic life, to "defer to suggestions made by junior colleagues." How little that Housman had in common with the aloof misanthrope recalled by the British-born classicist Bernard Knox! As a Cambridge undergraduate in the Thirties, Knox would occasionally glimpse Housman marching stiffly across the courts of St. John's College in his elastic-sided black boots, his "thousand-yard stare" intended, as was the out-of-the-way location of his rooms, to discourage casual contact.

In his history of English classical scholarship, one-fourth of which is devoted to Housman (a discussion divided, significantly enough, into two chapters: "Life and Poetry" and "Critic and Scholar"), C. O. Brink warns against indulging the seemingly irresistible urge to create one coherent figure out of all these Housmans, which seem to fall so naturally into two groups roughly aligned with "two such apparent incompatibles as pure poetry and pure scholarship." (Those "two different people" again.) "The bearing of the one on the other," he writes, "cannot be direct." But the risks that the cautious academic historian, bound by the available evidence, fears to take are the bread and butter of the artist. It is to writers like Stoppard that we turn to find the answers to "puzzles" like the one seemingly posed by Housman's life.

There are many pleasures to be had from Stoppard's play, which was presented this spring in Philadelphia, in a visually striking staging. Like all of his plays, this one is a clever and articulate work written for a large popular audience. Like his 1993 hit *Arcadia*, the new play seeks, often successfully, to create drama out of technical intellectual material. (The quite emotional climax of one scene in *The Invention of Love* turns on the correct repositioning of a comma in Catullus's poem about the marriage of Achilles' parents.) And yet the playwright hasn't solved the puzzle. Or, to be more precise, he isn't interested in the puzzle. The reason for this is that the real hero of *The Invention of Love* isn't Housman at all, but a contemporary of his who cut a far more dashing figure, someone who was, if anything, the Anti-Housman—in nearly every way, his temperamental, creative, and intellectual opposite; someone who, after being gossiped about, invoked, admired from a distance, and

quoted throughout Stoppard's play, finally appears at its close for a climactic showdown: Oscar Wilde.

=====

Wilde's life certainly *looks* more dramatic. "With Housman," his most recent and most judicious biographer, Norman Page, has written, "the extent of our knowledge of the various aspects of his existence is usually in inverse proportion to their interest or significance." We know, in other words, a tremendous amount about the meals Housman ate, the trips he took, his opinions about publishing matters ("I want the book to be read abroad, and continental scholars are poorer than English," he wrote when urging Grant Richards, his longtime friend and publisher, to keep the sale price of the first Manilius volume low), his opinions about bibliophiles who wrote to him asking for autographs ("an idiotic class . . . the only merits of any edition are correctness and legibility"); and yet little if anything about the kind of emotional dramas that typically make for engrossing theater. In Housman's case there were two such dramas which, perhaps predictably, represent, between them, the heart and the mind: his unrequited love for Moses Jackson, which seems to have affected him profoundly for the rest of his life; and his mysterious, apparently deliberate failure at Oxford, the humiliation of which took him ten dreary years to recover from.

Alfred Edward Housman was born in March 1859 into a respectable if troubled middle-class Worcestershire family. (Shropshire, as he never tired of pointing out, was a place he wasn't very familiar with; the topographical details described in his poem were, he wrote two years before his death, almost always "wrong and imaginary." The place's resonance for him was, if anything, symbolic: "Shropshire was our western horizon, which made me feel romantic about it.") Both of his grandfathers had been clergymen. His father, who had no luck with money, drank, and seemed to have been somewhat unbalanced: Edward Housman would sometimes assemble his children at bedtime and shout his favorite Tory slogans at them. Young Alfred's adored mother, Sarah,

died just before his twelfth birthday, an event that apparently precipitated his abandonment of his grandfathers' High Church religion. "I became a deist at thirteen and an atheist at twenty-one," he wrote to an interviewer in 1933. One of seven children, Housman was particularly close to his sister Kate, to whom he wrote frequently, warmly, and wittily throughout his life; for his brother Laurence, also homosexual, he seemed to have less esteem. Most Housman scholars agree that Alfred's decision to appoint Laurence as his literary executor was based on the cynical belief, eventually borne out, that Laurence would, contrary to his instructions, make public some revealing poems of a personal nature that Housman had never published: a passive-aggressive coming-out if ever there was one.

Housman found refuge from family troubles in reading. Despite an early passion for astronomy, his "affections," he recalled in old age, were already "attached to paganism" by the time he was eight when, as he put it, a copy of Lemprière's classical dictionary fell into his hands. After distinguishing himself in the local village school he went up to St. John's College, Oxford, on a scholarship in the fall of 1877, at the age of eighteen. Oscar Wilde had arrived three years earlier and made a big splash with his blue china décor and his assiduous courting of Pater and Ruskin; by contrast, Housman "lived a quiet student's life," according to a fellow student, "reading hard, and not taking any interest in the general life of the College."

Housman did well enough, but his great passion, already at this early age, was in the unglamorous field known as textual criticism. The printed texts of the Greek and Latin classics which we read today are based on ancient and often erroneous medieval manuscripts that were themselves copied from even older and, likely, error-riddled manuscripts. Only close reading of, and comparison among, various manuscripts of an ancient author allow a scholar to surmise what that ancient author most likely wrote, assuming such a scholar has total mastery of language, grammar, manuscript tradition, lexicography, and the author's style, taste, and diction. This mastery Housman had, at an astonishingly early age. As an undergraduate, he blithely ignored the assigned readings in philosophy and instead was hard at work on a new edition of the Roman love elegist Propertius. This intellectual inclina-

tion went against the grain of the rather romantic mid-Victorian cult, led by Benjamin Jowett, the Master of Balliol, that celebrated classical education as a means of improving moral tone among the ruling classes, and which was dismissive of what Jowett condescendingly referred to as "exact scholarship."

Housman's Oxford experience was marked, characteristically it would seem, by not one but two distinct disasters. The first was emotional. In his first year he met, and struck up a friendship with, Moses Jackson, an athlete and engineering student who was utterly different from him: a contemporary remembered Jackson as being "a perfect Philistine . . . quite unliterary and outspoken in his want of any such interest." However reticent the documentary record may be about the content of the relationship between the two, it seems clear that Housman fell swiftly and deeply in love with Jackson, whom in later life he referred to as "the man who had more influence on my life than anyone else." Even though his feelings were not returned, Housman persisted in his obsessive crush, and he and Jackson (and Jackson's brother Adalbert, who according to Laurence Housman became Housman's lover) lived together in Bayswater for three years, after Housman was sent down in 1881 and subsequently went to work in the Patent Office, doggedly following Jackson, who'd gotten a position there after successfully completing his degree.

The extreme emotional tensions bound to make themselves felt in a ménage like the one in which Housman and his two love objects found themselves aren't hard to imagine, and it broke up in 1885, apparently after some kind of blowup between Housman and Moses Jackson. (Stoppard has the nice conceit of making the proximate cause of the break the news of the passage, in that year, of the infamous Labouchère Amendment to the Criminal Law Amendment Act, which made acts of "gross indecency," even between consenting adult men, punishable by up to two years' hard labor: it was the law under which Wilde would be convicted.) Moses soon left England for India, returning briefly in 1889 to marry, but by that time the relationship was over; Housman heard about the wedding secondhand. Jackson retired in 1911 and moved to Canada, where he died of cancer in 1923. Adalbert Jackson died at twenty-seven, in 1892. Till the end of his life, Housman kept portraits of the two brothers over the mantel in his rooms at Trinity. It is worth

noting that Housman's two bursts of poetic activity—the composition of *A Shropshire Lad* in the mid-1890s, and that of *Last Poems* (1922) in the early 1920s—coincided with crises related to Jackson: in the first case, the awful, awkward separation, in the second, the news that Jackson was seriously ill.

The second disaster was an academic one. For reasons that have never been satisfactorily explained, and about which Housman himself remained silent, he failed his final exams in May 1881. Housman was a scholarship boy from a financially beleaguered family; his failure meant that avenues of possibility that Oxford could have opened for him were (or at any event seemed at the time) forever closed. What is striking is the almost willful manner of his downfall: one of the examiners later reported that he had barely written anything at all in response to the examination questions. Various explanations for the catastrophe have been put forth over the years. A week before he sat for the exams, Housman had received news that his father had suffered a life-threatening breakdown; Housman had contemptuously ignored the set curriculum, heavy as it was with philosophy, in order to work on his edition of Propertius; there was some kind of confrontation with Jackson about the true nature of Housman's feelings for him.

A posthumously published lyric that appears as *More Poems* XXXIV— "For me, one flowery Maytime, / It went so ill that I / Designed to die"—suggests that the real explanation was, in fact, a combination of all three. Indeed, this allegedly great mystery of Housman's life won't seem very mysterious to anyone who has gone to college. It is easy to imagine that Housman, upset by the terrible news from home, was at long last jarred out of the rebellious undergraduate fantasy that he didn't have to prepare the set curriculum; with only days before the exams, he panicked. In his overwrought state, we can further imagine, he sought comfort from Jackson, and in so doing inadvertently betrayed the intensity of his feelings—or, indeed, was made aware of their intensity for the first time. (It may even be that he unconsciously welcomed the crises as a way of finally forcing a confrontation with Jackson.) Hence the disaster, the willed collapse, the "design to die": if not literally then, certainly, symbolically.

The Oxford and Bayswater fiascoes marked the nadir of Housman's life; from that point, it was, more or less, all uphill. Even during the decade between 1881, when he left Oxford, and 1892, when he got his first professorial position at University College, London—a period to which Norman Page refers as "the years of penance"—a typical bifurcation is in evidence. By day, Housman worked at the Patent Office and lived as an ordinary working man, an existence the details of which he described in vivacious letters to his stepmother, Lucy Housman, which display the often outrageous humor that characterized so much of his prose writing (a quality that the "dry-as-dust" school of Housman critics conveniently ignores). "One butcher's man," he wrote to her in 1885 after having served with great glee on a coroner's jury, ". . . cut his throat with a rusty knife and died a week after of erysipelas (moral: use a clean knife on these occasions)."

Nights he spent in the reading room of the British Museum, where he began producing a series of papers on the texts of Horace, Propertius, Ovid, and other classical authors that almost immediately won the admiration of the international scholarly community—the more so because the author had no official academic affiliation. His first published paper, "Horatiana," appeared when he was twenty-three, and reads like the work of a man three times as old. Housman's reputation was sufficiently established ten years after flunking out of Oxford that he won the appointment to the Chair of Latin at University College, London. In 1903 he published the first volume of his magnum opus on Manilius, and by 1911, when he was elected Kennedy Professor of Latin at Cambridge University, his reputation as a scholar who deserved to be ranked with his intellectual idols, Scaliger and Bentley, was secure. He remained at Cambridge until his death. The last of the millions of words he wrote appeared on a postcard to Kate, mailed five days before his death. "Back to Evelyn nursing home today (Saturday). Ugh."

=====

In an onstage conversation that took place in December 1999 at the Wilma Theater in Philadelphia, where *The Invention of Love* had its

American première, Tom Stoppard rightly asserted that "the appeal [of Housman as a dramatic subject] was to write the play about two people who inhabited the same person." There are indeed two Housmans in Stoppard's play, but they're the wrong ones. With the exception of a few disparaging references to *A Shropshire Lad* in the second act, which Stoppard puts in the mouth of the journalist and Wilde memoirist Frank Harris ("I think he stayed with the wrong people in Shropshire. I never read such a book for telling you you're better off dead"), Housman the well-loved sentimental poet is virtually nonexistent. Instead, *The Invention of Love* focuses on the formation of Housman the classical scholar, who is here split in two: the young, emotional, idealistic "Housman," and the dead, cynical "AEH," whose postmortem reveries of his youth, from his Oxford days through his appointment to his first academic position at the age of thirty-three, constitute the play's dreamlike action. What contrast there is between them is less a matter of the suggestive differences between Poetry and Criticism, or angels and devils, than one of age. "Housman," who spends the play getting into as much of a lather about misspellings and misplaced punctuation as he does about Jackson, and into whose mouth Stoppard puts many of the more acidulous aphorisms for which Housman became famous ("the passion for truth is the faintest of all human passions"), isn't different in kind from "AEH," who says pretty much the same things; he's just more wide-eyed and enthusiastic.

To be sure, much of Stoppard's presentation of Housman the developing scholar is engrossing; certainly the Philadelphia audience thought so. (The run there was extended several times; at the time of this writing, there are no plans to bring the play to New York. The rumors are that cautious producers fear that the subject matter is too esoteric.) Few playwrights delight in the surface dazzle of intellectual activity, the theorems, the Latin phrases, the arcane allusions, as much as Stoppard does, and—superficially, at least—he seems to honor his subject's intellectual energy and love of learning for its own sake. There's a wonderful scene toward the end of the first act in which the young Housman exults, apropos of that correction in the Catullus passage, that

by taking out a comma and putting it back in a different place, sense is made out of nonsense in a poem that has been read con-

tinuously since it was first misprinted four hundred years ago. A small victory over ignorance and error.

When I saw the play in March with a classicist friend of mine, we were amazed to see that the audience was rapt as Housman explained, in technical language that refused to condescend to the nonclassicist, how his emendation worked. ("So *opis* isn't power with a small 'o', it's the genitive of *Ops* who was the mother of Jupiter. Everything comes clear when you put the comma back one place.")

But as the play proceeds, it becomes evident that Stoppard himself isn't all that preoccupied with the kind of small victories over ignorance and error to which Housman devoted his life as a scholar. In the Inaugural Lecture he gave on assuming his position at University College, Housman the scrupulous scholar warned against what he called "dithyrambic" tendencies: self-indulgence on the part of the critic, reckless emotionality and idealization in interpreting texts, as opposed to cautious evaluation and strict consciousness of the author's, rather than the interpreter's, tastes and cultures. For all his interest in intellectual esoterica, Stoppard has always been the dithyrambic sort—a romantic at heart. However much it fussed over Fermat's last theorem, and over some of its characters' worries about "the decline from thinking to feeling," *Arcadia* ultimately celebrates the imperfectability of knowledge, and exalts the messiness of love and sex ("the attraction which Newton left out"). Henry, the playwright protagonist of *The Real Thing*, which is currently enjoying an excellent revival on Broadway, may be impatient with intellectual softness, and may have no patience for vulgar politicized writing, but everyone else realizes—with relief—that he's really "the last romantic," despite his reputation as someone who doesn't get "bothered" by things (as Housman was thought not to). The point of this popular play of love and infidelity among very clever people is to make Henry realize this, too. "I don't believe in behaving well," he exclaims toward the end of the play, when he realizes how fiercely he loves his second wife. "I believe in mess, tears, pain, self-abasement, loss of self-respect, nakedness. Not caring doesn't seem much different from not loving."

As it happens, similar words mark the climax of *The Invention of Love*, where a character rapturously catalogs the effects of love: "the

self-advertisement of farce and folly, love as abject slavery and all-out war—madness, disease, the whole catastrophe owned up to . . . " The character is Housman, but he's describing not love itself but love poetry—as near to the real thing, we are meant to feel, as this erotically thwarted man ever got. The structure of his play suggests that—as Auden might have done—Stoppard believes that Housman's devotion to the life of the mind was essentially a repressive (and depressive) reaction to, and a sublimation of, his failed love for Jackson.

This is where Wilde comes in: emotionally foolhardy, aesthetically flamboyant, Stoppard's Wilde is clearly intended as a foil to his Housman—he's the kind of character Stoppard likes to have triumph. (Stoppard's Wilde is valued here for his emotional messiness rather than his intellectual brilliance.) References to Wilde run like a basso continuo through the play from the very beginning, first in breathless undergraduate rumors of his notorious "Aesthete" excesses while at Oxford, and then in more grown-up gossip about his trial and conviction. In the climactic scene, set after Wilde's release from prison, he and Housman finally meet. (They never actually did, but Housman sent Wilde a copy of *A Shropshire Lad*, and we know that Wilde's intimate friend Robbie Ross recited some of the poems to Wilde when he was in prison.) There's little question of where your sympathies are meant to lie. It's no accident that in this play, the news of Wilde's trial and conviction comes at precisely the moment when Housman gets his first academic appointment, as if Housman's success were somehow predicated on Wilde's failure. And as Wilde himself is rowed across the Styx in the last scene, he recites some of his wittiest and most famous aphorisms, while Housman, standing upstage, recites some of his most vicious and mean-spirited.

"I'm very sorry," AEH says to Wilde in this final exchange:

Your life is a terrible thing. A chronological error. The choice was not always between renunciation and folly. You should have lived in Megara when Theognis was writing and made his lover a song sung unto all posterity . . . and not now!—when disavowal and endurance are in honour, and a nameless luckless love has made notoriety your monument.

If Housman stands for renunciation in Stoppard's eyes, Wilde stands for glorious folly:

> Better a fallen rocket than never a burst of light. . . . Your "honour" is all shame and timidity and compliance. . . . You are right to be a scholar. A scholar is all scruple, an artist is none. . . . I made my life into my art and it was an unqualified success. . . . I awoke the imagination of the century. I banged Ruskin's and Pater's heads together, and from the moral severity of one and the aesthetic soul of the other I made art a philosophy that can look the twentieth century in the eye. . . . I lived at the turning point of the world where everything was waking up new—the New Drama, the New Novel, New Journalism, New Hedonism, New Paganism, even the New Woman. Where were you when all this was happening?
> AEH: At home.

This exchange got a big laugh when I saw the play, but I have to think that it came at the price of intellectual fairness. Housman, after all, was an artist too, and a very good one. But then, it often seems like the point of *The Invention of Love* is to make Housman into the representative of timid, thwarted, dry-as-dust "scholarship" and "science," so that Wilde can become the heroic and tragic representative of "poetry" and "emotion"—a dithyrambic type for whom the playwright evidently has more fellow-feeling. And in fact, in his Philadelphia comments, Stoppard acknowledged as much: he talked there about Housman as an outwardly "successful person whose life—and this the play does try to do, does try to show—whose life is essentially a failure in many ways. He failed to live his own personality," whereas Wilde for him is "this other man who crashed in flames . . . [whom] we now see, for perfectly obvious reasons, as being somewhat of a heroic figure and a successful person."

For all their intellectual trimmings, indeed, you wonder whether Stoppard's plays aren't, ultimately, anti-intellectual; he loves to show—and audiences love to watch—brilliant, analytical minds humbled by messy, everyday emotions. (Stoppard has Housman cry out several

times during the action of the play, "Mo! Mo! I would have died for you but I never had the luck!") It's strange that a writer who presents himself—and is accepted as—an intellectual playwright shows so little real appreciation for "affections" (as Housman called them) that originate above the neck; you'd never guess from Stoppard's presentation of Housman that the mind can be a passionate organ, too.

A speech that Stoppard has chosen not to quote in his play—the 1892 Inaugural—suggests a different picture of Housman. The poet-scholar declared that

> Existence is not itself a good thing, that we should spend a lifetime securing its necessaries: a life spent, however victoriously, in securing the necessaries of life is no more than an elaborate furnishing and decoration of apartments for the reception of a guest who is never to come. Our business here is not to live, but to live happily.

It hasn't occurred to Stoppard, or indeed to many of those writing about Housman, that although he never received Jackson as a full-time lodger in his life, Housman could actually have been, for the most part, happy. *Pace* Stoppard, Housman was no grim Stoic. ("I respect the Epicureans more than the Stoics," he wrote.) Stoppard's Frank Harris gets Housman all wrong when he grumbles that the point of *A Shropshire Lad* is that "you're better off dead." If you read beyond the melancholy and obsession with mortality, the point that emerges is, if anything, an Epicurean one: tomorrow we shall surely die, so today we must live—and be happy as best we know how. "My troubles are two," Housman wrote, and this troubled Housman is all *The Invention of Love* cares about; but what about "My pleasures are plenty"?

During their climactic exchange at the close of *The Invention of Love*, Wilde mischievously tweaks Housman's famous devotion to scientific "truth," a passion that pervades both his poetic and scholarly utterances. ("It is and it must in the long run be better for a man to see things as they are than to be ignorant of them," he wrote in the UCL Inaugural;

and in the penultimate poem of *A Shropshire Lad*, the narrator says of harsh poetic truths that they are worth having even "if the smack is sour.") Stoppard's Wilde is somewhat more sanguine about the relation between facts and truth, and shuns unpleasant realities. "It's only fact," he tells Housman, referring to a newspaper report about a young cadet who killed himself because he was a homosexual—the incident that was the basis for one of the most searing and implicitly self-revealing of *A Shropshire Lad*'s poems ("Shot? So quick, so clean an ending?"). "Truth," Wilde goes on, "is quite another thing and is the work of the imagination."

You're meant to applaud this line, which ultimately provides the explanation of the play's title. Wilde knows that Bosie is nothing more than a "spoiled, vindictive, utterly selfish and not very talented" young man, but those are merely the boring "facts." The "truth" is that for Wilde, Bosie is divine Hyacinthus. "Before Plato could describe love," Stoppard's Wilde says, "the loved one had to be invented. We would never love anybody if we could see past our invention." This exaltation of "invention" over "reality," of complaisant fantasy over unpleasant facts, couldn't be farther from Housman's hardheaded view of things. (He loathed Tennyson's "In Memoriam," which he disdainfully summarized thus: "Things must come right in the end, because it would be so very unpleasant if they did not.")

Of the cold realities of life, Housman got an early and bitter taste; his reaction was to abandon illusion, "invention," and devote himself to laying bare reality as he saw it. If love, as Stoppard wants us to believe, lives in the province of the imagination—if it is, essentially, an invention—then Housman's handicap, we are meant to feel, was his limited, science-bound, fact-obsessed, philological mind. Even if you accept the dubious and disturbing proposition that we could never love people if we could see them for who they really are, Stoppard again isn't playing entirely fair here. Having erased all traces of Housman the poet, the amiable colleague, the warm and hilarious correspondent, there's nothing to stop the playwright from claiming that Housman wasn't a fully realized human being, wasn't capable of "inventing." This, in turn, allows him to deliver to his audience the always welcome news that scholars are dull and haven't got satisfying emotional lives, whereas other people live life to the hilt.

Had Stoppard dug deeper, been really interested in considering what the soul of a man who was both genuinely creative and rigorously intellectual might be like, he might have penetrated to the mystery of the "two different people" that Housman was. With his playwright's imagination and presumed interest in the textures of human character, he wouldn't have had to dig very deep. Is the "puzzle" of Housman's divided nature all that difficult to solve? To my mind, the fierceness of his scholarly invective is simply a mutation of the fierce protectiveness he felt for the beautiful lads he eulogized. *A Shropshire Lad* is a bitterly ironic antiwar poem: "The saviours come not home to-night, / Themselves they could not save," goes a line from the sequence's first lyric, which refers to the thousands of young men fighting and dying in the Empire's wars, and which is set on the night of Victoria's Golden Jubilee, as choruses of "God save the Queen" ring out into the bonfire-illuminated sky. Housman loves his young men, and hurts to think of them wounded ("lovely lads and dead and rotten," he spits), and scorns those who would wound them. So too with his beloved texts: he loves them, and hurts to think of them wounded.

And surely the life-altering rejection by Jackson has much to do with the tone and character of Housman's two personae. The two emotions that underlay this hopeless, humiliating incident—desire (his for Jackson) and contempt (Jackson's, implicitly, for him and his world)—each found its own outlet: desire in the elegies for young men, contempt in the vituperative footnotes. (Housman wryly dedicated his magnum opus to Jackson the *contemptor harum litterarum*—"the one who has contempt for these writings.") Indeed, that contemptuous "thousand-yard stare" seems all too clearly to have been a self-protective device, a way of distancing himself from the intense emotions that young men—students—could so easily arouse. For this we ourselves should feel sympathy, not contempt.

Desire, contempt; poetry, criticism. Housman's classical papers, abstruse as they may be, are filled with flashes of wit; they are also masterful examples of elegant and precise English. (Among his contributions to textual criticism was to make of what had been a truly dry-as-dust

genre, characterized by terse, abbreviated notations, an almost literary one.) There's a strange moment in one of these, an early review of a new edition of Euripides' *Iphigenia Among the Taurians*, in which, during a discussion of textual matters, emotion suddenly kindles: Euripides' *Hippolytus*, the author fiercely writes, was "by far the most faultless tragedy of Euripides, if not indeed the most faultless of all Greek tragedies with the exception of the *Antigone* alone." In Euripides' play, Hippolytus is portrayed as a proud and solitary youth who devoted himself to the austere cult of the virgin goddess Artemis; he perishes, as the indirect result of an unwanted erotic advance, because he would not break an oath of silence. Small wonder the play appealed so much to Housman, who in life had played not one but both of its great leading roles: the desire-maddened, rejected would-be seducer, and the solitary youth whose austere enthusiasms were a refuge from erotic confusions for which he claimed contempt.

As for Housman's exceedingly rarefied intellectual enthusiasms, we need not look to pathology to explain them. Of course it's tempting to think that there was, in his choice of Manilius as the object of his life's work, something deliberately perverse; it's as if, to punish the "system" that had punished him, he chose to waste his awesome talents on someone wholly beneath him. (It wouldn't have been the first time.) In 1984, Professor Knox lamented about this waste in *The New York Review*: "When I think of what Housman might have done for the improvement and elucidation of our texts of Aeschylus, Sophocles, and Euripides instead of devoting thirty years to the verses of an astrological hack, I am tempted to use his own words against him: "The time lost, the tissues wasted . . . are in our brief irreparable life disheartening to think of."

But even if there is some truth in the theory that Housman's choice of subject was deliberately perverse (after all, he had every reason to resent the system, and to want to subvert its needs and desires), to complain in this way is to inflict, as Housman might put it, the literary on the scientific. We may be interested in possessing the most accurate possible texts of the three great tragedians, but Housman's interest was to find corrupt texts and repair them—"to strike your finger on the page and say, 'Thou ailest here, and here.' " It is important, too, to remember that among Manilius's previous editors were the great scholars

Scaliger and Richard Bentley, whom Housman so revered. Whatever his modest refusal to be counted their equal, it would be inhuman to expect him to resist embarking on a project that, quite apart from its intellectual and technical appeal, would link his name permanently to theirs. And let us not forget that childhood fascination with astronomy. Why shouldn't Housman have had a Proustian motivation?

If Stoppard's interest in intellectuals and their lives and passions extended beyond his desire to use them as garnish for his essentially romantic, pop vision—if, for instance, he'd taken more seriously, and investigated more closely, the contexts for and nuances of Housman's utterances about classical learning and the role of the scholar—he'd have found many things to admire. (And would have had to write a different play.) Not least of these would have been the very trait which, in this play, is too often an object for fun: Housman's insistence on "scientific" scrupulousness in dealing with ancient texts. "The only reason to consider what the ancient philosopher meant about anything is if it's relevant to settling corrupt or disputed passages in the text," AEH declares in Act 1, as the audience, echoing Jowett—who also makes an appearance—sniggers knowingly. (How narrow he is, how horribly he has failed to see the glory that was Greece!) And again, toward the end of Act 1, AEH is lecturing young Housman on the qualities of a good textual critic; among these was "repression of self-will." This also got a solid giggle on the night I saw the play, perhaps because people were making a connection—as I suspect Stoppard intends them to—between Housman's mania for intellectual "repression" (by which he meant, of course, the effort to filter out the critic's own prejudices) and the alleged sexual and emotional repression for which, thanks to Auden and others, he is so well known.

Like many lines in this play, the one about self-repression is, in fact, a quotation from Housman, but Stoppard doesn't provide the idea with its proper context. In his Cambridge Inaugural Lecture of 1911, Housman argued passionately that scholars of ancient texts must repress their own tastes—what we today might call their cultural biases. He derides an appraisal of some lines by Horace as being "exquisite":

Exquisite to whom? Consider the mutations of opinion, the reversals of literary judgment, which this one small island has

witnessed in the last 150 years: what is the likelihood that your notions or your contemporaries' notions of the exquisite are those of a foreigner who wrote for foreigners two millenniums ago? And for what foreigners? For the Romans, for men whose religion you disbelieve, whose chief institution you abominate, whose manners you do not like to talk about, but whose literary tastes, you flatter yourself, were identical with yours. . . . Our first task is to get rid of [our tastes], and to acquire, if we can, by humility and self-repression, the tastes of the classics.

In the context of the fuzzy Victorian romanticization of classical culture, this is shockingly refreshing. The past thirty-five years of classical scholarship have, in fact, been devoted to stripping away our cultural preconceptions about and woolly idealization of the Greeks and Romans and trying to see them "cold," for what and who they were—which was, as often as not, strange and off-putting, despite our desire to make them into prototypes for ourselves, to "invent" them as "Hyacinths" even when the "facts" suggest otherwise. Stoppard has AEH recite most of this speech in his play, but you wonder whether he does so without being aware of its implications, without realizing how startlingly prescient and contemporary this musty old character was. Fact-loving, scientific Housman was unsentimental about the Greeks and Romans—and therefore more modern by far, when all is said and done, than "Hyacinth"-loving Wilde.

The back cover of the printed edition of The Invention of Love, like the play itself, is less interested in the two Housmans than in comparing Housman and Wilde; in so doing, it makes a little joke of A. E. Housman. On it, the publisher rhapsodizes about Wilde's superior allure, about the fact that although his life was short and tragic, he had, at least, lived: "The author of A Shropshire Lad lived almost invisibly in the shadow of the flamboyant Oscar Wilde"—this, of course, isn't true; Housman was hugely popular—"and died old and venerated—but whose passion was truly the fatal one?"

After seeing Stoppard's one-sided play about this fascinatingly two-sided figure, I was moved to ask a different question. Let's say that

Stoppard's Wilde is right—let's say he did invent the "new" twentieth century, mad as it is for everything new. And indeed, so much of what he was famous (and infamous) for inventing in the nineteenth century has become commonplace in the twentieth: media celebrity, and the celebrity trial; personality as a form of popular entertainment; glittering pronouncement as ideology; "image" culture; the adulation and tireless pursuit of idealized, rather than real, love objects. So let's say that Wilde (or at least the Wilde of Stoppard's play), the one who preferred silvery, seductive, vaporous images to unappealingly humdrum "facts" and unpleasant realities, invented that—gave us the world we now inhabit. And let's say that Housman, after failing—or refusing—to "invent" the one he loved, chose to be unglamorous, to devote himself to facts, to reality, to the dull task of bringing to light hard truths unlikely to endear him to a public hungry—as Stoppard's public is—for sentimental fantasies. Let's give Wilde that much, and Housman that little. Who is the greater hero?

—*The New York Review of Books,* August 10, 2000

The Truman Show

It comes as no surprise to learn, as you do in the preface to *Too Brief a Treat*, a new volume of Truman Capote's letters, that the author was as eccentric in his spelling as he was in pretty much everything else. Still, it's fascinating to find out that three words in particular gave him trouble—so much so that Gerald Clarke, Capote's biographer and the editor of the letters, decided in the end to let them stand uncorrected in the published text. One of the three trips up a lot of people ("receive"). But the other two are generally less troublesome—if only because one is a word that most of us dare not use of ourselves, and the other is a word we prefer not to use. Given all we know about Capote, his difficulties with both seem significant.

The first word was "genius"—or, as Capote sometimes spelled it, "genuis." At the beginning of his life and career the word cropped up often. "We all thought he was a genius," said the writer Marguerite Young, after the diminutive, flamboyant youth arrived at Yaddo, the artists' colony, in the spring of 1946. Capote was then only twenty-one, but had already attracted considerable attention. This was partly for his writing—a couple of macabre short stories, published in *Mademoiselle* and *Harper's Bazaar*—and perhaps more for his public antics.

He'd been fired from *The New Yorker* for impersonating an editor (he was a copyboy at the time) and was a regular at El Morocco and the Stork Club, swank nightspots where he would appear with fashionable young women like Gloria Vanderbilt and Oona O'Neill. At Yaddo, though, he worked hard: he was writing a novel for which he'd received a contract from Robert Linscott, an editor at Random House, who like so many others found Capote's combination of elfin charm and childlike vulnerability irresistible. "Truman has all the stigmata of genius," Linscott declared in 1948, after publishing the young author's first novel.

That novel was the career-making *Other Voices, Other Rooms,* an exercise in Southern Gothic that, as one newspaper put it, had "critics in a dither, as they try to decide whether he's a genius." In fact, many if not most of the major critics dismissed the novel, an overspiced gumbo of rape, murder, homosexuality, disease, madness, and transvestism. ("A minor imitation of a very talented minor writer, Carson McCullers," Elizabeth Hardwick wrote in *The Partisan Review*.) What made the book's reputation was the sensational publicity concerning the author's jacket photo, which showed the twenty-three-year-old Capote lying on a divan staring at the camera with the hungry look of a seasoned rent boy. Capote himself later acknowledged that it was the "exotic photograph" that marked "the start of a certain notoriety that has kept close step with me these many years."

When you pick up *Other Voices* today and slog through the Spanish-mossy plot and the overinflated sentences ("he knew now, and it was not a giggle or a sudden white-hot word; only two people with each other in witness"), it can be hard to see what the fuss was all about. And yet a powerful presence is unmistakable—you can see how clearly the deliberate, almost Wildean aestheticism of Capote's prose stemmed from his outré pose. Both excited an entire generation. Cynthia Ozick would later recall how brandishing a copy of *Other Voices* was like waving a banner against the "blight" of the drabness of the postwar milieu; Capote himself would work at the exquisiteness of his sentences until it became a hallmark of his mature style. Norman Mailer summed up the consensus of that generation of writers when he declared that Capote wrote "the best sentences word for word, rhythm upon rhythm," of any of them.

Remarkably, Capote's child-prodigy persona carried him nearly into his forties. "Yes, he's a genius, Ma'am," his friend Cecil Beaton told the Queen Mother late in 1962, when Capote was thirty-eight. But again it was unclear what, precisely, "genius" referred to. In the fifteen years since *Other Voices, Other Rooms* had been published, he'd added to his oeuvre just two slight novellas (*The Grass Harp* and *Breakfast at Tiffany's*), a few stories and a short book, *The Muses Are Heard*, that grew out of a long *New Yorker* piece about touring the Soviet Union with the cast of *Porgy and Bess*. Still, the royal lady found him a genius, "quite wonderful, so intelligent, so wise, so funny," over a lunch together at which Capote laughed and "whooped with joy when the summer pudding appeared," as Beaton later recalled. That last detail suggests why it was so hard not to think of the author as remarkable. Throughout his life he loved to play the child, and people reacted accordingly—they kept treating him like a prodigy into his middle age. Again and again in the various biographies and memoirs of Capote, you're struck by how often and how naturally people comment on this particular aspect of his charm. "A precocious child, so cute and funny," Eleanor Lambert declared at the beginning of his career; a "wonderful but bad little boy," David Selznick remarked, when Capote was twenty-eight.

Capote was certainly a bad little boy in one respect: he was an inveterate liar. (He enhanced the story of his lunch with the Queen Mother in later retellings, shifting the venue to Buckingham Palace and enlarging the guest list to include the Queen herself.) But it was with a work ostensibly devoid of any invention at all that he secured what was to many his most plausible claim to being a genius. In 1965, when he was forty, he completed *In Cold Blood*, his harrowing, tautly written account of the murders of four members of a wealthy Kansas farm family by a pair of young drifters—a "nonfiction novel" that used the techniques of fiction to achieve a narrative power rare in reportage. After an electrifying debut as a four-part serial in *The New Yorker*, the book was published in January 1966 and became an enormous best seller, adding considerable wealth to solid literary acclaim. Capote sealed this artistic triumph later that year with his greatest social success: the legendary Black and White Ball he gave at the Plaza Hotel in honor of Katharine Graham, one of the many rich women whom Capote, who prided himself on his social as well as his literary genius, so assiduously cultivated.

The second word Capote could never get right was one he often spelled "dissapoint." This, too, has a special resonance. For almost immediately after the double triumphs of 1966, something went catastrophically wrong. During the writing of *In Cold Blood* he'd begun to drink heavily; his friend Phyllis Cerf, wife of the Random House publisher Bennett Cerf, later claimed that writing the book had, essentially, made Capote an alcoholic. As the Sixties went on, and then the Seventies, he drank more and more, began taking pills, and wrote less and less. Increasingly, his public appearances became occasions for embarrassment. (In 1977 he had to be escorted off the stage at the beginning of a reading after he began to mumble incoherently.) There were halfhearted attempts to get back to work: Capote talked about doing a series of articles on a string of gay sex-torture killings for *The Washington Post*—all too clearly a reprise of *In Cold Blood*—and a magazine piece about touring with the Rolling Stones (just as clearly a ghost of *The Muses Are Heard*). But they never got written.

The one work he claimed to be seriously embarked on was a grand, "Proustian" novel that he had been contemplating for a long time—an epic work in which he planned to set down everything he knew about the very rich, whom he had been studying all these years. (The only standards he seems to have maintained, at the end of his life, concerned money: "In this day and age, you've got to have at least $500 million. Free. That you can pick up," he told an interviewer who had asked him his definition of "rich.") But the few chapters from this work in progress that appeared in *Esquire* in the mid-Seventies—like a naughty schoolboy, Capote kept claiming that he'd written much more but that it had been lost, or even stolen—suggested that he'd lost his touch. Amounting to little more than thinly disguised items of high society gossip, they were flatly, even slovenly, written and notable for a child's obsession with bodily functions and parts. One story concerns a sexual encounter between characters meant to be William Paley and the menstruating wife of the former governor of New York; another eavesdrops on Cecil Beaton and Greta Garbo discussing their genitals.

For betraying the secrets of the ladies whose lapdog he'd been, Capote was exiled from the jet set. By that point, his private life was a mess anyway. Increasingly estranged from his longtime lover, Jack

Dunphy, and now in his forties—undoubtedly a traumatic milestone for anyone as invested as Capote was in both looking and acting boyish—he embarked on a string of affairs with ostentatiously ordinary, and ostensibly heterosexual, family men. These lovers were repairmen, bartenders, and midlevel bankers, men whom Wyatt Cooper, Gloria Vanderbilt's husband, recalled as "men without faces"—chosen, many couldn't help thinking, to outrage his posh friends. ("Ooooh! I didn't want an air-conditioning man for a friend," Mrs. Graham exclaimed.) By the end, those few of his former set who still spoke to him encountered what looked like a parody of the old Capote: a bloated, baby-faced man, who soiled himself during alcoholic stupors and whose former naughtiness had curdled into a viciousness that was not always merely verbal. (One entry in the index of Clarke's biography is "O'Shea, John, Capote's hit men and": he twice had people vandalize the property of boyfriends who'd left him.) His boyish qualities had persisted, but less attractively. "I feel like a trust officer dealing with the senile and the infantile," John O'Shea, one of the men without faces, griped when he tried to organize the alcoholic writer's business affairs. Capote died in August 1984, a month shy of sixty, after nearly two decades of decline.

In his inexorable disintegration, Capote represents a distinct type of American failure—the artist whose early success is so spectacular that both life and art are forever trapped by, and associated with, long-past triumphs. (Orson Welles and Marlon Brando, whom Capote famously profiled in The New Yorker, maliciously and brilliantly, come to mind.) It was precisely because he himself was so dazzled by his own early persona—the literary golden boy and enchanting, honey-tongued child of high society—that Capote clearly felt he had to cap his career with that Proustian masterpiece. But it was a work he all too clearly didn't have the resources to write—and not merely because by the time he set out to write it, he was a pill-popping alcoholic. After grilling him on the subject, Gore Vidal concluded that Capote had never actually read Proust, and shrewdly observed that "Truman thought Proust accumulated gossip about the aristocracy and made literature out of it." Capote's problem was that he had the gossip, but didn't know how to make it mean anything to anyone not interested in the real-life figures behind it. He had, indeed, already written his great book; but because In Cold Blood was grittily realistic, Dreiserian rather than Proustian—

because it didn't fit his image of himself—Capote didn't know it. Thus seduced by his own reputation, he failed to pursue an artistic avenue that could well have led him to greater success.

As his life spun out of control, Capote had more and more opportunities to misspell "disappoint." He became obsessed with the idea that his work had been inadequately recognized: he never got over being passed over for the Pulitzer and the National Book Award for *In Cold Blood*. He grew bitterly jealous of the acclaim enjoyed by authors (Norman Mailer, for instance) who, he felt, had stolen his ideas and methods, particularly the technique of the nonfiction novel. In a letter to Bennett Cerf in the summer of 1964, Capote complained that Cerf had decided not to publish his *Selected Writings* under the "august imprint" of the Modern Library. "Can you imagine how very galling it is for me to see so many of my contemporaries . . . included in this series, while the publisher of same ignores its own writer? It's unjust—both humanly, and in terms of literary achievement."

Since then, Capote has received the recognition he so eagerly sought: there are now four volumes in the Modern Library devoted to the author's work. To that continuing project of canonization his old publisher, Random House, is now adding two more volumes of Capotiana: Clarke's new volume of the letters, entitled *Too Brief a Treat*, and *The Complete Short Stories of Truman Capote*. And yet although both volumes are undoubtedly meant to shore up Capote's posthumous reputation as an American classic, they end up shedding as much light on his shortcomings as they do on any genius he might have had. Together, they provide intriguing insights into the nature both of his gift and of his terrible failure.

━━━━

Despite its imposing title, *The Complete Stories of Truman Capote* is a slender affair, twenty pieces in all. It is a startlingly insubstantial output for a writer whose career lasted forty years, and who was most comfortable in the short form. Of the twenty stories, moreover, fourteen were written before Capote turned thirty (a dozen, indeed, before he was twenty-

five); another three were written during his thirties; and the final three during his forties.

Another way of putting this is that in the *Complete Stories* you're dealing, essentially, with a volume of juvenilia. What strikes you now is, in fact, how adolescently lurid and creepy the earliest stories are—and yet how earnestly "serious" and grown-up they're meant to be. At least half the new collection falls into this unfortunate class. There are hammy tales of erotic obsession ("The Headless Hawk," 1946); heavy-handedly dark stories like "Shut a Final Door" (1947), in which the comeuppance of a ruthless social and professional climber arrives in the *Twilight Zone*–ish form of anonymous phone calls that follow him wherever he goes; and morality tales about doomed young innocents, like the college girl in "A Tree of Night" (1945) who falls victim to sinister freaks on a train, or the depressive young working woman in "Master Misery" (1949) who sells her dreams to a man who's known as Master Misery and who may well be . . . the Devil. ("I figure it this way, baby: dreams are the mind of the soul and the secret truth about us. Now Master Misery, maybe he hasn't got a soul, so bit by bit he borrows yours.")

These works, with their affected Gothic darkness, are often marred by leaden symbolism (a number of them feature long dream sequences—always a crutch), juvenile awkwardnesses ("the hostess went toward her sudden guests"), and overwriting of the sort that characterized the young Capote's hothouse style. ("A knot of pain was set like a malignant jewel in the core of his head" is a sentence likely to induce a few headaches of its own.) But you can also see what caught people's eye. In "Miriam," the story that first won Capote serious attention, in 1945, a middle-aged widow called Miriam is befriended by a small girl, also called Miriam, who gradually insinuates herself into the older woman's apartment and eventually takes over her life. Here you can see the author struggling to control the prose and put his effects in the service of the narrative. Near the beginning of the story, a snow begins to fall during which "foot tracks vanished as they were printed"—a nice way of suggesting how the elder Miriam herself will soon be erased.

Others of these early tales give you glimpses of the aptness of detail and rigorousness of style that were so enthusiastically celebrated later on. In "The Bargain" (1950), a short story discovered among the writ-

er's papers after his death, the awkwardness of a transaction between a wealthy woman and her impoverished friend, who's trying to sell an old fur coat, is beautifully conveyed in the matron's somewhat pretentious lapse into French when the difficult subject of money comes up. (*"Combien?"*)

In these early stories, Capote often wrote about upper-crust ladies who experience tiny epiphanies. Small wonder. Capote, who was born Truman Streckfus Persons in New Orleans in 1924 to unhappily married parents—the father a pathetically failed huckster, the mother a child-bride beauty with, to put it mildly, convenient morals—spent only the earliest years of his childhood with the eccentric Alabama relatives he later memorialized in stories and novellas. From the age of eight (when his mother was remarried, to a rich Cuban whose name he later adopted) he lived in Greenwich, Connecticut, and later on Park Avenue. Glamorous ladies and fur coats were very much a part of his life. It was not a particularly happy life: Capote's mother, Nina, a narcissistic alcoholic, was horrified by her son's all-too-evident effeminacy, and frequently abused and humiliated him.

All this bears mentioning only because pretty much all of the stories tend to fall into either of two categories that reflect the author's bifurcated childhood. One of them features those grim, rather dutiful tales of doomed cosmopolites, New York ladies or well-brushed suburban girls, falling victim to Destiny. But the best of Capote's short fiction belongs to a second, far smaller group, which draws on his happier memories of Alabama, when he was cosseted by three elderly spinster cousins. It's a remarkable experience to encounter first the empty posturing of "Master Misery" and then to read "Jug of Silver," a charming tale about a poor Southern boy bent on winning a jar filled with coins at the local drugstore, or "My Side of the Matter," a slyly funny first-person narrative of a young Southerner's conflict with his bride's less-than-welcoming family. Here the young writer is clearly at home in every way, his assurance and perfect pitch evident in the kind of delicious details that can't be counterfeited. "The Odeon had not been so full since the night they gave away the matched set of sterling silver" tells you more about the sociology of its small-town setting than ten pages of earnest exposition could.

In these stories, too, the first of a distinctively Capote type of character appears: the stubborn misfit whose refusal to heed convention transforms and elevates those around her—not least, by reminding the grown-ups of the beauties and pleasures they knew as children but have since forgotten. "I think always," says Miss Bobbitt, the precocious ten-year-old heroine of "Children on Their Birthdays" (1947), "about somewhere else, somewhere else where everything is dancing, like people dancing in the streets, and everything is pretty, like children on their birthdays." This motif would reappear throughout the fiction for which Capote is best remembered: *The Grass Harp*, in which a crew of adorably eccentric Southern misfits leave their homes to go live in a tree; *Breakfast at Tiffany's*, whose heroine, Holly Golightly (née Lulamae Barnes), has, largely thanks to the 1961 film, become a cultural byword for a certain kind of enviable free-spiritedness.

Given the ferocity of his attachment to the distant happiness and emotional comfort of his Alabama years, it's not hard to see why Capote kept returning to this theme. When he does so, all his graces as a writer combine—the wise-child humanity, a real rather than faked lyricism, strong detail. This is nowhere truer than in "A Christmas Memory," his 1956 reminiscence of baking holiday fruitcakes with his elderly Alabama cousin. The story's stately, delicate, spun-caramel narration lends an incantatory aura to its almost hieratic lists of actions and ingredients ("cherries and citron, ginger and vanilla and canned Hawaiian pineapple, rinds and raisins and walnuts and whiskey and oh, so much flour . . .")—all in the service of evoking a memory whose delight is enhanced by the inevitable parting at the end. The story represents, perhaps, the acme of Capote's fictional art, whose special character lies in its ability to give voice to the childlike in us. The part of us, in other words, that resists adult strictures, that wants to retreat, delightfully, to treehouses or to the inviolable past; the part to which he himself had such remarkable access.

And yet you close *The Complete Stories of Truman Capote* with a sense less of genius than of disappointment—a feeling that there's somehow less than you thought there would be, and that the ingenious talent for spinning cotton-candy charm you may have recalled is, in fact, seldom in evidence. An overview of the career is likely to leave you with a similar feeling; the catalogue of Capote's substantial published

work is disarmingly short, at least in proportion to his reputation. That narrowness of output is matched by—and, I think, ultimately explained by—an infantile narrowness of outlook.

"Narrow" may seem unfair, given the way Capote's work veers from enchantment (in his best stories) to terror (those other stories, and of course *In Cold Blood*). But the extremes between which Capote's work seems to move may, in the end, be seen as no more than the poles of a child's consciousness, divided as it is between golden fantasies of pleasure and omnipotence, on the one hand, and terrors of the dark, on the other. That Capote's oeuvre should oscillate so consistently between the two was, if anything, overdetermined: the alternation clearly reflects the bifurcated nature of this particular child's early life, split between the womblike snugness of that house in Alabama and the cold limestone of 1060 Park Avenue, where lurked a monster who was, for him, only too real.

It is, indeed, in this light that Capote's famous characterization of *In Cold Blood* as "a reflection on American life—this collision between the desperate, ruthless, wandering, savage part of American life, and the other, which is insular and safe," takes on its proper meaning. If *In Cold Blood* is, of all Capote's work, the one that can stand as a classic outside the context of Capote's time and persona, the reason has much to do with the way it cannily maneuvers between the extremes that framed his artistic vision. There is, again, the alluring, cherished surface calm: the meticulous pacing, the careful enumeration of small details, everyday objects and moments ("for the longest while she stared at the blue-ribbon winner, the oven-hot cherries simmering under the crisp lattice crust"). And there is the horror that lurks, always about to explode—and which, like a child, you both do and don't want to see, when it's finally described. Here Capote's mature stylistic rigor, his eye for the telling detail, and the oral tradition of his haunted Southern boyhood brilliantly come together to create what is, essentially, one of the great ghost stories—a tale that continues to have the power to enthrall and terrify precisely because it conflates our childish fears of things that go bump in the night with our adult understanding of what those things can actually be.

One of the things Capote's perennially child's-eye view of the world accounts for in this book is his striking preoccupation more with the

killers, Dick Hickok and Perry Smith, than with the victims, the Clutter family. The author's presentation of the killers (particularly the "artistic" Smith) as children gone pathetically wrong, as poignantly misguided dreamers, was a terrible variation, but still a variation, on the type of child misfit that in his fiction he found irresistible. Capote's boyhood friend Harper Lee, who accompanied him to Kansas to research the story, recalled that when Perry Smith, whose legs had been shortened as the result of a motorcycle accident, took his seat at his arraignment, Capote noticed he was so tiny that his feet didn't touch the floor. "Oh, oh!" Lee remembered thinking. "This is the beginning of a great love affair." Capote knew a kindred spirit when he saw one.

Capote the child is also much in evidence in the letters collected in *Too Brief a Treat*. (The title quotes the opening lines of a letter Capote wrote to Bob Linscott in May 1949: "Your letter was too brief a treat, but a treat all the same.") Certainly there is much here that is charming. In his biography of Capote, Gerald Clarke writes of the "puppylike warmth" that was "basic to his personality," and this aspect of Capote's character goes a long way toward explaining why, despite his frequent malice, Capote was thought so adorable for so long by so many. But beneath the endearing, tail-wagging enthusiasm of his hyperbolic Southern salutations ("lover lamb," "Magnolia my sweet") lies, all too obviously, an infantile neediness. "Dear Marylou," he wrote his *Harper's Bazaar* editor, Mary Louise Aswell, in 1946, "everyone loves you so much! I am really jealous, because I love you more than anybody, but everyone keeps saying how much they love you without seeming to realize that you belong to me, and that I love you more than anyone." You can almost hear him waiting to be told that she loves him more than anyone, too.

This, alas, sets a claustrophobic tone that never really lets up. It's true that the letters will doubtless provide many tasty morsels for students of midcentury American social and publishing history. Some of the gossip is literary. ("Did you see the Guggenheim list?! Ralph Bates!") And much of course is decidedly and exaltedly jet-set: in August 1953, he writes, "everything became too social—and I do mean social—the Windsors (morons), the Luces (morons plus), Garbo (looking like death with a suntan), the Oliviers (they let her out), Daisy Fellowes (her face

lifted for the fourth time—the Doctor's [sic] say no more.)" And some, of course, mark milestones both golden and black in Capote's career. "The reaction," he wrote to William Styron in January 1976 after one of the "Answered Prayers" chapters appeared in *Esquire*, "has ranged from the insane to the homicidal."

But after nearly 500 pages of this, you can't help noticing how small Capote's world—and worldview—really was. What the letters don't provide is, indeed, anything beyond the personal, the local, at any point in his life. (Here again, chronology is revealing: of this volume's 452 pages of letters, almost 400 pages' worth were written before Capote turned forty.) There are virtually no references to larger world events; nor are there substantial literary insights apart from what Capote thought of his own work and the occasional contemporary novel. For comparison's sake, while reading these *Letters*, I took down a volume of letters by Evelyn Waugh—another writer whose literary substance was matched by a keen interest in Society—and opened to random pages. On one: musings on the history of heraldry and the nature of a stable social structure. On another: tart thoughts about religion in the novel, following the publication of *Brideshead Revisited* ("No one now thinks a book which totally excludes religion is atheist propaganda"). Another: Mme. de Pompadour's disastrous influence on Louis XV's foreign policy in the wars of 1759. And so on.

Or take the letters of another socially ambitious, adorably popular gay littérateur. Oscar Wilde's correspondence sparkles with true wit rather than mean cracks, and the personal warmth that emerges is generous and adult, rather than childishly selfish. When you read these and other authors' letters, in other words, you get a sense not only of them but of their time, the world. But to read Capote is to note how little interest he showed in any life but the social life, in any experience but his own. He prided himself on refusing to go on sightseeing tours of the exotic Mediterranean locales to which his rich ladies' yachts took him (he preferred the nearest bar to ruins or museums); prided himself, too, on never having voted. Like a small, imaginative child, he was, to himself, the world entire.

The smallness of Capote's world helps explain what is, in the end, so curiously unsatisfying in his work—even, to some extent, in *In Cold Blood*, with its distasteful attraction to the childlike, "gifted" killer.

However appealing are the fantasies of freedom that recur in his writing, they are, at bottom, un-adult: if to be an adult means to grapple successfully with the unyielding realities of life, it's interesting that this is something that so many of his characters—like Capote himself, in the end—never do. Capote may have written Lulamae/Holly a ticket to freedom at the end of *Breakfast at Tiffany's*, but he knew, and we all know, too well what happens to the real Lulamaes. (The real name of Nina Capote, the author's awful mother, was Lillie Mae.) The transformation of the monstrous Lillie Mae of real life into the adorable Lulamae of fiction seems, in fact, to be much more than conventional artistic chemistry that turns life into art. It may, rather, be seen as a symbol of Capote's distaste for hard realities, as opposed to the kind of gossamer fantasies he spun in both his work and, increasingly, his life. (Before he died he dreamed, rather pathetically, of giving another grand ball, at which he planned to appear disguised in peasant clothing, "revealing his true identity only by the huge emerald that would sparkle from his forehead, dazzling all those who approached his royal presence.")

This, in turn, provides the key to understanding one of the great puzzles of Capote's career: why he had such notorious difficulty writing the endings of his works. In many of his letters he complains bitterly of the torture of completing everything from *Other Voices* to *In Cold Blood*—he took a three-month hiatus before tackling the final section—and you feel that difficulty, that struggle, in the finished product. "I couldn't help feeling that you had gotten a little bit tired of the book," Bennett Cerf wrote to him upon receiving the manuscript of *The Grass Harp* in 1951, "and were hurrying to close it in much shorter a space than you originally had intended." Much, if not indeed most, of Capote's fiction leaves you with a feeling of incompleteness; there's often a sense of abruptness, of a failure to resolve. (*Breakfast at Tiffany's* in particular simply grinds to a halt.) Here again, the image of a child comes to mind—one who, having toyed with a bit of tinsel, or an object that has caught his interest for a while, suddenly throws it away, as if he'd been distracted by something shinier or sweeter.

Or, perhaps, as if something had scared him away. Surely the most revealing expression of Capote's difficulty with endings, and all that

they represent, is the lyrical scene with which *In Cold Blood* ends. He liked to say that part of the appeal of writing the book lay in the discipline imposed by having to recount a true story: "I like the feeling that something is happening beyond and about me and I can do nothing about it. I like having the truth be the truth so I can't change it." The great sweep of the story he tells in *In Cold Blood*, with its severe and measured pacing—the discovery of the terrible crime; the search for the killers, craftily intercut with flashbacks to their wretched lives; the canny rhythms with which Capote presents the hasty trial and the prolonged delay before the executions—culminates beautifully in a final scene that takes place in a cemetery where, on a windswept day a few years after the killings, Alvin Dewey, the detective who solved the murders, encounters a young woman who had been the best friend of the teenage Nancy Clutter, one of the victims. A brief conversation between them pointedly gives both Dewey and the reader a gentle sense of closure, and the novel ends with one last alliterative evocation of the bleak Kansas landscape: "Then, starting home, he walked toward the trees, and under them, leaving behind him the big sky, the whisper of wind voices in the wind-bent wheat."

The problem is that this ending is too artful: as it turns out, the scene was entirely fictional. Capote added it, he later told Clarke, because the ending that real life had provided him—the hangings of the killers—didn't seem satisfying. "I felt I had to return to the town, to bring everything back full circle, to end with peace." Faced with an ugly reality, he withdrew into a beautiful fantasy—the kind of gentle peace that imbues his evocation of childhoods long past. (Gerald Clarke rightly notes that this final scene rehashes the ending of *The Grass Harp*.) Capote knew, finally, that he wasn't up to bringing his most serious and important work to an authentic conclusion. The coda as it stands was just the last in a series of endings that he fudged, or from which he retreated; and you can't help wondering whether the inability to face unalterable facts (as represented by this particular false ending) was, in some way, the key to Capote's disintegration. His own words suggest as much. "No one will ever know what *In Cold Blood* took out of me," he later said. "It scraped me right down to the marrow of my bones. It nearly killed me."

Indeed, the experience of writing his grim best seller may have traumatized the writer in profound ways unrelated to the usual creative anxieties. Norman Mailer observed a change in Capote during the Kansas years. "He was getting more masculine. . . . Getting to know all those people out in Kansas . . . had given him fiber. He was toughening up." Capote himself acknowledged this transformation. "I've gotten rid of the boy with the bangs," he told *Newsweek* in 1966. "He was exotic and strange and eccentric. I liked the idea of that person, but he had to go." But once that boy left, it wasn't clear what remained.

And so, after being forced to inhabit a world other than his inner child-life for a long time, he turned inward again. But somehow, the stark confrontation with his limitations, symbolized by his inability to complete his book honestly, permanently destabilized him. The simultaneous publication of the author's stories and letters has the unintentional effect of reminding you that however enchanting Capote's interior world may have been, and however lovely the writings it inspired, it was a very limited world—a space that the writer was unable to break out of. Between them, these two new volumes—the one preserving a body of work that should have been larger, but was in fact all "too brief"; the other a too-lengthy record of a life that clung too long to childhood, a record that, like his consciousness itself, could not move beyond youth—constitute an appropriate epitaph for the writer who might have been, rather than a tribute to the one who was. Not entirely a disappointment, but no genius, either.

—*The New York Times Book Review*, December 5, 2004

Winged Messages

"Angel," a word that today can have connotations at once sublime and a bit saccharine, ultimately derives from a rather mundane classical Greek masculine noun of the second declension, *angelos*, "messenger." In Greek, it's not a very exciting word at all—no more so than, say, "postman" or "radio announcer" is in English. If you happened to be an ancient Greek and had some bit of news or a message you needed to get across, an *angelos* was the man for the job; or, rather, *angelos* was the way you referred to anyone who ended up doing the job. In Greek tragedies, for instance, the character who delivers those famous fact-packed "messenger speeches"—the ones in which we learn how Oedipus handles the news that he's adopted, or just what's inside those nicely wrapped gift boxes that Medea sends to her ex's new bride—is referred to as, simply, the *angelos*.

The related verb, *angellein*, "to announce," is equally unsensational. When the great lyric poet Simonides of Keos wrote, in his old age, the famous epitaph for the Spartans who fell at Thermopylae—"Go tell the Spartans that here we lie"—the word we translate as "tell" was *angellein*. However exciting his news might be, the classical Greek *angelos* was, generally, a featureless vehicle for transmitting crucial

knowledge. It was only much later, after the word was appropriated for biblical purposes, that *angeloi*, "angels," started to rival their messages in glamour and importance: sprouting wings, blowing mighty horns, and singing in celestial choirs, and altogether becoming religious and iconographic objects in their own right, the forerunners of the cloying figures that have become ubiquitous, in our post-millennial moment, on greeting cards, dashboards, New Age Web sites, and hit TV series such as *Touched by an Angel*, in which the eponymous, carefully multicultural leads, an attractive young Irishwoman and a soulful middle-aged African-American, go around teaching mortals Important Life Lessons.

And so the classical Greek *angelos*, grimly transmitting his urgent report of the horrors he has seen, horrors that always result when men find themselves trapped in irresolvable dilemmas, may be thought of as the Angel of Tragedy, and hence very different from the adorable, glittering sylphs who have, lately, alighted in stationery stores and aromatherapy counters and on our television screens, bringing the comfy tidings that everything will be OK: the Angels of Sentimentality.

Part of the excitement of being in the audience of Tony Kushner's Pulitzer Prize– and Tony Award–winning dramatic epic *Angels in America* when it first came to Broadway in 1993 was the fact that it seemed eager to give back to its (very real) angels something like their original job description. Kushner's two-part drama turns, in fact, on the arrival of an urgent message from Heaven. The action of the first part, "Millennium Approaches," culminates in the magnificent appearance of an angel, crashing through a ceiling in the bedroom of an AIDS-stricken gay man, and much of the second part, "Perestroika," is devoted to an explication of what's on the angel's mind, which among other things allows Kushner to elaborate a complicated cosmology of his own idiosyncratic invention. But far more exciting than the culminating angelic message in the play (basically, that God abandoned His Creation early in the twentieth century and hasn't been heard from since, something many may have suspected even before entering the theater) was the message *of* the play.

Although *Angels* premièred in the early 1990s, Kushner had been working on it since the late 1980s, and with the exception of a brief

epilogue it's set during a five-month period between October 1985 and February 1986—which is to say, the early years of the AIDS crisis, a period in which the terrible sense of emergency and paranoia in the gay community, which at that point seemed to be horribly singled out by the virus, stood in agonizing counterpoint to the sluggish and halfhearted response of official America, represented by a deeply conservative Republican administration, from whose "family values" the homosexual victims of the illness were excluded. It was only in 1987 that President Reagan finally addressed the illness in public; it had been six years since the first cases were reported, and three since the virus that causes it had been identified, and by that point, twenty-four thousand people had died of it.

Angels in America came as an enraged, seethingly articulate, intellectually ambitious, high-flown response to that stultifying and smug atmosphere of denial, silence, and willful ignorance. The admiration and, in a way, relief that immediately greeted its première (first on the West Coast, in San Francisco and Los Angeles, then in London and finally on Broadway) had to do with the general sense that finally someone was saying something grand, if occasionally grandiose, and important not just about AIDS, but about AIDS as a symptom of a profound rupture in American life. There had, by that point, been other plays inspired by the epidemic: William Hoffman's *As Is* and Larry Kramer's *The Normal Heart* both premièred, early in 1985, to considerable acclaim, as did the musical *Falsettos*, in 1990. But what made *Angels* feel different was its enormous scope. Here was a work about AIDS, and what it was revealing about the American body politic, on a scale sufficiently epic to suit the subject.

One of the most moving moments in Mike Nichols's new made-for-television film of *Angels*—and one of the few moments that finds a cinematic equivalent for the ambitions of the original—comes, indeed, during the opening credits, during which the camera floats elegiacally in the air above San Francisco, then zooms through banks of woolly clouds across the continent itself, hovering briefly above Salt Lake City, St. Louis, and Chicago, to settle, finally, beside the Bethesda Fountain in New York's Central Park, a monument that not coincidentally takes the form of an angel. The shot is moving because it suggests something essential about the mighty scope both of Kushner's concerns—few

contemporary playwrights are as intellectually ambitious as this one, steeped as he is in Marx, Brecht, and Melville—and of the drama he's written, which ranges from the East Coast to Salt Lake City to Heaven itself (which, we're told, looks just like San Francisco) and includes not only gays (and not only "good" gays, either) but Jews, Mormons, blacks, and Mayflower WASPS; pill addiction, loneliness, mental illness, homelessness, sexual repression; the westward migration of Eastern European Jews to America and of Mormons to Utah; the Bayeux tapestry, Tocqueville's *Democracy in America*, the McCarthy hearings, and the decisions of Reagan's judicial appointees; invented characters—there are rabbis, drag queens, housewives, nurses, doctors, and of course angels— as well as historical figures such as Roy Cohn and Ethel Rosenberg, whose ghost, in a gesture of imaginative boldness on the playwright's part that is more or less typical, says Kaddish over the body of one of the men responsible for her execution.

Angels wanted, in other words, to be a play not about gays, or, for that matter, about AIDS and the rottenness of official America's handling of the crisis, but about the texture of American experience itself. The message—that what the AIDS crisis was revealing wasn't a moral flaw on the part of gay men, as the conservatives running the country would have it, but rather a moral failing in America itself—may not have come as a surprise to many in those first audiences, but it came as a profound relief to many that someone, finally, was delivering it with such fervor. "Greetings," the angel intones as she crashes through the ceiling in the amazing finale of Part One, "the Messenger has arrived." Many in the audience that first night felt that the words applied as much to the play as to the character.

It is for this reason above all that the *Angels* that members of the thirty million households that subscribe to HBO have been able to see since December 2003 and the *Angels* that Broadway audiences first saw late in 1993 seem to be two vastly different works. To be sure, there are other reasons that the new *Angels* looks and feels different: not least, the difference between the stage, with its self-conscious acknowledgment of itself as illusion, and TV and movies, which if anything try to seduce us into forgetting that what we are seeing isn't, in fact, real. This is a differ-

ence that has particular import for a work whose author has elsewhere written with gusto of his "deep distaste" for screenplays and teleplays ("I love movies, but somebody else should write them"), and insists that *Angels* should retain its theatricality. The play, Kushner writes in the published edition,

> benefits from a pared-down style of presentation, with minimal scenery and scene shifts done rapidly (no blackouts!). . . . The moments of magic—the appearance and disappearance of Mr. Lies and the ghosts, the Book hallucination, and the ending— are to be fully realized, as bits of wonderful theatrical illusion— which means it's OK if the wires show, and maybe it's good that they do, but the magic should at the same time be thoroughly amazing.

"Opening out" any work of theater for film is a risky business, but it would be hard to think of a riskier enterprise than opening out a play like *Angels*, with its over-the-top theatricality, its ghosts and angels, its hallucinatory fantasies (some scenes are set in an imaginary "Antarctica" to which the pill-popping Mormon housewife, Harper, flees in her hallucinations), its frequent use of split scenes to emphasize parallels in its various plotlines, and above all its Jonsonian verbal grandiosity. (An early play of Kushner's, typically overstuffed with action and ideas and much better than its original audiences or critics gave it credit for being, was a farce set in seventeenth-century England entitled *Hydriotaphia or the Death of Doctor Browne*, first written in 1985 and hugely unpopular when it premièred in 1997, even after Kushner had become famous.) It's true that Mike Nichols made a name for himself translating works for the theater into films, starting with *Who's Afraid of Virginia Woolf?* in 1966, but Nichols's smoothly naturalistic style of late seems antithetical to the rough, angular, hypertheatrical spirit of *Angels*. There's a glossiness to the HBO *Angels* that saps it of its original, seething vigor.

But the real reason why Nichols's *Angels* feels so different from the Broadway version has less to do with the difference between stage and screen than with the difference between 1993 and 2003. The AIDS crisis is certainly far from over, but no one can deny that it's a much different kind of crisis now from the kind it was ten years ago. (A friend

remarked to me recently that if Kushner were writing his play today, he'd have to call it *Angels in Africa*.) The paranoia and outrage of 1993 have largely evaporated, thanks in no small part to the activism that galvanized the gay community as a result of the crisis. The culture has shifted profoundly, too—again, because of the empowerment and newfound visibility that were by-products of the original crisis. When, in 1985, a prime-time drama called *An Early Frost*, about an American family's reaction to a gay son's illness, aired on network television, it was a daring entertainment "event": the first time the subject had been given major treatment on television. Today, gay characters are not only common on numerous television shows, but there are gay-themed prime-time sitcoms, gay reality shows, and hit series like *Queer Eye for the Straight Guy* whose premise is that most straight men could, in fact, stand to be a bit more gay.

Because of all this, you experience *Angels* in an entirely different way today than you did ten years ago. Not least of the advantages afforded by this shift is that much of what seemed crucial about the play then seems artificial or even dated now—you realize how much the play depends on a cozy kind of politically correct goodwill and the easy prejudices of its audience, and so you realize, too, how often it makes its points not through dramatic logic or motivational coherence, but by means of emotional gimmicks and dramatic fudging. (Some of these wires shouldn't be showing.) But a re-viewing of *Angels* now also, and somewhat frustratingly, reveals—partly because of a new cultural setting, and partly because of decisions on Nichols's and Kushner's part (emphases, cuts, new material)—the bones of a much grander and more important work than the one that the trumpets of the press corps and Sunday cultural supplements have been heralding.

———

Structurally, the TV *Angels* is similar enough to its predecessor to obviate the need for lengthy comparisons between the two versions. The first part, "Millennium Approaches," is almost identical to the stage version; you can follow the dialogue almost verbatim from the printed

text of the play, as I did. The second part, "Perestroika," has, on the other hand, undergone more serious revision: the five acts of this play have become three "chapters" in the TV version, mostly by means of welcome cuts and judicious rearrangement of certain scenes. (Part Two, which includes among other things the play's vision of Heaven and its explication of an elaborate Kushnerian cosmology, always felt bloated, and it still does.) In very few cases lines have been added.

Kushner, an unabashedly old-fashioned Upper West Side Socialist Jewish intellectual, has more in common with the politically motivated dramatists of the 1930s (Odets comes to mind) than with any of his contemporaries, and *Angels* is a work that hangs a great deal of ideological freight on what looks, at first, like a particularly overstuffed domestic drama. The action of "Millennium Approaches" is organized around a series of abandonments and escapes, which are meant to make us think about the issues of responsibility and love and freedom; the second part, which is organized around a series of unexpected scenes of forgiveness, shows the consequences of those flights, and is meant to make us think about change, and about redemption.

"Millennium Approaches" is the tighter, more controlled, and more effective work. When it opens, Louis Ironson, a neurotic, thirty-two-year-old, fast-talking Jewish New Yorker given to grand theoretical pronouncements about history and culture, discovers that his lover, a wisecracking, unabashedly queeny Mayflower descendant named Prior Walter, has been diagnosed with Kaposi's sarcoma, an early sign of AIDS. ("I'm a lesionnaire," Prior quips. "The Foreign Lesion. . . . My troubles are lesion.") Soon afterward Louis, who doesn't like it when the messiness of human experience interferes with his pristine theoretical and literary models—he loves quoting Tocqueville, among others—will abandon his lover. This is the first instance of what is intended to be an ongoing critique in the play of the failures of "ideology." At the beginning of *Angels*, a phobic character worries about the disintegration, as the new millennium approaches, of the Old World Order: "beautiful systems dying, old fixed orders spiraling apart." Among these may equally be counted both the American Dream and Soviet Communism, both of which, Kushner seems to be arguing, failed because they imposed on human experience monolithic fantasies incompatible with its complexity and variety. Part One begins with the funeral of Louis's

grandmother, who came to America from Eastern Europe like millions of others in search of a dream, and Part Two begins with a speech by "the World's Oldest Living Bolshevik," to whom Kushner gives the name Prelapsarianov. (Perhaps because it might now seem stale, the second of these has been cut in the film version, which has the disadvantage—as many of the new cuts do—of destroying certain symmetries in the original play intended to limn Kushner's larger intellectual preoccupations.) Free-market Capitalism, world Communism: to these "systems"—and one of the surprises of the play is that the angels represent such a system—the drama opposes (approvingly, we feel) what are presented as the churning, complex, ultimately redemptive forces of "life": suffering, change, emotional evolution, even politics (as distinguished from stultifying ideology).

At the moment that Louis leaves Prior, another couple falls apart. Joe Pitt is a thirtysomething Mormon lawyer and, more significantly for the first part's themes of falsehood and moral responsibility, a protégé of Roy Cohn, with whom Joe turns out to have more in common than the practice of the law and a penchant for power: like Cohn, Joe is secretly gay, and after being made aware of his true nature (following a flirtatious exchange with the sexually avid Louis in the men's room of the courthouse building in which they both work), he gets up the courage to leave his wife, Harper. Or perhaps it's Harper who's left Joe first: sexually frustrated, agoraphobic, fixated on the disappearance of the ozone layer, she spends much of her time in a Valium-induced hallucination in which a celestial travel agent called Mr. Lies offers her blissful escapes to places like Antarctica, which by the end of Part One she happily inhabits in her dreams.

By the end of the first part of *Angels*, Joe and Louis end up together—they meet one night in the Ramble in Central Park, a famous gay pickup spot—while their abandoned spouses are left to their increasingly elaborate fantasies. For, like his counterpart Harper, Prior begins to hear and see things, too: there are ever more intimations (visions of flaming books, ward nurses suddenly chattering in biblical tongues, ghostly apparitions) that he will be visited by some kind of celestial messenger—the very angel who crashes through his ceiling at the end of this first part. Prior is, indeed, meant to be a latter-day Joseph Smith; ingeniously, Kushner's play continually overlaps three outcast groups: gays, Mormons, Jews.

It's the figure of Roy Cohn who ties not only the parallel actions but also the themes of "Millennium Approaches" together. Just as Louis represents the cold inhumanity of rigid ideologies that cannot account for the messy realities of human existence, Cohn represents the opposite: the raw, soulless appetite, process for its own sake. Like Prior Walter, Cohn gets a diagnosis of AIDS at the beginning of the play, but instead of lapsing into otherworldly fantasies, which the affectingly weak and passive Prior and Harper do, he's unable to leave the crude, fervent world of ambition and power behind. As Cohn physically deteriorates before our eyes, we see him nonetheless furiously advancing his worldly interests—trying to pull the necessary strings to get disbarment proceedings against him dismissed, or using his Washington connections to corner a private stash of AZT. Cohn wants to co-opt the idealistic Joe Pitt into helping with these plans, but Joe, whatever his distraught sense of himself as a sinner ("I'm going to hell for doing this," he cries after merely touching Louis's face, the night they first have sex), can't bring himself to participate in an activity he knows to be illegal. "Millennium Approaches" ends by bringing each of its three stories to a conclusion that has the unsentimental inevitability that you associate with classical tragedy: Joe and Louis go home together to enact a consummation that is anything but ecstatic ("I'm a pretty terrible person, Louis." "See? We already have a lot in common"); the power-mad Cohn, succumbing to his illness at last, collapses on the floor of his town house, where he is visited by the ghost of Ethel Rosenberg (who calls 911 for him, while admiring the push buttons on his phone—to her, a newfangled novelty); and a terrified Prior gets that climactic visit from his heavenly messenger.

One reason why "Millennium Approaches" is a much more successful play than "Perestroika" is that all it needs to do to be effective dramatically (while being suggestive intellectually) is to convey an unsettling sense of imminence—of a failing world, filled with both individual and ideological deception, weakness, and fatigue, about to crack asunder. ("The twentieth century," sighs one of Prior's ghostly ancestors toward the end of the play. "Oh dear, the world has gotten so terribly, terribly old.") "Perestroika" has the much trickier job of putting something in the

place of what "Millennium Approaches" has swept away, and much of the material that Kushner cooks up—from the nature of the angels' "great work" to the dénouements of the crises he provokes in the first part—feels synthetic, and tends to be sentimental, whereas the first part feels more genuinely like a critique—more brilliantly destructive, more tragic.

Another way of saying this is that Part Two belongs more to the world of dashboard angels, with their fuzzy feel-good slogans, than to the world of the stark and urgent messenger of Part One, with her tidings of destruction and collapse. At one point late in this second part, Hannah Pitt, the mother of the gay Mormon, who has sold her house in Utah and come to New York in order to straighten out her son's life, tells Prior—she's explaining to him why, as a Mormon, she's particularly inclined not to disbelieve his tales of angelic visions—that "angels are beliefs with wings." This seems to be not only false to the spirit of the play as a whole but false to what Hannah ought to believe. What the young Joseph Smith saw, all those years ago in upstate New York, was not a glib metaphor. We are told, in a recent *Times* profile of Kushner published to coincide with the new HBO *Angels*, that Kushner takes his Judaism very seriously, but stuff like this suggests that he's not quite as serious about other people's religions.

As its title suggests, "Perestroika" is about revisions and changes, and its aim, indeed, is to work out solutions to the blockages and failures so strongly conveyed in "Millennium Approaches." As flight and abandonment are the motifs of Part One, so forgiveness is the motif of Part Two. In his introduction to the printed version of the second part, Kushner describes how he wants the audience to react:

> Perestroika is essentially a comedy, in that issues are resolved, mostly peaceably, growth takes place and loss is, to a certain degree, countenanced. But it's not a farce; all this happens only through a terrific amount of struggle, and the stakes are high. . . . There is also a danger in easy sentiment. Eschew sentiment! Particularly in the final act—metaphorical though it may at times be (or maybe not), the problems the characters face are finally among the hardest problems—how to let go of the past, how to change and lose with grace, how to keep going in the face of overwhelming suffering. It shouldn't be easy.

To my mind, there isn't enough struggle, and sentiment runs rather high. Many of these forgivenesses are artificial: it's as if, like Louis, Kushner wants to force the actions of his characters to fit a prefabricated template, in order to demonstrate the "theme" of his play. (To wit: that humanity, with all its messiness, always trumps the systems we try to impose on it. "Justice is simple," a wise, gay, black AIDS-ward nurse, Belize, who's a former lover of Prior, lectures Louis at one point. "Democracy is simple. Those things are unambiguous. But love is hard.") And so we see characters go through some rather forced changes. The brittle Hannah Pitt, who in the first part of the work hangs up on her son Joe when, during an anguished phone call, he tells her he's gay, ends up befriending the now desperately ill Prior, and stays by his side in the hospital; Belize, despite his loathing for Roy Cohn, gives the shrieking, abusive patient some important tips about which treatments to follow; and—even more striking, a famous moment in the play—the ghost of Ethel Rosenberg appears after Cohn finally dies to say Kaddish for him. Louis, too, is forgiven at the end of the play, once he comes back to Prior after abandoning Joe Pitt. (After a month in bed with his new lover, Louis discovers that Joe is not only Cohn's protégé, but the author of antigay legal opinions that he, Louis, finds loathsome—"an important bit of legal fag-bashing," Louis shrieks at a dumbfounded Joe, whom he goes on to call "fascist hypocrite lying filthy. . . ." You can only assume that the two didn't talk much during their four weeks together.)

The ability of human beings to evolve and change in time stands in stark contrast to the world of Prior's angels, whom he (and we) at last get to see in this second part. Why has the angel come to Prior, and what is the "great work" announced at the end of Part One? It's here that Kushner's need to tie up all the big themes of his work starts to feel forced; the cosmology that he invents to account for the situations and characters he's created feels at once imaginatively overblown and intellectually undernourished. It would seem that the angels are in turmoil because God, bored by the sempiternal stasis that was life in Heaven, and "bewitched" by man's ever-evolving ingenuity, curiosity, and forward-moving aspirations, abandoned Heaven early in the twentieth century, and hasn't come back. (He left, in fact, on the day of the San Francisco earthquake: perhaps only a gay man of a certain age

could equate the demise of the Divine Order itself with the razing of San Francisco.) The angels want to turn back the clock, to reverse the "virus of TIME."

So what the heavenly apparition whom Belize rightly dubs a "cosmic reactionary" wants is—as the Angel cries in a climactic utterance— "STASIS!" Kushner, in other words, has created a cosmic model for the conflict between beautiful abstract systems and the unruly, illogical energies of lived life, and there's no doubt about which side we must be on. "This is the Tome of Immobility, of respite, of cessation," the Angel intones, pointing to the otherworldly text that has been given to Prior; to which Prior feistily replies, "I still want . . . my blessing. Even sick. I want to be alive." This is a perfectly understandable and human sentiment, but as a payoff for the lofty and grandiose machinations that have set up this climactic utterance, it comes off as tinny. You wanted, not unreasonably, something more . . . Miltonian, perhaps; but all Kushner can fall back on here is high sentiment—and some Borscht Belt wise-cracking. As Prior turns his back on Heaven, he rouses himself for his, and the play's, culminating cry against Heaven:

> If He ever did come back, if he ever dared to show His face . . .
> if after all this destruction, if after all the terrible days of this
> terrible century He returned to see . . . how much suffering His
> abandonment had created, if He did come back you should sue
> the bastard. . . . Sue the bastard for walking out. How dare he.

Much of the second part feels this way: an attitude posing as an answer.

———

Television is, for better or worse, an intimate medium, and on it much of the more grandiose and fantastical elements of Angels seems pretty silly—not least, the scenes that take place in Prior's "Heaven," in which the orders of angels hang around in heavy overcoats and mufflers, intoning about God's Abandonment of Creation. This broken-down-

looking, earthquake-addled Heaven of Kushner's grand imagining, the South Pole, some razzmatazz special effects for the magical Book and the Angel's apparition: all this comes off on TV as a trifle embarrassing, or perhaps embarrassed, as can be the case when highly artificial or formalized elements are represented in a naturalistic medium. The unfortunate result is that a large part of Kushner's project—the intellectually ambitious, theatrically daring gestures meant to make us think abstractly about the workings of the cosmos and of large movements in history and the great forces that animate human affairs—now feel strained and inconsequential, while simultaneously showing up certain of the work's excesses. To imply that the AIDS crisis was more likely to make the heavens break apart than any number of other disasters of the twentieth century suggests, now, a myopia that was the result of the crisis footing that many of us were on ten years ago.

On the other hand, television, precisely because it is so intimate, can focus your attention on, and make you feel, an actor's performance more minutely than can be the case in the theater, and the mostly excellent performances that Nichols has drawn from his cast—some are superb—help to illuminate, and even transform, aspects of Kushner's text. The big stars are Al Pacino and Meryl Streep, he as a deeper, more complex, and surprisingly more sympathetic Cohn than the character was in the stage production (there's a remarkable scene, which hovers somewhere between the heartbreaking and the grotesque, in which Cohn manipulates Rosenberg's ghost into singing a Yiddish lullaby to him, and you don't know whether to loathe or thank the character for making it happen), and she as Ethel Rosenberg—and, even better, as a properly flinty Hannah Pitt. (As she leaves Prior's hospital room the morning after the Angel's final apparition, he thanks her by campily quoting Blanche DuBois's "I've always depended on the kindness of strangers," to which Hannah tersely replies, "Well that's a stupid thing to do.") In what is surely a tongue-in-cheek nod to her famous versatility, Streep even plays the rabbi whose eulogy opens the work. Of particular note are the two young actors who play Louis and Joe: respectively Ben Shenkman, who suggests the nervousness and guilt behind the know-it-all intellectual posing of this seriously selfish character, and, even more, the remarkable Patrick Wilson as Joe Pitt, a character who, thanks to Wilson's subtle and anguished performance, comes across in the televi-

sion film as far more tragic than had been the case on Broadway—and, I'm now convinced, than even Kushner knew, or perhaps wanted.

Less appealing, and more damaging to your sense of the balance of the text, are the cliché madwoman-in-the-attic, off-rhythm mumblings of Mary-Louise Parker as Harper, and the misfired performance by Emma Thompson as the Angel. (She also plays a homeless woman and, disastrously, the brisk Italian-American nurse who watches over Prior in the hospital.) On Broadway in 1993, Marcia Gay Harden had a solidity and concreteness that made Harper's slide into madness all the more pathetic—her physical presence provided some traction; whereas Mary-Louise Parker's wispy, whiny, one-note pathos seemed culled from old Julie Harris movies, and got to be grating fairly early on. (This Harper makes you realize, now, how necessary it is for the play to work that we feel sorry for her, that she be a victim.) And Thompson's Angel, writhing in her harness and seeming always to be on the verge of giggling, has none of the angular authority that Ellen McLaughlin brought to the role onstage, and as a result you cringe through the Angel's scenes.

One result of these performances, good and bad, was that you were likely to shift your focus in different directions—to notice different elements of the play, to reevaluate characters. To my mind, the most significant result of this refocusing—away from the supernatural material, away from those characters you felt compelled to feel sorry for or admire (the fact that the black drag queen is the fount of all wisdom and realism in the play strikes you now, if anything, as patronizing)—was to be made aware of a fundamental dishonesty, something not fully worked out or perhaps even avoided, at the heart of *Angels*. The terrible anguish evident in every facet of Patrick Wilson's fierce performance as Joe Pitt—his telephonic coming-out conversation was, for those of us who have had conversations like that, almost impossible to watch—made me realize, as I had not done before, that Joe is, in fact, the only truly tragic—Greek-tragic, that is—character in the play. And yet the play itself seems neither to know nor acknowledge this; if anything, Kushner goes to no little lengths to make us think of Joe as morally deficient, when in fact he isn't. Why?

From the beginning of "Millennium Approaches," we are asked to see Joe as an exact structural counterpart to that other lover who abandons his spouse, Louis. Many elements in the play invite us to draw parallels between the two men—not merely the fact that they end up in each other's arms, but even more to the point, the number of split scenes that the two unhappy couples (Louis/Prior and Joe/Harper) share. (In the film version, the splitting is elegantly conveyed by some very adroit cross-cutting between the two pairs at crucial moments.) And yet this parallelism is surely both unfair and unbalanced. Louis, after all, abandons Prior out of weakness and fear of AIDS, whereas Joe abandons Harper because of his dawning self-knowledge: in order to be who he really is, he can't remain in a marriage that has become a lie. It's true that both Louis and Joe cause their loved ones to suffer horribly, but this ostensible similarity is undercut by an important moral difference: the freedom and happiness Louis seeks—freedom from messy diseases, freedom from responsibility to someone else—isn't, in fact, a bona fide good (it's just selfishness), whereas most of us, today, would agree that for Joe to come out of the closet, to realize and emancipate his true self, is both a psychological good and, in the end, a moral necessity, whatever the temporary pain it causes.

And yet the moral difference—the difference that ought to redeem Joe—is overlooked in *Angels*; indeed, in the television version, it's papered over quite purposefully. There's a scene in the stage version of "Perestroika" in which Hannah confronts her son after he's gone to live with Louis; she hasn't heard from him in weeks, and they have a spat in the Mormon Visitors Center, where she's got herself a job. Exasperated, Joe cries out that he's fled the breadth of a continent to get away from her. "And what are you running away from now?" she snaps. "You and me," he replies. In the film version, some lines have been added between Hannah's impatient question and her son's weary answer, and the addition is a telling one, because it reveals a failure of sympathy on the author's part, which in turn illuminates a great problem of the play:

HANNAH: And what are you running away from now? You have a responsibility to your wife, and you cannot wish it away.
JOE: I want to—I don't know anymore what I want.
HANNAH: What you want, what you want. Well, that shifts with

the breeze. How can you steer your life by what you want?
Hold to what you *believe*.

The added exchange is clearly an attempt to saddle Joe with a moral failure (he's failed in responsibility to his wife, a responsibility that cannot be wished away) and, further and much more doubtful, to make it seem as if the reason for his abandonment is a kind of selfish, self-indulgent whim, like the reason for Louis's abandonment of Prior: "What you want, what you want," his mother dismissively snipes, as if the desire to be a fully fledged human being unashamed of his most profound self is nothing more than a between-meal snack. It's an odd line for a gay playwright to have written: you somehow suspect that, in real life, Kushner doesn't expect gay men to remain in false marriages to make their mothers happy.

The truth of his inner nature is of course a great deal more than a whim, and it's for this reason that the spectacle of Joe's suffering is a true tragic spectacle: which is to say, the spectacle of a man torn between two competing goods (his happiness, his wife's sanity), neither of which can be attained without the destruction of the other. In the classical sense, Joe is the only character in the entire work deserving of those tragic emotions, pity and fear; he's the only character who has a kind of Sophoclean grandeur. Or, that is, should have, but doesn't—because instead of working through the meaning of Joe's conundrum, Kushner sweeps it under the dramatic rug, trying to persuade us that, like Louis, he's just a selfish monster. (The real evil that Joe does—the legal opinions that he composes— can be seen as a function, if anything, of his closetedness; like many closeted gay men, he is attracted to repressive ideologies that seem to promise the "order" he craves at this stage, the control he wants over his own irrepressible desires.)

Indeed, of all the desertions that *Angels* depicts, none is as striking as the desertion of Joe by his creator. *Angels* presents many images of suffering: Prior's abandonment and illness; Harper's loneliness and madness; Cohn's pain; Rosenberg's death; the angels' confusion; the discrimination and racism to which Belize alludes; Hannah's nervous failure as a mother, for which her compensatory crispness can barely cover; even selfish Louis's spasms of guilt and self-torment. Each of these characters

is, by the end of the play, healed, comforted, or forgiven. Prior's fever breaks, and we are meant to understand that he'll grow better (in the epilogue, we learn that he's doing just fine on AZT); Harper asserts herself, grabs Joe's credit card, and takes a night flight to San Francisco to start a new, emancipated life; Hannah is seen at the end of the play, relaxed, attractively dressed in New Yorker chic, amiably chatting with her new gay pals; Louis has been forgiven, if not taken back, by Prior; and, as we know, even Roy Cohn is absolved, by no less a personage than his most famous victim, Ethel Rosenberg. Of all the sufferers in *Angels*, only Joe is left alone at the end, the only character who is neither forgiven nor redeemed in a way that conforms to Kushner's sense of "Perestroika" as a "comedy."

Why is this? When you look over the cast of characters in *Angels* and think about whom we're supposed to sympathize with, and who gets forgiven, you can't help noticing that the most sympathetic, the "best" characters are either ill, or women, or black, or Jewish. Looking over this rather PC list, it occurs to you to wonder whether, in the worldview of this play's creator, the reason why Joe Pitt—who alone of the characters is the most genuinely and interestingly torn, who in fact seeks love the hardest and suffers the most for self-knowledge—can't be forgiven by his creator, and is the only character who goes unredeemed in some way at the end of the play, is that he's a healthy, uninfected, white, Anglo-Saxon, male Christian. This in turn makes you realize how much of the second part of this play depends, from the in-joke of San Francisco as Heaven to the closing scene (in which Prior addresses the audience and in a valedictory blessing vapidly declares us all to be "fabulous creatures, each and every one") on a certain set of glib, feel-good, rather parochial assumptions about the world, assumptions that in the end undercut the ambitions and, occasionally, the pretensions of what has come before. I, for one, would have respected much more a play that invited its presumably liberal, often largely gay or gay-friendly audiences to see as its central and truly tragic figure a white, healthy, Protestant male on the verge of something truly transformative and redeeming: not illness and suffering, but self-knowledge. When all is said and done, *Angels* itself is guilty of its own kind of reprehensible abandonment: abandonment of the tragic for the merely sentimental, of real intellectual challenges for feel-good nostrums, of hard questions

about guilt and responsibility for easy finger-pointing at all the usual suspects.

For this reason, it's hard to know just how the television *Angels* is going to play during its inevitable reruns and airings during the next few months. The excitement that greeted the six-hour, $60 million production has had, perhaps appropriately, something of the messianic about it—something redolent more of those latter-day, heralding, biblical angels than of their drab classical forbears. *The New York Times* devoted not one but two front-page Arts & Leisure articles (on the same day) to Kushner and the *Angels* film; *The New Yorker* deemed the TV version "cause for celebration." More ecstatic than either by far was *The Washington Post*, which declared the TV film "awesome," "spectacular," and "one of the most dazzling movies ever made for television or any other means of projecting a film." I say "messianic" because, behind all this enthusiasm, it was hard not to detect a sense of deep satisfaction that Kushner's American epic was finally going to be seen in—well, in America. "The number of people who see it the very first night should easily outnumber those who have seen the play in the several hundred North American stage productions since it opened on Broadway 10 years ago," the *Times* exulted in one of its two articles, entitled "Hurricane Kushner Hits the Heartland."

Within *Angels* lurks that great work about America itself, one that could well speak to the heartland, a work about migrations and revelations and about the essential tragedy of American and possibly even human experience, in which one person's liberation—now more than ever before—often means another's suffering. But the play as we have it is a more limited affair, one meant to reassure not the heartland but the marginal groups whom the play cozily addresses. What, in the end, can the "heartland" be expected to make of the play's real message: that those who come from it are unforgiven, and unforgivable, by those of us who reside on the coasts? Still, the fanfares are loud. Not for the first time, in the case of angels, will the messenger have outdazzled the message.

An Affair to Remember

*B*rokeback Mountain—the highly praised new movie as well as the short story by Annie Proulx on which the picture is faithfully based—is a tale about two homosexual men. Two gay men. To some people it will seem strange to say this; to some other people, it will seem strange to have to say it. Strange to say it, because the story is, as everyone now knows, about two young Wyoming ranch hands who fall in love as teenagers in 1963 and continue their tortured affair, furtively, over the next twenty years. And as everyone also knows, when most people hear the words "two homosexual men" or "gay," the image that comes to mind is not likely to be one of rugged young cowboys who shoot elk and ride broncos for fun.

Two homosexual men: it is strange to have to say it just now because the distinct emphasis of so much that has been said about the movie—in commercial advertising as well as in the adulatory reviews—has been that the story told in *Brokeback Mountain* is not, in fact, a gay story, but a sweeping romantic epic with "universal" appeal. The lengths to which reviewers from all over the country, representing publications of various ideological shadings, have gone in order to diminish the specifically gay element is striking, as a random sampling of the reviews collected

on the film's official Web site makes clear. *The Wall Street Journal*'s critic asserted that "love stories come and go, but this one stays with you— not because both lovers are men, but because their story is so full of life and longing, and true romance." The *Los Angeles Times* declared the film to be

> a deeply felt, emotional love story that deals with the uncharted, mysterious ways of the human heart just as so many mainstream films have before it. The two lovers here just happen to be men.

Indeed, a month after the movie's release most of the reviews were resisting, indignantly, the popular tendency to refer to it as "the gay cowboy movie." "It is much more than that glib description implies," the critic of the Minneapolis *Star Tribune* sniffed. "This is a human story." This particular rhetorical emphasis figures prominently in the advertising for the film, which in quoting such passages reflects the producer's understandable desire that *Brokeback Mountain* not be seen as something for a "niche" market but as a story with broad appeal, whatever the particulars of its time, place, and personalities. (The words "gay" and "homosexual" are never used of the film's two main characters in the forty-nine-page press kit distributed by the filmmakers to critics.) "One movie is connecting with the heart of America," one ad that's part of the current publicity campaigns declares; the ad shows the star Heath Ledger, without his male costar, Jake Gyllenhaal, grinning in a cowboy hat. A television ad that ran immediately after the Golden Globe awards a few weeks ago showed clips of the male leads embracing their wives, but not each other.

The reluctance to be explicit about the film's themes and content was evident at the Golden Globes themselves, where the film took the major awards: for best movie drama, best director, and best screenplay. When a short montage of clips from the film was screened, it was described as "a story of monumental conflict"; later, the actor reading the names of nominees for best actor in a movie drama described Heath Ledger's character as "a cowboy caught up in a complicated love." After Ang Lee received the award he was quoted as saying, "This is a universal story. I just wanted to make a love story."

Because I am as admiring as almost everyone else of the film's many

excellences, it seems to me necessary to counter this special emphasis in the way the film is being promoted and received. For to see *Brokeback Mountain* as a love story, or even as a film about universal human emotions, is to misconstrue it very seriously—and in so doing inevitably to diminish its real achievement.

Both narratively and visually, *Brokeback Mountain* is a tragedy about the specifically gay phenomenon of the closet—about the disastrous emotional and moral consequences of erotic self-repression and of the social intolerance that first causes and then exacerbates it. What love story there is occurs early on in the film, and briefly: a summer's idyll herding sheep on a Wyoming mountain, during which two lonely youths, taciturn Ennis and high-spirited Jack, fall into bed, and then in love, with each other. The sole visual representation of their happiness in love is a single brief shot of the two shirtless youths horsing around in the grass. That shot is eerily—and significantly—silent, voiceless: it turns out that what we are seeing is what the boys' disgusted boss is seeing through his binoculars as he spies on them.

After that—because their love for each other can't be fitted into the lives they think they must lead—misery pursues and finally destroys the two men and everyone with whom they come in contact, with the relentless thoroughness you associate with Greek tragedy. By the end of the drama, indeed, whole families have been laid waste. Ennis's marriage to a conventional, sweet-natured girl disintegrates, savaging her simple illusions and spoiling the home life of his two daughters; Jack's nervy young wife, Lureen, devolves into a brittle shrew, her increasingly elaborate and artificial hairstyles serving as a visual marker of the ever-growing mendacity that underlies the couple's relationship. Even an appealing young waitress, with whom Ennis after his divorce has a flirtation (an episode much amplified from a bare mention in the original story), is made miserable by her brief contact with a man who is as enigmatic to himself (as we know but she does not) as he is to her. If Jack and Ennis are tainted, it's not because they're gay, but because they pretend not to be; it's the lie that poisons everyone they touch.

As for Jack and Ennis themselves, the brief and infrequent vacations that they are able to take together as the years pass—"fishing trips" on

which, as Ennis's wife points out late in the story, still choking on her bitterness years after their marriage fails, no fish were ever caught—are haunted, increasingly, by the specter of the happier life they might have had, had they been able to live together. Their final vacation together (before Jack is beaten to death in what is clearly represented, in a flashback, as a roadside gay-bashing incident) is poisoned by mutual recriminations. "I wish I knew how to quit you," the now nearly middle-aged Jack tearfully cries out, humiliated by years of having to seek sexual solace in the arms of Mexican hustlers. "It's because of you that I'm like this—nothing, nobody," the dirt-poor Ennis sobs as he collapses in the dust. What Ennis means, of course, is that he's "nothing" because loving Jack has forced him to be aware of real passion that has no outlet, aware of a sexual nature that he cannot ignore but which neither his background nor his circumstances have equipped him to make part of his life. Again and again over the years, he rebuffs Jack's offers to try living together and running "a little cow and calf operation" somewhere: he is hobbled by his inability even to imagine what a life of happiness might look like.

One reason he can't bring himself to envision such a life with his lover is a grisly childhood memory, presented in flashback, of being taken at the age of eight by his father to see the body of a gay rancher who'd been tortured and beaten to death—a scene that prefigures the scene of Jack's death. This explicit reference to childhood trauma suggests another, quite powerful, reason why *Brokeback* must be seen as a specifically gay tragedy. In another review that decried the use of the term "gay cowboy movie" ("a cruel simplification"), the *Chicago Sun-Times*'s critic, Roger Ebert, wrote with ostensible compassion about the dilemma of Jack and Ennis, declaring that "their tragedy is universal. It could be about two women, or lovers from different religious or ethnic groups—any 'forbidden' love." This is well-meaning but very seriously misguided. The tragedy of heterosexual lovers from different religious or ethnic groups is, essentially, a social tragedy; as we watch it unfold, we are meant to be outraged by the irrationality of social strictures that prevent the two from loving each other, strictures that the lovers themselves may legitimately rail against and despise.

But those lovers, however star-crossed, never despise *themselves*. As *Brokeback* makes so eloquently clear, the tragedy of gay lovers like Ennis

and Jack is only secondarily a social tragedy. Their tragedy, which starts well before the lovers ever meet, is primarily a psychological tragedy, a tragedy of psyches scarred from the very first stirrings of an erotic desire that, beginning in earliest childhood, in the bosom of their families (as Ennis's grim flashback is meant to remind us), the world around them represents as unhealthy, hateful, and deadly. Romeo and Juliet (and we) may hate the outside world, the Capulets and Montagues, may hate Verona; but because they learn to hate homosexuality so early on, young people with homosexual impulses more often than not grow up hating *themselves*—they believe that there's something wrong with themselves long before they can understand that there's something wrong with society. This is the truth that Heath Ledger, who plays Ennis, clearly understands—"Fear was instilled in him at an early age, and so the way he loved disgusted him," the actor has said—and that is so brilliantly conveyed by his deservedly acclaimed performance. On screen, Ennis's self-repression and self-loathing are given startling physical form: the awkward, almost hobbled quality of his gait, the constricted gestures, the way in which he barely opens his mouth when he talks all speak eloquently of a man who is tormented simply by being in his own body—by being himself.

So much, at any rate, for the movie being a love story like any other, even a tragic one. To their great credit, the makers of *Brokeback Mountain*—the writers Larry McMurtry and Diana Ossana, the director Ang Lee—seem, despite the official rhetoric, to have been aware that they were making a movie specifically about the closet. The themes of repression, containment, the emptiness of unrealized lives—all ending in the "nothingness" to which Ennis achingly refers—are consistently expressed in the film, appropriately enough, by the use of space; given the film's homoerotic themes, this device is particularly meaningful. The two lovers are only happy in the wide, unfenced outdoors, where exuberant shots of enormous skies and vast landscapes suggest, tellingly, that what the men feel for each other is indeed "natural." By contrast, whenever we see Jack and Ennis indoors, in the scenes that show the failure of their domestic and social lives, they look cramped and claustrophobic. (Ennis in particular is often seen in reflection, in various mirrors: a figure imprisoned in a tiny frame.) There's a sequence in which we see Ennis in Wyoming, and then Jack in Texas, anxiously

preparing for one of their "fishing trips," and both men, as they pack for their trip—Ennis nearly leaves behind his fishing tackle, the unused and increasingly unpersuasive prop for the fiction he tells his wife each time he goes away with Jack—pace back and forth in their respective houses like caged animals.

The climax of these visual contrasts is also the emotional climax of the film, which takes place in two consecutive scenes, both of which prominently feature closets—actual closets. In the first, a grief-stricken Ennis, now in his late thirties, visits Jack's childhood home, where in the tiny closet of Jack's almost bare room he discovers two shirts: his and Jack's, the clothes they'd worn during their summer on Brokeback Mountain, Ennis's protectively encased within Jack's. (At the end of that summer, Ennis had thought he'd lost the shirt; only now do we realize that Jack had stolen it for this purpose.) The image—which is taken directly from Proulx's story—of the two shirts hidden in the closet, preserved in an embrace which the men who wore them could never fully enjoy, stands as the poignant visual symbol of the story's tragedy. Made aware too late of how greatly he was loved, of the extent of his loss, Ennis stands in the tiny windowless space, caressing the shirts and weeping wordlessly.

In the scene that follows, another misplaced piece of clothing leads to a similar scene of tragic realization. Now middle-aged and living alone in a battered, sparsely furnished trailer (a setting with which Proulx's story begins, the tale itself unfolding as a long flashback), Ennis receives a visit from his grown daughter, who announces that she's engaged to be married. "Does he love you?" the blighted father protectively demands, as if realizing too late that this is all that matters. After the girl leaves, Ennis realizes she's left her sweater behind, and when he opens his little closet door to store it there, we see that he's hung the two shirts from their first summer (Jack's now encased protectively within Ennis's) on the inside of the closet door, below a tattered postcard of Brokeback Mountain. Just as we see this, the camera pulls back to allow us a slightly wider view, which reveals a little window next to the closet, a rectangular frame that affords a glimpse of a field of yellow flowers and the mountains and sky. The juxtaposition of the two spaces—the cramped and airless closet, the window with its unlimited vistas beyond—efficiently but wrenchingly suggests the man's tragedy:

the life he has lived, the life that might have been. His eyes filling with tears, Ennis looks at his closet and says, "Jack, I swear. . . . " But he never completes his sentence, just as he never completed his life.

One of the most tortured, but by no means untypical, attempts to suggest that the tragic heroes of *Brokeback Mountain* aren't "really" gay appeared in, of all places, the *San Francisco Chronicle*, where the critic Mick LaSalle argued that the film is

> about two men who are in love, and it makes no sense. It makes no sense in terms of who they are, where they are, how they live and how they see themselves. It makes no sense in terms of what they do for a living or how they would probably vote in a national election. . . .
>
> The situation carries a lot of emotional power, largely because it's so specific and yet undefined. The two guys—cowboys—are in love with each other, but we don't ever quite know if they're in love with each other because they're gay, or if they're gay because they're in love with each other.
>
> It's possible that if these fellows had never met, one or both would have gone through life straight.

The statement suggests what's wrong with so much of the criticism of the film, however well meaning it is. It seems clear by now that *Brokeback* has received the attention it's been getting, from critics and audiences alike, at least partly because it seems on its surface to make normal what many people think of as gay experience—bringing it into the familiar "heart of America." (Had this been the story of, say, the love between two closeted interior decorators living in New York City in the 1970s, you suspect that there wouldn't be full-page ads in the major papers trumpeting its "universal" themes.) But the fact that this film's main characters look like cowboys doesn't make them, or their story, any less gay. Criticisms like LaSalle's, and those of the many other critics trying to persuade you that *Brokeback* isn't "really" gay, that Jack and Ennis's love "makes no sense" because they're Wyoming ranch hands who are likely to vote Republican, only work if you believe that

being gay means being some specific, essential thing—having a certain look, or lifestyle (urban, say), or politics; that it's anything other than the bare fact of being erotically attached primarily to members of your own sex.

Indeed, the point that gay people have been trying to make for years—a point that *Brokeback* could be making now, if so many of its vocal admirers would listen to what it's saying—is that there's no such thing as a typical gay person, a strangely different-seeming person with whom Jack Twist and Ennis Del Mar have nothing in common—thankfully, you can't help feeling, in the eyes of many commentators. (It is surely significant that the film's only major departure from Proulx's story are two scenes clearly meant to underscore Jack's and Ennis's bona fides as macho American men: one in which Jack successfully challenges his boorish father-in-law at a Thanksgiving celebration, and another in which Ennis punches a couple of biker goons at a July Fourth picnic—a scene that culminates with the over-the-top image, familiar from the trailer, of Ennis standing tall against a skyscape of exploding fireworks.) The real achievement of *Brokeback Mountain* is not that it tells a universal love story that happens to have gay characters in it, but that it tells a distinctively gay story that happens to be so well told that any feeling person can be moved by it. If you insist, as so many have, that the story of Jack and Ennis is OK to watch and sympathize with because they're not really homosexual—that they're more like the heart of America than like "gay people"—you're pushing them back into the closet whose narrow and suffocating confines Ang Lee and his collaborators have so beautifully and harrowingly exposed.

—*The New York Review of Books,* February 23, 2006

The Man Behind the Curtain

Who knows how classical scholarship might have evolved if Oscar Wilde had gone to grad school? Already at boarding school, and later at college, the young Oscar's mastery of both Greek and Latin was legendary. "The flowing beauty of his oral translations in class," a schoolmate later recalled to Wilde's biographer Frank Harris, "whether of Thucydides, Plato, or Virgil, was a thing not easily to be forgotten." Among the many classics prizes he carried off was his school's gold medal for Greek. (The essay subject was, perhaps prophetically, "The Fragments of the Greek Comic Poets, as edited by Meineke.") When Wilde went up to Oxford, it was on a classics scholarship; he left it with a prestigious double First in Greats. Yet when he was asked what he proposed to do after leaving, the otherwise aporetic undergraduate ("God knows," was his immediate response) was emphatic about at least one thing. "I won't be a dried-up Oxford don, anyhow," the twenty-four-year-old replied. "I'll be a poet, a writer, a dramatist. Somehow or other I'll be famous, and if not famous, I'll be notorious."

Times have changed. As the current *siècle* lurches to its own *fin*, ambitious young classics graduates need hardly choose between philology and fame. According to a recent *New York Times Magazine* report on the

Modern Language Association convention—the annual gathering of literature professors where scholarly papers are given, job interviews are conducted, and professional contacts maintained or made—many of today's dons aspire to an A-list world of six-figure salaries and fast-lane accessories. Some, like NYU's Weather-Channel *Wunderkind* Andrew Ross, have publicly traded in their Harris tweed blazers for the considerably more *recherché* creations available at Comme des Garçons; others, like archaeologist Iris Love, have come to be associated less with Doric or Ionic than with columns of a more gossipy order. As you sit in your dentist's waiting room, you can read about Professor Ross in *New York* magazine, or Cornel West in the newly hot *New Yorker*.

These, however, are merely the external symptoms of more substantive, and indeed more desirable, developments in the relations between the academy and the real world since 1878. If academics have been power-lunching along with everyone else lately, it's because they've got more . . . well, power. For the first time in over a generation, professional scholars are actively participating in public life.

It is no accident that many of the scholars who do so are, like Wilde, "marginal" in some sense: women, gays, African-Americans, professors whose intellectual energies have been focused on recuperating lost or long-repressed voices from those margins. On the face of it, this agenda is more closely entwined with their personal experience than are the professional activities of those who study, say, Greek grammar or patristic church history. Over the past few years, the writings and public appearances of such scholar-stars as Catharine MacKinnon and Cornel West and Martha Nussbaum have done much to change the way we think about the potential for symbiosis between scholarship and public life. (Because she has written a lot about Plato's *Symposium*, for instance, the last of those three testified as an expert witness in hearings on the constitutionality of Colorado's anti-gay Proposition 2 in 1993.)

The reappearance of professional intellectuals in the public arena would appear to be a healthy corrective to the cultural ailment plaintively diagnosed by Russell Jacoby in his 1987 study *The Last Intellectuals*. In this book, Jacoby catalogs a number of factors that have contributed to the decline of vigorous and intelligent discourse in America. Among these he counts the rise of suburbia and the accompanying diffusion of urban centers of intellectual life, and of course television, which Jacoby

rightly blames for having eroded the public's critical acumen, to say nothing of overall intelligence. But for him none of these factors is more critical than the increasingly narrow restriction of serious intellectual activity over the past two generations to a highly professionalized and hence ultimately solipsistic academic elite.

Despite its sometimes frivolous accoutrements, therefore, scholarly engagement with "real" life appears to be a good thing—from whichever end of the political spectrum such engagement may come. This is true both for the scholars themselves and for the public they address. In the case of the former, the opportunity to apply sophisticated techniques and erudite insights to (as it were) a living subject helps to inoculate against what George Steiner, in an essay on the case of Sir Anthony Blunt, once referred to as *odium philologicum*, that all-too-familiar perversion of perspective that results when the objects of intellectual inquiry occlude our vision of the everyday world. (By airing his thoughts in the pages of *The New Yorker*, Steiner was practicing what he preached.) And the participation of professional intellectuals in public discussion of urgent everyday issues presumably raises the level of that discourse itself, bringing to it the expertise, erudition, and argumentative finesse expected of those who have undergone rigorous intellectual and scholarly training.

All of these developments take on a certain poignancy when you think back on the fate of poor Oscar Wilde, whose postgraduate career, viewed from the comfortable vantage point afforded by hindsight, assumes a depressingly familiar Sophoclean shape. At first, Wilde's choice of fame over philology seemed a good one: he became very famous indeed. The astonishing verbal facility that had won him all the glittering prizes at university became the weapon with which he skewered Victorian convention, thereby earning him considerable literary *kleos*. But the dazzling intellectual self-assurance gradually fermented into the deluded hubris of his libel suit, followed by the nemesis of a humiliating public defeat. (Even his wit betrayed him: his glittering, flippant responses during the trial were what destroyed his case.) Wilde was the Ajax of early literary celebrity, impaled on his own desire for fame. After the brief stint of penal servitude, he fled to Paris, where he expired in the last year of the last century, outlived by Victoria herself.

And so, despite the recent erosion of the once-rigid distinctions that

forced Wilde to choose between philology and fame—and by "fame" I mean conspicuousness within, and impact upon, the outside, public, "real" world—every now and then you're still tempted to see in his unhappy trajectory from Magdalen to maudlin a sort of morality tale. Sometimes, it's safer to stick to stichomythia.

I couldn't help thinking of Wilde as I read and reread a recent book by another precociously gifted philologue who, like Wilde, came to chafe at the dried-up donnish bit, and who as a result sought an audience outside of the academy's walls. His book is, in fact, expressly aimed at a broadly public rather than a narrowly academic audience, and toward that end was published by a trade rather than university press. Indeed, like much of Wilde's oeuvre, this work seeks to present a devastating indictment of social and especially religious hypocrisy on the subject of human sexuality. It is a nice further coincidence that its late author was, like Wilde, charming, personable, erudite, and above all an extraordinarily gifted linguist. (His defenders invariably point to his expertise in such arcane tongues as Old Church Slavonic.) And like Wilde, he was a homosexual who suffered both personally and, according to some, professionally for it.

The book I am talking about is John Boswell's *Same-Sex Unions in Premodern Europe*. In it, the author claims to have unearthed a medieval ecclesiastical ceremony known as the *adelphopoiêsis* which, he argues, was in fact a liturgy to be performed at (primarily male) homosexual marriages. As much today as a hundred years ago, that is the kind of claim that makes you very notorious indeed.

The tortured relationship between homosexuality and Roman Catholicism is familiar territory for Boswell's readers—as it was, indeed, for Boswell himself. In his extremely well received 1980 study *Christianity, Social Tolerance, and Homosexuality*, published by the University of Chicago Press, Boswell shed welcome light on the early Church's by no means straightforward attitude toward male homosexuality. Hence though he was to eventually become generally (and laudably) more cautious about the anachronistic use of words like "gay" to describe the affective states experienced by members of cultures radically different from our own, Boswell's latest project may be seen as the next charge in

a polemic whose opening salvo was fired nearly fifteen years ago. There is little doubt, moreover, that this scholarly interest was fueled by deep personal feeling. Boswell, a homosexual, was also a devout Catholic.

In view of the undeniably powerful political uses to which the Church's institutionalized opposition to homosexuality has been put over the centuries, it was inevitable that what began as the author's personal and scholarly interest in destabilizing the theological and historical premises for the Church's position should end up serving a political purpose as well. This last consideration explains why, upon its publication in the summer of 1994, *Same-Sex Unions* won the kind of fame—and notoriety—that would have warmed even Oscar Wilde's heart. The apogee of this publicity was the triumphant citation of Boswell's book in the popular comic strip *Doonesbury*. "For 1,000 years the Church sanctioned rituals for *homosexual* marriages," declares Mark Slackmeyer, a gay character who has recently come out; he then goes on to mention the source for his information: the "new book by this Yale professor."

Given the political climate at the time of the book's publication, you can hardly blame Slackmeyer for his enthusiasm. If they were indeed what Boswell says they were, the ecclesiastical ceremonies discussed in *Same-Sex Unions* would be considered by many to be powerful ammunition in the increasingly ugly battles about social tolerance now being fought in America. Among the liberal press and especially gay activists, it was hoped that what Boswell's publisher, Villard, calls his "sensational discovery" would, in the words of an approving *Nation* reviewer, "have a chance of intervening effectively in this debate [i.e., over gay marriage]." This fantasy of "effective intervention" is a potent one: how nice it would be for us gay men and women to go clumping down to the Senate floor, Byzantine manuscripts firmly in hand, and hurl the appropriate bits of papyrus and vellum into Senator Helms's empurpled visage. In more ways than one, it would all be Greek to him.

This makes it all the more unfortunate, both for that political project and for Boswell's posthumous reputation (he died a few months after the book's publication in 1994), that the only people who have reason to be intimidated by Boswell's ceremonies of *adelphopoiêsis*—and, perhaps more important, the only people likely to use them as weapons in a political battle—are, in fact, those who have no Greek: that is, readers who lack the training and expertise necessary to evalu-

ate what are, in the end, this work's very dubious claims. For seen as a work of philology, *Same-Sex Unions in Premodern Europe* is a bad book. Its arguments are weak, its methods unsound, its conclusions highly questionable. Most disturbing of all is its rhetorical stance: the complexities and ambiguities of the historical, literary, and linguistic material Boswell discusses are of a very high order indeed, and hence give the lie to his rather disingenuous assertion that no specialized scholarly training is necessary to the proper evaluation of this book. (Professional scholars have been arguing heatedly over his conclusions since the day the book appeared.) Given the author's inevitable awareness of his thesis's potential impact on a wider public discourse, his decision to target precisely those readers who have no particular expertise is alarming.

Seen, however, as a work of that other category—"fame"—*Same-Sex Unions* has been considerably more successful; even Professor Nussbaum didn't make it to *Doonesbury*. In Boswell's case, what's striking is that so obvious a philological failure should be accompanied by so great a public impact. This correlation, I think, should provoke serious discussion about the means by which intellectual celebrity is achieved and the aims to which it can be put. In the end, *Same-Sex Unions in Premodern Europe* provokes questions that are far more disturbing than the "controversial" answers it claims to provide. It exemplifies the dangers inherent in careless cross-pollination of scholarship and politics, of philology and fame.

——————

Why all the fuss? That's an easy one. Pretty much any evidence that marriages between male homosexuals were performed under the auspices of the early Church would certainly put a crimp in the Vatican's current rhetorical style. Referring to increasing debate about the legalization of same-sex marriages in (post)modern Europe and America— at the time of the present article's publication, it is on the constitutional agenda in Hawaii—Pope John Paul II denounced such unions as "a serious threat to the future of the family and society."

I should say at the outset that I characterize Boswell's book as being about "gay marriages," despite the fact that some have defended his book

from scholarly skepticism precisely on the grounds that Boswell himself carefully eschews that tendentious term in favor of the ostensibly more judicious "same-sex unions." To do so, these defenders argue, bespeaks a praiseworthy scholarly prudence. Although it is true that Boswell himself hedges his rhetorical bets in this fashion, the overarching thrust of his arguments, his own description of the unions as celebrating "permanent romantic commitment," the enormous quantity of material he marshals concerning both the language and diction of erotic (versus, say, agricultural) activity in the ancient world and about the history of homosexual relationships from archaic Greece to the early years of the Christian Church—all this makes it clear that what Boswell is talking about in this book is what his intended audience of nonscholars will surely understand as "gay marriages celebrated by the church."

Indeed, when halfway through his study Boswell pauses to frame one of three "nonpolemical" questions that a responsible historian faced with the manuscripts in question might pose—"Was it a marriage?"—Boswell is, in his own words, "unequivocal":

> The answer to this question depends to a considerable extent on one's conception of marriage, as noted in the Introduction. According to the modern conception—i.e., a permanent emotional union acknowledged in some way by the community—it was unequivocally a marriage. (p. 190)

It seems more than likely that, to Boswell's own unequivocally modern audience, "same-sex unions" will be taken as meaning "gay marriages." These are Boswell's own words. If the "unions" he's talking about here are any other than the kind of affective, mutual, primarily erotic partnerships that people today understand as constituting a marriage, then his elaborate dissertation becomes a pointless exercise. To deny this essential point, or to hide behind sophistries about the alleged neutrality of the English term "same-sex" as opposed to "gay," is disingenuous.

At the center of Boswell's four-hundred-page thesis about medieval gay marriages stands the text of an early Christian ceremony known as the *akolouthia* (occasionally *eukhê*), *eis adelphopoiêsin*, the "liturgy" (or "prayer") "for the creation of brothers"—or the "creation of lovers," depending on how figuratively you care to read the *adelpho-* (literally, "brother") in *adel-*

phopoiêsis. (This interpretive point, to which I shall return later, is the fulcrum of Boswell's thesis.) The service has survived in various versions in a large number of manuscripts from all over Europe. These documents date to the period between the tenth and fifteenth centuries. In order to provide proper cultural context for these strange texts, however, Boswell laudably devotes nearly a third of his study to what he sees as the Greek, Roman, and late antique "background" evidence; and it is to his handling of this material (often well over a millennium older than the manuscripts themselves) that I shall devote most of my own discussion. I do so because the foundation of Boswell's argument about the meaning of the *adelphopoiêsis* ceremony is, in fact, an interlocked series of interpretations of linguistic and cultural material that is primarily classical.

Since the *adelphopoiêsis* liturgy proved to be a novelty even to a highly trained medievalist like Boswell himself, it seems appropriate to give an example here. Of those furnished in Boswell's "Appendix of Documents," the one that is most ample and that contains the greatest quantity of material that could be construed as being helpful to the author's argument is the eleventh-century manuscript known as Grottaferrata Γ. β. II. I provide it here in Boswell's own translation, along with my own bracketed transliterations of important phrases from the original Greek. (I retain the author's italicization of the rubrics of priestly activity.)

OFFICE FOR SAME-SEX UNION
(akolouthia eis adelphopoiêsin)

i.

The priest shall place the holy Gospel on the Gospel stand and they that are to be joined together [hoi adelphoi] *place their <right> hands on it, holding lighted candles in their left hands. Then shall the priest cense them and say the following*:

ii.

In peace we beseech Thee, O Lord. For heavenly peace, we beseech Thee, O Lord.

For the peace of the entire world, we beseech Thee, O Lord.

For this holy place, we beseech Thee, O Lord.

That these thy servants, N. and N., be sanctified with thy spiritual benediction, we beseech Thee, O Lord.

That their love [*agapê*] abide without offense or scandal all the days of their lives, we beseech Thee, O Lord.

That they be granted all things needed for salvation and godly enjoyment of life everlasting, we beseech Thee, O Lord.

That the Lord God grant unto them unashamed faithfulness [*pistin akataiskhynton*] <and> sincere love [*agapên anypokriton*], we beseech Thee, O Lord.

That we be saved, we beseech Thee, O Lord.

Have mercy on us, O God.

"Lord, have mercy" shall be said three times.

iii.

The priest <shall say>: Forasmuch as Thou, O Lord and Ruler, art merciful and loving [*philôn*], who didst establish humankind after thine image and likeness, who didst deem it meet that thy holy apostles Philip and Bartholomew be united [*adelphous genesthai*], bound one unto the other not by nature but by faith and the spirit. As Thou didst find thy holy martyrs Serge and Bacchus worthy to be united together [*adelphous genesthai*], bless also these thy servants, N. and N., joined together not by the bond of nature but by faith and in the mode of the spirit, granting unto them peace and love and oneness of mind [*agapên kai homonoian*]. Cleanse from their hearts every stain and impurity, and vouchsafe unto them to love one other [*sic*] without hatred and without scandal [*to agapân allêlous amisêtôs kai askandalistôs*] all the days of their lives, with the aid of the Mother of God and all thy saints, forasmuch as all glory is thine.

iv.

ANOTHER PRAYER FOR SAME-SEX UNION
(*eukhê hetera eis adelphopoiêsin*)

O Lord our God, who didst grant unto us all those things necessary for salvation and didst bid us to love one another

[*agapân allêlous*] and to forgive each other our failings, bless and consecrate, kind Lord and lover of good, these thy servants who love each other with a love of the spirit [*pneumatikêi agapêi heautous agapêsantas*] and have come into this thy holy church to be blessed and consecrated. Grant unto them unashamed fidelity [and] sincere love [*agapê*], and as Thou didst vouchsafe unto thy holy disciples and apostles thy peace and love [*agapên*], bestow <them> also on these, O Christ our God, affording to them all those things needed for salvation and life eternal. For Thou art the light [and] the truth and thine is the glory.

<div align="center">v.</div>

Then shall they kiss the holy Gospel and the priest and one another, and conclude [apoluetai]:

ECCLESIASTICAL CANON OF MARRIAGE
OF THE PATRIARCH METHODIUS
[Kanôn ekklêsiastikos epi gamou, poiêma Methodiou patriarkhou]

O Lord our God, the designer of love [*agapê*] and author of peace and disposer of thine own providence, who didst make two into one and hast given us one to another, who hast [seen fit?] to bless all things pure and timeless, send Thou now down from heaven thy right hand full of grace and loving kindness over these thy servants who have come before Thee and given their right hands as a lawful token of union and the bond of marriage [*episynoikêsian kai syndesmon gamou*]. Sanctify and fill them with thy mercies. And wrapping the pair in every grace and in divine and spiritual radiance, gladden them in the expectation of thy mercies. Perfect their union [*synapheian*] by bestowing upon them peace and love and harmony [*agapên kai homonoian*], and deem them worthy of the imposition and consecration of the crowns, through the prayers of her that conceived Thee in power and truth; and those of all thy saints, now and forever.

VI.

And after this prayer the priest shall lift the crowns and dismiss them [apoluei autous].

This, then, is the ceremony of "same-sex union."

In beginning his discussion, Boswell describes this ritual as being swathed in mystery and even, perhaps, in danger. His own study of it, he informs us in the Preface, "was undertaken as the result of a notice about a ceremony of same-sex union sent to me by a correspondent who prefers not to be named." The hint at an urgent desire for anonymity provides a nice, John Grisham-y touch sadly absent from most scholarly prose; but the dark intimation that these rites were unknown to scholars is misleading. Since the end of the nineteenth century, when Giovanni Tomassia studied the ceremony, and into the twentieth when it was taken up again by Paul Koschaker, the *adelphopoiêsis* has been known to scholars. They have argued that the ceremonies celebrated some kind of "ritualized" friendship along the lines of a blood-brotherhood—a formalized relationship for which the parallels from ancient Mediterranean cultures, as the title of Gabriel Herman's 1987 study *Ritualized Friendship in the Greek City* suggests, are as numerous and well attested as are the competing parallels, drawn from the context of ancient sexual and erotic conventions, that Boswell adduces in support of his own argument. And indeed, nothing in the first four sections of this text (which closely resembles the entirety of the other examples Boswell gives) provides sufficient support for Boswell's "gay marriage" reading of the *adelphopoiêsis* over and above the less controversial and better-supported readings. The emphasis on peace, mutual Christian love, *agapê*, and aversion to scandal conform to any number of nonerotic interpretations—for example, that the ceremonies formalized alliances or reconciliations between heads of households or perhaps clans.

But few would contest the stunning and controversial force of the Grottaferrata manuscript's fifth part, which is indisputably a liturgy of Christian marriage, and indeed even of the sixth, with its reference to the traditional crowns of the Orthodox wedding service. On the force of this single document, as it appears in Boswell's Appendix, the case for gay marriage would seem to be incontrovertible.

The problem is that this is not, in fact, a single document: the fifth and sixth parts are almost certainly *not* part of the *adelphopoiêsis* ceremony. Rather, these appear to be the first two parts of an entirely separate, bona fide marriage ceremony—one of various kinship-related rituals that appear to have been collected in this and other of the various manuscripts in which the *adelphopoiêsis* liturgy appears. And here we come to the first example of what turns out to be a pattern of methodological and argumentative sins, both of commission and omission, on Boswell's part. Among these are a presentation of the evidence that is so tendentious as to be misleading; a highly selective use of anomalous or unrepresentative evidence to support key premises of the arguments; and a pervasive failure to account adequately for nuance and context in citing original sources. Subtending all of these is a rhetorical strategy whose disingenuousness verges on fraud, given the popularizing aims of Boswell's book: and here I refer to Boswell's self-serving deployment of notes and ancillary scholarship, the overall effect of which is to suppress information crucial to the proper interpretation of the arguments presented in the text itself.

Boswell previews his ostensibly harmless footnoting strategy in an introductory admonition to his readers:

> [A]lthough composing the pages that follow has required mastery of many different specialties (other than arcane languages), many readers may not be interested in the technical niceties of liturgical development or the details of moral and civil laws regarding marital status. *The text has been aimed, therefore, at readers with no particular expertise in any of the specialties that have undergirded the research*; all technical materials have been relegated to the notes, which will be of value to specialists *but can generally be skipped by other readers*. (p. xxx; emphases mine)

The author goes on to suggest that whole chapters may indeed be skipped by all except those interested in what he dismisses as "liturgical niceties"—the kind of stuff that is, he self-deprecatingly hints, "perhaps not fascinating for the general reader." I stress here, and shall emphasize again, how at the very outset of this study Boswell insinuates into his (general) audience's mind the notion that his copious footnotes will

deal with mere technicalities (he uses the words twice): that is, arcane fodder for the abstruse activity of "experts" and "specialists."

With this in mind, then, let us turn to the author's discussion of the Grottaferrata text. At the end of Part IV of Grottaferrata Γ. β. II, a line is drawn across the page following the Greek word *apoluetai*—that is, after the sentence that Boswell translates as "Then they shall kiss the holy Gospel and the priest and one another, and conclude." This scribal line is a fairly standard indication that what follows constitutes a separate text, and hence in this case strongly suggests in itself that Patriarch Methodius's Ecclesiastical Canon of Marriage is not, in fact, related to the *adelphopoiêsis* at all. That this is in fact the case seems to be supported by the use of the verb *apoluô* here, which generally marks the conclusion of liturgies from this period—as indeed it does in every other *adelphopoiêsis* ceremony provided by Boswell in which that word appears.

But not for Boswell, who instead tries to get around both the scribal line and the *apolusis* formula in a number of ingenious ways. The first of these involves a clever rearrangement of the text, at least for the benefit of his Greekless readers. In the Greek text, the closing instruction to kiss the Bible and the priest appears, as I have said, as the *last* line of section IV—that is, the last section of the *adelphopoiêsis*. But in Boswell's English translation—the one, of course, that the book's intended audience must consult—*the author transposes this line so that it appears to be the first line of section V*—that is, Methodius's marriage canon. In so doing Boswell slyly creates one seamless ceremony where in the original there were almost certainly two. (This presentation is helped along by Boswell's misleading insertion of an anachronistic colon following the word "conclude" at the end of the line in question, as if the word's function was to announce what was to follow, rather than to conclude what preceded it.)

Still, Boswell seems to be aware that his decision to conjoin these two texts, based on a desire to demonstrate that *adelphopoiêsis* was a true marriage ceremony, requires more than a quick scissors-and-glue job. His self-justification takes the form of a lengthy footnote to the English translation that is filled with untranslated (even untransliterated) Greek. He begins by pointing out that there are occasional cases in which the scribal line usually drawn between separate texts has been

drawn in error. And in order to justify appending an entire matrimonial service *after* the *apolusis*—the closing formula—that ends Part IV of the *adelphopoiêsis*, Boswell notes that the *apolusis* was occasionally accompanied by certain "final acts" or further prayers. This is indeed true, as Boswell's citations of various learned definitions of the *apolusis* indicate. (Brightman: "the conclusion of an office and the formula with which it is concluded"; *Oxford Dictionary of Byzantium*: "a formula pronounced at the end of a liturgical service or sometimes of one of its parts.") According to Boswell, the matrimonial service should be considered such a "formula."

At best, these are tenuous arguments. To pin a radical textual claim on a fervent hope that scribal error took place is ludicrous, and hardly qualifies as rigorous scholarly methodology. In addition, the entire Methodian marriage service constitutes much more than a mere "formula or closing prayer." (The *ODB*'s "sometimes one of its parts" is, moreover, every bit as shaky a ground for Boswell's case as are his devout hopes for a scribal goof.) Indeed, in the examples that Boswell himself provides, the "final acts" and formulae that he posits as valid analogues for the matrimonial service consist of no more than a valedictory kissing of the Bible, the priest, and the participants of the ceremony. A kiss on the cheek may be quite continental, but it's neither as lengthy nor as substantial a parallel as what Boswell needs to justify his appendage of the marriage rite to the *adelphopoiêsis* in his presentation of Grottaferrata Γ. β. II.

The real problem, though, is that a general audience has absolutely no way of knowing any of this. Aside from the fact that he or she has, in any case, been warned off the notes to begin with, and hence will accept Boswell's extremely tendentious presentation here at face value, the interested nonspecialist reader who takes the trouble to go through the Grottaferrata text in English cannot evaluate Boswell's argument about, say, the content of those final acts, because Boswell leaves the descriptions of them in the original Greek—a peculiar choice, given that this is, after all, the "Appendix of Translations." If Boswell really intends his notes primarily for the specialist, why bother appending this Greek-filled, two-page-long note to the *English* text? The polyglot scholarship stuffed under the English translation makes for an impressive-looking footnote that indeed lives up to the author's scarifying description, but

it's not going to be all that much use to those most likely to consult these translations in the first place: the Greekless readers at whom the book is aimed.

Here it is worth remarking that there is, in fact, a footnote that much more straightforwardly acknowledges the problems with Boswell's organization of the manuscript. In it, the author articulates very clearly the twinned possibilities that this [i.e., the *apolusis* concluding part IV] is the closing rubric of this ceremony and that therefore "the following prayer is separate." But this note, oddly enough, is appended to the *Greek* text, and hence occurs in a section destined to remain safely outside the general reader's field of vision.

━━━━━━

The convenient cutting-and-pasting and the self-serving deployment of notes vis-à-vis text that you get in the case of the Grottaferrata manuscripts are the most egregious examples of an unfortunate tendency on the author's part to prefer (and proffer) the tendentious, when the judicious is what's called for. Perhaps because they are less easy to manhandle without attracting attention, his discussion of his Greek and Roman sources often resorts to subtler tactics in order to alchemize the arcane, technical dross of *adelphopoiêsis* into the political gold of gay marriage. These come under the rubric of evidentiary abuses, and they pervade his discussion of classical material.

Boswell's idiosyncratic interpretation of the *adelphopoiêsis* ceremony as an open, sanctioned rite of "gay marriage" depends on two lines of argument. First, he wants to demonstrate that the *adelphos* in *adelphopoiêsis* would have been most naturally understood figuratively, as "lover," rather than literally, as "brother." (This is indeed one possible sense of the word in certain contexts.) And to bolster this claim, he needs to show that the kind of homosexual relationship allegedly celebrated in the *adelphopoiêsis*—i.e., a loving, reciprocal, socially accepted affective bond—was in fact part of a long-standing tradition in Mediterranean culture dating back to classical Greece, rather than being some kind of aberrant blip on the socioerotic screen of late antique and early medi-

eval culture. This is why the first third of Boswell's book is devoted to detailed discussions of both erotic vocabulary and erotic institutions; without them, his argument crashes and burns.

When all is said and done, however, it is on the brother/lover ambivalence that Boswell's thesis depends. After all, if the official title of the ceremony were something with less potential for ambiguity—the *symmakhopoiêsis* ("creation of military allies"), say, or for that matter the *kinaidopoiêsis* ("creation of sissies")—there would hardly be any need for lengthy interpretive exegeses in the first place. And in his first chapter, "The Vocabulary of Love and Marriage," Boswell laudably sets the interpretive stage by calling attention to the dangers inherent in walking the "excruciatingly fine line" between "providing too much or too little specificity" in translating ancient words and concepts.

But the discussion that follows seems intended to muddy the lexical waters precisely so that his own slippery readings will appear no more or no less approximate than any other in a semantic field that he constantly portrays as being hopelessly prone to inexactitude. "Many ancient and modern tongues," he writes, "fail to distinguish in any neat way between 'friend' and 'lover.' " "Fail" here is sly. What clarifies the differences between literal and figurative usages is, of course, context: but throughout *Same-Sex Unions*, the only context that Boswell recognizes is a homoerotic one. His repeated suggestions that our classical sources are characterized by a pervasive inability to sort the literal from the figurative merely serve to justify his own unwillingness to distinguish between "brother" and "lover."

Boswell's sometimes willful indifference to context becomes apparent when he attempts to bolster his claim about lexical confusion by using the example of the classical Greek word *hetairos*. According to conventional scholarship, the masculine form of this noun denotes "companion"; by classical times, however, the feminine form seems to have assumed the almost exclusively figurative meaning of "courtesan." To those who accept that Greek society was characterized by strict separation of the sexes, this etymological evolution makes sense: the only women who would have been available to mix freely with men as their "companions" would have been prostitutes. But not for Boswell, who hints that this traditional construction of the word is an instance of homophobia on the part of a repressive scholarly tradition:

For classical Greek, for example, it is conventional (especially in societies marked by extreme antipathy to homosexual feelings and behavior) to render [*hetairos*] as "companion" and [*hetaira*] as "courtesan" or "lover," although the basic meanings of the two words are the same, and there is every reason to believe (especially about classical Athens) that there was little distinction in the nature of the relationships in the two cases. (p. 4)

Everything in this paragraph that follows the word "although"—which is to say, the part that is characteristic of Boswell's readings throughout his book—is mere assertion. (And rhetorically speaking, that first parenthetical aside amounts to little more than coercion.) The basic meaning of the English word *bottom* is "the underside of something," but that won't get you very far if you hear your gay friend wondering whether that cute guy he met at the gym is a "bottom"—that is, gay slang for someone who tends to be the passive, receptive partner during intercourse. The great weight of our evidence indicates that there is in fact very *little* reason to believe that we should eroticize masculine *hetairos* on analogy with *hetaira* (or de-croticize *hetaira*, for that matter); the nature of the two relationships to which Boswell here alludes was quite different. Classical Greek has perfectly good words to describe male homosexuals as erotic subjects (*erastês, erômenos, paidika*, etc.) and does not need to resort to code words like *hetairos*. But you can't tell any of this to Boswell, because he's too busy spotting same-sex eros lurking behind every linguistic palm. Indeed, you'd never guess from his remarks here that according to more conventional scholarship, a clearly erotic sense of the masculine *hetairos* occurs only twice in the entire classical Greek corpus. But then, why *would* you, a well-intentioned and liberal-minded reader, want to guess as much—and in so doing reveal your "extreme antipathy to homosexual feelings"?

Boswell then goes on to declare that the semantic slippage that is "most significant" for his own argument is "the use of sibling designations for romantic partners, of either gender." Characteristically, he begins by offering a flawed English analogy for this alleged confusion. " 'Brother' and 'brotherhood,' " he remarks, "have often had sexual or romantic overtones in modern English during the last two centuries." Whose modern English? Boswell's examples are hardly

representative: he cites lyrics of Walt Whitman and Elton John (in the pop song "Daniel"). More questionably still, the author then goes on to intimate that "brother" does in fact mean "sexual partner" in the argot of today's gay community. This is simply wrong, and grossly misleading. Gay men do not use "brother" to mean "lover." The author's so-called evidence for such usage is wrenched from a quite specific context—the personal ads in popular gay publications—where "younger brother" or "kid brother" typically refer to specific physical (and occasionally psychological) types. But it's ludicrous to suggest that these are synonymous with "sexual partner" in everyday speech among gay men. They're not—or at least, no more than "redheaded professional" or "cuddly, overeducated mensch" are among straights.

Boswell's analogies from English are, therefore, hardly cogent—unfortunately, the one respect in which they do in fact parallel his arguments about other languages. But they do get him to the bottom of the slippery slope that ends in his assertion "that the nouns most commonly translated from Greek (αδελφός), Latin (frater), or Slavic (брат) are similar"—i.e., similarly ambiguous with respect to potential erotic overtones. Indeed, it's somehow appropriate that when the author concludes that the supposedly erotic connotations of English "brother" in the gay subculture are "closely related to the imperial Latin usage of the word 'brother,' " it turns out that his evidence for the erotic potential of the Latin, frater, comes from literary or lyric sources as stylized in their way as is the Whitman and Elton John material.

For this discussion, Boswell depends primarily on Petronius's *Satyricon*. Citing Circe's attempted seduction of Encolpius at *Satyricon* 127 ("You've clearly got a 'brother'—I wasn't too bashful to ask, you see—so what's to stop you from 'adopting' a 'sister' as well?"), he asserts on the basis of this that *frater* is "manifestly . . . a technical term for long-standing homosexual partner" in Roman culture (67). This passage, he says, "implies" that *frater* was "widely understood in the Roman world to denote a permanent partner in a homosexual relationship." Although the author of *Same-Sex Unions* goes out of his way to admire Petronius's "sharp ear for quotidian speech," he neglects to indicate how precarious it might be to base far-ranging claims about popular Roman mores and argot on a single line from a work whose author (Nero's *arbiter elegantiarum*, for Heaven's sake) belonged to the rarified Roman *beau monde*.

The nonliterary evidence for Boswell's claim that the words *brother* and *sister* were "common terms of endearment for heterosexual spouses in ancient Mediterranean societies" turns out to be equally problematic. To support his point about the eroticization of sibling terminology in Roman poetry, Boswell cites papyri from Hellenistic Egypt. But the very ancient cultural traditions of brother-sister incest make the use of Egyptian material problematic, to say the least, especially as the basis for sweeping statements about the "ancient Mediterranean." Indeed, when the author cites the historian Keith Hopkins on the prevalence of *sister* as a term of endearment used by Egyptian husbands of their wives, he fails to mention that the thrust of Hopkins's article is that there was in fact real sibling incest going on in Roman Egypt, perhaps because this information might weaken the force of Boswell's own linguistic interpretations, which forever shun the literal in favor of the figurative. This is not to say that Hopkins is necessarily right (or wrong); the debate about sibling incest in Greco-Roman Egypt is an ongoing and fierce one. But it's a typical omission on Boswell's part. (Indeed, he often allows bibliographical trees to obscure the argumentative forest. For example, he cites snippets of Susan Treggiari's thoroughgoing study of Roman marriage, but you'd never guess from them that her overarching conclusion is that mutual affect and the procreation of offspring were vital elements of that institution, which Boswell insists on portraying as a mere "property arrangement.")

Ah well. Why quibble over secondary sources like Hopkins and Treggiari when you can support your claims about Latin usage in the first century A.D. with a footnote about the Old Babylonian epic of Gilgamesh, composed two thousand years earlier? This Boswell does—just one example of the astonishing methodological free association that continually mars this book. In this scholar's approach to world literature, pretty much everything turns out to be about same-sex unions, and he's hardly shy about sharing that insight with you. For Boswell, the phrase *ambo fratres* ("both brothers"), as used by the theologian Tertullian at the end of the second century A.D., is "strongly reminiscent" of the phrase *fortunati ambo* ("fortunate pair!"), used by the pagan Vergil to describe the lovers Nisus and Euryalus in Book 9 of the *Aeneid*, written two hundred years earlier, because each contain the Latin word *ambo*, "both." This is the kind of thing that gives pedantry a bad name;

you may as well say that Tertullian's *fratres* are the literary antecedents of the eponymous sibling in the American pop tune "He Ain't Heavy, He's My Brother," simply because both are about brothers. But then, why bother, when Boswell himself goes on to suggest as much? This isn't scholarship, it's Rorschach. Blotches like that one turn up on too many of *Same-Sex Unions*'s pages.

As you sputter through Boswell's attempts to demonstrate that *frater* was essentially interchangeable with *amator* for the early Christian clerics who first concocted the same-sex unions, you can't help thinking that, even if he's right about all the *frater* stuff, it's still a pretty oblique line of argument. The oldest manuscripts in which the *adelphopoiêsis* is transmitted were written in Greek by Greek speakers; the later Latin and Old Church Slavonic versions are merely translations. (Boswell is right to omit them from his appendices here.) I suppose that Boswell's inclusion of the *frater* stuff is meant to establish a context of pervasive brother/lover confusion throughout the ancient Mediterranean, but what he really needs is incontrovertible evidence for extensive and commonplace use of the Greek word *adelphos* to mean "lover"—and in everyday, rather than highly specialized, contexts. Come to think of it, even that may not be enough. The assumption that allows Boswell's conclusion to be properly drawn is that the word *adelphos* would have *superseded* any other word for "lover" in the minds of the Greek speakers who first wrote down the *adelphopoiêsis* ceremony. But Boswell can't, in fact, reliably demonstrate this, and so all of the carefully rigged dissertations about the erotic, figurative potential of *frater* and *soror* turn out to be window dressing.

Here again, it's worth noting that Boswell suppresses a pesky bit of information by sticking it in a thicket of thorny notes. There, he observes that postclassical Greek *adelphos* lacked a clearly erotic sense, which in fact had to be supplied by the transliterated Latin *frater* (in a special poetic sense, as his example from the *Greek Anthology* indicates). If it is "inescapably" clear that *adelphos* would have been widely understood as meaning "lover" to those who invented and later transcribed the *adelphopoiêsis* ceremony (as Boswell goes on to claim), then why the need to borrow from Latin?

This contortion of the Greek and Latin tongues turns out to be only the first storey, as it were, of a wobbly argumentative structure. Here is its blueprint:

The ceremony discussed [i.e., *adelphopoiêsis*] is titled and uses phrases that could be translated "become brothers," or "make brotherhood" . . . and one approach would be to render them this way, "literally." But if, as seems inescapably clear . . . the meanings of the nouns to contemporaries were "lover," and "form an erotic union," respectively, then "brother" and "make brothers" are seriously misleading and inaccurate translations for English readers. (p. 19)

Note again the slippery rhetorical slope: the denigration of any nonerotic sense of *adelphos* to a "literalness" that the author has taken considerable pains to show is insufficient; the tendentious aside about the "inescapable" truth of what are, in fact, merely his own premises; the logically flawed progress by which a potential connotation becomes, finally, always and absolutely denotative.

Boswell's discussion of the language and diction of "same-sex" *eros* is meant to be grounded in a far-reaching demonstration that the social context for the equation Brother=Lover was a venerated tradition of institutionalized homosexual unions in Greek and Roman culture. It is from this cultural source, he argues, that *adelphopoiêsis* flowed—the liturgical celebration of a reciprocal, mutual affect between male lovers that was first publicly celebrated in pagan antiquity.

In the case of Greece, this argument must necessarily take the form of debunking what has become the prevailing view that male homosexual relationships in Greece were structured according to a clear-cut hierarchical distinction between the attitude of the lover, or *erastês*, and that of his younger beloved, the *erômenos* or, more colloquially, *paidika*. Now it is surely true, as Boswell and others (such as John Winkler and Kenneth De Vries) have argued, that the strict hierarchization of Eros in classical culture, like other Greek social institutions such as the seclusion of women, was likely to have been more "rhetorical" than both ancient accounts and modern interpretations of them often give credit for. But Boswell's own discussion of relevant texts hardly justifies his impatient dismissal of what he calls the "arch, stylized, and misleading view of Greek homosexuality" advanced by many contemporary scholars,

as a "shallow misreading of 'popular' literature." Hence, for example, the fact that even the ancients were unsure as to whether Achilles or Patroclus was the *erastês* in that particular relationship does not necessarily support the author's claim that "it is probably wrong to imagine that 'lover' and 'beloved' were clearly defined positions or roles." You could just as well argue that the fact that ancient writers were willing to devote time and energy to pondering this question suggests that such roles were in fact institutionalized—to the extent that who was on top was something worth knowing in the first place.

Boswell tends to support his assertions about Greek cultural institutions with references to important (if often unrepresentative) texts that are, as often as not, given without their proper context. Hence, for example, his liberal and rather sentimental use of the *Symposium*, which according to him provides a clear demonstration that Greek same-sex love was as completely reciprocal as the (alleged) medieval same-sex unions that were (he alleges) its cultural descendants. The proof, he argues, is in the fact that in this work, both *eros* and *philia*, "desire" (erotic) and "friendship" (unerotic), could be used to describe a single relationship:

> In describing one of the most famous same-sex couples of the ancient world—Harmodius and Aristogeiton, whose enduring and exclusive love was thought to have brought about the institution of Attic democracy—he [Plato] uses both [*erôs*] and [*philia*] (182C). (p. 78, n. 122)

He then goes on to translate a line of the *Symposium* that refers to Aristogeiton's *eros* and Harmodius's *philia*; and elsewhere reiterates the fact that Plato used within a single sentence both *eros* and *philia* for the same relationship as proof that the two words were synonymous. But his subsequent acknowledgment (relegated to a footnote) that "the phrasing could be taken to suggest that the two men had quite different sorts of feelings for each other"—i.e., Aristogeiton felt *eros*, erotic desire, whereas Harmodius felt *philia*, nonerotic affection—gives little indication of the extent to which the passage he cites here could, in fact, be construed as ideal support for the "arch, stylized, and misleading" view of Greek homosexuality that he elsewhere denigrates. The

Athenian tradition was that Aristogeiton was the *erastês* of Harmodius: so Thucydides, in his account of the tyrannicides' plot (6.54). Aristogeiton's *eros* is thus hardly interchangeable with Harmodius's *philia* in an affective dynamic characterized by a perfect reciprocity of loving friendship, as Boswell would have it. If anything, each of the emotions described in this passage conforms with great precision to the Greek schematization of homosexual affect described by Dover in his edition of the *Symposium*: "The more mature male, motivated by *eros*, pursues, and the younger, if he yields, is motivated by affection, gratitude and admiration" (Dover, p. 4).

I should add that throughout his discussion of the *Symposium* and other texts, Boswell neglects to consider any potential interpretive ramifications of speaker and context—for example, that there might be a grain of self-interest in the opinions expressed by the *erastês* Pausanias, or by the comic poet Aristophanes, in *Symposium*. Here as elsewhere, he merely cites a given passage as an example of "what Plato thinks," regardless of speaker or of dramatic, philosophical, or ideological context. Given that Plato's discourse about love retains considerable cultural authority not merely in the West in general but, perhaps more important for many readers of *Same-Sex Unions*, in gay culture particularly, this is careless.

But the selective and ultimately self-interested nature of Boswell's use of classical sources is most apparent in his discussion of what he asserts was a tradition of "formal [homosexual] unions" in ancient Rome. These, he declares, were "publicly recognized relationships entailing some change in status for one or both parties, comparable in this sense to heterosexual marriage"; he goes on to make the claim that such relationships occasionally used "the customs and forms of heterosexual marriage."

Incredibly, the sole piece of evidence adduced in favor of this outrageous claim consists of a satiric epigram of the first-century A.D. writer Martial, in which the writer describes a male-male "wedding" (12.42). "Such unions," the author of *Same-Sex Unions* asserts, "were not always private." That "always" is a good demonstration of a typically Boswellian one-two argumentative punch: the slippery slope followed by begging the question. For "always" slyly alchemizes a single (alleged) instance into a widespread social practice; and in making this highly

tendentious insinuation (that private wedding ceremonies between men in fact *regularly* took place) the premise for an even broader conclusion (i.e., that such unions were in fact often *public*), Boswell is, in effect, assuming what he needs to prove.

This questionable reasoning is buttressed by some rather casual methodology. Boswell's discussion of what he insists were formal public marriages between men in ancient Rome treats Martial's verses (and, later, Juvenal's) as if they were straight reportage rather than acidic satire; once again, he rips literary evidence out of its proper generic and historical context in order to score his same-sex points. You'd never guess that Martial ran with, and wrote for, a café society crowd with whom John Q. Roman is unlikely to have hobnobbed. Not for the first time, Boswell here makes a methodological error that J. P. Sullivan, in an article that Boswell himself, oddly enough, cites, succinctly characterized: "We cannot easily distinguish," Sullivan wrote, "in Martial or his audience, between what is reality, i.e., common sexual facts or practices, and what is desired or feared, sometimes even repressed. . . ." In order to realize one particular fantasy of happily-ever-after, boy-boy weddings in ancient Rome, Boswell keeps adducing supporting material that is highly unrepresentative.

Most questionable of all, perhaps, is the historical evidence used to demonstrate that gay marriage ceremonies weren't "always" private: an account of a feast at which Nero married a freedman eunuch called, delightfully, Pythagoras. Here as always, the author provides an impressive-looking footnote: Suetonius, Dio Cassius, and especially Tacitus are all cited ("generally a very reliable source," Boswell approvingly notes of the last). But you can't help wondering why, if Tacitus is so reliable, Boswell doesn't quote the historian's introduction to this narrative—the bit where Tacitus disapprovingly recalls Nero's feast as a prime example of the excess and depravity (*luxus, prodigentia*) of the decadent imperial court. Using Nero's sozzled antics as evidence for the assertion that marriage ceremonies between gay Roman men were regularly and publicly held is intellectually dishonest and philologically irresponsible. It's like relying on *Town and Country*'s coverage of Truman Capote's 1966 Black and White Ball as the basis for generalizations about the lives of gay white men before

Stonewall. This stuff wouldn't pass in an undergraduate paper, and it shouldn't have passed here.

Such are the bases for Boswell's claims about the classical background for *adelphopoiêsis*. It is unfortunate that this inadequate discussion of classical material turns out to be a rich preparation for what follows; for in treating the ceremonies themselves in their medieval context, the author of *Same-Sex Unions* merely reiterates the skewed linguistic and cultural analyses that are by now all too familiar. In his discussion of premodern Christian Europe, the author again insists on a pervasive failure to distinguish between the literal and the figurative—in this case, between "the chaste, charitable sense in which all Christians addressed each other as siblings, and the erotic, marital sense" (134). But his evidence for the claim that "the conjugal implications of the words in question, *frater* and *soror*, 'brother' and 'sister,' were not absent" from liturgical contexts turns out to be little more than idiosyncratic readings that once again beg rather than answer the important questions.

To support his point about sibling vocabulary, for example, the author cites Justinian's *Novel* 133.3, a rule prohibiting women from entering male religious space "even if he should call himself her brother, or she his sister" (*nec si quis forte frater esse dicatur, aut soror*) (135). For Boswell this rule demonstrates that "even in this ecclesiastical context, the phrase [*sic*] 'sister' . . . suggested distinct disapproval" (135)—disapproval, presumably, because of what Boswell alleges are the word's inevitably conjugal and erotic implications. Yet the phrasing of the rule surely derives its force from an assumption of a wholly *nonerotic* sense of *frater* and *soror* (whether literal or, as is here more likely, in the figurative sense applied to the inhabitants of monastic communities): the sense seems clearly to be that the woman is to be prevented from entering "even if she claims to be *merely* a sister, or he claims to be *merely* a brother": for the author of this rule, the sibling terms were unequivocally innocent words that might successfully provide a cover for not-so-innocent goings on. Only a fairly deaf interpretive ear could take evidence such as this to support the extraordinary claim that "the countererotic"—which is of course to say *literal*—"sense of 'brother' was largely unknown in the premodern Christian world, because *all*

relationships were expected to be chaste in the sense of subordinating desire to responsibility" (24). This is a bit like saying that the literal sense of the word "brother" is unknown in urban African-American communities today, because young black men often refer to one another as "brother." Context is everything.

Boswell then proceeds to an oddly insubstantial treatment of the late antique and early medieval sociosexual context for his *adelphopoiê-sis* ceremonies. This discussion is as wobbly as his discussion of homoerotic relationships in the classical period. When he provides a detailed description of early Christian ambivalence about sexuality in marriage, it is only to promote a portrait of marriage in the Middle Ages as being largely unconcerned with procreation—an arch, stylized, and misleading model if ever there was one. And all this serves to justify yet another careless tumble down the logical slope: he argues that because celibacy was endorsed by the Church in a way that was unthinkable in classical times (and his evidence for classical attitudes about celibacy is a note remarking that the number of vestal virgins was low), then it stands to reason that nonprocreative—and hence eventually same-sex—unions would have been endorsed with equal vigor:

> Given what has already been adduced about the veneration of same-sex pairs (especially military saints) in the early church, and a corresponding ambivalence about heterosexual matrimony, it is hardly surprising that there should have been a Christian ceremony solemnizing same-sex unions. (p. 180f.)

What, you may ask, has already been adduced about the veneration of same-sex pairs? Little more than Boswell's own hints that the early Christian martyrs Saints Serge and Bacchus were . . . *comme ça*. And how do we know? Well, they call each other "brother," and by now we all know what *that* means. (The circularity of Boswell's argumentation here leaves you a bit dizzy.) Then there's the fact that the parading of the pair through the streets "recalls," as Boswell puts it, one of the penalties for homosexual acts—although one that even Boswell admits postdated the historical date of the saints' martyrdom (and which, moreover, was not unique to those being punished for sodomy). Finally, the Greek word used in the account of their martyrdom to de-

scribe their affection for each other, *syndesmos* or "bond," is also used in the New Testament in the phrase *syndesmos adikias*, "bond of iniquity" (i.e., sodomy). Boswell exclaims over what he sees as the "fascinating association" between these two instances of *syndesmos*, but for his readers it's merely another example of the author's penchant for free association—a demonstration of the "He Ain't Heavy, He's My Brother" variety. Such is the evidence that Boswell keeps "adducing"; but more often than not, it's induction rather than adduction.

The author's refusal to acknowledge the validity of any interpretive or sociological contexts other than homoerotic ones results in the addition of a third argumentative fallacy to his repertoire: the strawman. Ignoring the ritualized-friendship tradition, he addresses himself to demolishing what he calls the "least controversial" interpretation of the ceremony, i.e., that it was an ecclesiastical formalization of some kind of "spiritual fraternity." But of course the "least controversial" interpretation is the one scholars have advanced for over a century: that the *adelphopoiêsis* was created to solemnify alliances between heads of households or to formalize reconciliations between mutually distrustful members of opposing clans. (As the historian Brent Shaw pointed out in his negative *New Republic* review of Boswell's book, the ceremony's emphasis on the right to asylum and safe conduct surely supports such an interpretation.) Here as so often, Boswell ignores the evidence that doesn't suit him. Instead, he brandishes his famous erudition and plunges it deep into the heart of . . . a straw man.

The straw man isn't the only fantastical creature you're liable to run across as you travel down the twisty argumentative road leading to Boswell's conclusion that the *adelphopoiêsis* was a medieval gay wedding service. It's a journey filled with scary-looking beasts: philological lions and methodological tigers and plain old logical bears. And at the end of the road is the wizard himself. But even as his smoke-wreathed illusions of church-sanctioned gay marriages materialize before his awestruck readers' eyes, you realize that he's working the controls furiously, way down there in the footnotes where no one can see him. He's the man behind the curtain. Unfortunately, given the explosive political potential of this particular scholarly conjuring act, the author's introductory admonition to ignore the methods by which he achieves his impressive-looking results is deeply troubling, to say the least. "Pay no attention

to the man behind the curtain!" he may cry; but if you look closely enough, you realize you're being conned.

How could this have happened?

At the time of his death a few months after *Same-Sex Unions* first appeared, Boswell had secured the highest honors attainable in the academy: author of several learned tomes, A. Whitney Griswold Professor of History at Yale, chairman of his department—the university's largest, as he himself reminds us in his Preface. These are very distinguished credentials. How could the scholar who earned them have produced a work characterized by such obvious and egregious flaws? On first examination, pretty much any explanatory road you take leads to an unpleasant destination. Either you know that Nero's wedding wasn't a shindig typical of Roman social life but you cite it anyway, thereby violating what you, as a trained historian, surely know to be the standards for scholarly use of historical evidence; or you *don't* know that Nero's shenanigans were atypical, which is of course just as bad if you happen to be writing a book that is largely based on evidence from ancient Rome. There's just no way out.

Yet *Same-Sex Unions* owes its failure to a deeper and more disturbing lapse, one that brings us back to our Wildean allegory about the dangers of forsaking philology for fame. For it was clearly the latter that seduced Boswell away from the former; to his credit he did not yield his virtue easily. Despite its frequent recourse to the dubious tactics I have already described, *Same-Sex Unions* occasionally bears witness to a troubled scholarly conscience. "It is not the province of the historian to direct the actions of future human beings," Boswell rightly observes in closing, "but only to reflect accurately on those of the past" (281). But this observation is accompanied by a more typical tendentiousness, as when, a few lines earlier, the historian refers to his thesis as "historical facts" whose "social, moral, and political significance is arguable, but considerable." Arguable but considerable? Such uneasy juxtapositions bespeak a conflict that is surely understandable in a scholar who was at once a gay man and a devout Catholic. How could he not have wished to find the philologue's equivalent of the magic potion, an authentic text that would effortlessly reconcile those two ostensibly incompatible as-

pects of his own identity—that would, as he himself put it, allow people to "incorporate [homosexual desire] into a Christian life-style"? It is indeed possible to see *Same-Sex Unions*, along with its predecessor, as the professional expression of what was surely a fervent personal wish.

But this is precisely the problem. The failure of Boswell's book on so many intellectual and scholarly grounds forces us to question the extent to which the standards of scholarship can comfortably accommodate the exigencies of a private—or political—vision. In the case of *Same-Sex Unions*, this question is especially critical because the tensions between scholarly standards and personal goals become exacerbated when the latter happen to serve the interest of a much larger political agenda shared by millions who, unlike the professional scholar, are unlikely to feel burdened by the exacting standards of a "particular expertise." Unfortunately, this audience is likely to attach as much importance to, say, Boswell's prefatory announcement that many of his close friends died of AIDS, as to his less rhetorical utterances about material that is actually relevant to his argument.

Indeed, it is Boswell's attempt to go over the heads of expert readers that makes it that much more difficult to justify his work. In a heated attack on Brent Shaw and his negative appraisal of *Same-Sex Unions*, the classicist Ralph Hexter argued that it was inappropriate for Shaw to pass judgment on certain of Boswell's arguments in the first place. Shaw, he declared, is neither an expert on early Christian liturgy nor on matters medieval, as was Boswell; Shaw's knowledge of Greek, he went on—all-important for an evaluation of Boswell's critical linguistic claims—is bound to be rooted in classical rather than medieval training. This credential-checking was accompanied by a boastful reference to Boswell's great linguistic expertise, even in such arcane tongues as Old Church Slavonic.

But Hexter's attack on Shaw's credentials inevitably leads you to question Boswell's own credentials—the ones that actually matter, rather than the arcane fluencies that merely serve as rhetorical passementerie. For if you accept Hexter's argument that Shaw's discussion of late antiquity and the early Christian Church is handicapped by the fact that he was trained as a classicist rather than as a medievalist, then what do you do about Boswell himself—a medievalist who bases his radical claims on a lengthy discussion of classical culture, literature, sexual and social

institutions, and history? The extent of Boswell's methodological and interpretive errors in dealing with classical material makes it increasingly difficult, even for other gay scholars like myself, to dismiss doubts about his scholarship merely as instances of "institutional homophobia."

Much more significant is the way that Hexter's backfired defense provides the basis for an even broader and unfortunately more devastating critique of Boswell's book. For if Shaw's alleged lack of expertise in medieval matters makes him unfit to judge Boswell's book, how on earth are Boswell's intended nonspecialist readers supposed to judge Boswell's book? The answer is that they can't, and the results have been depressingly predictable across the board.

Some examples. In an admiring 1994 "Talk of the Town" piece commemorating the twenty-fifth anniversary of the Stonewall uprising, a gay *New Yorker* editor staunchly defended Boswell, lavishly praising his "erudition," "scholarly acumen," and "linguistic dexterity." (This last was followed by a suitably awed reference to Old Church Slavonic.) In a letter protesting a brief and critical review of the book that I contributed to the gay monthly *OUT*, a reader duly described himself as being "awed by the extensive erudition of the still youthful John Boswell." But awe does not make for critical readers—something Boswell knew, and something borne out in my correspondent's closing remark. "Boswell's text admittedly is heavy with copious footnotes," he went on, "[but] the author stated [that] readers can skip the technical footnotes included for others." (But as we have seen, Boswell often hides the potential objections to his arguments in those very footnotes.) And then there's the Washington, D.C., gay couple who, inspired by *Same-Sex Unions in Premodern Europe*, were married using the *adelphopoiêsis* ceremony. You can only be thankful that Boswell chose not to write about human sacrifice.

You can't blame these people, of course. Between the rhetorical sleight of hand and the august-looking footnotes, how could they *not* be duped? As depressing as these uncritical endorsements of Boswell's thesis may be, they do serve to demonstrate the effectiveness of his approach. And they make it clear that, until the audience for the classics journal *Dioniso* outnumbers the audience for *Doonesbury*, tendentious attempts to mainstream complex and technical material in a way that produces such results must remain a questionable strategy.

Less easy to excuse than the deluded D.C. duo (who, for all we know, have unwittingly pledged to be well-behaved clan leaders, till death them do part), is the endorsement of Boswell's book by people who should in fact know better. There is little point getting flustered by heated opposition to and feverish denunciations of Boswell's book from right-wing political and religious groups, who clearly have a vested interest in resisting his thesis. But what does invite concern is the readiness with which some scholars and journalists of a more liberal temperament have knowingly suppressed discussion of the work's intellectual failings in order to promote what they see as its broader political agenda. Or, in the case of Boswell's publisher, to promote sales of a controversial book about a "hot" topic. (It's interesting to wonder why *Same-Sex Unions* wasn't brought out by an academic press: and whatever the answer to that question may be, it's not an appealing one.)

An example. To review Boswell's book, *The Nation* found a gay graduate student in comparative literature who readily acknowledged to me, when I contacted him about his review, that he is "not an expert at all in any of the fields that Boswell is." What appears to have won him the assignment was, instead, his journalistic expertise in writing about "sexuality and cultural politics." (Small wonder that his review gratefully acknowledges Boswell's inclusion of the Appendix of Translations: "general readers won't have to worry about brushing up on"— what else?—"their Old Church Slavonic.") Yet even with this stacked critical deck, *The Nation* couldn't necessarily produce a winning hand for Boswell. "My review really didn't reflect how critical I was of the book," the reviewer told me. But you'd never guess as much from the finished review; it's a rave. *The Nation's* respectful review reflects its writer's conviction that Boswell's book should be defended from the "slanted treatment" he felt it was receiving in the popular press. If abandoning your intellectual standards to advance a political agenda isn't slanted, it would be nice to know what is. But then, that's what *Same-Sex Unions* is all about.

In the era of the culture wars, the politicization of scholarship by both left and right is hardly news. But the failure thus far on the part of liberal and, especially, gay intellectuals to respond with an appropriately

vigorous and public skepticism to Boswell's questionable methods and tendentious conclusions is, I think, particularly distressing—not least because it leaves the liberals embarrassingly vulnerable. This silence is partly a matter of strategy—an interest in, say, promoting the work of once-silenced "marginal" voices such as those of openly gay intellectuals—but it is also a product of ideology: that is, a resistance to invoking certain standards of intellectual or aesthetic quality that is the legacy of a commitment to eradicate oppressive hierarchies and to demystify claims to authority.

It is one thing to acknowledge that we are all of us, scholars, critics, philosophers, implicated in the social, political, and historical contexts we inhabit; that realization has precipitated considerable soul-searching on the part of Boswell's fellow historians more than most. But it is entirely another matter to make this insight the basis for a wholesale abandonment of what one historian called the "noble dream": a common standard of methodological and argumentative scrupulousness, if not actually some elusive "objectivity," in historical, critical, and philological enquiry. Writing in 1934, Theodore Clarke Smith cautioned that

> a growing number of writers discard impartiality on the ground that it is uninteresting, or contrary to social beliefs, or uninstructive, or inferior to a bold social philosophy.
>
> It may be that another fifty years will see the end of an era in historiography, the final extinction of a noble dream, and history, save as an instrument of entertainment, or of social control will not be permitted to exist.

Although Smith was writing at a moment when egregious distortions of history for the purposes of "social control" were already being committed by both left and right, his chronological estimate was depressingly accurate. In their potential for wreaking far-ranging epistemological and methodological damage, the various fashionable "posts"—structuralism, modernism, whatever—have far exceeded anything Smith could have imagined, even in the era of Soviet jurisprudence or Nazi medicine.

This is precisely why the "noble dream" is even more indispensable for the left today than it is to right-wing intellectuals (who have successfully hijacked contemporary discussion of academic and aesthetic

standards). The overt politicization of science and scholarship in favor of a "bold social philosophy" has, as we know, always been a *totalitarian* project. Now more than ever, when much of what the left values is in danger, liberal thinkers have, if anything, an even greater investment in espousing the impartial forms and rigorous standards of logical and reasonable debate, rather than constructing jerry-built appeals to dubious authority in order to support some foregone ideological conclusion— or indeed merely to vent political frustrations. ("Conservative religious groups deserve to be riled," one Boswell supporter wrote in response to my *OUT* review. "They have dominated Western culture and thought far too long.")

All this is why Boswell's defenders are as troubling as his book. In slavishly championing an ostensibly liberal (because gay-friendly) agenda—and in suppressing potentially contrarian voices—they have come to resemble their own ideological enemy. You keep hoping someone on the left will notice this and say something; but so far, the silence on the party line has been deafening.

The list of gifted and prolific littérateurs who have been torn between the desire for seriousness and the desire to make it is a long one. Oscar Wilde is on it; as it happens, our Roman satirist, Martial, is on it, too. Indeed, the Latin poet's ill use at the hands of the author of *Same-Sex Unions* is not only representative of this particular book's shortcomings but stands, perhaps, as a symbol of the risks involved when Philology flirts with Fame. To the former, it always looks like a harmless enough fling; but the latter is a great seducer. That much, at least, we can safely glean from the classical past. On learning of Martial's death, a saddened friend summed up his career: *At non erunt aeterna quae scripsit: non erunt fortasse, ille tamen scripsit tamquam essent futura.* "You will say that his writings were not immortal," Pliny wrote to Cornelius Priscus. "Perhaps they weren't. But he wrote them as if they would be."

PART FOUR

———

Theater

The Greek Way

I

"Nothing to do with Dionysos!" So went the proverbial Athenian complaint about tragedy. And no wonder: after all, the annual theatrical productions at Athens—with their brilliant costumes and special effects, the rich musical accompaniment and complex choreography, the poetically sophisticated and intellectually provocative libretti, the keenly watched competitions for playwrights—seemed to have very little indeed to do with the quaint rural shindig in honor of the wine god Dionysos from which, if we are to believe Aristotle, Greek theater evolved. For tragedy (as he asserts in the *Poetics*) got its humble start as a festive choral song called the dithyramb, sung in celebration of the god's birth; while comedy owed its origins to a genre that clearly had something to do with Dionysos's role as a fertility deity, as we may infer from its rather louche name ("phallic songs").

Still, however far from its folksy holiday roots it may have strayed, Athenian drama in its heyday represented much more than an evening (or, more accurately, morning) of secular, private entertainment—the kind of experience we expect when we go to the theater. "Dionysos" was indeed present—nearly every extant work for the Athenian stage

returns obsessively to the subject of religion—as were a host of other issues crucial to the city and its self-image. These matters were explored with a combination of intellectual subtlety and theatrical verve made possible by the genre's natural affinity for the symbolic, abstract, and metaphorical over the naturalistic. Only in tragedy, where (for instance) women so often represent the domestic realm, and men the public, where a red carpet embodies a family's bloody past, and a trial lawyer is an Olympian deity, could a family melodrama involving bad career decisions, spousal abandonment, child abuse, and retributive homicide become, as it does in the *Oresteia*, an allegory for the establishment of justice, of orderly civic life, of civilized culture. And indeed, the grand religious and civic ceremonials that framed the performances—the opening libations to *Dêmokratia*, democracy personified, the patriotic parades, the reading of the names of patriotic citizens, the sacrifices on behalf of the city, even the visible presence of fifteen thousand other citizens in the Theater of Dionysos—underscored, in a fashion impossible to reproduce in today's theater, the sense that the plays being performed had much larger social, civic, ritual, and political resonances.

"Nothing to do with Dionysos" would, on the other hand, be a fair assessment of most modern-day stagings of tragedy. Of the vast number of works composed for production at the annual Dionysiac festival in Athens—the three great tragedians Aeschylus, Sophocles, and Euripides wrote nearly three hundred between them, and there were many more poets writing over a period of a couple of centuries, all of them together producing a total of perhaps a thousand works in the fifth century alone—only thirty-two survive. Of those thirty-two, contemporary productions of tragedy have favored those that seem to be about recognizably contemporary emotions and dilemmas—subjects, in other words, that seem to be able to transcend the loss of the plays' original contexts and speak to some larger, "universal" truths about human nature . . . or, at least, to early-twenty-first-century truths. At least part of the contemporary admiration for (say) Euripides' *Bacchae* derives from the play's affinity with Freudian notions about repression and libido; certainly a great deal of our admiration for Sophocles' *Antigone* comes from the fact that it seems to be a sympathetic portrait of a hot-blooded young woman valiantly preserving her family against

encroachments by the cold and anonymous State—a modern (and modernist) dilemma if ever there was one.

How the Athenians would have viewed Antigone, and *Antigone*, is another matter; this is where context makes a difference. After all, they saw the play after also seeing the orphaned children of the war dead—and, perhaps more to the point, the tribute money from Athens's subject-allies—paraded around the theater. How, in that situation, the audience would have looked upon the willful girl's defiance of a man who is not only her uncle but also, as she herself acknowledges, the city's *stratêgos*, "general," is anyone's guess. But it seems safe to say that without the formalities that accompanied the original performances, we have, at best, a partial sense of how the plays were understood; the evidence suggests, if anything, that their original resonances were very different from those that we associate with gripping drama. (It is entirely possible that, whereas we like courtrooms because they remind us of theaters, of "drama," the notoriously litigious Athenians liked the theater because it reminded them of courtrooms.) Our discomfort with the idea of tragedy as essentially public, political theater is reflected, notoriously, in our embarrassment about what to do with the most distinctive feature of Greek drama, the chorus—that ever-present reminder on the Greek stage that the ostensibly personal decisions made by the individual characters are always made in the setting of, and always affect, the larger society.

Those who would stage Athenian drama today must, like Aeschylus's Agamemnon, make an unsavory choice that involves a terrible sacrifice. To strip away (as often happens) the inconvenient bits that don't speak to us today—the chorus, the masks, the angular gestures, the abstruse mythic allusions, the high poeticisms of the language—is essentially to misrepresent the genre; without those elements, the elements that make plots into allegories, the domestic into the political (and even the cosmic), tragedy is miniaturized. And yet to reproduce a Greek tragedy today would be a meaningless exercise in theatrical embalming. Even if it were possible to re-create the elements of the staging, it would be quite impossible to replicate the shared civic experience that was Athenian theater.

How, then, to proceed? Three stylistically very different productions of Greek tragedies that were staged in New York in the past few

months—of which I discuss two here, and the third in a subsequent essay—suggested, paradoxically, that the best way to honor the spirit of the ancient plays was to stray very far indeed from what the playwrights wrote.

———

All three of the canonical Athenian tragedians were represented onstage in November and December 2001; ironically, it was Euripides, the most formally daring and ideologically subversive of the three, who received the most banal and conventional treatment.

You can see where the temptation to treat this twenty-five-hundred-year-old author as a contemporary might come from. The youngest of the three great dramatists—he was born a decade after Sophocles and forty years after Aeschylus—Euripides has always seemed to be the most accessible to contemporary audiences. For the postwar generation of classicists, there has indeed always been something eerily familiar about the playwright's mordantly ironic tone, about his prescient interest in, and use of, female psychology in his plays, about his flirtation with the Derrida-like Sophists and their newfangled arguments about the nature of, and connection between, language and reality; something bracingly contemporary about his language, which eschews the archaic and hieratic grandiosity of his predecessors and approaches something more streamlined, more "modern."

And indeed, as the Peloponnesian War ground on for thirty bitter years, during which Athens collapsed both politically and morally, that playwright increasingly rejected the traditional received forms of theater in favor of what looks to us like an almost postmodern array of theatrical modes and styles—pageant, melodrama, absurdist farce, romance, sci-fi fantasy—in order to expose the morally bankrupt behavior of his city, and the immorality of war itself. *Iphigenia at Aulis* was the last of the poet's so-called war plays—a group that includes, most famously, *Trojan Women*. (It is, indeed, the last of all his plays: composed during Euripides' final years of self-imposed exile in Macedon, it was produced posthumously, along with the *Bacchae*, following his death at

seventy-nine early in 406 B.C.) In this final work, the poet returned to a mythic beginning: the pivotal moment in the story of the Trojan War when Agamemnon, the Greek commander in chief, decides to sacrifice his own daughter in order to win favorable winds for the expedition to Troy and (he thinks) everlasting glory.

Aristotle rather enigmatically calls Euripides the "most tragic" of the three great tragedians; *Iphigenia at Aulis* suggests why. You'd think that the brutal murder of a young girl by her own father would be enough to arouse pity and fear; Aeschylus, after all, narrates the sacrifice briefly but harrowingly in a chorus of *Agamemnon* (which achingly describes the gagged girl pleading with her eyes for mercy). But Euripides brilliantly ratchets up the emotional ante in his last play, creating a complex and convoluted plot that yields terrible poignancies. Here Agamemnon, becalmed with his fleet at Aulis, has written home to lure Iphigenia to Aulis with the false promise that she is to be married to the hero Achilles (who is ignorant of the ruse); tormented by guilt, he sends a second letter warning his wife to ignore the first and thereby to save their child. This second letter is intercepted, however, and so the clueless Clytemnestra and her daughter arrive, preparing for a wedding that—as Agamemnon knows but now, pressured by his fellow generals, can no longer reveal—will be a murder. (Now it is he who is "gagged.") The ongoing tension in the play between the rite that Iphigenia and her excited mother expect to take place and the one that does in fact occur—the climax of the play is the narration of Iphigenia's bravery at the moment she is sacrificed—is one of the most wrenching that tragedy has to offer.

If the plot is contrived and artificial, then so too is the characterization. Euripides more than any other playwright had no qualms about sacrificing naturalistic verisimilitude to a larger dramatic point. In play after play, he introduces spectacular surprises and bizarre turnarounds in an almost absurdist attempt to provoke reexamination of our expectations of human nature, or divine goodwill, or fate (or indeed of the theater). One of the striking things about *Iphigenia at Aulis* is the way in which nearly every major character has a sudden *volte-face*: Agamemnon writes his second letter; his brother Menelaus at first denounces him for trying to save Iphigenia, only to return in the next scene, repentant and swearing fealty to his kin; Achilles furiously rejects the idea of the

false wedding—and then seems to fall in love with Iphigenia; Iphigenia herself at first resists her fate, only to embrace it moments later, volunteering for death. ("Second thoughts are somehow wiser," the Nurse in Euripides' *Hippolytus* famously asserts, and that would certainly seem to be the case here.) Aristotle cited the heroine of this play as a particularly egregious example of "inconsistency"; but as you watch *Iphigenia at Aulis*, you wonder if the real point here is that consistency of thought and emotion is impossible during a war—that violence has a disintegrative effect on the very minds of those touched by it.

None of this—a feeling for the dire real-life circumstances that shadow the play; an awareness of Euripides' personality as a dramatist, or of the centrality of this particular moment in the myth as the ideal vehicle to investigate the nature of violence and our apparent inability to resist it; a sensitivity to apparently deliberate structural anomalies— was evident in the performances of this play by New York's Pearl Theatre Company. You'd never have guessed, from Shepard Sobel's blandly earnest production, that there was much difference between Euripides and Philip Barry; it would certainly come as a surprise, after seeing his *Iphigenia*, that this play is one that the classicist Bernard Knox could cite as an example of tragedy's, and especially Euripides', penchant for creating characters who speak "more like marionettes than living, feeling human beings."

Indeed all you got, in Sobel's production, was living, feeling men and women, as if what happened at Aulis was Lyme disease, or a bad dot-com investment, something awful that might well befall the nice people next door and that you vaguely hope won't happen to you. In high tragedy, complex abstractions and extreme emotion are conveyed by means of high stylization: the deeply poetic texts, the rich allusive vocabulary of myth, the ritualistic singing and dancing that resonates with shared religious and social values—the very artificiality, to which Knox alludes, that enhances rather than diminishes grand themes and emotions. Without the stylization, the naked texts seem embarrassingly deflated.

Sobel's failure to appreciate this key point was evident first of all in

his casting: the bearing, gestures, and diction of the actors suggested an unfortunately extended acquaintance with made-for-television miniseries. This wasn't always necessarily disastrous, at least during those moments when Euripides does get sentimental: the Pearl's Iphigenia nicely combined virginal fragility and bouncy girlishness, with the result that her first scene with her father (the horribly ironic "Aren't you happy to see me, Daddy?" scene) had some real pathos. But more often than not, the style grotesquely dishonored the play—and the genre. This was particularly true of the dismally suburban Clytemnestra, who conveyed absolutely no sense that the play in which she was appearing was a unique representation of the pivotal moment in her towering and tormented character's evolution—the great and terrible day that turns Agamemnon's conventional wife into the monster we recognize from the *Oresteia*. In this production, Clytemnestra's dire discovery of the real reason for Iphigenia's presence at Aulis had all the moral and emotional impact of a Long Island matron discovering a faux pas in the *placement* for her daughter's bat mitzvah reception.

It's something when you can reach the end of *Iphigenia at Aulis* with no sense that anything of great import—the morality of the characters' political goals, the fate of their marriages and households, the destinies of their royal houses, their honor, their lives—had ever really been at stake. But then, there are no stakes if you see this as being about real people in plausible situations—if you smooth away the baroque artificiality of the plot and diction, and therefore make nothing of the deeper questions that such artificiality raises. Sobel is good at producing real-looking surfaces, and as far as they went, I suppose you could say that these answered some questions. You knew this was Greece, for instance, because the characters went around in classical-looking tunics, and you knew there was a war going on, because there was a rack of very real-looking spears downstage left. But you didn't learn much else. Why does everyone in the play change his or her mind at some crucial juncture? What are the public pressures that might compel a man who is at once a general and a father to kill his own child? What is this play telling us about war and what it does to people's characters? In such a production as Sobel's you neither know nor care. The narrow focus of Sobel's production on what, to us, looks reassuringly familiar and

"relevant"—on the domestic, private nature of the pain in Euripides' play—ultimately robs it of its truly tragic stature, and effect. True, Aristotle argues that the best dramas are those about families, and this play is nothing if not a drama about one of the most dysfunctional families in world literature. But Sobel's failure to provide any sense of the vast public, imperial, and martial ramifications of this family's actions (ramifications that the Athenians would have felt) trivializes what Euripides wrote.

It's not that you can't do *Iphigenia* "straight," as Sobel clearly wants to do; others have, with impressive results. In Michael Cacoyannis's harrowing if uneven 1977 film version of the play, the director devotes a great deal of time to a lengthy opening sequence showing the restive soldiers grumpily hanging around next to their becalmed ships, bickering and getting into scuffles out of sheer boredom, and after seeing a few dozen shots of this sort of thing you had a very solid sense that the lack of favorable wind was more than a meteorological annoyance, but rather a potentially disastrous political and military crisis just waiting to explode, with fearsome consequences for Agamemnon, his rule, and indeed for all of Greece. It was clear, because Cacoyannis had made it clear, that the heroes at Aulis would welcome a fair wind at any price, even the price of a young girl's life piteously cut short. Sobel gave you none of this. Or, maybe, half: there was pity, but no fear.

———

In many ways Tadashi Suzuki's Sophocles—a Noh-inflected *Oedipus*, performed in Japanese with English surtitles at the Japan Society last fall—represented a huge improvement over the Pearl Company's Euripides and showed a thoroughgoing understanding not only of the spirit of classical drama but of its style. Suzuki has devoted much of his distinguished career to staging Greek tragedy, and his highly stylized technique (which arises out of philosophical antipathy to technology, and which emphasizes the alternating containment and explosion of "animal energy" by the actors onstage) has suited the highly stylized Greek texts very well. In his printed comments on the *Oedipus* produc-

tion, Suzuki rightly notes the affinities between the Japanese and Greek theaters:

> Obviously, they resemble each other on the levels of stage structure. Both use a chorus as an inseparable part of the dramatic action, and both use masks, thus enabling one to three main actors to play more than a single role. . . . Depicting the disastrous deaths of noble heroes, both dramas pay homage to them, or pacify their souls. What they ultimately face up to is the inevitable fact of human weakness in the context of eternal nature or laws beyond human understanding. It is this vision, and the starkness with which it is represented, that are significantly common to Greek tragedy and noh.

It would have been difficult to find a more starkly beautiful representation of Sophocles' great drama of fate and self-knowledge (and ignorance) than the one Suzuki presented. The pared-down, elemental quality you want from performances of tragedy—that is, the sense of distillation that makes allegory and allusiveness possible—was present here in a number of ways, starting with superb performances that, in the classical style, made use of a limited but extreme gestural vocabulary, conveying a great deal with a fierce economy. I suppose there is a way that a real woman might react on hearing she'd borne four children to her own son, but Sophocles isn't interested in that—in his play, the incest and parricide are part of more abstracted and elaborately coded theatrical and mythic discourse about selfhood and otherness and "knowing." The brilliantly drawn-out, stylized recoil of Suzuki's Jocasta, when she finally realizes who her husband is, suggested extremes of horror, loathing, and abjection in a way that no realistic enactment could ever have attained.

Suzuki's deeply classical technical emphasis on patterns of movement, on alternating compressions and explosions of physical energy, is, indeed, ideally suited to the highly conventional structure of Greek tragic action, which itself is organized as a series of compressions and explosions: dialogic exchanges, each beginning more or less calmly and climaxing in anger or violence or revelation, are framed between choral interludes of comparative calm. This is nowhere more the case

than in *Oedipus*, which is constructed as a series of confrontations be-
tween Oedipus and various other characters, during each of which Oe-
dipus gleans another piece of information that leads him to the identity
of the criminal whose crime, we learn, is so terrible that it has brought
a plague down on Thebes. First there is the priest who appeals to him
to discover the cause of the plague; then his brother-in-law, Creon, who
returns from a mission to Delphi with an oracle saying that the cause
of the plague is a sinner who lives among the Thebans; then the seer
Teiresias, who eventually reveals that the sinner is Oedipus himself;
then his wife, Jocasta, who tells him to pay no heed to silly oracles, since
after all she and her late husband once had an oracle saying that the hus-
band would be killed by his son, which never came to pass (he was, she
says, killed by some robbers at a crossroads just before Oedipus came
to town); and so forth. What's interesting is that not only that each suc-
cessive dialogue is of increasing urgency, but each dialogue is itself con-
structed as a progression from calm to explosion. Oedipus begins by
listening to his brother-in-law attentively, only to explode in rage later
on, accusing Creon of taking bribes; he is polite enough with Teiresias,
but that exchange also ends in rage and in threats that Oedipus makes
against the old man; and he similarly threatens physical harm at the end
of his exchange, late in the play, with the old shepherd who's brought in
to testify about what he knows about a certain baby who was supposed
to have been exposed years earlier. And so on.

 The striking physical control emphasized by the Suzuki technique,
the emphasis on alternations between restraint and release, was there-
fore ideally suited to the structure of *Oedipus*, and clarified Sophocles'
text in subtle ways. In what is surely one of the greatest dramatic gam-
bles ever made by a playwright, the truth of Oedipus's real identity—
that he is the pollution he seeks; that he is the incestuous parricide he
searches for—is announced to him by Teiresias very early on in the
play. (The old seer doesn't want to tell the young king what he knows
at first, but the arrogant Oedipus ticks him off so much that he finally
reveals all.) Since the drama is, at one level, about the Theban ruler's
search for the criminal whose past actions have brought a plague on his
city, the play could conceivably collapse at this point; after all, we're told
who the culprit is a third of the way through the action. But of course
this is really a drama about knowledge, and self-knowledge. The genius

of Sophocles' play, encapsulated in this scene, is the way in which it suggests that it is the process of knowing, rather than the possession of mere data, that is crucial to our humanity.

To bring off this moment you need to have the sense that Oedipus, the man who solved the Sphinx's riddle and thereby saved Thebes, is so intellectually and morally self-confident that Teiresias's words simply don't penetrate—with the result that the revelation of the truth all the characters are searching for doesn't feel like a revelation at all. In Suzuki's production, the sense of Oedipus as disastrously isolated in his self-sufficiency was admirably conveyed. The fierce Oedipus of Kiyosumi Niihori sits absolutely still, facing the audience, during the seer's tirade; that uncanny, almost ritualized, self-absorbed stillness (which will soon explode into violent movement as Oedipus in his turn rails at Teiresias) explains a lot about the character, about both his past and his present inability to see the evidence that is right before his eyes.

The physical production similarly emphasized to great effect the way in which minimalist, allusive style yields the greatest results in the staging of classical texts. The stage at the Japan Society was equipped, as was the Theater of Dionysos at Athens, with the bare minimum of structures necessary to convey both an interior space (the palace), in which things—terrible things—took place, and a public space outside, in which those things were revealed: there was a small platform downstage for Oedipus to speak from and to be spoken to, and some sliding screens upstage from which entrances and exits were made, sometimes with unnerving stealth. (One of the screens seemed at first to be nothing more than a mirror, but turned out to be transparent as well, so that characters could see both themselves reflected in it and other characters revealed behind it; this was a superbly well considered effect for a drama in which every "self" turns out, disastrously, to be an "other": the husband a son, the wife a mother, the detective a criminal, the city's rescuer its vile pollution, the king an outlaw, the foreigner a native.) The effect of these minimalist sets was to focus your attention fiercely on the characters—or, rather, on the magnificent costumes, by Tomoko Nakamura and Kana Tsukamoto, that these characters were weighed down by: ponderous, heavily embroidered robes and gowns and crowns that well conveyed the imperial status that these private persons enjoyed—or were oppressed by. In tragedy, as in its distant de-

scendant, nineteenth-century opera, what makes the private agonies particularly unbearable is the fact that they are often endured in public, where the characters' royal status squarely places them.

And yet the costumes may have been the only thing that did fully convey the larger, political aspect of the Oedipus drama—the sense, one that Sophocles goes to great lengths to underscore, that the terrible things happening are not merely happening to a private person but to the leader of a city, one that he himself had once rescued and one indeed that has turned to him for salvation once again. Suzuki has commented not only on the similarities between tragedy and Noh, but on what he sees as the differences:

> Noh focuses on the vanity of human passions seen under the spectrum of eternity, whereas Greek tragedy stresses the indefatigable power of the human spirit in fighting against fate. Even though the fight is destined to be lost, Greek heroes overwhelm us with their will to know the whole truth about their failure. . . . Oedipus is the representative case—with all the sinister premonitions, he pursues his own past sins like the severest of prosecutors.

There is no question that what is admirable in Sophocles' Oedipus is his heroic desire to know even when it is clear that the knowledge he seeks will bring disaster. But "indefatigable power of the human spirit" sounds suspiciously sentimental, and if there is anything that distinguishes the classical sensibility from the contemporary it is the former's almost total lack of sentimentality.

This is nowhere truer than in tragedy, a genre that draws our attention as unrelentingly to its protagonists' deficiencies of character as to the piteousness of the punishments that in some sense "correct" those deficiencies. Indeed the text that Sophocles has composed suggests over and over again that what Oedipus is fighting against is as much his own nature as some randomly hostile fate. (At least one aspect of Oedipus's nature that clearly ought to arouse suspicion is one that Suzuki's style of direction nicely underscores: those explosive rages against older

men—indeed, against every other male character in the play. Classicists like to observe that Oedipus doesn't have an Oedipus complex, but it would be hard to find a character who has bigger "issues" about older male authority figures than this one.) And yet even despite the care with which Sophocles limns his protagonist's character, Oedipus is much more than simply a heroic individual, tormented by psychological demons against which he struggles alone, valiantly, in his quest for knowledge. The grandeur and horror of Oedipus's position owes much to the fact that the acts he commits as an ostensibly private person—or at least within what we'd think of as the private sphere (he has serious problems with road rage; he marries an older woman)—have terrible public ramifications: there is, after all, a plague going on that's afflicting all of Thebes, and Oedipus and his past crimes are the reason why.

It is Oedipus's public role that Sophocles emphasizes throughout the play, particularly at the beginning. The curtain, so to speak, rises to reveal him surrounded by supplicatory priests and citizens, appealing to the killer of the Sphinx to find once again a solution to a civic crisis— the plague. The next scene, an exchange with his brother-in-law Creon, demonstrates the ruler's anxious concern for his people. (In the prologue, Oedipus assures the priest that he has already sent to Delphi for a clue about what's causing the plague; Creon's entrance, as he returns from his mission, is a concrete demonstration of the truth of his claim.) When it is revealed that the plague is a divine scourge in response to the presence among the Thebans of the old king's murderer, it is Oedipus the ruler—Oedipus *tyrannos*, Oedipus *rex*—who lays the famous curse on the killer, "whoever he or they may be"—unaware all the while that he is condemning himself.

All this has been stripped away from Suzuki's *Oedipus*: the prologue supplication, the Creon scene (he appears here only for what, in Sophocles, is his second scene with Oedipus), anything that gives a sense of Oedipus the public personage fulfilling his responsibilities to a people and a city—and, hence, anything that conflicts with Suzuki's notion of Oedipus as a type of romantic sufferer. Most bizarrely of all, Suzuki's version of the play ends immediately after the moment of revelation, when Oedipus realizes who he is. Everything in Sophocles' play that follows that revelation—the messenger's speech with its narrative of the self-blinding and of the discovery of Jocasta's suicide, the reap-

pearance of Oedipus at the end, abjectly bidding farewell to his two daughters, his climactic exit to begin a life of exile—was relegated to a two-minute summary delivered via loudspeaker. By chopping off Sophocles' beginning and, particularly, the ending (for it is the traumatic ending that shows us the fulfillment of the opening curse in the abjection of the man, and thus brings the drama full circle), Suzuki diminishes the public, political, and cosmic dimensions of the play, and thereby erodes the sense that what happens in the drama is the result of very great forces at work in the universe, inexorably effecting their terrible outcomes.

But that larger dimension is what raises the stakes and makes tragedy precisely what Suzuki thinks it is not: a cosmic drama about the vanity of human action. What brings Oedipus closer to the "spectrum of eternity"—what makes him worth the Greek gods' notice at all—is the fact that he is not a private person but is, and has been all along, royal, destined to rule the fates of others. Sophocles, of course, did not call his play what Suzuki called it for the purposes of this production—*Oedipus Rex*, which is merely the Latin translation of the title that an ancient editor, who'd cottoned on to how many times the epithet occurs in the play, gave it: *Oedipus tyrannos*, "Oedipus the supreme ruler of the city-state." But whatever its author called it, and however this director envisioned it, this is a work that is clearly about a man who is a ruler as well as an individual—a work about states, and states of being, as well as personalities. As admirable as it was in so many respects, Suzuki's production gave you the Oedipus, but not the *rex*.

For that—for the grand sense of the larger social, civic, political, and cosmic concerns that tragedy in its original context so fiercely and stylishly illuminated—you had to get very far from Athens, and go to Brooklyn.

II

How relevant to contemporary events should a classical Greek tragedy be? According to the classical Greeks, not too much so. We know that early in the genre's evolution, there were plays that treated "real life" subjects—stories that were, at the time, recent news. *The Capture of Miletus* by Phrynichus, produced in 492 B.C., was a harrowingly emotional depiction of the Persians' destruction of a Greek city on the coast of Asia Minor—one of the proximate causes of the Persian Wars, which Herotodus would so memorably record; twenty years later, Aeschylus would famously dramatize the Greeks' rout of the Persian navy, a victory that had taken place only eight years earlier and which, indeed, marked the end of the Persian conflict.

But for the most part, the Athenian dramatists embraced, exclusively as far as we can tell, another, subtler kind of "relevance," one that was at once more abstract and more enduring than that afforded by detailed allusions to current events. Tragedy was much more interested in vigorously exploiting the rich cultural vein of myth for its plots; these stories, about a relatively small number of divine and human families, could remind audiences of "calamities of their very own" (the phrase Herotodus used to describe the reasons that *The Capture of Miletus* affected its Athenian audience so deeply) without being mired in the kind of real-life particulars that could cloud aesthetic experience (and that would, in any case, be doomed to a relatively short cultural shelf life). Even when comment on current events warranted a response from what we today would call "the creative community," it was myth that provided the ideal armature. As witness, for instance, the well-known example of Euripides' *Trojan Women*, produced in the spring of 415 B.C., which uses the final, ugly chapter of the Trojan saga to indict Athens's ruthless annihilation of an unwilling "ally" the previous winter.

The shift from history to myth as a subject for drama was, perhaps, the first and greatest example of tragedy's special genius for abstraction and distillation—qualities that made it the artistic vehicle par excellence for examining, sometimes critically, the institutions of life in the *polis*, the city-state. The failure of many productions of Greek tragedy—and of two recent stagings in particular, one of Euripides' final "war play," *Iphigenia at Aulis*, another of Sophocles' great masterpiece *Oedi-*

pus Rex—to reproduce or even suggest the larger, more abstract, more public concerns that were integral to Athenian drama in its heyday was the subject of a previous essay. That failure, which is owing in part to the contemporary, post-Freudian preference for psychology over politics as the subject of drama, inevitably miniaturizes and misrepresents Greek tragedy. All the more ironic, therefore, that of a number of recent productions of Greek tragic texts to appear in New York, it was the one about what we think of as the most private issues—love, sex, marriage—that came closest to conveying how Athenian drama, with its grand public preoccupations, must have felt, and worked.

The work in question was a new theater piece by the playwright Charles Mee, entitled *Big Love*, at the Brooklyn Academy of Music. BAM's publicity material for *Big Love* states that it's based on Aeschylus' *Suppliant Maidens*, one of the seven extant plays by that poet, but that doesn't do justice to the scope (some might say audacity) of what Mee has done. Many of Mee's earlier plays are dramatic Humpty Dumptys—reassembled (as he has put it) out of the deconstructed shards of preexisting works, among them *A Midsummer Night's Dream*, Elaine Scarry's writings, the transcript of the Menendez trials, and of course various Greek tragedies. (Another play, called *True Love*, updates Euripides' *Hippolytus* to a gas station in upstate New York.) But the putting-together-again you get in *Big Love* is more impressive than any of those could ever be, since Mee's play in fact reconstitutes all of the action thought to have been dramatized in Aeschylus' Danaid trilogy, which had its première sometime around 463 B.C.—about five years before the *Oresteia* and seven before the dramatist's death—and of which *Suppliant Maidens* was the first, and only surviving, third. (The trilogy's plot we infer from later summaries and some fragments, of which the most significant is seven lines thought to be from the final play.)

Like so much of high classical tragedy, this lost trilogy entwines what we today would think of as the personal and the political in such a way as to make them inextricable. As far as it's possible to reconstruct it, the trilogy went something like this. In the first play, *Suppliant Maidens*, the eponymous chorus, the fifty daughters of Danaus, an Egyptian king and descendant of the Greek princess Io, arrive in Io's hometown of

Argos, having fled Egypt and their fifty cousins, to whom they've been promised in marriage. Whatever their assertions that the first-cousin betrothals are "unlawful"—difficult to take at face value, given that (as the Greeks knew) even brother–sister incest didn't raise eyebrows in Egypt—Aeschylus makes it clear that what really motivates the girls' flight is their profound aversion to sex, and to the very idea of marriage. The fifty girls supplicate their distant relation the Argive king, Pelasgus, who after consulting with his assembly—every tragic supplication, however intimate the reasons, precipitates a political crisis—nobly agrees to defend the girls. (Their threat of mass suicide at the holy altar, a terrible pollution, helps him to see the light.) The beastly cousins eventually arrive in hot pursuit, threatening war against Argos and testing the resolve of Pelasgus, who tells off their representative in no uncertain terms. The play ends with this tense standoff.

The next play in the trilogy, *Egyptians*, seems to have begun with the defeat of Pelasgus and his army by the Egyptians after a pitched battle; in his place, the steely and ambitious Danaus, father of the fleeing girls, assumes the throne. It is he who makes his daughters swear their famous oath to kill their husbands on their wedding night—which at the climax of this middle play they all do, with the exception of one girl, Hypermnestra, who has fallen in love with her betrothed. End of part two. The third play, *Danaids*, apparently portrayed the moral, legal, and political fallout of Hypermnestra's actions. In it, Hypermnestra is tried for breaking her oath, but acquitted by none other than Aphrodite herself, goddess of love, who (in that seven-line fragment) affirms the universal and inevitable power of love and sex—the very things that the cousins had neurotically shunned, and that Hypermnestra alone embraced. Just as the *Oresteia* ends with a delicately achieved equilibrium between the craving for retribution and the necessity of peace, so too the Danaid trilogy, which even as it gives voice to female terror of male aggression, reasserts the need for marriage, reproduction, and the social structures that further them.

At first glance, the stage of the Harvey Theater at the Brooklyn Academy of Music, which is where *Big Love* was performed late last year, didn't look as if anything very dramatic were going to happen on it, let

alone attempted rape, mass murder, and a climactic courtroom drama. What you saw, basically, was a bathtub and a chandelier. This was not necessarily what you'd expect in a production of a drama that the classicist Froma Zeitlin, in an article about the Danaid trilogy, described as one that "confronts the most primary questions about relations between the sexes," and that the French scholar Jean-Pierre Vernant called above all "an inquiry into the true nature of *kratos*"—that is, of power. According to Vernant, the play raises questions that typically entwine the domestic and the political: "What is authority, the authority of the man over the woman, of husband over wife, of the head of the State over all his fellow citizens, of the city over the foreigner and the metic [resident alien], of the gods over mortal men?" Power, gender, marriage, politics, religion—all this in a bathtub?

Well, yes. Mee understands that tragedy's genius is for abstracting big ideas from concentrated resources; what, after all, did you really get in Athens but a few actors, a handful of stylized gestures and dance movements, highly conventional poetic speech, a door upstage center that conveniently stood for a palace, a hut, a city, a temple, a tomb? His stage directions alone show a remarkable grasp of this all-important notion: "The setting for the piece should not be real, or naturalistic. It should not be a set for the piece to play within but rather something against which the piece can resonate." And resonate it did: Mee created new harmonies by weaving into the mythic plot sounds and images and movement and artifacts—acrobatics, tomato-throwing, dance, tons of music ranging from *Le nozze di Figaro* to the blues song "You Don't Own Me," some business about Estée Lauder 24 Karat Color Golden Body Crème with Sunbloc—familiar from the contemporary culture.

The plot was basically Aeschylus's. Here again, there are fifty girls in flight from an unwanted marriage, and fifty brothers in pursuit—although we actually only meet three of each (Lydia, Olympia, Thyona; Nikos, Oed, Constantine), a nice concession on Mee's part to the contemporary discomfort with choruses, yet one that preserves the corporate character of Aeschylus's choral protagonist. In Mee's play, the girls are fleeing not to Argos but to a posh hotel in Italy ("If Emanuel Ungaro had a villa on the west coast of Italy, this would be it," go the stage directions), but as in *Suppliant Maidens* there's a supplication to a kindly protector, this time a suave tycoon named Piero instead of a king called

Pelasgus, and a threat of mass suicide. Interestingly, the one major cut that Mee has made is to excise the character of the scheming father, Danaus; in this Danaid trilogy, the girls' hearts don't belong to Daddy.

It's at this point, rightly about a third of the way through, that the rest of Aeschylus's lost trilogy kicks in: you get the murderous oath, and the graphic wedding-night murder (with the exception of the one sister, Lydia, who's fallen in love with her intended, Nikos), and a furious confrontation between Lydia and her outraged sisters. Of the latter, none is more outraged than the hot-tempered redhead Thyona, who here embodies the sexual anxiety and hatred of men you find in Aeschylus's text ("These men should be snuffed out! Who needs a man?") much as her opposite number, Constantine, embodies masculine violence and sexual aggressiveness, with a Bret Easton Ellis twist. "You want me to sew your legs to the bed and pour gasoline on you," Constantine screams at one point. "Is that what I have to do to keep you?"

Mee provides a nice Aeschylean resolution, too, presided over by a mature female—here, an outspoken Italian grandma named Bella— who ends this play, much as Aeschylus ended his, with a paean not only to the generative powers of nature and sex ("Love is the highest law," she declares among the bodies and broken wedding meats), but to the urgent importance of familial, social, and civic order. "So we all get along," she tells the girl as the play ends, a statement clearly meant to be less descriptive than prescriptive. "So Lydia: she cannot be condemned, and that's the end of it. And as for you, there will be no punishment for you either. . . . For the sake of healing. For life to go on." That may sound like Mrs. Buitoni, but the sentiment is pure Aeschylus.

Still, none of this looked like your typical Greek tragedy. For one thing, there's humor here, and lots of it: these Danaids enter by clomping onto the stage in their wedding dresses, loaded down with luggage; almost immediately they strip and jump into that bathtub. Their cousins arrive, noisily, by helicopter, and peel off their flight suits to reveal dinner jackets beneath. There are, thankfully, no attempts to reproduce the craggy grandiosity of Aeschylean diction: Aeschylus's terrified fiancées compare themselves poetically to heifers and doves pursued by hawks, ravens, wolves, serpents, and dogs, whereas Mee's girls are worried about being "the kind of person who ends up in a ravine with her underpants over her head." And it's a safe bet to say that Aeschylus

wouldn't have thought up the Cupid-like character of Giuliano, Piero's gay nephew and Bella's sidekick, who collects Barbie dolls and confesses a penchant for being "taken forcibly from behind"—one of several additions Mee has made in order to emphasize the variety and inexplicability of love (which is Aeschylus's subject, or one of his subjects). At the end of *Big Love*, this Giuliano and the wise old Bella sing an eerie climactic hymn: a song that corresponds to those seven preserved lines from *Danaids*, the ones in which Aphrodite waxes ecstatic about how love produces the fodder for flocks and the fruit of the trees. Here, Aphrodite's lines become a lyric poem to what Mee's characters, if perhaps not Aeschylus, believe to be the pleasures that make civilized life worth living: "silk stockings," "buttons," "birds nests/hummingbirds," "lessons for the flute," "a quill pen." But it amounts to the same thing.

Nor does *Big Love* show the physical restraint characteristic of Greek tragedy: the centerpiece of the first, *Suppliant Maidens* part of Mee's play is an acrobatic tour de force in which the girls repeatedly and quite violently hurl themselves to the ground, crying out things like "Who needs a man?" and "These men are parasites, these rapists." That scene is nicely balanced by one a little later on, in the part that corresponds to the second third of Aeschylus's trilogy—Mee has thought a lot about the construction of his model—where the men hurl themselves on the same mats, angrily denouncing "the expectations that people have that a man should be a civilized person" and screaming "Fuck these women!" while one of them viciously hurls circular saw blades into a wall. With perhaps one exception (a spectacular onstage suicide by a bereaved widow in Euripides' *Suppliants*), no Greek tragedy of which we know represented acts of violence onstage—let alone violence on the order of the graphically depicted sex and then murder that Mee shows us in the wedding-night climax of the second, *Egyptians*, part of his play.

And yet you left *Big Love* with the feeling that you'd seen, if not a Greek tragedy, then a play that had the theatrical and intellectual vigor that Greek tragedies must have had when they were first produced— a work that grappled with all the big social and political issues that Aeschylus grappled with, and made you grapple with them, too. The humor, physicality, and inventiveness of Mee's play, the way he chose to represent, visually and gesturally, sexual anxiety and masculine aggressiveness, the mysterious power of love, the whimsy and violence

and beauty of life, made you care about what was happening onstage, and hence about the underlying issues, which not surprisingly turned out to be the very ones that Aeschylus's play is about; which is to say, the most pressing questions about relations between the sexes, and the true nature of power. You didn't leave Shepard Sobel's *Iphigenia at Aulis* worried about the moral corrosiveness of war, and you didn't come out of Tadashi Suzuki's sober and beautiful *Oedipus* at the Japan Society ruminating about knowledge and fate and self-determination, but you did emerge from Charles Mee's adaptation of Aeschylus's Danaid trilogy arguing (as people were doing as they left the Brooklyn Academy of Music) about women and men and violence and sex and power. About *eros* and *kratos*, that is, the twin poles around which Aeschylus's trilogy was organized. If Mee's production seemed to be about something (something other than giving people the edifying feeling that they'd been to a Greek play, that is), it was because he'd thought hard about not only what this tragedy meant, but *how* it meant—about the figurative forms and allusive structures that might allow tragedy, twenty-five centuries after the demise of Athens, to keep signifying, just as those forms and structures allowed the dramas, in their original productions, to investigate so much more than the lives and feelings of a few unfortunate heroes and heroines and their families.

The tensions and negotiations between the demands of the past and the needs of the present are, as it happens, a very Aeschylean concern: one that drives not only the *Oresteia*, as we know, but also, according to at least one critic, the trilogy that Mee has so idiosyncratically resuscitated. In her discussion of the Danaid trilogy, Froma Zeitlin remarks that the fifty sisters' anxiety about embarking on lives as sexually mature females is paired with, and enhanced by, a morbid obsession with the past—in particular, with the tale, the *mythos*, which they keep repeating, about their illustrious ancestress Io, another famous female victim of male desire. (She was turned into a cow when Zeus tried to hide her from his wife.) As Zeitlin observes, awareness of the past, as expressed in myth, anchors and perennially renews our sense of who we are; yet obsession with the past cuts us off from the present—and the future.

What we, like Aeschylus's Hypermnestra and Mee's Lydia, want—from life but also from art—is a complex negotiation, one in which, as

Zeitlin puts it, "myth remains the *mythos*, the primary story and the plot of the action, but it is also coded to speak about the present." It would be hard to find a better description than that of what tragedy was in its heyday, and of what Mee accomplished with *Big Love*. His new work is a model of how to present tragedies today: preserving their primary stories while imaginatively reconfiguring the codes—the ancient, formalized theatrical vocabularies of the telling gesture and potent symbol and striking image—in a way that allows the works, after so many centuries, not merely to speak but to be heard.

—*The New York Review of Books*, March 29 and April 11, 2002

Bitter-Sweet

"A talent to amuse" or "*just a talent to amuse*"? Even before Noël Coward's death in 1973, the former phrase—a line from one of his songs—had become the standard celebratory summation of Coward's contribution to popular culture during a half century as a playwright, actor, songwriter, diarist, composer, autobiographer, novelist, and cabaret entertainer. *A Talent to Amuse* is the title of Sheridan Morley's admiring but judicious 1969 biography of Sir Noël; A TALENT TO AMUSE is the epigraph that adorns the Westminster Abbey memorial stone dedicated to him (located—appropriately, you can't help thinking, for this master of light verse—not in, but just adjacent to, the Poet's Corner).

But "a talent to amuse" is not what Coward actually wrote. Or at least, not all of what he wrote. The phrase that has come to summarize Coward was, in fact, snipped from its context in a song called "If Love Were All" that Coward composed for his 1929 "operette," *Bitter-Sweet*. It's sung by a lovelorn café chanteuse after she's been reunited with a former lover who has since remarried. Here is the entire verse:

Although when shadows fall
I think if only—

Somebody splendid really needed me,
Someone affectionate and dear,
Cares would be ended if I knew that he
Wanted to have me near.
But I believe that since my life began
The most I've had is just
A talent to amuse.

In its proper context, then, "a talent to amuse" is not so much a self-celebration as it is something more wistful and self-ironic, and not a little sad. A talent, yes, but a talent for something relatively minor: *just* a talent to amuse. A gift, yes, but one with limited power: the *most* she can offer.

The elision of that "just" over the years, the gradual loss of the phrase's original, piquant context, can be seen as a symbol of our increasing failure to understand just what "amusement" meant for the author of those words. Noël Coward's distinctive sensibility, as both writer and performer, was, in fact, a particularly complex one. Shaped in his Edwardian boyhood but ripened in his Jazz Age youth, it owed much to the revues of the late 1910s and early 1920s, like those of his early producer André Charlot, with their swift shifts in mood and tone. It's a sensibility that's poised, we might say, on the fulcrum between "a talent to amuse" and "just a talent to amuse"—between self-assertion and self-deprecation, merriment and melancholy, sweet and bitter. This curious hybrid is difficult to sustain in the present era of popular entertainment, with its effortfully ironic tone, its brittle carapace of postmodern knowingness, and its omnipresent violence and explicitness. To us, Coward's light touch, like the "light" genres at which he excelled—light comedy, light verse, the latter in particular nearly extinct today, both aiming above all to provide pleasure, gaiety, amusement—is bound to come off as trivial, un-hip.

As a result, we tend to get Coward wrong: we find the elements that appeal to us, and forget the rest. Coward tends to be played as camp these days; the brittleness of his dialogue appeals to our own desire to appear knowingly world-weary. But emphasizing the cold glitter leaves out the strong feelings that run just beneath the surface, the sentimen-

tality that lurks in the background of the comic plays and explodes into the foreground in the 1945 film *Brief Encounter*, based on one of his 1935 *Tonight at Eight-thirty* sketches, or his patriotic paean *In Which We Serve* (1942).

Coward's estimation of his own talent to amuse was itself characterized by a mix of celebration and deprecation. On the one hand, he had the healthy self-regard of talented people who have achieved success through tremendous hard work. ("I am bursting with pride, which is why I have absolutely no vanity.") Born just before Christmas 1899—hence the given name—to a lower-middle-class Teddington piano salesman and his strong-willed wife, he first stepped on a stage at the age of ten, and throughout his life he was proud to have been in the business of giving pleasure. When he described his five canonical comic masterpieces—*Hay Fever* (1924), *Private Lives* (1930), *Design for Living* (1932), *Present Laughter* (1939), and *Blithe Spirit* (1941)—as being "important," it was because they gave "a vast number of people a great deal of pleasure."

He himself took unabashed pleasure in the success that his ability to amuse had brought him already at a very tender age. He composed that bittersweet lyric for *Bitter-Sweet* when he wasn't quite thirty; by then, he'd been an international celebrity for five years, having rocketed to stardom in 1923, at the age of twenty-four, with his sensational cocaine-addiction melodrama *The Vortex*, which was followed the next year by a solid comic hit in *Hay Fever*. "The world has treated me very well—but then, I haven't treated it so badly either."

Yet Coward's satisfaction in what he did so abundantly well (and so abundantly: sixty published plays, three hundred published songs, a multivolume autobiography, dozens of short stories, a novel) was balanced by a healthy lack of illusions about the nature of his gift. "I don't write plays with the idea of giving some great thought to the world," he wrote on the eve of his sixtieth birthday, "and that isn't just coy modesty. . . . If I wanted to write a play with a message, God forbid, it would undoubtedly be a comedy." That "God forbid" reminds you of Coward's distrust of weighty messages, his fervent belief that amusement could

have nuance and substance; and it explains why, even after the rise of John Osborne and the kitchen-sink drama, he went on insisting, with perhaps pardonable shrillness, that the theater must above all amuse, must be what it surely seemed to him in his Edwardian boyhood, "a house of strange enchantment, a temple of dreams." "Nowadays," he wrote in his late fifties,

> a well constructed play is despised and a light comedy whose only purpose is to amuse is dismissed as "trivial" and "without significance." Since when has laughter been so insignificant? No merriment apparently must scratch the set, grim patina of these dire times. We must all just sit and wait for death, or hurry it on, according to how we feel. To my mind, one of the most efficacious ways of hurrying it on is to sit in a theatre watching a verbose, humourless, ill-constructed play, acted with turgid intensity, which has received rave notices and is closing on Saturday.

His characterization of what makes a play bad reminds us of what makes his own best work so good: verbal precision and economy (he declared himself "one of the few remaining guardians of the English language"), merriment and humor, elegance of construction, all of them showcased by an acting style that is gossamer, playful, blithe—a technique that easily reflects the many colors that shimmer across the surfaces of his lines. ("The befeathered sheen of a pheasant's neck" is how Kenneth Tynan described Coward's dialogue.) A technique, that is to say, that understands that his plays consist of nothing but surfaces— and that takes their superficiality with, of course, the utmost seriousness.

The difficulty of getting just right Coward's many complexities— the paradoxical ways in which wistfulness can be entwined with glitter, and meaning can exist in surfaces—is all too evident in two new productions. One of them is easy enough to dismiss, since Coward himself dismissed it: the world première of *Long Island Sound*, a 1947 play whose value even as a curio is, however, marred by a vulgar, tasteless staging. The other is a shiny new production of *Private Lives*. The fact that the latter manages to make this finest of Coward's comedies seem verbose,

humorless, and ill-constructed—to say nothing of the fact that it has received rave notices on both sides of the Atlantic—indicates how far from Coward we now are, and how fragile his legacy is.

=======

"Fragile" is a very good way to describe *Private Lives*. Its plot is as thin as any that Coward concocted—the most tenuous of structures on which to hang his mousseline wit. In the first act, Elyot Chase, an elegant young man of "about thirty, quite slim and pleasant-looking," is honeymooning at a luxe hotel in France with his second wife, Sybil, a pretty blonde of twenty-three. The adjoining suite, of course, turns out to be occupied by Elyot's firecracker of a first wife, Amanda, who's honeymooning with *her* new spouse, Victor Prynne. Storming onto the terrace after fights with their respective mates, Elyot and Amanda catch sight of each other and, in the course of some verbal sparring realize they're still mad about each other; and then proceed to flee their nice if somewhat conventional new spouses. The second act, set a few days later in Amanda's Paris flat, suggests why Elyot and Amanda divorced in the first place: tart-tongued, volatile, inventive, restless, each is the other's best audience—but who wants to live onstage? The third act, typical of Coward's finales, is less a resolution than an escape: Victor and Sybil catch up with their wayward mates, growing to loathe each other into the bargain, and during a furious breakfast-time fracas Elyot and Amanda laughingly sneak off together as Victor and Sybil start hammering away at each other. How they will actually live together is of no concern.

Typically, Coward had few illusions about the weightiness of this work, which was written in four frantic days in Shanghai after a vision of his acting partner and beloved friend Gertrude Lawrence "in a white Molyneux dress on a terrace in the South of France" came to him as he readied himself for bed. (He'd promised to write a play for her while he was traveling in the Far East; leaving nothing to chance, Lawrence slipped a photograph of herself into the Cartier desk set that she'd given him as a going-away present.) In the first volume of his au-

tobiography, *Present Indicative*, which he published at the tender age of thirty-seven, the playwright, with his usual blend of self-deprecation and self-celebration, characterized his creation as "a reasonably well-constructed duologue for two experienced performers. . . . As a complete play, it leaves a lot to be desired. . . . From the playwright's point of view, [it] may or may not be considered interesting, but at any rate, from the point of view of technical acting, it is very interesting indeed." And again, later: "a shrewd and witty comedy, well-constructed on the whole, but psychologically unstable; however, its entertainment value seemed obvious enough, and its acting opportunities for Gertie and me admirable."

It's significant that Coward always rates the work's "entertainment value" and, particularly, its "acting opportunities" more highly than he does its structural or psychological coherence. The real hero of Coward's best comedies is, after all, Coward himself. A lot, if not most, of his oeuvre was composed with himself in mind as the male lead. (You'd think that this would alert directors to the fact that an appreciation of Coward's performance style is likely to be crucial to the success of his plays.) The repeated characterization of his plays as vehicles for interesting acting is one of the many things that distinguish Coward from Oscar Wilde, that other homosexual British master of crisp wit, to whom Coward is often, and for the most part inaccurately, compared. Wilde's plays are the creations of a playwright; Coward's are those of a performer. If the former's work achieves a hermetic perfection of structure that Coward's never does, it's because Coward is ultimately more interested in the performance than in the play.

And yet Coward's shrewd spotlighting of entertainers was more than a matter of giving himself work; it goes to the heart of what his plays are about. If he couldn't imagine writing plays with a weighty underlying "message," it was because in his plays, the medium was the message: entertainment, amusement are our weapons against the vagaries of life. "Laugh at everything," Elyot tells Amanda, as they plot to abandon their brand-new spouses. "We're figures of fun." In part, this emphasis on laughter and fun reflected the outlook of a well-balanced person who had an agreeably optimistic view of life. (Of his longtime acquaintance Somerset Maugham, Coward wrote that "he believed, rather proudly, I think, that he had no illusions about people but in fact

he had one major one and that was that they were no good.") But the omnipresent self-consciousness about fun and laughter in his work—his characters' amused awareness of being performers in a delicious play—was also his "message": his serious response, as a popular entertainer (and no doubt as a homosexual, too) to what Elyot calls "all the futile moralists who try to make life unbearable."

The sense that Coward's favorite characters are performers in some way or another is particularly strong in *Private Lives*. Anomalously among this playwright's characters, neither Elyot nor Amanda has a career, and yet there is a strong sense throughout the play that the core of their enjoyment of each other (when they're not fighting) is their dramatic and verbal fantasy. They're writers, or perhaps playwrights, manqués, and they can't be together for two minutes without launching into a decidedly theatrical playfulness. Snuggling in Amanda's Paris flat in Act Two, Elyot starts the gramophone and asks Amanda to dance, and they're immediately off and running:

> ELYOT: Are you engaged for this dance?
> AMANDA: Funnily enough I was, but my partner was suddenly taken ill.
> ELYOT: It's this damned smallpox epidemic.
> AMANDA: No, as a matter of fact it was kidney trouble.
> . . .
> AMANDA: Is that the Grand Duchess Olga lying under the piano?
> ELYOT: Yes, her husband died a few weeks ago, you know, on his way back from Pulborough. So sad.
> AMANDA: What on earth was he doing in Pulborough?
> ELYOT: Nobody knows exactly, but there have been the usual stories.

By contrast, the perfectly nice Sibyl and Victor have no "usual stories"—indeed, have no stories at all: the extent of their fantasy is the awful little nicknames they've given their new spouses ("Elli" and "Mandy"). It's this lack of imaginative élan that makes them losers in Coward's eyes. If what distinguishes the exchanges between Amanda

and Elyot is the way in which they so readily pick up each other's cues, what alerts us to the unsuitability of Sibyl and Victor to their respective mates is their flat-footed inability to recognize good cues when they see them. At the beginning of Elyot's first-act spat with Sibyl—he's just caught sight of Amanda on the next balcony, and desperately tries to convince his new wife that they should leave the hotel at once—Elyot roars at his uncomprehending young bride that "if there's one thing in the world that infuriates me, it's sheer wanton stubbornness." Then, the characteristic, deliciously deadpan Cowardian gearshift: "I should like to cut off your head with a meat axe." To which Sibyl can only respond, "How dare you talk to me like that, on our honeymoon night." This is clearly not a marriage made in Coward heaven.

The marriage between Noël Coward and Howard Davies, the director of the new Broadway Private Lives, isn't so great either. Davies's problem is that he doesn't trust Coward's belief in the fundamental seriousness of play; instead, he just goes for seriousness. The result is about as interesting as Sibyl.

The irony is that Davies's heart is in the right place. Too often, Private Lives has been the vehicle for some good-natured camping on the part of middle-aged actresses eager for an adorable vehicle. (The last major Broadway revival was in 1992, featuring Joan Collins; before that, it was Elizabeth Taylor, in 1982, and long before that, Tallulah Bankhead, in 1948.) Coward himself deplored this approach to his work. As early as 1949, he expressed dismay at a revival of Fallen Angels (1925) that was done as camp self-parody, and he elsewhere denounced a production of Present Laughter in which the lead role, a famous, Cowardesque actor, was portrayed as being vicious. And a young actress performing Amanda in what she thought was the approved Coward style he dismissed as "too piss-elegant by half."

It's easy to see why he was so annoyed. Such interpretations fail to see that there are feelings in Coward's work; they miss the side of

Coward that the playwright himself cherished as "the romantic quality, tender and alluring," which Gertrude Lawrence brought to Amanda. They make impossible anything like what Coward's close friend and biographer Cole Lesley records in his description of Coward and Lawrence's original performance of the play: "They played the balcony scene so magically, lightly, tenderly that one was for those fleeting moments brought near to tears by the underlying vulnerability, the evanescence of their love."

But in his quest to get the feeling back into *Private Lives*, Davies has grossly miscalculated; he fails to understand just where the feelings are. No doubt there was a superficial allure to the idea of reuniting Lindsay Duncan and Alan Rickman, the stars of the 1987 *Dangerous Liaisons* that he'd directed, as his Amanda and Elyot: the vicious, big-cat murderousness of the Marquise de Merteuil and the Vicomte de Valmont is a distant ancestor of what Coward's leads, "biting and scratching like panthers," do to each other. Yet Davies doesn't even let his actors have that feline fun, because he's too busy having them emote—stretching out their lines, and the spaces between them, with long pauses, giving each other burning glances, and in every other way apparently trying to get behind the characters' witty repartee and excavate their true feelings.

In an interview with *The New York Times*, Rickman and Duncan revealed why. Davies, who'd never read the play until he got this job, wanted them to say the lines "without any of the usual stuff that comes with Noël Coward"—to "make these people real." The problem is that there's nothing "real" about them. In the stagey worlds of Coward's comedies, the witty repartee isn't a cover for feelings, as Davies seems to have felt; it *is* the feelings, or rather the vehicle for expressing them. In their recordings of *Private Lives*, Coward and Lawrence delight in their dialogue as if it were a tennis match, speaking briskly, each capping the other's lines; Rickman and Duncan, by contrast, took so much time delivering their volleys that it sometimes seemed as if they were hoping a "message" would pop up in the pauses, if they could only make them big enough.

One result was to throw the play's delicate dynamics off-kilter. By making Amanda and Elyot comparatively normal (well, neurotically normal), their mates come off looking like morons, whereas they're just

nice people unlucky enough to have drawn too close to the leopards' cage. (Preparing to revive the play, John Gielgud hoped to find a Sibyl and Victor as *nice* as Adrianne Allan and Laurence Olivier, who'd created the roles.) What should fascinate us is the leopards: their danger, their beauty, the way they're lethal to others but necessary to each other.

The other result was what must be the longest *Private Lives* on record: Act One alone took nearly an hour. No wonder people asked Duncan if the play had been rewritten.

Deprived of Coward's fizzy pacing, *Private Lives* does just what an early reviewer of the play, for whom it "hardly mov[ed] farther below the surface than a paper boat in a bathtub," feared it all too easily could do: become "a shapeless, sodden mass." (That, incidentally, is a good way to describe Louise, the hapless French maid to whom Davies, presumably out of desperation, gives a distracting series of vulgar pratfalls, as if to compensate for the lack of laughs elsewhere.) Part of the way in which Coward kept his little boats afloat was, in fact, to juxtapose, with giddy hilarity, his characters' fantasy with soggy everyday "reality" (which is what Davies is interested in). There's a wonderful moment in the play, during the extended second-act love interlude, when Elyot starts getting frisky and Amanda rebuffs his advances on the grounds that it's "so soon after dinner." Angrily, Elyot accuses Amanda of having "no sense of glamour, no sense of glamour at all." For all its ravishing décor, this *Private Lives* is devoid of glamour; it's so suspicious of camp style that it ends up having no style at all. "I see you're determined to make me serious, whether I like it or not," Amanda sulks at Victor toward the end of the play. It's a line Coward might well address to Davies, if only he were here. That he isn't is all too obvious.

———

If Davies's Coward is rather stodgy and Victorish, the world première performance of *Long Island Sound*, based on an early short story called "What Mad Pursuit?," reminds you of no one so much as poor, slapstick Louise. After his friends gave a reading of the new farce a cool reception, Coward had the good sense not to try to get it produced. No

wonder: the story of a debonair English writer's hapless visit to a Long Island country house peopled by vulgar American nouveaux riches and their famous friends is all situation and no plot, and—not least because it assigns all the eccentricities to the frenetic Americans in order to make its victimized British hero, Evan Lorrimer, the "good guy"— inverts the normal and usually successful structure of Coward's best comedies. (The writer's own home life was surprisingly domestic and, as his longtime companion Graham Payn recalled, "simple": but that simplicity, like the "reality" that Davies wants, isn't a fruitful object of Coward's dramatic sensibility.) Even so, the play surely deserves better than the crude treatment it gets from Scot Alan Evans, whose idea of Coward style is to have men's faces shoved into women's bosoms and to allow the actor playing Don Lucas, Evan's temporary roommate, to flounce around in a dressing gown emitting high-pitched laughs—and giving a nonplussed Evan a kiss on the mouth.

In response to the first production of *Private Lives* in 1930, Ivor Brown surmised that "within a few years, the student of drama will be sitting in complete bewilderment before the text of *Private Lives*, wondering what on earth these fellows in 1930 saw in so flimsy a trifle." Stagings such as Davies's and Evans's, alas, produce just that sense of bewilderment. They remind us in an unfortunate way just how much Coward's texts were fragile armatures for a very specific sensibility, and in the absence of an appreciation for that sensibility, the student of drama cannot be blamed for wondering what everyone saw in Coward—why we thought him so damned amusing.

Assuming, that is, that the student of drama even knows who he is; and how should he? "Even the youngest of us will know, in fifty years' time, exactly what we mean by 'a very Noël Coward sort of person,'" Kenneth Tynan confidently predicted in 1953. Fifty years later, I asked a student of mine what he thought "a very Noël Coward person" was. The student, a Princeton undergraduate who's very involved in campus theatricals as both a performer and writer, cocked his head and gave it some thought. "Wait," he said. "Noël Coward—weren't there two of him? And one was a songwriter?" Talk about bittersweet.

—*The New York Review of Books, June 27, 2002*

Double Take

At the climax of Mel Brooks's 1968 comedy cult classic movie *The Producers*—the opening night of an intentionally awful musical about the Third Reich called *Springtime for Hitler*—the show's grandiose producer, Max Bialystock (Zero Mostel), tries to alienate the *Times* theater critic by ostentatiously offering him a bribe: he hands the prim man a complimentary ticket wrapped in a $100 bill. As even those who haven't seen the film are likely to know by now, Bialystock wants the play to bomb so that he and his partner, a timid accountant named Leopold Bloom, can abscond with the backers' money. Figuring the play will close after its first performance, they've sold 25,000 percent of the show, never dreaming they'll have to pay the investors back. Naturally, the show's a hit.

In the case of the phenomenally successful new musical based on the film, the ticket itself would make a far more tempting bribe. The day after it opened last month to ecstatic reviews, the producers of *The Producers* raised the top ticket price to $100 (a Broadway record); but for the present, tickets are much harder to find than hundred-dollar bills. "That beloved Broadway phenomenon: the unobtainable seat," the editors of the real-life *Times* were moved to gush in one of two editorial-

page comments devoted to the musical's huge success. By the Sunday after opening night, $50,000 worth of tickets were being sold every ten minutes, according to one of its producers; nearly $3 million in tickets were sold on a single day. (Another record.) When the Tony Award nominations were announced on May 7, the fact that *The Producers* received fifteen of them (another record) seemed like a foregone conclusion—as if recognition of a musical's actual qualities ought to follow naturally from its box office success, rather than the other way around. A Bialystockian view of things if ever there was one.

Inevitably, the phenomenal success of *The Producers* has spawned a cottage industry in ruminations about its appeal. Attempts to explain what one critic, writing for a British audience, calls the "cultural repercussions" of the musical's success have appeared in print from London to the East Village. Many of these writers attribute the show's popularity to its refreshing refusal to abide by "politically correct" standards: it mocks, with gleeful evenhandedness, Nazis, Jews, dumb blondes, gays, lesbians, blacks, Irishmen, old people, and (lovingly) theater people. "For a show that is attracting family audiences," the *Times*'s former theater critic and current Op-Ed page columnist Frank Rich wrote three weeks after the play's première, "this one is about as un-Disney as you can get. . . . It hasn't been pre-tested with focus groups but insists on speaking only in the singular voice of Mel Brooks."

But precisely what's interesting is the fact that, although it's based on Brooks's most famous movie (a critical failure for which he nonetheless won an Academy Award for Best Original Screenplay in 1968), and boasts seventeen new songs, with music and lyrics all by Brooks (in addition to the memorable "Springtime for Hitler" production number and the finale "Prisoners of Love," which he wrote for the movie), the new *Producers* doesn't sound like Brooks at all. For the seventy-five-year-old Brooks, the show's success represents the highly satisfying culmination of a sixty-six-year-old dream: in an article that appeared in the *Times* Arts & Leisure section the Sunday before his play opened, the writer, comedian, and director reminisced about being a stage-struck boy in Brooklyn during the Depression and being taken to his first show. And yet there's another victory evident here. Despite its ostentatiously Brooksian manner, the un-PC trappings, the show represents

not so much the defeat of what Rich calls the "show-business corporate-think" that creates "bland pop culture" as—subtly—its triumph.

The Producers began its life forty years ago as an idea for a novel. Brooks, who'd been a well-paid writer for Sid Caesar's *Your Show of Shows*, claimed that he'd never considered himself to be a writer, but instead thought of himself as a funny "talker." Nonetheless, he found himself thinking about a novel based on the kind of scenario that only someone who'd spent a significant number of years in analysis, as he and Caesar both had done, would find irresistible: what happens when someone with a highly overdeveloped superego—the Bloom character, "a little man who salutes whatever society teaches him to salute," as Brooks recalled in a *New Yorker* profile by Kenneth Tynan that appeared in 1978—runs headfirst into someone who's a walking, talking Id. "Bite, kiss, take, grab, lavish, urinate—whatever you can do that's physical, [Bialystock] will do," he told Tynan. The novel was to focus on a dynamic point that barely survived in the movie: how the two vastly different men would end up influencing each other, with Bloom instilling in the grandiose, greedy Bialystock "the first sparks of decency and humanity" and Bialystock breathing some life into gray little Bloom. As Brooks worked on his book, however, he realized that nearly everything he was writing was dialogue. "Oh, shit, it's turning into a play," he recalled thinking.

His instincts were right. The film version is, essentially, a three-act play. In the first act, Bialystock, who raises money for his disastrous productions by providing sexual thrills to little old ladies, and Bloom (played by Gene Wilder in his second film role—the first was as a victim of Bonnie and Clyde) form their unlikely partnership one day while Bloom is doing Bialystock's books and suddenly realizes that they could, theoretically, make more money with a flop than with a hit. In the second act, the two mismatched partners set about finding the most appalling script they can get their hands on ("Springtime for Hitler: A Gay Romp with Adolf and Eva in Berchtesgaden," composed by an ex-Nazi who raises pigeons on the roof of a Greenwich Village tenement); the most inept director (the ultra-queeny Roger DeBris, who "never knew the Third Reich meant Germany" until he read the script—"it's drenched with historical goodies like that!"); and the most incompe-

tent lead actor, a burned-out hippie named L.S.D. (The pair also spend some of the old ladies' money on a buxom Swedish secretary named Ulla, who gyrates around the office dancing whenever Max tells her to get to work.)

The climax of the second act is what Brooks referred to as a "big neo-Nazi musical number right in the middle": a fully staged performance of the show's opening number, "Springtime for Hitler," which DeBris turns into a Busby Berkeley spectacular, complete with chorines goose-stepping in swastika formation. Initially appalled, the opening-night audience ultimately finds the play hilarious: when it becomes clear that the show will be a hit, Bialystock and Bloom realize that they're ruined. In the haphazard dénouement that is the third act—Brooks likes his MacGuffins, but tends to lose interest in his endings—the two desperately decide to blow up the theater, are caught, tried, and convicted ("incredibly guilty" is the jury's verdict), and end up in prison. The film closes with the two men producing a musical called *Prisoners of Love*, excessive percentages of which they sell to their fellow prisoners—and to the warden.

The Producers was the first film that Brooks wrote and directed. He'd go on to make others, some of which, like the sublime horror-movie parody *Young Frankenstein* ("that's Frahn-ken-*steen*," the baron's embarrassed grandson keeps telling people), would be more polished and better put-together than his debut. But the deliciously anarchic, gleefully grotesque energies you get in *The Producers*, which find expression in the many repellent close-ups of Zero Mostel and in the choppy, hectic pacing and camera work, were to become hallmarks of Brooks's directorial style, such as it was. ("Almost prehistoric" was the verdict of the distinguished film editor Ralph Rosenblum, who worked on *The Producers* and reminisced none too flatteringly about his sole collaboration with Brooks in his memoir, *When the Shooting Stops . . . The Cutting Begins*.) Even in the funniest Brooks movies there's an improvisatory feel; in Brooks the director you always sense the presence of Brooks the onetime Borscht Belt comic—he started working the Catskills hotels while still in his teens—frenetically firing off whatever gags he has at hand, whatever would work.

This seemingly ad hoc style was less noticeable when the comic and parodic energy had a consistent object. This is why Brooks's best films are the tetralogy of genre parodies: *Young Frankenstein* (horror), *Blazing Saddles* (westerns), *High Anxiety* (Hitchcock), *Silent Movie* (silents). But in the least successful movies, precariously thin plotlines—a billion-aire makes a bet that he can survive in the streets of L.A., for example, which is the donnée of the 1991 film *Life Stinks*—are clearly little more than excuses for stringing together gags (jokes about bums, say), some of which, as in any stand-up routine, are better than others. Other films, like *History of the World, Part I*, which zips merrily from the Stone Age through the seventeenth century ("It's good to be the King," Brooks, as a particularly goatish Louis XIV, keeps saying as he shuffles around Versailles, goosing buxom courtiers), are transparently little more than revues.

And, like a stand-up, Brooks likes to reuse successful material. In *Young Frankenstein*, the humpbacked Igor's hump keeps moving from one side of his back to the other; in *Robin Hood: Men in Tights*, it's King John's mole that switches from left to right, to the strangulated dismay of his associates. The hoary "walk this way" gag appears not only in the original *The Producers* and in *Young Frankenstein* but in the new musical as well, where the mincing walk of Carmen Ghia, Roger DeBris's fey assistant, comes in for predictable mockery. (Effeminate gay men are particular targets for Brooks's humor, and nowhere more so than in the new musical. In this context it's worth noting the striking frequency with which jokes and stories about "fags" come up in the Tynan profile.)

The problem is that, precisely because the gags are recyclable, they're not organically connected to anything else; as a result, the movies, however funny, feel slapdash and disjointed at best—the jokes may be funny, but they never really build to anything. I recently watched all of Brooks's films again, and, having looked forward to the hilarious bits I'd remembered, was surprised at how many *longueurs* there were. As with a Catskills comic, you tend, with Brooks's films, to recall the brilliantly funny moments and forget the rest.

Despite the mixed-to-terrible notices *The Producers* received when it opened in 1968 ("amateurishly crude," Pauline Kael wrote in *The New*

Yorker; "a violently mixed bag," "shoddy and gross and cruel," Renata Adler wrote in the *Times*), Brooks's film soon established itself as a cult favorite. Today, it's not unusual to see it counted among the funniest movies ever made. This popularity surely owes a great deal to the same crudeness, grossness, cruelty, and amateurishness that the critics complained about. Unlike Woody Allen, with whom Brooks is often lumped in discussions of comic moviemaking, not least by himself ("Listen, there are one hundred and thirty-one viable directors of drama in this country. There are only two viable directors of comedy"), Brooks has made no attempt to become more "artistic," more ostentatiously polished. To Allen's intellectual *artiste*, Brooks has been more than happy to play the outrageous clown; like Bialystock, he gives audiences access to their ids. (However ably it parodies old favorite westerns like *Destry Rides Again*, *Blazing Saddles* is most famous for a scene that follows a cowboy meal of baked beans to its logical, if protracted, gastroenterological conclusion.)

"Half of Mel's creativity comes out of fear and anger," the comic Mel Tolkin has said. "He doesn't perform, he screams." Brooks, the former stand-up who knew how much the public loves the high-wire spectacle of improvisation, of someone just standing there screaming, forcing the audience into delighted and sometimes outraged submission, had no plans to smooth himself out. "If someone wants to call my movies art or crap, I don't mind," he told Tynan. "I produce beneficial things. A psychiatrist once told me he thought my psyche was basically very healthy, because it led to product. He said I was like a great creature that gave beef or milk. I'm munificent." It's good to be the king.

The comedian's willingness to go as far over the top as necessary to get his audience's attention was nowhere more evident than in his first movie, whose technical crudeness attested to the wildly megalomaniac energies of its creator. But then, *The Producers* was nothing if not a testament to the obstinacy of vulgarity, the tenacity of bad taste; Brooks included that big neo-Nazi production number "right in the middle of the movie" because he knew that audiences occasionally want bad taste, want to have their faces rubbed in bona fide kitsch. (*Springtime for Hitler* is, Max declares, the musical about the unknown Hitler, "the Hitler with a song in his heart.") The impulse to force us to confront the grotesque is the germ of a certain kind of comedy—the kind that we're

relieved to participate in because it frees us, temporarily, from everyday conventions and proprieties.

Or allows us vicariously to vent "fear and anger." The idea for a musical about storm troopers wasn't as random as it may look: Brooks has recalled how, as a private who saw action in Europe at the end of World War II, he "sang all the time" when confronted with American corpses, and "made up funny songs." It's worth keeping in mind, when comparing the original *Producers* to its shiny new epigone, that Brooks and the audience for his film, when it first came out, were old enough to have fought the Germans—a fact that tells you a lot about the nature and outrageous appeal of his comic style at its provocative best. *Springtime for Hitler* was a far more daring violation of taste twenty years after the end of the Second World War than it could ever be now. Indeed (in one of his rare if grudging concessions to considerations of taste and sensibility) Brooks agreed to change the name of his movie to the innocuous *The Producers* from its original title, *Springtime for Hitler*, because the film's Jewish distributor was afraid that the latter, even in a comedy, would alienate Jewish audiences.

———

It is precisely in its utter lack of outrageousness that the new musical version of the film differs from its model. Fear and anger aren't in evidence here so much as a successful showman's desire to take a proven hit and package it with more polish for an already appreciative public; the new *Producers* is to the old one what the new versions of *The Fly* or *Batman* were to their film or television originals: fancier repackagings of a product that has otherwise changed very little—although times have. The new show is "product," all right, but not in the way that Brooks once thought of his output.

The changes *The Producers* has undergone in its transformation into a musical aren't so much qualitative as quantitative—more songs, more dances, and, most important, a more elaborately imagined *Springtime for Hitler* production number. (But credit should be given where it's due: a lot of the bits that people are raving about—for instance, the

beer steins and pretzels that adorn the outfits of the Ziegfeldesque Nazi showgirls—are taken directly from the film.) The story has remained intact, with a few unimportant modifications. Ulla, the big-busted Swedish secretary, has more brains than she did before; the lead actor, L.S.D., is all but dispensed with (the hippie jokes simply won't work today); and the business about blowing up the theater has been eliminated. In the new version, Max ends up being caught and arrested and Leo flees with Ulla, only to return in time to give a moving speech on Max's behalf at his trial. The latter is the most drastic revision of the original, and serves as a nod, perhaps, to Brooks's original intention to have his story be about the relationship between the big showman and his timid sidekick. (It's a pairing that Brooks, for whatever reason, finds resonant, and has used in everything from *The Twelve Chairs* to *Blazing Saddles*.) And some things that were cut from the movie, apparently to Brooks's chagrin, have been restored in the musical, to no great effect; there's a lot of business about "the Siegfried oath" that the loony Nazi playwright forces Bialystock and Bloom to swear to, which Ralph Rosenblum, the film's editor, wisely told Brooks to cut, to Brooks's fury. ("You're talking about half the fuckin' scene!" he yelled at Rosenblum.)

If the musical version of *The Producers* has gained little substantively in its transition to the stage, it's certainly been brilliantly gussied up. Generally, stage plays become more polished-looking when they become movies; it's a measure of how raw the film version of *The Producers* was that it looks better onstage than it did on the screen. It's every bit as sleek and cleverly choreographed, lighted, designed, and costumed—and as splendidly performed—as the delirious critics have unanimously declared it to be, and it probably deserves its fifteen Tony nominations. There's a hilarious new production number in which Max's old ladies do an elaborate dance with their walkers; just as entertaining is a sequence, more than a little reminiscent of *How to Succeed in Business Without Really Trying*, that's set in the depressing offices of Whitehall and Marx, the firm where Leo toils away in anonymous drudgery. And here, at last, you get to see just how preposterous Max's glory days really were: the walls of his office are adorned with posters for plays like *When Cousins Marry* and *The Kidney Stone*. There are, too, a great many theatrical in-jokes and arcane allusions, the best of which takes the form of a camp homage to Judy Garland at the Palace.

Roger DeBris sits at the edge of the stage crossing his legs with a certain gamine pluck and mouthing the words "I love you" at the audience, who got the allusion, and loved it.

That may be the problem. The old Mel Brooks liked to push his audience around, see how much they could take. (And not just at the expense of stereotypical Jewish schlemiels and goniffs; you lose count of how many times the word *nigger* crops up in *Blazing Saddles*, produced in 1974.) The new Mel Brooks is in winking complicity with an audience he knows, by this point, he can count on. If the new *Producers* is a hit, it isn't, after all, because it challenges social norms about taste or propriety in any significant way, as the film tried so strenuously to do. Which norms, you wonder, and what propriety? Making jokes about gay theater folk for an audience of New Yorkers comfy enough to giggle at Nathan Lane's in-jokes about his own homosexuality can hardly be considered a feat of artistic or social risk-taking. In any event, it's been impossible to be seriously offended by caricatures of swishy theater queens ever since *La Cage aux Folles*, the 1978 French film that brilliantly coopted those caricatures and which was, coincidentally, the basis for a sentimental 1983 Broadway musical—a musical that in turn spawned an even cuter movie version in which Lane himself, again coincidentally, starred. (Nothing suggests the difference between the film and musical versions of *The Producers*, in fact, than does the difference between the menacingly outsized Mostel and the impish Lane, who even when he's outrageous manages to be adorable.) And in the Viagra era, there's nothing all that outlandish about suggesting that old people have libidos.

As for Nazis—well, in a culture that has given us *Life Is Beautiful*, the Italian concentration camp comedy, and that can rehabilitate Leni Riefenstahl with a glossily admiring coffee-table book of her very own, there's not a great deal of shock value to Holocaust humor or Nazi kitsch.

Some of those who have attempted to explain the success of *The Producers* have focused not so much on what you could call the negative angle—the way the show allegedly violates political correctness—as on the "positive" angle. Which is to say, on its rehabilitation of what John

Lahr, in an ecstatic review for *The New Yorker* (whose cover that week depicted a glowering Hitler sitting among delirious theatergoers) called the element of "joy" in American musical theater: "a vivacious theatrical form, which for a generation has been hijacked by the forces of high art and lumbered with more heavy intellectual furniture than it can carry." In a similar vein, Michael Feingold in *The Village Voice* referred to "decades of musical theatre pundits declaring that musicals have to be solemn, unpleasant and good for you." Neither critic identified who, exactly, the hijackers and pundits were, and I'm sure that neither would point an accusing finger at Stephen Sondheim, who was sitting across the aisle from me on the night I was lucky enough to get a ticket to *The Producers*, and seemed to be having a very good time. (Few critics, in fact, have written about Sondheim's achievement as incisively as Lahr has.)

Still, as I read their remarks I found it hard not to think of Sondheim and his work, which surely represent the anti-Brooksian extreme, the forces of "high art," in the American musical theater. By coincidence, Sondheim's great, bitter showbiz classic, *Follies*, first produced barely three years after what we must now refer to as "the film version" of *The Producers* came out, was having a revival just as Brooks's new musical debuted. Superficially, the two works have a lot in common: both examine, with a kind of appalled admiration, the megalomania and delusional fantasies that the theater can inspire in weak people; both parody, with wicked knowingness, the forms and gestures peculiar to musical theater. And yet on a more profound level, no two works could have less in common than Sondheim's and Brooks's respective tributes to Broadway do. *Follies* may be all-singing and all-dancing, but it's *about* something; it uses its songs and dances to comment on how popular culture shapes our emotional lives, and explores, memorably, nostalgia and loss. In contrast to *Follies*—and, perhaps even more tellingly, to its own cinematic model—the musical of *The Producers* risks absolutely nothing; there's nothing at stake anymore. Brooks's new musical has smoothly processed his movie, whose greatest virtue was its anarchic, grotesque energy, into a wholly safe evening. In this respect, the new *Producers* doesn't represent a break from, but is in fact wholly consistent with, the erosion of the musical as an art form—as a vehicle for expressing and exploring something meaningful about the culture (other, that

is, than the culture's ability to cannibalize itself). The Sondheim revival was a small-scale affair, and got mixed reviews; the producers of the megahit *The Producers* are already talking about a fifteen-year run. You have to wonder what kind of culture finds its greatest entertainment in expanded repackagings of preexisting entertainments.

The answer to that query, according to one successful film director of screen comedies, is a culture characterized by sensory deprivation, unable to digest anything but the artistic equivalent of pablum— smooth, flavorless, safe. Great comedy, after all, as much as great tragedy, requires a head-on confrontation with life. "We are all basically antennae," this director remarked. "If we let ourselves be bombarded by cultural events based on movies, we won't get a taste of what's happening in the world." Those words seem even more apt today, when musical theater seems incapable of engaging the world except at second or third hand, than they were twenty years ago. Is it a comic or a tragic irony that it was Mel Brooks who spoke them?

—The New York Review of Books, June 21, 2001

Harold Pinter's Celebration

In the 1990 Paul Schrader film *The Comfort of Strangers*, a young English-woman is forced to witness the murder of her lover. The attractive young couple, Mary and Colin (Natasha Richardson and Rupert Everett), had come to Venice for a restful, sexy change of scenery. One evening, after getting lost while looking for a restaurant, they encounter Robert, a wealthy local who scoops them up and takes them to dinner at his favorite out-of-the-way eatery, where he laughingly plies them with drink and tells them a lot of weirdly inappropriate stories about his private life. Most people, of course, would take the first decent opportunity to flee at the sight of Christopher Walken in a white suit, even if he weren't always repeating lines that, like Robert himself, are ostensibly harmless yet somehow deeply sinister. ("My father was a very *big* man.") But part of the film's macabre joke is that Mary and Colin are English, and hence diffident and accommodating to the point of self-destructiveness; more important, they're characters in a film written by Harold Pinter, in whose work everyday situations often devolve, with the irreversible momentum of nightmares, into horror. And so the couple get more and more involved with Robert and his equally unsettling, if superficially more sympathetic, wife, Caroline (Helen Mirren),

who moves around their opulent palazzo gingerly clutching various body parts in pain, as if she's just been beaten. She probably has.

The younger couple continue to socialize with their older, worldly counterparts, despite the unwholesome vibes that Robert and Caroline are giving off, and despite certain other incidents, for instance the moment, fairly early on in their joint socializing, when Robert suddenly punches Colin in the gut, viciously but smilingly, as if merely checking to see how the handsome young man would react. Then, just as Mary and Colin begin to pull away from their hosts, the bizarre and yet somehow logical climax: while paying a goodbye visit to Caroline, Mary is given a drug that renders her immobile and speechless, and as she sits in her hostess's sumptuous salon, making inarticulate noises and rolling her eyes in an attempt to warn him, Colin is brought in, like some kind of sacrificial victim, and Robert slashes his throat before her wide and terrified eyes.

Even if the story isn't by Pinter—the film was adapted from a 1981 novel by Ian McEwan—*The Comfort of Strangers* is emblematic of the British playwright's work in a number of ways. The darkness lurking under vacuous everyday exchanges; the oppressive sense of impending disaster haunting a quotidian scene (going to a restaurant, say, or sightseeing); sudden and apparently unmotivated acts of violence; relationships between sadistically bullying men and passive, helpless women; the unsettling feeling that some larger, explanatory narrative has been repressed or stripped away, leaving behind the discrete, apparently unrelated actions and the flatly conventional talk; the way in which that talk can become terribly menacing: all these have characterized Pinter's output, in one way or another, since his first play, *The Room*, was produced in 1957.

That output was celebrated in July during an ambitious festival of Pinter's work, presented by the Lincoln Center Festival 2001 and featuring productions imported from Dublin's Gate Theatre and London's Almeida and Royal Court Theatres. (Concurrent with these productions was a tribute to Pinter the screenwriter, presented by the Film Society of Lincoln Center.) Pinter has written twenty-nine plays; the nine presented in New York were enough to remind you of the idiosyncrasies of the playwright's style and, indeed, the almost obsessive

narrowness of his themes. All of Pinter's work is, in some way or another, about violence—whether expressed in the corrosive interactions among family members (*The Homecoming*), the hurtful and confusing silences between couples (*The Room, Landscape, Ashes to Ashes, Betrayal*, many others), or in repressive and cruel actions on the part of the State against individuals (*The Birthday Party, One for the Road, Mountain Language, Party Time*). Over the years, Pinter has won a dedicated audience who have found a curious comfort in his bleak dramatizations of the ways in which our unwillingness or inability to make connections, to communicate meaningfully (here you think of those famous Pinteresque silences and pauses), lead to disasters both private and public.

And yet because it allowed you to absorb a good amount of Pinter in a short amount of time, the festival also reminded you that Pinter has remained within the same narrow artistic topography for much of his career; with one splendid exception (the American première of his latest play), the nine plays presented suggested a playwright who has stuck with the same thematic and stylistic formulae that first made him famous, reusing them in play after play with, it now seems, diminishing intensity of inspiration. The once-stimulating idiosyncrasies—the silences, the pauses, the hesitations—have in too many cases devolved into tics; worse, the showily "disturbing" exteriors of these works too often failed to hide the fact that the plays seem less and less to illuminate, in any profound way, the dark forces that have always interested Pinter. Indeed, the festival suggested that *The Comfort of Strangers* may be emblematic of the playwright's work in more ways than one. For it revealed a playwright who is implicated, one might say, in the aggression and unreason he wants to indict; an author who, like so many of his villains—like Robert—is more interested in making you feel pain than in explaining what the pain might mean.

———

The festival began with a double bill of two short works, *A Kind of Alaska* (1982) and *One for the Road* (1984). This was a canny pairing, for

these plays represent not only Pinter's two basic theatrical modes of expression—small people engaged in quiet, futile conversations that go nowhere, and loud, angry men doing cruel things to helpless victims—but his two main, interrelated themes: the failure of language in its proper role as a vehicle for human connection, and the violent abuse of power.

A Kind of Alaska, which received a starkly effective production, is based (like the 1990 Robin Williams film Awakenings) on Oliver Sacks's book Awakenings, which first appeared in 1973. Pinter's play is about a woman, excellently played by Penelope Wilton with just the right mix of anxious humor and desperate pathos, who awakens from a twenty-nine-year-long coma; as she gradually, incredulously realizes what's happened, she tries to reconcile what's inside her mind—a bright, terrified sixteen-year-old girl—and what the world around her has become. "Do you know me?" she asks; and then: "Are you speaking?"; "I sound . . . out of tune"; "I've been nowhere." The lines suggest the extent to which Sacks's story is an ideal vehicle for Pinter's obsession with linguistic and emotional alienation, an obsession that also shapes The Homecoming, Landscape, Monologue, and The Room.

The other play in the opening double bill was One for the Road, a product of the playwright's later, overtly "political" period, which began about twenty years ago, at the onset of the Reagan-Thatcher era. First published in The New York Review of Books in 1984, this twenty-minute-long mini-drama is a brief visit with a sadistic, if exaggeratedly civil, torturer in some nameless police state. A man called Victor, wanted for some reason by the State, is brought before the well-dressed, benevolent-seeming Nicolas (played with great relish, in the Lincoln Center Festival performances, by Pinter himself); there follows some chitchat that suggests why Pinter found in McEwan's sinister Robert a kindred spirit. (Like Robert, Nicolas oscillates between arch politesse and sinister inappropriateness: "You're a civilized man and so am I," he tells the terrified Victor, and then goes on to talk about his penis.) Victor is then dragged offstage, where something terrible is done to his tongue, as is made clear when he reappears onstage, unable to speak clearly. Then his wife appears, and she's interrogated, too, only to be taken off to be used as a sex toy by the police; then their child, Nicky, comes on, is asked a few questions, and he's taken off, too, to be killed. That's pretty much it. One for the Road prepared audiences

for the brutalities of Pinter's angry political works, a group that includes *Mountain Language* and *Ashes to Ashes*, which were also performed during the festival.

A perhaps unintended consequence of presenting *A Kind of Alaska* and *One for the Road* together was that audiences could see the extent to which these works are suggestive rather than fully discursive— moody sketches for plays, which provoke unpleasant feelings without being rigorously thought-provoking. This almost semaphoric quality should not come as a surprise. From the start, as he himself has said many times, Pinter has been a playwright who finds inspiration for his dramas in striking or disturbing images he's noticed: in the case of *The Room*, for instance, it was a glimpse, during a party he'd been attending, of a dithering man (it turned out to be Quentin Crisp) talking nonstop as he served eggs to an unresponsive oaf; in that of *The Caretaker*, it was a couple of threatening-looking men he saw in a building he once lived in. As the playwright likes to explain it, these images start him writing; quite often, he acknowledges, he himself doesn't know in advance where an image will lead him. The "formal construction," he told Mireia Aragay and Ramon Simó at the University of Barcelona during a 1996 interview, "is in the course of the work on the play."

Pinter has, indeed, always liked to characterize himself as an "intuitive" writer, and he enjoys expressing a kind of bemusement about what he does and, sometimes, a downright incomprehension about how he does it. In a 1957 letter to his former English teacher, Joseph Brearly, a portion of which was reprinted in the Stagebill program for the festival, he wrote, "I have written three plays this year. I don't quite know how, or why, but I have." And again, in April 1958, in a letter to Peter Wood, who would be directing *The Birthday Party*: "The thing germinated and bred itself. It proceeded according to its own logic. What did I do? I followed the indications, I kept a sharp eye on the clues I found myself dropping." This emphasis on an odd kind of passivity in the face of his inspiration is something you'd be tempted to write off as youthful diffidence, or pretentiousness, were it not for the fact that Pinter continues today to work in much the same way, and indeed likes to emphasize that he begins with the concrete image and then waits to see what comes next. "I've never written from an abstract idea at all," he told his Spanish interviewers.

The lack of ideological foundations, the want of a comforting, overarching theory or abstraction to organize the concrete images and words you see and hear onstage, is what lies behind the menacing emptiness you feel in Pinter's plays. At the beginning of his career, the absence of explanations of the conventional variety (psychology, plot) for the unsettling actions and tableaux that Pinter liked to stage was striking, and original. It seemed to be the point. In quasi-political plays like *The Birthday Party* and in domestic dramas (for lack of a better word) like *The Room* and *The Homecoming*, the hermetic quality of the works, the disorienting lack of obvious connection between the concreteness of his surfaces—the action, the dialogue—and any kind of subtext; the plays' famous refusal, or apparent refusal, to be "political": all this, while angering some critics, seemed to others, and certainly to audiences, an apt theatrical analog for many of the anxieties of the postwar world. (It *was* political, but just not in the obvious way.) The existential dread and moral emptiness that were the by-products of the Cold War at its height, the debasement of serious political discourse by cynical and self-congratulatory democracies that acted tyrannically, the fragility and tentativeness of meaningful human communication—all these seemed to be what Pinter's work was somehow "about," even if the playwright himself avoided claims to any kind of organizing theory or ideology. In this, he was very much in the tradition of post-Beckettian drama. (Pinter has often and rightly acknowledged his debt to Beckett, and there are indeed many similarities, with one crucial exception: you feel that Beckett likes the human race, whereas Pinter doesn't.)

Yet the selection of works presented during the Lincoln Center Festival suggested that, however original the writer's tone, theatrical gestures, and modes of presentation once were, there's been surprisingly little sign of significant artistic growth or experimentation since those stunningly disorienting early works. (The inclusion of Pinter's adultery drama, *Betrayal* [1978], in more than just its film version, would have helped to dispel this impression, perhaps; it's one of the rare works from what you could call the second half of his creative life that's about emotions more complex than either abjection or rage.) An early work like *The Room* can still unsettle you, as it did in a taut production at Lincoln Center featuring the superb Lindsay Duncan as the harried, desperate,

disoriented Rose (in, as it were, the Quentin Crisp role), whose endless chatter is meant less to be heard than to insulate herself from the terrifying reality of the world around her. But its epigones now seem, at best, exercises in mood rather than meaning (even when it's the meaning of no meaning). This was true of *Monologue*, that one-sided dialogue between a lonely man and an absent friend with whom he may or may not have quarreled over a woman, which, at Lincoln Center, was unfocused and without urgency, as if merely to have staged it was enough; and true, too, of *Landscape*, which in its Lincoln Center incarnation was almost embarrassingly mannered, with its fussily choreographed exchanges and precious, *Masterpiece Theatre* enunciation of the fruitless dialogue between its dreamy female lead and her clunky, earthbound husband—that recurrent Pinteresque duo. He talks about beer while she rhapsodizes about love.

And it was certainly true of *Ashes to Ashes*, which yet again pairs a dreamily nostalgic woman and a hard-nosed man in a fruitless dialogue. But this time, the woman's erotic reveries, out of which the man keeps trying to rouse her, are about a man much like Nicolas in *One for the Road*: he's a figure of some kind of sinister authority who sexually humiliated her—"Kiss my fist," she recalls him ordering her—and was, it turns out, responsible for the death of her baby. This makes for some creepy moments. But while the sinister surface hints at a connection between eros and violence and oppression, it's hard to cash out just what it is that connects them, or what that might mean, because there's nothing really there apart from the sinister surface. (In Pinter's works about torture and totalitarianism you find yourself wishing for the moral subtlety and emotional complexity of Jacobo Timerman.) Ironically, it may be that the superficiality and unpersuasiveness of this and so much else of what was presented at Lincoln Center have to do with the fact that the times have caught up with Pinter. The silences, pauses, hesitations, disorientations, the subtle indictments of talk without signification and action without effect, of the inadequacy of traditional personal and political narratives, which once seemed groundbreaking and new, have been so internalized by postmodern, post-political culture that many of the plays seem almost like period pieces. These extremely reverent productions only emphasized that impression; if anything, the productions seemed to outweigh the plays themselves.

It would be hard to think of a better symbol for the way in which Pinter's work has devolved into showy displays of "Pinteresque" style than the Lincoln Center performances of *The Homecoming*. As it happened, the 1973 film version of this work, which reunited some of the stars of the original 1964 stage production, was shown during the festival, and hence offered a record, however imperfect, of the play as originally presented—and, to some degree, experienced.

The Homecoming, a work that is generally considered the cornerstone of the playwright's oeuvre and may well be his masterpiece, is a gruesome domestic tragicomedy about a man and his sons, a kind of scarily bipolar *Death of a Salesman*. Set in an old house in North London, the play follows the acidic interactions between an elderly man named Max (Ian Holm, who played the role of the son Lenny in the original production) and his three grown sons: the seedy underworld entrepreneur Lenny (Ian Hart), the dumb would-be boxer Joey, and the refined Teddy, who's left home for the States years before to become a philosophy professor, and who's now returning with his wife, Ruth, for a visit. As Max interacts with his three "boys" (each of whom can be thought of as representing a different component of the human character: intellect, cunning, brute strength), strange tensions, buried hurts, and a characteristically Pinteresque blend of eros and violence become discernible. By the end of the play, Ruth has engaged in erotic play with all three brothers, and decides to stay on in London, partly as a kind of den mother to these men, partly as a prostitute working for Lenny in order to pay her way.

Of all of Pinter's plays, *The Homecoming* is the most successful in its attempt to fashion a dramatic world in which people say and do everyday things—talk about the past, fix meals, drink glasses of water—and yet, because of the hidden internal logic, the result is anything but everyday. (Critics like to point to Pinter's influence on young contemporary playwrights; Michael Billington, partaking in *The New York Times*'s lavish and adulatory coverage of the festival, listed Joe Orton, David Mamet, Neil LaBute, Sarah Kane, and Patrick Marber as the inheritors of the older playwright's "enduring legacy." But I often wonder whether Pinter's real heir isn't the British filmmaker Peter Greenaway, whose work is also distinguished by the sense

it gives you of a hermetic world whose coherences you must trust in, even if you're not sure what they mean.) In order for the piece to have its proper impact, to produce that characteristic tension between quotidian surfaces and submerged menace, the surfaces have to be persuasively quotidian. Few other playwrights have been so intent on, or successful at, conveying the feel and rhythms of everyday talk and movements, however bizarre or unexpected the eventual result of those words and actions may be.

The film of *The Homecoming*, photographed in drab browns and grays, looks wilted and ordinary, which is just right. (It must be said that the print shown at the Film Society retrospective was embarrassingly inadequate: pitted, pocked, striated to the point of being nearly unwatchable, with a distracting wobbly green vertical line that refused to budge. If Lincoln Center wants to pay homage to cinematic artists, a good start would be to obtain decent prints of their work.) More important, the performances were perfect: the young Ian Holm's Lenny had just the right combination of menacing braggadocio and an underlying weakness, and Vivien Merchant (the first Mrs. Pinter) is brilliant as Ruth, the plainness and openness of her broad face making all the more terrifying, somehow, her character's apparent transformation from a self-effacing, carefully well-mannered housewife into a controlling, sexually manipulative siren.

The Lincoln Center *Homecoming* couldn't have been more different from the film. Fussily directed—choreographed would be a better word—by the Gate Theatre's Robin Lefevre, the action was balletic, artificial, mannered. Ian Holm's Max was excellent; he felt lived-in and shrunken and yet, somehow, still powerful. But the three sons were all, in their way, too attractive, too actor-y. Worst of all was the Ruth of Lia Williams, a model-thin, high-cheekboned blonde with a breathy, Marilyn Monroe voice and creamy pastel suits that made her look like a vintage 1960s Barbie—or, perhaps, a first-class stewardess in a 1960s airline ad. Her whippet-like elegance, the anomalous smartness of her costumes, the high stylization of her delivery all warped the play's crucial dynamics. From the minute Ms. Williams entered, smirkingly confident of her allure, there was no doubt in your mind that she'd take control of these angry, inarticulate men. Because there was no doubt, the play lost its tightly wound tension and, ultimately, its point.

So the festival suggested, if anything, the extent to which one strand of Pinter's output—those self-contained works in which any obvious meaning is submerged under the lapidary surfaces and the potent moods and effects they create—have degenerated into increasingly empty exercises in style. As for the works in which there was, unmistakably, "meaning"— *One for the Road* and its spiritual successor, *Mountain Language* (1988), which received a noisy, unfocused production—the substance is obvious (police states are bad), and the presentation of it coarse, obtuse, undigested.

The political plays are meant to be indictments of totalitarian repression, of the way that power corrupts, of the fact that, as the playwright said apropos of *Party Time*, "there are extremely powerful people in apartments in capital cities in all countries who are actually controlling events that are happening on the street in a number of very subtle and sometimes not so subtle ways." And so, in these works, the playwright depicts torturers manipulating their subjects, or soldiers abusing innocent old women. It is here, in his attempt to engage in substantive political discourse, that the famous flatness of Pinter's surfaces, their odd texturelessness, his tendency to depict rather than to explicate, become a serious liability. It's often hard to sense anything beneath the surface of these works but the author's righteous ire.

In this respect, these overtly political plays—*One for the Road*, *Party Time*, *Mountain Language*, and *Ashes to Ashes*, the latter of which combines the domestic duologue with the political outrage—resemble the poems that Pinter has written, inspired by his sensitivity to the world's injustices. (However much it's overshadowed by his plays, Pinter's poetry is clearly very important to his sense of himself as a writer. "I'm essentially, shall we say, a poet," he told Charlie Rose when he was in New York for the festival. His fans agree. "An intuitive rather than a conceptual writer, a poet rather than a peddler of theses," Michael Billington concurred in the *Times*.) One clearly political poem is called "The Old Days," from 1996:

> Well, there was no problem,
> All the democracies

(all the democracies)
were behind us.
So we had to kill some people.
So what?
Lefties get killed.
This is what we used to say
back in the old days:
your daughter is a lefty
I'll ram this stinking battering-ram
All the way up and up and up and up
Right the way through all the way up
All the way through her lousy left body. . . .

The political plays, with their heated indictments of tyranny, may be said to be the theatrical analogue of this clanking brand of writing. Unfortunately for Pinter, in order to engage seriously with politics, you have to have "peddled" in theses—you need a rigorous and subtle theoretical grasp of what the issues are, and of what's at stake, in order to make valid judgments of complex issues. Pinter's political plays, by contrast, tend to flash angry images of oppression, and that's that. After you've seen two or three in swift succession, and see how much of a muchness the political work is, it's hard not to wonder whether what they're really about is Pinter, excellently showcasing his anger, his frustration with corrupt democracies, and so on. "I wrote *One for the Road* in anger," he told Rose. "It was a catharsis. . . . I felt better after having written it, certainly." Catharsis, as we know from Aristotle, is an emotion that serious theater may legitimately aim at; but of course, Aristotle was talking about the *audience*'s emotions. However admirable his feelings may be, and however urgent his need for catharsis, the catharsis is meaningless, from the point of view of successful art, if it is reserved to the playwright but denied the spectators. Because the characters in these works are rarely more than stick figures—those abusive men and noble, suffering women—your concern for the victims in Pinter's political plays tends to be abstract; you can't be moved to political insight, because you're not moved at all.

So the tendency in these plays is to bully rather than to argue. In

his Charlie Rose appearance, the playwright talked primarily about his political convictions, and about the cynicism and corruption of the United States and Great Britain, which he has frequently denounced in interviews and editorial pages; but, significantly, he never really engaged Rose's objections to some of his points. After Pinter dramatically declared, apropos of the NATO-backed bombings in the former Yugoslavia, that Clinton was morally indistinguishable from Milosevic, Rose raised the quite reasonable objection that whereas the two leaders had used force in Yugoslavia, those uses stemmed from distinct political and moral motivations. Rather than responding, however, Pinter changed the subject, and went on to flourish another indictment—as if merely to have denounced were enough. This is appropriate for activists, but not for artists.

As we know, questions of motivation have never had much allure for Pinter; but while the apparent absence of traditional motivations may have made for some striking theater, the failure to come to grips with intent and motivation in forming moral and political judgments is a serious limitation in someone who wants to be taken seriously as a political dramatist. Pinter's convictions can be laudable, and his support for oppressed East Bloc writers such as his friend Václav Havel was admirably fierce; but the "political" plays unhappily reflect the lack of subtlety of thought that you saw in the Rose interview. In them, we're much closer to *Waiting for Lefty* than we are to *Waiting for Godot*.

There is an irony here. When he was in his early thirties (still in his hermetic, apolitical phase), in his speech to the National Student Drama Festival in Bristol, the newly famous playwright warned against

the writer who puts forward his concern for you to embrace, who leaves you in no doubt of his worthiness, his usefulness, his altruism, who declares that his heart is in the right place, and ensures that it can be seen in full view, a pulsating mass where his characters ought to be. What is presented, so much of the time, as a body of active and positive thought is in fact a body lost in a prison of empty definition and cliché.

It would be hard to find a better description right now of Pinter and his later, patently political work. However much he may profess to be out-raged by his villains, Pinter has come in some strange way to resemble them. Like the fictional Robert in *The Comfort of Strangers*, he's a man in a position of considerable power whom you begin by trusting, someone who's pulling all the invisible strings, who lures you with the promise of a rich and enjoyable evening, who will even make you laugh with his stories (few playwrights combine humor and horror as disconcertingly as this one) and yet ends by making you watch images of disturbing, sometimes horrifying actions, without ever explaining them. Without, perhaps, being able to explain them, either explicitly or implicitly, be-cause his ultimate concern is his own feelings, his own gratifications. Your only option is to sit there, immobile and mute, and take it.

In view of the way in which the Lincoln Center tribute exposed Pinter's weaknesses and pretensions as much as it did his strengths, it was a gratifying surprise to witness the New York première of his most recent work, *Celebration*. First presented in London in the grand millennial year of 2000, this, at last, was a work that brought together all of the playwright's well-known preoccupations, modes of expression, and theatrical tropes. Yet it managed to create something very new for him, and for his audiences—something, finally, that was deeply and mov-ingly political.

The play takes place in an upscale restaurant. There are two sets of diners, each of which is spotlighted in turn until the end, when it evolves that they have an uneasy connection to each other and they begin to communicate directly. There's a quiet couple, Matt and Suki, playfully talking about their romance, about sex. The larger, more boisterous group consists of a quartet of sozzled vulgarians out for a celebratory night on the town: two brothers, Lambert and Russell, married to two sisters, Julie and Prue. These four may be wearing expensive (if a tad cheesy) togs, but they're essentially working-class—not all that different,

beneath their suits and cocktail dresses, from the grim couple in *The Room* (which was presented with *Celebration* as a double bill). Lambert and Julie, Russell and Prue are cheerfully, loudly ignorant (they don't know whether they've just been to the ballet or the opera), coarse ("they don't want their sons to be fucked by other girls," one of these aging girls cries out, apropos of mothers-in-law), and wholly unconcerned if everyone else in the restaurant knows it. The men are clearly rich and smug about the success they've snatched from the Nineties glut. (Russell's a banker, and Matt and Lambert are "strategy consultants.")

Appearing onstage from time to time to disrupt these two groups are three members of the restaurant's staff: the maître d', who's very solicitous of his customers' pleasure; his assistant, Sonia, a young woman who chats with the two parties and can't help revealing intimate things about herself (she's a hilarious parody of stereotypical British insularity: "You don't have to speak English to enjoy good food," she says, with some incredulity, after telling a story about a trip abroad); and, finally, a young waiter, who constantly interrupts both parties. "Do you mind if I interject?" he'll ask, each time, and then launch into stories about his now-dead grandfather and all the famous people he'd known and all the world-historical events he'd been grazed by. At one point, it's Hollywood in the Thirties; at another, it's Archduke Franz Ferdinand and the beginning of the First World War. The sheer, loony excess of these fevered riffs generates its own kind of hilarity:

> He knew them all, in fact, Ezra Pound, W. H. Auden, C. Day-Lewis, Louis MacNeice, Stephen Spender, George Barker, Dylan Thomas, and if you go back a few years he was a bit of a drinking companion of D. H. Lawrence, Joseph Conrad, Ford Madox Ford, W. B. Yeats, Aldous Huxley, Virginia Woolf, and Thomas Hardy in his dotage. My grandfather was carving out a niche for himself in politics at the time. Some saw him as a future Chancellor of the Exchequer or at least First Lord of the Admiralty but he decided instead to command a battalion in the Spanish Civil War but as things turned out he spent most of his spare time in the United States where he was a very close pal of Ernest Hemingway—they used to play gin rummy together until the cows came home.

Funny as this almost Homeric name-dropping is, it's the waiter and his heedlessly eager, puppy-dog attempts to interject, to insert himself, however inappropriately, into the proceedings that give the play its tension, poignancy, and meaning. Without him, the interactions among the two sets of diners would constitute a typical Pinter "drama." Their vacuous, self-important chitchat and boasting and flirting would be entertaining—this is by far the funniest play Pinter has written; even if there had been those silences, you'd never have heard them, the audience was laughing so much—without being anything beyond a static parody of the avarice and greed that flourished in the last decade of the century. (Here again you think of Peter Greenaway, with whose *The Cook, The Thief, His Wife, and Her Lover*, that vitriolic send-up of Thatcher-era greed, the new Pinter work shares a certain mood and style.)

But as the waiter keeps trying to catch the attention of his self-important, superficial charges, it's hard not to start noticing which names he drops. The eponymous celebration in this rich play may be an anniversary party—that's what the characters think, at any rate—but it soon becomes clear that what *Celebration* is celebrating, or at least marking, is the passing of the twentieth century. What this waiter keeps interjecting is, in fact, an endless string of references to gigantic swaths of twentieth-century culture: books, film, the Hollywood studio system, Mitteleuropa, Kafka, the Three Stooges, and so on. It's his third and final speech, with its reference to the assassinated archduke, that clues you in: before your eyes the whole twentieth century passes, from its beginning (the outbreak of World War I), to its middle, and right through to its tawdry end. But of course the diners don't really listen, because they've been blinded to the culture, to the century itself and its meanings, by their own narrow greed—by the kind of success that the century and its culture have, ironically, made possible, if not indeed inevitable.

Most of Pinter's work shows you evil things, and for that reason can upset you in some way, but precisely because he so often stacks the dramatic deck, so often tries to make up your mind for you, the plays are depressing without being the least bit tragic. What makes *Celebration* so provocative is the way in which it tantalizes you, as real tragedy

does, with the specter of missed opportunities. The fact that its sub-
ject—what it is that its characters are talking about, even if they can't
hear each other—is world-historical, and has a great deal to do with this
specific postmillennial, post-ideological moment, gives this short, vivid
work a deep political gravity that none of the more obtuse "political"
plays can match. You feel, for the first time, as if something's at stake
here—something, that is, other than the playwright's feelings. In the
week and a half of the Pinter Festival, with its nine plays and numer-
ous showings of the films, its onstage valentines posing as discussions,
all accompanied by the endless drone of ongoing press adulation, you
feel that here, at last, was something you wouldn't mind being forced
to watch.

—*The New York Review of Books*, October 4, 2001

War

Theaters of War

The early spring of 431 B.C. witnessed, at Athens, the beginning of a great war, the commencement of a great book, and the première of a great play.

The war was the culmination of fifty years of simmering tensions between two superpowers: the Athenian empire and the Spartan alliance. It was, naturally, advertised by each side as a war of liberation (each of the antagonists claimed to be freeing some injured third party), but it was really a struggle for total domination of the Greek world. Like some other world wars, it began relatively small—a diplomatic crisis involving Corinth, a Spartan ally; some low-level combat in a small town near Athens—but it eventually metastasized into a conflict that lasted nearly three decades, involved numerous states both Greek and non-Greek, and resulted, finally, in the defeat and disarmament of Athens and the abolition of her democratic institutions. Because Sparta and her allies dominated the large southern peninsula called the Peloponnesus—and, more to the point, because the men who wrote the best-known histories of the conflict were Athenians—the war would come to be called the "Peloponnesian." The Spartans, as the Yale historian Donald Kagan dryly points out in *The Peloponnesian War*, his brisk

if tendentious new history of the war, probably thought of the conflict as the "Athenian War"; but then, there were no Spartan historians to call it that.

The book was the work of an affluent young Athenian who, on the hunch that the conflict just getting under way that spring would be "a great war and more worth writing about than any of those which had taken place in the past," began taking notes "at the very outbreak" of hostilities. About the life of the historian we know relatively little, apart from the crucial fact that he himself commanded troops in the war—something you might have guessed anyway, since an officer's crisp lack of sentimentality informs nearly every page of his work, which would come, in fact, to be valued above all for a scrupulous insistence on getting the story straight, on allowing readers to "see the past clearly" for themselves. This soldier-historian gives his name in the first line of his book, which had no official name and which is generally referred to as the *History*. He was called Thucydides.

The play was by an Athenian citizen in his mid-fifties who'd been writing for the theater since the age of thirty. Like the war, the play involved trouble in Corinth and some minor violence that eventually came home to roost in Athens; as with the war, it would be some time before people appreciated its magnitude. (The year the play was entered in the annual springtime dramatic competition at Athens, the year the Peloponnesian War began, it took third prize.) The playwright's name was Euripides. The play was called *Medea*.

Thucydides' *History* is the only extant eyewitness account of the first twenty years of a war that was unlike anything anyone had ever seen up until then—what he called "the greatest disturbance in the history of the Hellenes, affecting also a large part of the non-Hellenic world, and indeed, I might almost say, the whole of mankind." The war lasted so long that the author didn't live to finish his manuscript; it ends in midsentence during a description of the aftermath of a naval battle in 411. (We do know, from references in his text, that he lived to see Athens's ultimate surrender, in 404.) But such was his achievement that others who wrote about the war—for instance Xenophon,

whose *Hellenica* covers the final decade of fighting—began where Thucydides left off.

Until the Peloponnesian War, warfare among the various Greek city-states had for centuries been a regular, predictable, and unsentimental affair—part of the rhythmic cycle of seasons. You planted your crops in the spring, went away to do battle with this or that enemy in the summer, and (hopefully) came back in autumn for the harvest. Wars were decided by the outcome of a single pitched battle on a single day, after which the victorious army set up a victory trophy and headed home. Then the whole cycle would repeat itself the next year.

The war that began in the spring of 431, however, represented what Kagan rightly calls "a fundamental departure" from this tradition—not only in scope, and complexity, and length, but also in savagery and bitterness. It began, that night early in 431, with a nocturnal sneak attack by the Thebans, allies of Sparta, on a small Athenian protectorate called Plataea—a sordid violation of the norms of Greek warfare that set the tone for things to come. As the conflict roiled on over many years, on many fronts, from the Hellespont to Sicily to the coast of Asia Minor, and under the banners of many Spartan kings and many Athenian governments, with many victories and defeats for both sides, none of which signaled a clear resolution to the conflict, it began to seem frustratingly unwinnable—not that it was any longer clear just what "winning" might consist of. The result, as Kagan emphasizes at the outset of his own retelling of it, was a cycle of cruelty and reprisal, ending, ultimately, in a "collapse in the habits, institutions, beliefs, and restraints that are the foundations of civilized life." The anomalous treachery that led to that first nocturnal attack would devolve, by the end, into the kind of atrocity that had never before featured as part of Greek warfare: schoolboys murdered in their classrooms by mercenaries, civilians slaughtered, suppliants dragged from (or burned at) altars, the war dead left to rot on the battlefield. All this was symbolized by the unimaginable collapse of the great standard-bearer of Greek civilization itself: after nearly three decades of fighting, bankrupt, imploded by civil strife, crushed from without by an unholy alliance between Sparta and the Greeks' old enemies, the Persians, Athens finally surrendered in 404.

It was impossible to foresee any of this in the spring of 431. Athens was at her peak: the mistress of a far-flung empire of subject-allies stretching all across the Mediterranean, commander of a huge and well-trained navy, her special national character—raucously democratic with yet an aristocratic esteem for the finest products of high culture—emblematized by her leader, Pericles, an aristocrat of what Kagan calls "the bluest blood" who had, nonetheless, a populist appeal. (Teddy Roosevelt, say, rather than JFK.) It was Pericles who advised his countrymen, during the first few years of the war, to follow an unusual—and unusually difficult—defensive strategy: to remain within the city's walls (which included the so-called Long Walls, a pair of parallel structures that connected Athens to her strategically crucial port, Piraeus, eleven miles away) as the Spartans came each summer to burn their crops, and to put their faith in the sea.

The Athenians' power, and economy, depended on her fleet, after all: food could be supplied from various trading partners abroad, and meanwhile Athenian and allied ships could harry the coastal towns of the Peloponnese, seeking to exhaust the enemy (as Kagan notes), "psychologically, not physically or materially." Pericles well knew that the Spartans ruled their own alliance with an iron hand; behind the Athenian leader's ostensibly passive strategy lay the assumption that after a few years of this harrying, this psychological attrition, the alliance would crumple and the Spartans would be eager for peace. Kagan relates all this with briskness and authority. He's a particularly shrewd reader of the realities behind certain kinds of political rhetoric—not least, the material and economic considerations that affect policy and strategy. Where others might see in Pericles' famous exhortation to restraint an admirably and very Apollonian impulse to moderation, Kagan sees the calculations of a politican who knew he had only enough drachmas in the bank "to maintain his strategy for three years . . . but not for a fourth." Let alone a twenty-seventh.

Pericles' strategy, however, died fairly swiftly after the man himself did, in 429, a victim of the plague that ravaged Athens from 430 to 426—the first blow of many that resulted in the disintegration of the city, both physically and morally. (In a rare reference to his personal life, Thucydides writes in the *History* that he had the illness but survived.) He was succeeded at first by the hawkish demagogues Cleon

and the aptly named Hyperbolus, two men who never met a peace offer they couldn't walk away from. Thucydides, himself related to a royal family (of the northern region called Thrace, from whose silver mines he earned an income substantial enough to allow him to devote himself to writing), evinces disdain for these nouveaux riches, examples of the so-called new politicians of the second half of the fifth century B.C. in Athens—politicans who didn't come, as did Pericles and his protégé Alcibiades, from the rarefied ether of Athenian society, but who were pragmatic self-made men with mercantile fortunes at their disposal, and who cared little for the genteel pieties of the upper crust. (Cleon's father made a fortune in leather, the subject of no little amusement for the comic playwright Aristophanes.) It was Cleon, more than anyone else, who broke with the Periclean strategy and urged Athens on to the more aggressive stance that, for many historians—Kagan isn't one of them—cost Athens her empire.

It was under the ambitious, risk-taking, and aggressive Cleon that the war began to oscillate between unforeseeable victories (such as the Athenians' capture of one tenth of all of Sparta's citizen-soldiers on the island of Sphacteria in 425, which would provide tremendous strategic and diplomatic leverage for years to come) and unnecessary defeats (such as the dreadful Athenian defeat at Delium in 424, the outcome of a rash effort to force a decisive encounter). Under Cleon, Athenian policy also began to reflect the notion, then fashionable in certain intellectual circles which rejected old-fashioned pieties, that "might makes right," a principle of which Cleon himself was the greatest exponent. When the city of Mytilene, on the island of Lesbos, revolted from the Athenian alliance in 427, it was Cleon who proposed to the Athenian assembly that all of the rebellious city's adult men should be put to death and all its women and children sold into slavery as a punishment—a motion that passed, only to be revoked the following day by the guilt-ridden Athenians. Luckily for the Mytilineans, the ship bearing the reluctant executioners was overtaken by that bearing news of the reprieve. (Not for nothing does the action of Euripides' final bitter wartime drama, *Iphigenia at Aulis*, turn on a comparable volte-face involving two dispatches, one bearing death and the second bearing a reprieve; in the play, however, the second fails to catch up with the first.)

After Cleon's death in battle in 421, a brief peace—negotiated by his longtime rival for leadership, a wealthy, deeply pious man called Nicias—soon gave way to a cycle of more and more arrogant strategies that led to ever greater disasters. By the time the tiny island of Melos, a Spartan colony, refused to become part of Athens's alliance in 416, the Athenians no longer felt any compunctions about punishing civilians: in Book 5 of the *History*, Thucydides crisply relates how all of the men were put to death, and all of the women sold into slavery.

For many historians, Melos marks the watershed in Athens's moral decline. The next year, greedy for more empire, the Athenians decided to invade another island, Sicily—a decision heavily influenced by the glamorous but untrustworthy political wild-card Alcibiades, a figure whose beauty, taste, intellectual brilliance, and diplomatic smoothness (to say nothing of his unpredictability, his lack of ethical compass, and mercurial nature) make him, in the latter part of the *History*, a useful symbol for Athens herself. The Sicilian Expedition, which takes up the entire sixth and seventh books of the *History*, ended in the complete annihilation of the Athenian armada, the death of Nicias, and the beginning of the end for Athens.

Even Athens's occasional triumphs during the dismal last decade of the war were vitiated by capricious behavior that suggested a polity no long in control of itself. After the great Athenian naval victory at Arginousae, the Assembly voted to put the victorious admirals to death on the grounds that they failed to rescue sailors who'd drowned in a tempest following the battle. It's during a description of the aftermath of this horror that Thucydides' narrative breaks off, in midsentence. What came next, we learn from his contemporary, Xenophon: increasingly violent internal strife, the overthrow of the democracy and its replacement with a succession of oppressive oligarchic regimes, the fatal alliance between Sparta and Persia, which put terrible pressures on an increasingly cash-poor Athens; the final, catastrophic defeat of the Athenian navy at Aegospotami in the Hellespont—all but ten ships of the great Athenian fleet destroyed, all four thousand Athenian prisoners put to death by the Spartans. The following year, in March 404, exactly twenty-seven years after the war had begun, Athens capitulated. The visible sign of her defeat was the destruction of the Long Walls by the gleeful Spartan allies, an event that Kagan rightly does not

presume to describe, instead quoting Xenophon: "With great zeal they set about tearing down the walls to the music of flute-girls, thinking that this day was the beginning of freedom for the Greeks."

━━━━

Twenty-five years ago, you knew what to make of all this. Indeed, it used to be easy to teach the Peloponnesian War: all you had to do was think of the Cold War. For most of the half century from the end of the Second World War to the fall of the Soviet Union—and certainly during the late 1970s, when I was an undergraduate Classics major wrestling for the first time with Thucydides' prose—the parallels between the Peloponnesian War and the Cold War seemed self-evident. It wasn't that the course of the contemporary conflict was following that of the ancient one—or at least you hoped not, given Athens's fate. It was more a matter of personality. You knew, as you read about Athens, about her boisterous democratic politics and fast-talking politicians, her adventurous intellectual and artistic spirit, that these were the good guys— our own cultural forbears. And you knew, just as surely, as you read about Sparta, about her humorless militarism and geriatric regime, her deep antipathy to democracy and her drab cultural life, that these were the bad guys. They, too, looked awfully familiar.

You knew, too, what it was like to live in a world divided between "two sides [that] were at the very height of power and preparedness," as Thucydides remarks at the beginning of his *History*; and you knew how that polarization created a global political climate in which "the rest of the . . . world was committed to one side or another," and how the blind adherence to ideology or established policy which resulted from such polarization could result in a fearful illogic. (Kagan dryly points out, of the Greek conflict, that "the Spartans were therefore willing to expose themselves to the great danger of a war to preserve an alliance they had created precisely to save them from danger.") The Peloponnesian War—or, to be more precise, Thucydides' account of it—was, in short, every Classics professor's dream: an ancient text whose relevance to contemporary society could not be questioned.

In the bipartite world of the Cold War, there were two ways to read Thucydides as a political text. If you leaned to the left, you saw, in the carefully structured presentation of Athens's gradual descent from cautious self-restraint first into brutality and then into anarchy, a cautionary tale: about the abuses of imperial power, say, and the moral decay that accompanies unscrupulous exercises of such power. If you leaned the other way, you took Thucydides' famous detachment, his failure to pass explicit moral judgments on the Athenians and their wartime behavior, as an implicit if cautious endorsement of *Machtpolitik* as a grim requirement for being a superpower. ("Our opinion of the gods and our knowledge of men lead us to conclude that it is a general and necessary law of nature to rule whatever one can," the Athenians blandly opine during the debate about the fate of the Melians.) But whichever way you read Thucydides, the bipolar structure of the real world, the world in which you actually lived as you read the *History*, implied that you needed to heed the implied message of its numerous polarities—between the Athenians and Spartans, between the Corinthians and their frisky former colonists the Corcyreans, between the Athenians and Melians—which was that one side or the other must be right. Or, more to the point, must win.

Almost as soon as the Cold War had begun, in fact, people who knew their history were using the Peloponnesian War as a lens through which to examine the modern-day global geopolitical scene. On February 22, 1947, Truman's secretary of state, George Marshall, came to Princeton University to talk about world affairs. In his speech, he declared that he "doubt[ed] seriously whether a man can think with full wisdom and deep conviction regarding certain of the basic international issues today who has not at least reviewed in his mind the period of the Peloponnesian War and the Fall of Athens." These words were no more than a fulfillment of a prophecy that Thucydides confidently, if rather cynically, makes in the Introduction to his *History*:

It will be enough for me, however, if these words of mine are judged to be useful by those who want to understand the events which happened in the past and which (human nature being what it is) will, at some time or another and in much the same ways, be repeated in the future.

That the American general-diplomat could so emphatically invoke the Athenian historian's narrative twenty-three hundred years after the death of its author would seem to bear out not only the latter's dim assessment of human nature, but also his declaration that his book would be "a possession for all time."

But what kind of possession, and whose? Time, or rather times, have changed—far more radically, you could argue, between Marshall and the present than between Thucydides and Marshall. What do you make of Thucydides—or, for that matter, the Peloponnesian War itself—at the "end of history," when there is only one superpower?

One answer to this question is to be found in the new book by Kagan, who is alert to the opportunities presented by the new world order for rereading—or, some might say, rewriting—the Peloponnesian War. At the beginning of his new history, he writes that although the Greek conflict's "greatest influence as an analytical tool may have come during the Cold War," he wants his work to "meet the needs of readers in the 21st century." Self-consciously echoing the famous Thucydidean objectivity, he declares that he will refrain from drawing parallels between the ancient event and any modern counterpart, in the hopes that "an uninterrupted account will better allow readers to draw their own conclusion." Uninterrupted, yes, but not disinterested. Kagan is famous on campus and off for his conservatism (he numbers Ronald Reagan and Otto von Bismarck among his "heroes"); what strikes you the most after reading his history of the Peloponnesian War is that you can come away from it with an entirely different view of the war than the one you take away from Thucydides. Unsurprisingly, it's a view that could be taken to support a very twenty-first-century project indeed: a unilateralist policy of preventive or preemptive war, with no tolerance for rivals.

The only way to do this, of course, is make the Peloponnesian War unilateral, too—to strip all the Thucydides out of the *History*, omitting the many voices and famously dialogic structure that the Athenian historian worked so hard to include. Kagan is, indeed, far less shy about intruding his own voice into the proceedings than Thucydides is. This is nowhere more apparent than in his revisionist championing of Cleon

and the war party in Athens, whose hawkish policies Kagan consistently presents as the only reasonable choice for the Athenians: in the debate over the punishment of Mytilene, in the crude rejection of Spartan peace offers in 424 (after Athens gained the upper hand at Sphacteria) when the Athenians refused to allow the peace-seeking Spartans to save face, in the city's harsh punishment of generals who'd concluded a peace with the Sicilian states in 424, even in the "un-Periclean aggressiveness" that backfired at Delium. "It is tempting to blame Cleon for breaking off the negotiations," goes a typically tendentious sentence. "But what, realistically, could have been achieved?" Anyone who hasn't read Thucydides (whose comment on the Athenians' rejection of peace is that "they were greedy for more") will be inclined to agree.

The desire to rehabilitate Cleon results, inevitably, in a corresponding denigration of the peace party (with their "apparently limitless forbearance," as Kagan dismissively remarks) and of the cautious policies recommended first by Pericles and then by Nicias, a figure for whom Kagan has great disdain. ("Misguided.") It's here that Kagan's revisionism borders on the misleading. At one point, for instance, Kagan bizarrely refers to the Sicilian expedition as "the failed stratagem of Nicias." This is absurd. The pious Nicias had no taste for the Sicilian expedition: what happened was that Nicias had tried to bluff the Athenian Assembly into abandoning the invasion of Sicily, declaring that it would require far greater expense than people realized; but they simply approved the additional ships and troops. It's a grotesque stretch to use his failed political ploy to blame the disaster on Nicias, who indeed paid for it with his life. As for the Athenians' massacre of the Melians, Kagan dismisses it as "the outlet they needed for their energy and frustration."

Kagan's reading of the war, with its pervasive pro-Athenian triumphalism, its willing, Cleonic disdain for anything that doesn't serve the aggrandizement of Athenian power, may indeed be the right reading for the twenty-first century, when the United States, unlike the ancient city-state to which it used to be confidently compared, has no traditional military opponents, and no global ideological system to oppose its own ideological aims, of the kind it had thirty years ago. But while his approach owes something to an admirable, and perhaps Thucydidean, desire to look at the war with fresh and unsentimental eyes, you often can't help feeling that it also owes something to a hawkishness

on the author's part, a distaste for compromise and negotiation when armed conflict is possible. His book represents what you could call the Ollie North take on the Peloponnesian War: "If we'd only gone in there with more triremes, we would have won that sucker."

This way of reading Thucydides in light of the new world order is reflected in other recent books about the Greeks at war, none more so than those by Victor Davis Hanson. Hanson, who is extremely prolific on the subject of war—his most recent book, *Ripples of Battle: How Wars of the Past Determine How We Fight, How We Live, and How We Think* (Doubleday; $27.50), is his fourteenth in twenty years—writes absorbingly and well about ancient infantry battles. Increasingly, he's devoted himself to other topics. Among other things, he's a tireless opponent of what he sees as corrupt practices in the current academic study of the Classics. For instance, in his 1998 polemic *Who Killed Homer?*, he suggests that we discard what he clearly sees as a decadent preoccupation with femininity and sexuality, and instead pay more attention to the average guy in ancient Athens—ordinary men who (like Hanson himself, as it happens) farm the land.

But Hanson's own handling of the texts that he wants to reclaim for authentic Greek manliness is itself more than a little suspect. In an article for the National Review Online entitled "Voice From the Past: General Thucydides Speaks About The War," since collected in a volume of essays entitled *An Autumn of War: What America Learned from September 11 And the War on Terrorism*, he poses questions about the Gulf War and has Thucydides "answer" them, by means of citations from the *History*. For example, to the question "Why do you think bin Laden and his terrorists . . . believed they could repeatedly get away with killing Americans, win prestige, and gain concessions—without eventually incurring the destructive wrath of the United States?" he gives the following "answer" from Book 3 of the *History*:

> Their own prosperity could not dissuade them from affronting danger; but blindly confident in the future, and full of hopes beyond their power though not beyond their ambition, they declared war and made their decision to prefer might to right.

Their attacks were determined not by provocation but by the moment which seemed propitious.

Any classicist will immediately recognize in this an appalling mis-representation. Hanson neglects to mention, in citing this implicit Thucydidean endorsement of a "right" American response to 9/11 (presumably one that would involve "destructive wrath" in the Middle East), that the words he's citing here aren't, strictly speaking, Thucy-dides', but rather Cleon's: the speech he quotes, as it happens, is the one in which the politician urged his fellow Athenians to slaughter all of the adult males and enslave the women and children of Mytilene, a punish-ment from which the Athenians themselves, before they entirely lost their moral bearings, shrank in guilty horror. (Cleon's apparent distaste for the enemy's preference for "might to right" in this passage is, in any case, a disingenuous piece of rhetoric; as we know, he was the most out-spoken advocate of *Machtpolitik*.) To make matters even worse, nearly all classicists agree that Thucydides had a special loathing for Cleon. To cite Cleon's speeches as if they represented Thucydides' views on the subject of retributive violence is grotesque—it's like quoting Iago's speeches and saying it's what Shakespeare thought about love.

Hanson's sly (and, in view of his familiarity with the text, deliberate) misrepresentation of Thucydides—the implication that this is a great Dead White Male's response to contemporary political issues, when it is in fact the response of a character whom Thucydides is merely quot-ing—is, at one level, a betrayal of the Athenian historian's ostentatious emphasis on methodological rigor. This is particularly ironic, given that Hanson apparently sees himself as a writer not unlike Thucydides himself: tough-minded, unsentimental (except, perhaps, about farmers, and those who fell in the last world war, "that better age" as he calls it in *Ripples of Battle*), perhaps more in touch with the tough realities of lived life than most effete academics. "My interests," he writes at the begin-ning of *Carnage and Culture*, his 2001 study of why Western warfare has proved superior to that of all other cultures, "are in the military power, not the morality, of the West." Unsurprisingly, a certain self-conscious machismo characterizes much of the writing; you can't help sensing a certain relish in the author's descriptions of dead hoplites "washing up in chunks on the shores of Attica" or "the collision of a machine-gun

bullet with the brow of an adolescent, or the carving and ripping of an artery and organ in the belly of an anonymous Gaul."

This Tarantino-esque swagger inevitably colors Hanson's reading of Thucydides. In Hanson's introduction to *The Landmark Thucydides*, the amply annotated presentation of Richard Crawley's 1874 translation of the *History*, the soi-disant gimlet-eyed modern historian takes the measure of his gimlet-eyed predecessor's narrative. The latter, Hanson asserts, shows us peoples and states "all caught in the circumstance of rebellion, plague and war that always strip away the veneer of culture and show us for what we really are." But did Thucydides think that what human beings "really" are is (say) what the Athenians had become during the Melian debate and its aftermath, or what the mercenaries who murdered the schoolboys were? It's not clear that he does; and, as we know, he never comes out and says so directly. (Then again, he does seem to admire the Melians, who certainly weren't that way.)

To some extent, then, "what we really are" may have less to do with Thucydides than it does with Hanson's image of himself: a tough guy who knows the score better than his soft counterparts on the East Coast do. "There is an inherent truth of battle," he asserts in "Carnage and Culture":

> It is hard to disguise the verdict of the battlefield, and nearly impossible to explain away the dead, or to suggest that abject defeat is somehow victory. . . . To speak of war in any other fashion brings with it a sort of immorality.

But if this is true, then Hanson's catalog of the immoral would have to begin with the Greeks themselves—not least, Thucydides himself. In fact, it is Hanson and Kagan who strip away the moral meaning that underpins Thucydides' account of the war. To get a better sense of what that meaning is, you have to turn from the book that was started in 431 to the play that premièred that spring—which is to say, from history to tragedy.

To the Athenians, Thucydides' *History* may well have looked a lot more like a tragedy than it does to us. You are, indeed, inclined to be suspicious from the very start of Thucydides' notorious claim, in his Introduction, that his account of the war will lack "literary charm" (the Greek here is *mythodes*, a word related to *myth*). He begins his work by boasting of having used only "the plainest evidence" and having "reached conclusions which are reasonably accurate"—stringent methods that, he declares, set him apart from literary types such as poets ("who exaggerate the importance of their themes") and certain earlier historians "who are less interested in telling the truth than in catching the attention of their public"—the latter being a swipe at his predecessor, Herodotus, whose narrative flourishes and fondness for the colorful anecdote the younger historian famously eschews. That said, Thucydides must nonetheless admit to a methodological difficulty that will result in some fiction-writing of his own:

> I have found it difficult to remember the precise words used in the speeches which I listened to myself and my various informants have experienced the same difficulty; so my method has been, while keeping as closely as possible to the general sense of the words that were actually used, to make the speakers say what, in my opinion, was called for by each situation.

As it happens, this is precisely what tragedians do, too: it dovetails perfectly with Aristotle's recommendation, in the *Poetics*—his treatise on poetry and stagecraft—that tragic dialogue needs to reflect what a character is "likely" to say. What's noteworthy about the speeches you find in Thucydides (and there are 141 of them) is that the most memorable of them aren't, as it were, monologues: nearly all of the turning points of the war, the crucial moments in Athenian policy-making, are cast in dialogue form. This, more than anything, is what gives the *History* its unique texture: the vivid sense of an immensely complex conflict reflected, agonizingly, in hundreds of smaller conflicts, each one presenting painful choices, all leading to the great and terrible resolution.

Why did Thucydides cast so much of his history as dialogue? One reason is that the Greek habit of mind was to think in terms of polar op-

posites. There is, built into the Greek language itself, a grammatical element that structures most sentences into balanced clauses. (Most Greek prose, and a lot of poetry, too, sounds like this: "On the one hand, *x*; on the other hand, *y*.") This habit of thought was reflected in the institutions of Greek life, nowhere more so than at Athens. Athenians were, even in ancient times, notoriously litigious—which is to say, both highly verbal and highly combative: a daunting number of the extant prose texts that we have from the great age of Athenian literature are, in fact, lawyers' speeches. In that context, it comes as no surprise that the three greatest intellectual achievements that came out of Athens— Platonic philosophy (treatises cast as dialogues between Socrates and his interlocutors), Thucydidean historiography (historical events reduced to dialogues between opposing viewpoints), and tragic theater (verbal "contests," called *agones*, between characters representing differing moral, religious, or ethical positions)—are all genres that aim to elucidate the truth of the human condition by means of dialogue, of verbal contests. Plato, according to legend, started out wanting to be a playwright and only later turned to philosophy.

The common intellectual heritage of tragedy and Thucydidean history helps explain why it's possible, and indeed desirable, to read the two genres against each other. To see just how "tragic" Thucydides can be, it's worth studying the most famous dialogue in Thucydides: the Melian Dialogue, the historian's presentation of the confrontation in the spring of 416 B.C. between the representatives of Athens and those of Melos. In this section, the Athenians have come to demand cooperation from the Melians, on pain of total destruction, insisting on their right, as the more powerful, to decide the island's fate. (They blandly dismiss any considerations of what is actually just, since for them Justice "depends on the equality of power to compel and that in fact the strong do what they have the power to do and the weak accept what they have to accept.") Slyly taking up the Athenians' argument for action based on self-interest, the spirited Melians reply that it might be in the Athenians' best interests to exercise restraint and refrain from devastating the island, since "in war fortune sometimes makes the odds more level than could be expected from the difference in numbers of the two sides." Instead, they doggedly place their trust in "hope" and "fortune." As we know, the negotiations soon collapsed; that winter, the city fell

and the Melians surrendered unconditionally to the Athenians who, true to their word, put to death all the men of military age and sold into slavery all of the women and children.

The tragedy of the Melian episode doesn't lie so much in the fact that it has an unhappy ending (many Greek tragedies don't), as in the crisp exchanges between the principals, which indeed resemble the *stichomythia*, the rapid-fire dialogue, between warring duos in so many Greek tragedies: unscrupulous tyrants threatening innocent women who have taken sanctuary at altars, as in Aeschylus's *Suppliants* and numerous other plays, or all-powerful kings locking horns with physically powerless yet morally ferocious antagonists, as in (to take the best known example) Sophocles' *Antigone*. As if to underscore the similarities between his text and those of the tragic poets, Thucydides gives this debate a remarkable physical resemblance to the scripts of real tragedies, with the names of the "characters," the Athenians and Melians, abbreviated before their respective speeches, like this:

> MEL.: And how could it be just as good for us to be the slaves as for you to be the masters?
> ATH.: You, by giving in, would save yourselves from disaster; we, by not destroying you, would be able to profit from you.
> MEL.: So you would not agree to our being neutral, friends instead of enemies, but allies of neither side?
> ATH.: No, because it is not so much your hostility that injures us; it is rather the case that, if we were on friendly terms with you, our subjects would regard that as a sign of weakness in us, whereas your hatred is evidence of our power.

A thrilling, if disheartening, bit of drama.

It is, however, in yet further manipulations of his text that Thucydides suggests the extent to which we are to read his book as a play, his history as a tragedy. In the *Poetics*, Aristotle observes that even good dialogue doesn't make a good tragedy. "If a man writes a series of speeches

full of character and excellent in point of diction and thought," he observes, "he will not achieve the proper function of tragedy nearly so well as a tragedy which, while inferior in these qualities, has a plot or arrangement of incidents." Chief among the devices that give a narrative the sense of being a true tragic plot, he goes on to say, are *peripeteia*, "reversal of fortune," and *anagnorisis*, a "recognition," resulting from the reversal of fortune, of what one hadn't realized before. (When the Melians remind the Athenians that the latter could well be the losers one day, they're talking, rather optimistically, about a *peripeteia*.) Tragedy, after all, thrives on shocking reversals and morally pointed echoes and inversions: so Oedipus, in Sophocles' play, is a king who turns out to be an outcast, a sleuth who turns out to be the criminal he seeks, the foreigner who is revealed to be native-born, the son who replaces his father in his mother's bed. So Pentheus, in Euripides' *Bacchae*, the rigid young man obsessed with maintaining the boundaries of his city and his own psyche, ends up literally disintegrating, torn into tiny pieces by god-maddened women.

Thucydides, naturally, couldn't "arrange" his plot as Aeschylus, Sophocles, and Euripides so artfully did; throughout the *History*, as we know, he sticks to his careful narration of events as they happened. But while Thucydides can't invent what his characters did, he does have more control over what they say (since, as he himself tells us, he's putting words in their mouths). It's here, in the diction and arrangement of the speeches, that he forges the literary parallels and verbal echoes that allow you to perceive how much of what happens to Athens is an Aristotelian *peripeteia*.

This is certainly evident in the masterly portrayal of Athens's disastrous Sicilian Expedition. In tragedy, reversals are usually punishment for hubris, and there are clues, in the *History*, that Sicily is to be seen as a heroic delusion on a scale as grandiose as anything you find in tragedy. When the magnificent Athenian fleet, led by Alcibiades, set out for Sicily in the winter of 416 B.C., she was equipped with lust for conquest and not much else, apart from a hubristically misplaced self-confidence: "They were," Thucydides writes, "for the most part ignorant of the size of the island and of the numbers of its inhabitants, both Hellenic and native, and they did not realize that they were taking on

a war of almost the same magnitude as their war against the Peloponnesians." And there's little doubt that we're meant to see in the disaster that ensued a grand retribution for the cynical policies of which the Melian slaughter stands as the great symbol. The Melian affair closes Book V, and the Sicilian Expedition opens Book VI—a pointed juxtaposition. In Sicily, moreoever, the Athenians are forced, in a typically tragic reversal, to "play" the Melians whom they themselves had destroyed. In the very moment of the Athenians' total defeat, Nicias urges his troops to place their trust in "hope," "fortune," and the gods—the very things that the Melians, facing obliteration at the hands of a vastly more powerful enemy, had trusted in, to the derisive amusement of the Athenians during the Melian debate. What befalls the Athenians in Sicily therefore fulfills the desperate prediction of the Melians: "We know that in war fortune sometimes makes the odds more level than could be expected."

This is surely why Thucydides takes special care to present the climactic defeat of the Athenian forces in the Sicilian campaign, at the Assinarus River in 413, as a theatrical spectacle, with what can only be described as an audience of Syracusans watching the battle, "prey to the most agonizing and conflicting emotions." How better to behold what the author describes as "the greatest reverse that ever befell an Hellenic army"? The notion of reversal colors the entire passage: the Athenians, those great seafarers who had come across the vast waters to this island, greedy to fatten their empire, finish by crawling around in the river mud, pathetically desperate for nothing more than enough water to slake their dreadful thirst. "They now suffered very nearly what they had inflicted," Thucydides writes. "They had come to enslave others, and were departing in fear of being enslaved themselves."

But no reversal in Thucydides' presentation of his native city is more pointed, or more appalling, than one that would have been obvious to his contemporaries. In Herodotus's history of the glorious conflict in which Athens and Sparta fought side by side against a common enemy, the Persians, he relates how the Great King of Persia, confident of his military superiority, the enormous numbers of troops and rich provisions at his disposal, tried to persuade the Greeks that resistance was futile; that might made him, if not right, then inevitable. And yet they trusted to hope, and fortune, and the gods, and were richly rewarded

in their stunning victories at Marathon in 490 and at Salamis ten years later. That the Athenians, in Thucydides' *History*, should, in the course of fifty years, have come to resemble the villain of Herodotus's *Histories*, using the same words to the Melians that the Great King had once addressed to them, is an irony as bitter as any you find in Sophocles. This was something that Thucydides' ancient readers already understood. "Words like these," the first-century B.C. historian Dionysius of Halicarnassus wrote in his analysis of the Melian dialogue, "were appropriate to oriental monarchs addressing Greeks, but unfit to be spoken by Athenians to Greeks."

So the lessons to be learned from Thucydides are no different from the ones that the tragic playwrights teach: that the arrogant self can become the abject Other; that failure to bend, to negotiate, inevitably results in terrible fracture; that, because we are only human, our knowledge is merely knowingness, our vision partial rather than whole, and we must tread carefully in the world.

These are, indeed, the lessons of *Medea*, that other product of the spring of 431 B.C. To our post-Freudian eyes, *Medea* looks like an over-the-top domestic and psychological drama; to the Athenians, that fraught March, it may well have looked like a political fable. The play's setting is Corinth—a highly unusual locale for a Greek tragedy—and its heroine is obsessed with violated oaths. These two facts suggest an underlying commentary on the Corinthian diplomatic crisis of a few years earlier—an event characterized by broken covenants and explosive confrontations between "kindred" states—which led to the outbreak of the war. Then there's the heroine's philandering husband, Jason the Argonaut. With his aggressive bearing and fancy rhetorical footwork (at one point he tells Medea that he's abandoning her and their children in a strange land for their own good), he begins to look like a parody of a certain kind of Athenian politician—the kind who might for the sake of winning an argument denounce in an enemy the crass ethics (a preference for might over right, say) that he himself is known to hold dear.

Nearly all of Euripides' extant works were written during the war, and, more than any other tragedian, he kept returning to the tragic lessons of history. His *Trojan Women*, which depicts the horrific after-

math of the Greeks' sack of Troy, was first produced in the spring of
415 B.C.—all too clearly a bitter artistic reaction to the slaughter of the
Melians the preceding winter. One of the questions the play asks is, in
fact, a question that Hanson scorns as "immoral": whether abject defeat
can yet somehow be a victory—not, obviously, a military victory, but a
moral victory.

Euripides' answer to this question is as clear as Hanson's, although
somehow the Greek has come to a conclusion different from that
reached by the Californian. The first great speech of the play is given
to the mad Trojan princess Cassandra (she's the one who's doomed to
make prophecies that no one will believe), and bizarrely, although the
Greeks have utterly destroyed Troy, the monologue is a paean to an al-
leged Trojan (or "Phrygian") victory:

> O Mother, star my hair with flowers of victory . . .
> The Trojans have that glory which is the loveliest:
> They died for their own country. So the bodies of all who took the
> spears were carried home in loving hands,
> Brought, in the land of their fathers, to the embrace of earth
> And buried becomingly as the rite fell due. The rest,
> Those Phrygians who escaped death in battle, day by day
> Came home to happiness the Achaeans could not know;
> Their wives, their children. . . .
> Though surely the wise man will forever shrink from war,
> Yet if war come, the hero's death will lay a wreath
> Not lusterless on the city. The coward alone brings shame.

The Greek invaders have, by contrast, lost all the accoutrements of civi-
lized life—family ties, burial in the soil of their hometowns; so that in
the play we are made to understand that the exercise of absolute power
can come at a terrible price. And indeed, we know from the prologue
that the capricious gods are about to wreak havoc on the Greeks, as
surely as they did for the Athenians immediately after their moment of
unthinking triumph at Melos.

One definition of *coward*, as the play makes clear, is an armed adult
male who murders small children, as Cassandra's nephew will soon be

murdered by the Greeks for the seemingly pragmatic reason that, if allowed to reach adulthood, he might yet avenge his city's downfall. While the child's mother, Andromache, screams in anguish as her son is pried from her arms, the Greek envoy addresses her with words that uncannily recall those of the Athenians to the Melians:

> *Let it happen this way. It will be wiser in the end.*
> *Do not fight it. Take your grief as you were born to take it,*
> *Give up the struggle where your strength is feebleness*
> *With no force anywhere to help. Listen to me!*
> *Your city is gone . . . you are in our power.*

Physical power, perhaps; but it's clear who the moral winners are. The emotional climax of the play is, in fact, the pathetic little funeral ceremony for the little boy; it's not without significance that the same Greek soldier whose swagger, a few episodes earlier, couldn't help reminding the audience of the attitude of Athens's own emissaries on Melos a few months before, is moved, in the play, to perform the funerary rites himself. This is another kind of *peripeteia*, another reversal of character; but it's too late. The Greeks will soon go to their ruin: Agamemnon to be murdered, Ajax to suicide, Odysseus to his terrible wanderings.

So who are the real victors here? And whose vision of Greek war is, by Greek standards at least, "immoral"? Cassandra's speech suggests why it is the tragic vision, rather than the glib pose of pragmatism, that should guide us in examining the moral questions raised by the wars to which Professors Kagan and Hanson have devoted their efforts. For all that these authors admire, and to some extent seek to imitate, Thucydides' hardheadedness and his careful method, their books lack what makes Thucydides' book (which is, after all, so much like a play) so great: his broader vision of history and statecraft and war, his humanity. Like Greek tragic drama, the *History* is an artful object, a careful manipulation of words and actions that can lead you, if you pay attention, to a "clear vision" of that which Thucydides, like the Attic dra-

matists, prized so highly: not necessarily the facts, but the truth. (As, for instance, the truth about the real motives for "wars of liberation.") It's worth remembering that "ship of state" is a metaphor we owe not to a historian but to a tragedian; Aeschylus, who fought in the Persian Wars—the war whose "bad guy" Athens herself would, in a quintessentially tragic inversion, ironically come to resemble—coined it for his play *Seven Against Thebes*, a work ferociously preoccupied with questions of how the state ought to handle itself during times of war. If you miss the connections between tragedy and history, between poetry and politics, you're likely to miss the boat.

Certainly the Athenians thought so. We are told that when Cleon scored his stunning success at Sphacteria, the rewards granted to him by a grateful city included front-row seats at the Theater of Dionysus, which was located just behind the Acropolis and which was the site of the annual tragic festival. Whether he actually made use of that gift, and what he made of the plays he would have seen there if he did, Thucydides doesn't say.

—*The New Yorker*, January 12, 2004

The Bad Boy of Athens

In the early spring of 411 B.C., Euripides finally got what was coming to him. The playwright, then in his seventies, had always been the bad boy of Athenian drama. He was the irreverent prankster who, in his *Elektra*, parodied the famous recognition scene in Aeschylus' *Libation Bearers*. He was an avant-garde intellectual who took an interest in the latest theorists—he is said to have been a friend of Socrates, and it was at his home that Protagoras ("man is the measure of all things") first read his agnostic treatise on the gods; in works like *The Madness of Herakles*, he questioned the established Olympian pantheon. Stylistically, he was a playful postmodernist whose sly rearranging of traditional mythic material, in bitter fables like *Orestes*, deconstructed tragic conventions, anticipating by twenty-five centuries a theater whose patent subject was the workings of the theater itself.

But no aspect of the playwright's roiling opus was more famous, in his own day, than his penchant for portraying deranged females. Among them are the love-mad queen Phaedra, whose unrequited lust leads her to suicide and murder (the subject of not one but two *Hippolytus* plays by the poet, one now lost); the distraught erotomane widow Evadne in *Suppliant Women*, who incinerates herself on her dead husband's

grave; the ruthless granny Alcmene in *Children of Herakles*, who violently avenges herself on her male enemies; the wild-eyed Cassandra in *Trojan Women*; the list goes on and on. And, of course, there was Medea, whom the Athenians knew from established legend as the murderess of her own brother, the sorceress who dreamed up gruesome ways to destroy her husband Jason's enemy Pelias, and whom Euripides—not surprisingly, given his tastes in female characters—decided, in his staging of the myth, to make the murderess of her own children as well.

And so it was that, shortly after winter was over in 411, the women of Athens had their revenge on the man who'd given womanhood such a bad name. Or at least they did in one playwright's fantasy. In that year, the comic dramatist Aristophanes staged his *Thesmophoriazousae*. (The tongue-twister of a title means "Women Celebrating the Thesmophoria"—this latter being an annual, all-female fertility festival associated with Demeter.) In this brilliant literary fantasy, Euripides learns that the women of the city are using the religious festival as a pretext to hold a debate on whether they ought to kill the playwright in revenge for being badmouthed by him in so many works over the years. Desperate to know what they're saying about him, and eager to have someone speak up on his behalf—something no real woman would do—Euripides persuades an aged kinsman, Mnesilochus, to attend the festival in drag, spy on the proceedings, and, if necessary, speak in the poet's defense. The plan, of course, backfires, Mnesilochus is found out, and only a last-minute rescue by Euripides himself—he comes swooping onto the stage, dressed as Perseus, in the contraption used in tragedies to hoist gods aloft—can avert disaster. Peace, founded on a promise by the playwright never to slander women again, is finally made between this difficult man of the theater and his angry audience. The play ends in rejoicing.

Many contemporary classicists—this writer included—would argue that the females of Athens were taking things far too personally. Athenian drama, presented with much ceremony during the course of a public and even patriotic yearly civic festival, structured on the armature of heroic myth, rigidly conventional in form and diction, was not "realistic"; we must be careful, when evaluating and interpreting these

works, of our own tendency to see drama in purely personal terms, as a vehicle for psychological investigations. If anything, Athenian tragedy seems to have been useful as an artistic means of exploring concerns that, to us, seem to be unlikely candidates for an evening of thrilling drama: the nature of the state, the difficult relationship—always of concern in a democracy—between remarkable men (tragedy's "heroes") and the collective citizen body.

In particular, the dialogic nature of drama made it a perfect vehicle for giving voice to—literally acting out—the tensions that underlay the smooth ideological surface of the aggressively imperialistic Athenian democracy. Tensions, that is, between personal morality and the requirements of the state (or army, as in Sophocles' *Philoctetes*), and between the ethical obligations imposed by family and those imposed by the city (*Antigone*); and the never-quite-satisfying negotiations between the primitive impulse toward personal vengeance and the civilized rule of law (*Oresteia*). Greek tragedy was political theater in a way we cannot imagine, or replicate, today; there was more than a passing resemblance between the debates enacted before the citizens participating in the assembly, and those conflicts, *agones*, dramatized before the eyes of those same citizens in the theater. Herodotus tells the story of a Persian king who bemusedly describes the Greek *agora*, the central civic meeting space, as "a place in the middle of the city where the people tell each other lies." That's what the theater of Dionysus was, too.

This is the context in which we must interpret tragedy's passionate females—as odd as it may seem to us today. The wild women characters to whom Aristophanes' female Athenians so hotly objected weren't so much reflections of real contemporary females and their concerns—the preoccupation of Athenian theater being issues of import to the citizen audience, which was free, propertied, and male; we still can't be sure whether women even attended the theater—as, rather, symbolic entities representing everything "other" to that smoothly coherent citizen identity. (Because women—thought to be irrational, emotional, deceitful, slaves of passion—were themselves "other" to all that the free, rational, self-controlled male citizen was.) As such, Greek drama's girls and women—pathetic, suffering, angry, violent, noble, wicked—were ideal mouthpieces for all the concerns that imperial state ideology, with its drive toward centralization, homogenization, and unity, necessarily

suppressed or smoothed over: family blood ties, the interests of the private sphere, the anarchic, self-indulgent urges of the individual psyche, secret longings for the glittering heroic and aristocratic past.

For this reason, the conflicts between tragedy's males and females are never merely domestic spats. Clytemnestra, asserting the interests of the family, obsessed by the sacrifice of her innocent daughter Iphigenia (an act that represents the way in which the domestic and individual realms are always "sacrificed" to the collective good in wartime), kills her husband in revenge, but is herself murdered by their son—who later is acquitted by an Athenian jury. Antigone, for her part, prefers her uncle's decree of death to a life in which she is unable to honor family ties as she sees fit. To be sure, this is a schematic reading, one that doesn't take into account the genius of the Attic poets: men, after all, who had wives and mothers and daughters, and who were able to enhance their staged portraits of different types of females with the kind of real-life nuances that we today look for in dramatic characters. But it is useful to keep the schema in mind, if only as a counterbalance to our contemporary temptation to see all drama in terms of psyches rather than polities.

Two recent productions of works by Euripides illuminate, in very different ways, the dangers of failing to calibrate properly the precise value of the feminine in Greek, and particularly Euripidean, drama. As it happens, they make a nicely complementary pair. One, *Medea*, currently enjoying a highly praised run on Broadway in a production staged by Deborah Warner and starring the Irish actress Fiona Shaw, is the playwright's best-known and most-performed play, not least because it conforms so nicely to contemporary expectations of what a night at the theater should entail. (It looks like it's all about emotions and female suffering.) The other, *The Children of Herakles*, first produced a couple of years after *Medea*, is his least-known and most rarely performed drama: Peter Sellars's staging of it in Cambridge, with the American Repertory Theatre, marks the work's first professional production in the United States. That this play seems to be characterized far more by a preoccupation with dry and undramatic political concerns than by what we think of as a "typically" Euripidean emphasis on feminine passions is confirmed by classicists' habit of referring to it as one of the poet's two "political plays." And yet *Medea* is more political than you might at first

think—and certainly more so than its noisy and shallow new staging suggests; while the political message of *The Children of Herakles* depends much more on the portrayal of its female characters than anyone, including those who have been bold enough to stage it for the first time, might realize.

———

By far the more interesting and thoughtful of the two productions is the Cambridge *Children of Herakles*. Euripides' tale of the sufferings of the dead Herakles' refugee children, pursued from their native land by the evil king Eurystheus and forced to seek asylum in Athens, has been much maligned for its episodic and ostensibly disjointed structure: the Aristotle scholar John Jones, writing on the *Poetics*, summed up the critical consensus by calling it "a thoroughly bad play." But the imaginative if overcooked staging by Peter Sellars, who here effects one of his well-known updatings, suggests that it can have considerable power in performance.

The legend on which this odd drama is based was familiar to the Athenian audience, not least because it confirmed their sense of themselves as a just people. After his death, Herakles' children are pursued from their native city, Argos, by Eurystheus—he's the cruel monarch who has given Herakles all those terrible labors to perform—and, led by their father's aged sidekick, Iolaos, they wander from city to city, seeking refuge from the man who wants to wipe them out. Only the Athenians agree to give them shelter and, more, to defend them; they defeat the Argive army in a great battle during which Eurystheus is killed—after which his severed head is brought back to Herakles' mother, Alcmene, who gouges his eyes out with dress pins. (There was a place near Athens called "Eurystheus' Head," where the head was supposed to have been buried.) The legend was frequently cited in political orations of Euripides' time as an example of the justness of the Athenian state—its willingness to make war, if necessary, on behalf of the innocent and powerless.

And yet Euripides went to considerable lengths to alter this mythic

account precisely by adding new female voices. In his version, the two most significant actions in the story are assigned to women. First of all, he invents a daughter for Herakles, traditionally called Macaria but referred to in the text of the play simply as *parthenos*, "virgin"; in this new version of the famous patriotic myth, it is not merely the Athenians' military might that saves the day, but Macaria's decision, in response to one of those eleventh-hour oracles that inevitably wreak havoc with the lives of Greek tragic virgins, to die as a sacrificial victim in order to ensure victory in battle. The playwright also makes Alcmene a more vigorous, if sinister, presence: in this version, it is she who has Eurystheus killed, in flagrant violation of Athens's rules for the treatment of prisoners of war. The play ends abruptly after she gives the order for execution.

Classicists have always thought the play is "political," but only because there are scenes in which various male characters—the caustic envoy of the Argive king, the sympathetic Athenian monarch Demophon, son of Theseus—debate what the just course for Athens ought to be. (Come to the aid of the refugees and thereby risk war? Or incur religious pollution by failing to honor the claims of suppliants at an altar?) But it's only when you understand the political dimensions of the tragedy's portrayal of women that you can see just how political a play it really is. The contrast between the two female figures—the self-sacrificing Macaria, and the murderous Alcmene; one concerned only for her family and allies, the other intent on the gratification of private vengeance—could not be greater.

In symbolic terms, the terms familiar to Euripides' audiences, the play is about the politics of civic belonging. Herakles' children, homeless, stateless, are eager to reestablish their civic identity—to belong somewhere; Macaria's action demonstrates that in order to do so, sacrifices—of the individual, of private "family" concerns—must take place. (In her speech of self-sacrifice, she uses all of the current buzzwords of Athenian civic conformity.) Her bloodthirsty grandmother, on the other hand, eager to avenge a lifetime of humiliations to her family, dramatizes the way in which private concerns—she, like Aeschylus' Clytemnestra, is the representative of clan interests—never quite disappear beneath the smooth façade of public interest. "I am 'someone,' too," she hotly replies, during the closing minutes of the play, in re-

sponse to an Athenian's statement that "there is no way that someone may execute" Eurystheus in violation of Athenian law.

It is a shame, given the trouble Euripides goes to in order to inject vivid female energies into a story that previously had none, that Peter Sellars (who you could say has made a specialty of unpopular or difficult-to-stage Greek dramas: past productions include Sophocles' *Ajax* and Aeschylus' *Persians*, a work that has all of the dramatic élan of a Veterans Day parade) has focused on those issues in the play that appear "political" to us, rather than those that the Athenians would have understood to be political. Because there are refugees in the play, Sellars thinks the play is about what we call refugee crises—to us, now, a very political-sounding dilemma indeed. He has, accordingly, with his characteristic thoroughness and imaginative brio, gone to a great deal of trouble to bring out this element, almost to the exclusion of everything else.

Indeed, the American Repertory Theatre's performance of *Children of Herakles* is only one third of a three-part evening. It begins with a one-hour panel discussion—the guests change each night of the play's run—hosted by the Boston radio personality Christopher Lydon, that focuses on refugee crises around the world. The night I saw the play, his three guests were Arthur Helton, the director of Peace and Conflict Studies for the Council on Foreign Relations; a female asylum-seeker from Somalia called Ayisha; and a Serbian woman from the former Yugoslavia who'd emigrated to the United States after suffering during the Balkan wars. Then comes the performance of Euripides' play, which lasts two hours; and then a screening of a film. The latter represents, in the words of the program, "an artistic response to the current crisis—a series of films made in countries that are generating large numbers of refugees."

This probably sounds more pretentious and gimmicky than it really is. It's true that a lot went wrong the night I saw the play: the Serbian woman, rather than shedding light on her own experiences as a refugee, lectured the audience rather stridently about the meaning of freedom (she chided us about our lust for large refrigerators); the first part took longer than expected, with the result that the film at the end of the evening began late, and people started disappearing, despite the temp-

tations of a buffet dinner between parts two and three that featured appropriately politicized entrees ("grilled Balkan sausage"); and so on. But a lot about the evening was right. It's rare to see a production of a Greek drama that so seriously and conscientiously attempts to repli-cate, in some sense, the deeply political context in which the ancient works were originally performed. Whatever its flaws, Sellars's *Children of Herakles* makes you feel that an appropriate staging of Greek tragedy entails more than a couple hours' emoting followed by an argument about where to have dinner.

I found myself objecting, at first, to one of the most extreme gestures the director made: that is, having the children of Herakles themselves embodied (they're not speaking roles) by Boston-area refugee children, who every now and then went up into the audience to shake our hands. But the sense of being somehow implicated in the real lives of the actors, so foreign to contemporary theatrical sensibilities, would not have been that strange to Euripides' audiences. The choruses in the theater of Dio-nysos at Athens were chosen from among Athenian citizens, boys and men, who would indeed have been known to the spectators, or at least some of them. Modern drama seeks to create estrangement, and dis-tance, between the artifice onstage and the spectators' everyday lives; ancient drama relied, in its way, on a sense of communal concern.

Sellars understands, furthermore, that tragedy doesn't need a lot to achieve its effects, and his staging is rightly stark: a stepped altar in the middle of the stage surrounded by the huddling male offspring of Herakles, who have taken sanctuary there (the top of the altar was sup-posed to be occupied by a female Kazakh bard—a nice, if misplaced, Homeric touch—but she was ill the night I attended); a microphone, downstage left, into which the Argive envoy and Athenian king speak, which—not inappropriately, I thought—gives the debates at the open-ing of the play, where the city's course of action is decided, the air of a press conference; and, for the chorus (their lines were read by Lydon and another person, a woman) a little conference table at the extreme left of the stage, where they sit primly, occasionally making weary bu-reaucratic noises about how sorry they felt about the refugees' plight. This is perfect: it gets just right the tone of this work's chorus, which like the choruses in many tragedies is stranded between good inten-tions and a healthy self-protectiveness.

What robs the play of the impact it could have had is Sellars's failure to appreciate the subtle gender dynamics in Euripides' text. One of the reasons that the actions of Euripides' Macaria and Alcmene are so striking is that they're the only actions by females in a play otherwise wholly devoted to ostensibly masculine concerns: the governance of the free state, extradition issues, war. Part of Sellars's updating, however, is to give the roles of the nasty Argive herald—the one whom Eurystheus sends to intimidate the Athenians into giving up the refugees—and of the Athenian king Demophon (here recast as "president" of Athens) to women. Although the parts are well played—the Demophon in particular comes across as a shrewd contemporary elected official, eager to do right but hamstrung by elaborate political obligations—the shift in gender results in a collapse of the playwright's meanings. In Euripides' play, the unexpected and electrifying entrance of Macaria and her offer of self-immolation dramatizes the need to sacrifice the "personal" and "domestic"—things that tragic women were understood to represent— to the larger civic good; the unusual and even revolutionary impact of her appearance and subsequent action is underscored, in the original, by her apology for appearing in public in the first place, something no nice Athenian girl would do. But Sellars's staging makes nonsense of the lines; it's absurd for this girl to be apologizing for talking to men outside the confines of the house (and for her to be asserting that she knows that a woman's place is in the home) when the most politically powerful characters in the play are, as they are in this staging, women. And so the end of the play—the old woman's violent explosion, reminder that the energies that must be sacrificed to establish the collective good always lurk uneasily within the polity, and can erupt—makes no sense, either. The women in this *Children of Herakles* are very healthy, thank you very much; there is no "repressed" to return.

Worse still, Sellars stages the sacrifice of Macaria—beautifully, it is true, and bloodily. But it's not in the play. One of the most famously disturbing things about *The Children of Herakles* is the irony that, after she makes her bid for immortality—the girl begs to be honored in her family's and Athens's memory before she goes off to die—we never hear another word about her. There are all sorts of explanations for this cold treatment of a warm-blooded character (not least, that the manuscript

of the play is incomplete), but surely one is precisely that everything that Macaria represents must, in fact, disappear in order for the community to persist. Tragedy loves its self-heroizing females, but like the state whose concerns it so subtly enacted, it always found a way to get rid of those unmanageable "others." By bringing Macaria back in the second half of the play, and allowing us to weep over the spectacle of the tiny young girl having her throat cut, Sellars reasserts the energies that Euripides shows—ironically or not—being silenced.

And so, like an earlier generation of classicists who saw little of value in this play except references to contemporary politicking—the speeches were thought to echo fifth-century-B.C. Athenian political debates—Sellars fails to see where the play's political discourse really lies. Which is to say, in the representation of the two characters who look the least like politicians: a young girl and an old woman. Did Euripides care about refugees? Yes, but only because of what refugee crises tell us about the nature of the state. ("The current event" he cared about was Athens's summary execution, the year before the play was produced, of some Spartan envoys—clearly the referent for Alcmene's climactic act of violence.) Peter Sellars, on the other hand, cares about refugees the way a twenty-first-century person cares—he feels for these poor kids, the mute, wide-eyed boys, the brutalized girls, and wants to make you feel for them, too. The result, alas, is a play that sends a message that isn't quite the one the one Euripides was telegraphing to his audience, by means of symbolic structures they knew well. Someone gets sacrificed in this *Children of Herakles*, but it isn't just Macaria.

———

A similar desire to update a Euripidean classic in terms familiar to today's audience has, apparently, informed Deborah Warner's vulgar, loud, and uncomprehending staging of *Medea*, which went from a limited run at the Brooklyn Academy of Music to its current Broadway run, which has been rapturously received by most critics—mostly because they are rightly impressed by Fiona Shaw's emotional ferocity. If only it were being put in the service of a reading that did justice to Euripides!

For if Sellars's Euripides ultimately betrays its source because it thinks "our" politics are the play's politics, Warner's Euripides fails because it mistakes "our" women for Euripides' women.

In an interview two years ago with *The Guardian*, before their *Medea* had crossed the Atlantic, Warner and Shaw decried the "misplaced image of Medea as a strong, wilful, witchy woman," suggesting instead that the key to their heroine was, in fact, her "weakness." "Audiences can identify with weakness," Shaw said. "I think the Greek playwrights knew that. That they could entice the audience into an emotional debate about failure and dealing with being a failed person." This betrays a remarkable failure to understand the nature of Greek tragic drama, which unlike contemporary psychological drama didn't strive to have audiences "identify" with its characters—if anything, Athenian audiences were likely to find the chorus more sympathetic and recognizable than the outsized heroes with their divine pedigrees—and which was relatively uninterested in the wholly modern notion of "dealing" with failure (and, you suppose, finding "closure"). For the Greeks, the allure of so many tragic heroes is, in fact, exactly the opposite of what Warner and Shaw think it is: the heroes' strength, their grandeur, their power, the attributes of intellect or valor that they must resort to in their staged struggles with a hostile fate—or, as in many plays, like *Ajax*, their struggles to adapt to post-heroic worlds that have shifted and shrunk beneath them, rendering the heroes outsized, obsolete. (Norma Desmond, the has-been silent film star in Billy Wilder's *Sunset Boulevard*, has something of the grotesque yet somehow admirable grandiosity of the latter type of hero; her famous *cri de coeur* "I *am* big. It was the *pictures* that got small" could, *mutatis mutandis*, be a line from Sophocles.)

And indeed, rather than being what Shaw called "very normal" and Warner referred to as "the happy housewife of Corinth," Euripides' Medea is deliberately presented as a kind of female reincarnation of one of the most anguished, outsized, titanic dramatic heroes in the ancient canon: Sophocles' Ajax, the hero of a drama first produced about ten years before *Medea*. Like Ajax, Medea is first heard, rather uncannily, offstage, groaning over her plight: her abandonment by her husband Jason, who has left her to marry the daughter of Creon, the king of Corinth. Like Ajax, she is characterized by what the classicist Bernard Knox has summarized as "determined resolve, expressed in uncom-

promising terms," by a "fearful, terrible . . . wild" nature, by "passion-ate intensity"; like Sophoclean heroes, she is motivated above all by an outraged sense of having been treated with disrespect, and curses her enemies while she plans her revenge; like Ajax, she is tormented above all by the thought that her enemies will laugh at her.

So "strong, willful, and witchy" is, in fact, precisely what Euripides' Medea is. But not Warner's Medea, who appears to be stranded some-where between Sylvia Plath and Mia Farrow—a frazzled woman who can't figure out how to act until the last minute. (Euripides' Medea can: from the start, she keeps repeating the terrifying word ktenô, "I will kill.") Shaw, an impressive actress, chews up the scenery doing an im-personation of a housewife gone amok. When she comes out on the rather bleak stage at the Brooks Atkinson Theatre—apart from a door upstage center, there are just some cinder blocks strewn around cov-ered with tarps, as if a construction project had been halted midway, and a swimming pool (by now de rigueur in contemporary stagings of classical texts; there was one in Mary Zimmerman's Metamorpho-ses, too) in the center with a toy boat floating in it—she's emaciated, hugging herself, haggard, nervously cracking jokes. (She draws a little witch hat in the air above her head at one point.) To reconcile this valium-starved wreck with the text's many references to Medea's fame, power, and semidivine status, Warner makes some halfhearted refer-ences to Medea as being some kind of "celebrity": the chorus, here, is a gang of autograph-seeking groupies—"the people who stand outside the Oscars," as Warner put it. The intention, you imagine, is to throw into the interpretative stew some kind of commentary on "celebrity," but it's a stupid point to be making: all the heroes of Greek tragedy are famous.

This scaled-down, "normal" Medea makes nonsense of the text in other, more damaging ways. Everyone in Euripides' play who interacts with Medea shows a healthy respect for the woman they know to be capable of terrible deeds. (She once gave the daughters of one of Jason's enemies a deliberately misleading recipe for rejuvenating their aging father, which involved cutting the old man into tiny pieces. Needless to say, it didn't work. This was the subject of Euripides' first drama, produced in 455 B.C., when he was thirty.) She is august, terrifying; the granddaughter of the sun, for heaven's sake. The Warner/Shaw Medea

looks as if she can barely get herself out of bed in the morning, and the result is that when the plot does require her to do those awful things (the murder of Jason's fiancée and her father, the slaughter of her own children), you wonder how—and why—she managed it. The problem with making Medea into one of those distraught Susan Smith types, pushed by creepy men into moral regions we can't ever inhabit, is that it substitutes pat psychological nostrums ("Someone pushed to the place where she has no choice": thus Warner) for something that is much more terrifying—and vital—in the play. Euripides' Medea is terrifying and grotesque precisely because her motivations aren't those of a wounded housewife, but those of a heroic temperament following the brutal logic of heroism: to inflict harm on your enemies at all costs.

You could argue, indeed, that what makes Euripides' heroine awesome is not that she's a woman on the verge of a nervous breakdown, but that, if anything, she has the capacity to think like a *man*. Or, perhaps, like a lawyer. Euripides, we know, was very interested in the developing art of rhetoric, an instrument of great importance in the workings of the Athenian state. The patent content of Euripides' play, the material that seems to be about female suffering, is by now so famous, and so familiar-seeming, that it has obscured the play's other preoccupations: chief among these is the use and abuse of language. In every scene, Medea is presented as a skilled orator; she knows how to manipulate each of her interlocutors in order to get what she wants, from the chorus (to whom she smoothly suggests that she's a helpless girl, just like them) to the Corinthian king Creon, whom she successfully manipulates by appealing to his male vanity. Indeed, we're told from the play's prologue right on through the rest of the drama that what possesses Medea's mind is not simply that her husband has left her for a younger woman, but that Jason has broken the oath (an iron-clad prenup if ever there was one) that he once made to her. Oaths are crucial throughout the play: its central scene has her administering one to Aegeus, the Athenian king, who happens to be passing through Corinth on this terrible day, and who is made to swear to Medea that he will offer her sanctuary at Athens, should she ever go there. (Among other things, this oath furnishes her with her escape plan: rather than being an emotional wreck, Medea is always calculating, always thinking ahead.)

For the Greeks, all this had deep political implications. One of the reasons everyday Athenians were suspicious of the Sophists, those deconstructionists of the Greek world (with whom Socrates was mistakenly lumped in the common man's mind, not least because Aristophanes, in another satirical play, put him there), was that the rhetorical skills they were thought to teach could confound meaning itself—could "make the worse argument seem the better," and vice versa. In Jason, Euripides created a character who is a parody of sophistry: he's glibness metastasized, rhetorical expertise gone amok. When he enters and tells Medea that he's only marrying this young princess for Medea's own sake, that he's doing it all for her and the kids, it's not because he thinks it's true: it's because he thinks he can get away with saying it's true. Language, words—it's all a game to him. Look, Euripides seems to be saying to his audience, men for whom the ability to make a persuasive speech could be, sometimes literally, a matter of life or death: look what moral corruption your rhetorical skills can lead to. Medea, of course—obsessed from the beginning of the play with oaths, the speech act whose purpose it is to fuse word and deed—is outraged by her husband's glibness, and spends her one remaining day in Corinth seeking ways to make him see the value of that which he so glibly uses merely as argumentative window dressing: his marriage, his children. That is why she kills the children. (The typically Euripidean irony—one that would likely have unnerved the Athenians—is that this spirited defense of language is mounted by a woman, and a foreigner: a sign, perhaps, of the sorry state public discourse was in.)

A *Medea* that was all about the moral disintegration that follows from linguistic collapse probably wouldn't sell a great many tickets in an age that revels in seeing characters "deal with" being failures, but it's the play that Euripides wrote. Because Deborah Warner thinks that Medea is a disappointed housewife, and the play she inhabits is a drama of a marriage gone sour, all of the political resonances are lost. (When Shaw administers that crucial oath to Aegeus, she shrugs with embarrassment, as if she has no idea how this silly stuff is done, or what it's all supposed to be about.) At the Brooks Atkinson, her Jason, a very loud man called Jonathan Cake, has been instructed to play that crucial first exchange between Medea and Jason totally straight—as if he believes what he tells Medea. ("He believes his argument that if he marries Cre-

on's daughter they will get this thing called security," the director told *The Guardian*.) But if Jason is earnest—if he really believes what he's saying, which is that he's running off with a bimbo and abandoning his children and allowing them to be sent into exile because, hey, it's *good* for them!—then the scene, to say nothing of the play, crumbles to pieces. If you take away the mighty conflict over language, over meaning what you say, *Medea* is just a daytime drama about two nice people who have lost that special spark. But then what do you do with the rest of the play, with its violence and anguished choruses and harrowing narratives of gruesome deaths—and, most of all, with the climactic slaughter—all of which follow only from Medea's burning mission to put the meaning back in Jason's empty rhetoric, those disingenuous claims to care for his family, his children, even as he shows nothing but naked self-interest?

Not much, except to do what Warner (who insists the play is "not about revenge") does, which is to fill the play with desperate, crude, almost vaudevillian efforts to manufacture excitement, now that all the intellectual and political excitement—to say nothing of the revenge motive—have been stripped away. This Medea makes faces, mugs for the audience, cracks jokes, does impressions. And it goes without saying that, when the violence does come, there's a lot of blood and flashing lights and deafening synthesized crashing and clattering. But for all the histrionics and special effects, you feel the hollowness at the core, and the staging soon sinks back into the place where it started: banal, everyday domesticity, a failed marriage. The Warner/Shaw *Medea* ends with the murderous mother sitting in that swimming pool, smirking and splashing the weeping Jason.

Ironically, Deborah Warner seems to understand tragedy's original political intent. In a interview she gave to the *Times* last September, after the first anniversary of the September 11 attacks and as her country, and ours, prepared for war on Iraq, Warner made a case for the renewed relevance of Greek tragedy:

We desperately need Greek plays. We need them when democracies are wobbly. I am living in a very wobbly democracy right now, whose Parliament has only just been recalled, and Commons may or may not have a vote about whether we go to war.

Greece was a very new democratic nation, and a barbaric world was not very far behind them. They offered these plays as places of real debate. We can't really say the theater is a true place of debate anymore, but these plays remind us of what it could be.

She's absolutely right; all the more unfortunate, then, that none of this political awareness informs her production. The end of Warner's *Medea* feels very much like the aftermath of a marital disaster. Euripides' *Medea*, by contrast, ends with a monstrous ethical lesson: Jason is forced, as his wife had once been forced, to taste exile, loss of family; forced, like her, to live stranded with neither a past nor a future; is made to understand, at last, what it feels like to be the *other* person, to understand that the things to which his glib words referred are real, have value, can inflict pain. At the end of Euripides' *Medea*, the woman who teaches men these terrible lessons flies off in a divine chariot, taking her awful skills and murderous pedagogical methods to—Athens.

Indeed, while it's hard to see what Warner's "happy housewife of Corinth" can tell us about the war she referred to in her comments to the *Times*—i.e., Iraq—Euripides' *Medea*, by contrast, ends by literally bringing home a shattering warning against political and rhetorical complacency: a lesson that, as we know, went unheeded in Athens. It's worth noting that his *Medea* was composed during the year before the outbreak of the Peloponnesian War, when the Athenians were eagerly preparing for conflict—a conflict, as it turned out, that would thoroughly reacquaint the Athenians with the meaning of the word "consequences." Which is the play we need more desperately?

It's unlikely that *Medea*—Euripides' *Medea*, that is, not the play that Deborah Warner staged—will have trouble surviving the grotesque, giggling, wrongheaded treatment it received on Broadway. If so, it wouldn't be the first time that the playwright bounced back after some rough treatment. Soon after Aristophanes lampooned him (intentionally) in his *Thesmophoriazousae*, Euripides left town for good. His destination was about as far from Athens, culturally and ideologically, as you could get: the royal court of Pella, capital of the backwoods kingdom of Macedon, a country that would take another century to achieve world-

historical status. (It's where Alexander the Great was born.) He left, so the story goes, because he was disgusted by his city's descent into demagoguery, intellectual dishonesty, political disorder, and defeat. But perhaps he was also smarting because of *Thesmophoriazousae*; perhaps he was tired of being misunderstood.

And yet perhaps, too, there was time for one more effort; perhaps he might have the last laugh. Perhaps, from a burlesque, a deliberate misinterpretation, a pandering by a comedian to the common taste in order to achieve a glib success, something worthwhile might result. Let us imagine this aged poet as he leaves Athens and embarks on his difficult northward journey, turning an idea over in his mind—an idea that comes to him, as it happens, from *Thesmophoriazousae* itself. An all-female festival; a man eager to see what the women get up to, when the men aren't watching. A grotesque foray into drag that convinces no one; a masquerade that ends in apprehension, and terrible peril. Not a bad idea for a play—not a comedy, this time around, but something terrible, something that will bring his citizen audience close to the core of what great theater is about: plotting, disguise, recognition, revelation, violence, awful knowledge. He arrives in Macedon and gets to work. Three years later, the play is finished: *Bacchae*. By the time it is produced back home in Athens, winning its author one of his rare first prizes, Euripides is dead. But from the mockers, those who willfully mistake his meanings, he has stolen a victory. This show, it is safe to say, will go on.

—*The New York Review of Books*, February 13, 2003

For the Birds

During the harsh Balkan winter of 407–406 B.C., the Athenian play-wright Euripides died in his self-imposed exile in Macedonia. He was a bit shy of eighty, and had been presenting tragedies at the Theater of Dionysus in Athens for just under half a century. In view of the ways in which he had so daringly exploded tragic convention during that time—pushing the genre in the direction of romance, showing an ever-increasing preference for happy endings, introducing "low" and even quasi-comic elements (plebeian characters, outright parody)—it was perhaps only appropriate that the tidings of the tragedian's demise, when they were received back home in Athens, should have inspired both a moving tragic spectacle and a great comic invention.

The evidence for the tragic spectacle is to be found in one of the highly unreliable (but often just as highly delectable) ancient biographies, or *Vitae*, of the great poets—in this case the *Vita Euripidis*, or "Life of Euripides." Here we are told that just a few weeks after the news from Macedonia reached Athens, another famous poet—Sophocles, who at that point was nearing ninety and himself had only a few months to live—honored his longtime rival by donning a black cloak and having his chorus and actors appear without the traditional fes-

tive wreaths when they took part in the civic ceremony known as the *proagon*, the parade that preceded the annual dramatic competition. There is no reason to doubt that, as the *Vita* goes on to say, "the people wept" in response to this irresistible (and, you can't help suspecting, rather self-serving) bit of theater from the aged master. But it is hard to swallow the anecdote that immediately follows, which gives the cause of the great man's death. Euripides, the author of the *Vita* solemnly reports, died after being torn apart and devoured by a pack of wild dogs.

Two pieces of evidence are traditionally cited to refute this alarming story. The first is that the bizarre *modus moriendi* is suspiciously similar to one we find in one of Euripides' own plays—his last tragedy, *Bacchae*, which ends with the young Theban king Pentheus being torn to pieces by frenzied maenads. The second, which is of greater interest to us here, is laconically summarized in the Oxford Classical Dictionary as follows: "unlikely in view of Aristophanes' silence." Which is to say, if Euripides had perished in the headline-grabbing fashion described in the *Vita*, it would surely have been mentioned in what was, as it happens, the other noteworthy contemporary response to Euripides' death, the comic one: Aristophanes' *Frogs*.

Whatever form it actually took, the death of Euripides was unlikely to have gone unmarked by the popular comic playwright, who was then perhaps in his early forties. From the beginning of his career, Aristophanes had made Euripides the particular object of his parodic mirth. No other real-life figure—not even the poisonous demagogue Cleon, who took the irreverent Aristophanes to court for (an ancient commentator notes) "wronging the city" by mocking its politicians—turns up as often as a character in Aristophanes' plays. There he is, his comic persona already firmly in place, in *The Acharnians* of 425, just two years after Aristophanes' first comedy was staged: Euripides the misanthrope and misogynist, a faddish devotee of the intellectual avant-garde, a modernist who puts beggars and cripples onstage and outfits his kings in rags.

There he is again in *Women at the Thesmophoria* (411), a brilliant fantasy in which the women of Athens, fed up with being portrayed by Euripides as adulteresses, sex fiends, and murderesses, come together

under cover of the all-female Demetrian rite called the Thesmophoria to plot the kidnapping and murder of the playwright. And there he was yet again—or so we are told by an ancient commentator on the *Wasps*—in two comedies, now lost, suggestively entitled *Dramas* and *Proagon*. The association between the comedian and the tragedian was so familiar to Athenian audiences that another comic playwright, Aristophanes' older contemporary Cratinus, coined a verb to commemorate it: *euripidaristophanizein*, "to Euripidaristophanize."

Euripides would appear as a comic character one final and unforgettable time, in *Frogs*, which was produced at the Lenaea Festival, a civic and theatrical event at which comedy predominated, in the early spring of 405—just a few weeks, as it happened, before the first, posthumous performance of *Bacchae*, at the city Dionysia. The play is yet another ingenious fantasy involving the abduction of Euripides, although this time the kidnapping may be said to be more of a rescue mission than an ambush. The donnée of the comedy is that the theater god Dionysus, sorely missing his favorite playwright, decides to sneak down to Hades in order to restore the recently dead poet to the upper world. (In order to get there in one piece, the rather fey god of theater and wine goes disguised as the macho Herakles—a clever inversion of the drag scene from *Women at the Thesmophoria*, and a source of a good deal of comic business.) But as so often in Aristophanes, the burning private yearning of a single, rather monomaniacal character ends up involving the body politic itself. For when he finally reaches Hades, Dionysus finds himself embroiled in a "great fight among the corpses" (in Richmond Lattimore's felicitous translation): a "high argument," one that has been raging between the rather august Aeschylus, dead for fifty years, and the newcomer Euripides, about "which one really was better than the other."

It is only now that the mission of the god shifts: he agrees to judge the theatrical contest, and in so doing he assumes a public role that would have been familiar to Athenian audiences, for whom theater, like nearly everything else, was a competitive event. It is during this contest that the comedy's most memorable literary-critical claim emerges: that the dramatic poet's duty is, in fact, a public one—to "inject some virtue into the body politic." Given Aristophanes' generally old-line tastes, it's inevitable, once this claim is made, that it will be Aeschylus—here

presented as manly, patriotic, rather bombastic—and not the prickly, overintellectual, avant-gardiste, doubt-mongering Euripides whom Dionysus will bring back to Athens in order to set the grim, war-torn polity on a straight course once again. Clearly this choice struck a responsive chord: the Athenians liked the play so much that they not only awarded it a first prize, but—a rare distinction—granted it a second performance.

In view of the fact that most of his theatrical career overlapped with the drawn-out and ultimately disastrous Peloponnesian War, and, further, that there was no shortage of corrupt, inept, and harmful politicians to make fun of, the popular comedian's marked preoccupation with a poet of high tragedy may strike us, today, as odd. (It's as if Jon Stewart were to hold forth every week about Arthur Miller.) And yet the way in which the contest between the dead poets in *Frogs* enmeshes artistic concerns and political issues reminds us that for the Athenian theatergoer attending the play's first performance, theater (occurring only during the course of the annual state-sponsored patriotic festivals) and politics (played out, as often as not, by prominent "actors" on the public "stage," artfully trained to perform before audiences of citizens sitting in assemblies much as they sat in the theater) were far closer to one another than we can even begin to imagine today. Indeed, although there has been a great deal of scholarly comment during the past generation on the way in which Greek tragedy—which is to say, Athenian tragedy—was a vehicle for working out issues central to the ideology and identity of the democratic state, it was of course also the case that comedy, too, was deeply political.

Even if you don't go as far as some modern critics have in their attempts to set comedy on an equal footing with tragedy (claiming, for instance, that comic poets "were the constituent intellectuals of the *dêmos* [the citizen body] during the period of full popular sovereignty . . . and in their institutionalized competitions they influenced the formulation of its ideology and the public standing of individuals"), it is easy to see,

from the remains of Athenian comedy, that it was able to comment on the preoccupations of the city—corruption in political office, the excesses of the radical democracy, the effect of the war on families back home—with a kind of caustic gusto and explicitness that tragedy, sealed as it was in the world of mythic allegory, could not. Here a vignette from another of those ancient *Vitae*—this time the "Life" of Aristophanes himself—is deeply suggestive, however apocryphal it may be. We're told that when Plato's not very apt pupil, Dionysius, the tyrant of Syracuse, declared that he wanted to study the *politeia* of Athens (a word that can mean not only "constitution" but also "the life of the citizen," the whole democratic way of life), Plato replied by sending him a text of Aristophanes.

It was precisely because it so strongly reflected the concerns of the state and its citizens that comedy was so preoccupied with tragedy. We must remember that for the Greeks, tragedy wasn't "high" and comedy wasn't "low"—at least not as we think of these categories today; we must remember that for the Greeks, Greek tragedy was, like Greek comedy, a form of *mass* entertainment. All citizens of Athens were expected to attend the tragic festivals; the nominal two-obol fee was subsidized by the state in the case of indigent citizens. It is impossible to understand Greek comedy's relationship to Greek tragedy—to understand, in other words, Aristophanes' obsession with Euripides—without acknowledging the extent to which tragedy was a form of what we today would call "popular" entertainment. In an essay about *Frogs*, Sir Kenneth Dover emphasized that since tragedies

> were written for mass audiences, tragedy as a whole could be used as material for humour in the same way as agriculture and sex and war could be used; it was part of the life of the community, not like chamber music or Shakespeare—the cultural interest of a minority.

It seems worth recalling these considerations about Aristophanes, comedy, politics, and mass culture just now because politics has, in large part, been the selling point of the recent and much-ballyhooed Lincoln Center Theater production of *Frogs*, which opened in June and closed in October. Interest in the production was, of course, already great for a number of other reasons. It was presented, for instance, in

the musical adaptation by Burt Shevelove and Stephen Sondheim that premièred in 1974 in the Yale University swimming pool, one that updated the literary milieu, making the playwright antagonists Bernard Shaw and William Shakespeare—a weekend-long run that has acquired a certain glamour in hindsight because in the company were a number of Yale Drama School students who went on to fame and fortune: Meryl Streep, Sigourney Weaver, Christopher Durang. The new production, moreover, starred Nathan Lane, who had a career-making triumph a few years ago in a revival of another Shevelove-Sondheim "classical" musical, *A Funny Thing Happened on the Way to the Forum* (an adaptation of several plays by the Roman comedian Plautus), and whose enormous success in the Broadway run of *The Producers* has made him a powerful star. It was, in addition, directed and choreographed by Susan Stroman, whose work on *Contact* and *The Producers* has made her something of a celebrity in her own right; and it featured new songs by Sondheim, commissioned especially for this revival.

But if it was felt that the troika responsible for such previous successes could not help but score a hit with *Frogs*, it was also felt by the show's creators that because of the war in Iraq, Aristophanes' ostensibly antiwar text suddenly had far greater relevance than it had had in a long while. A front-page article in the *New York Times* Arts & Leisure section that appeared just before the play's opening noted that Lane, who was responsible for extensively revising Shevelove's revision of Aristophanes (the program describes the play as "a comedy written in 405 B.C. . . . by Aristophanes, freely adapted by Burt Shevelove, even more freely adapted by Nathan Lane"), was especially eager to bring out the political strains he saw embedded in the Greek original:

> Mr. Lane also talked with Ms. Stroman about the political resonance of the source material, which concerned a great democracy fighting an unwise war, leaders too puny to inspire a complacent populace, a longing to reclaim the greater voices of the past. Mr. Shevelove, following Aristophanes, for the most part had used the story to lament the terrible state of the theater; Mr. Lane wanted to focus on the terrible state of the state.
>
> Ms. Stroman found the idea moving; "Remember, this was not yet a year after Sept. 11," she said.

And yet despite fervent efforts to make the revival relevant—the show is filled with in-jokes about the contemporary theater, and the final tableau is set against a glittering evocation of the New York skyline, in case you were likely to miss the post–9/11 point—this *Frogs*, however eye-popping its packaging, failed most egregiously in its attempts to be meaningful about the two principal themes of Aristophanes' play: theater and politics. In an irony its creators cannot have intended, it showed, if anything, how little the theater today is "part of the life of the community," as Dover put it; and, worse, it showed how clueless about the politics of *Frogs* the makers of this particular revival are.

———

Like so many contemporary updatings of Greek dramas (whether tragic or comic), this one actually becomes less relevant as a result of its frantic attempts to introduce contemporary topical references. Here I'm not referring to the way in which Nathan Lane has gussied up both Aristophanes and Shevelove with jokes that neither would have dreamed of; if anything, contemporary productions of Aristophanes demand updatings of this kind, given how notoriously difficult Aristophanic humor is to get across to modern audiences. This is partly because of the extreme topicality of Aristophanes' references (Euripides is one of the few victims of Aristophanes' humor whom audiences today will have heard of), and even more because so much of the fun provided by Aristophanes lies in his hilarious manipulation of Greek. But to explain his wild, Grouchoesque verbal play is, of course, to kill the humor; and so Lane has, very sensibly if none too subtly, updated the jokes. There are gags about cell phones (in this version, Dionysus's slave sidekick, Xanthias, gets a call from Sondheim during the opening dialogue, during which he and his divine master stand before the curtain in dinner jackets, drinking martinis) and about "Viagra, the God of Perseverance," in-jokes about the theater and about smoking pot, and arch allusions to camp film classics like the Joan Crawford biopic *Mommie Dearest*. (Dionysus: "Why can't you give me the respect I deserve?" Xanthias: "Because I'm not one of your *fans!*") Hillary Clinton's *It Takes a Village*

makes an appearance, too—as does pretty much anything that looks as if it might work in a quasi-classical context. (Xanthias remarks en passant that his parents once had a business selling condoms to Trojans.) The friend with whom I attended the first of the two performances I saw was surprised to learn that some of the jokes that got the biggest laughs were, in fact, Aristophanes'. "What's the quickest way to get to Hades?," Dionysus asks at the outset of his journey. "Oh, a hemlock and tonic." Sans tonic, the joke is vintage 405 B.C.

The visual analog of these seemingly random, hit-or-miss riffs is the eye-poppingly spectacular and yet somehow vacuous staging that Stroman, along with her set designer, Giles Cadle, and her costumer designer, William Ivey Long, have lavished on this retooled *Frogs*. Given Ms. Stroman's résumé, it was inevitable, perhaps, that in this version the bouncy eponymous chorus (which in Aristophanes appears very briefly at the beginning and then disappears for the rest of the play) should here take over the stage whenever possible, yo-yo-ing from bungee cords in their tropical-amphibian leotards, writhing across the floorboards, leapfrogging gleefully across each other. But it's a measure of how extravagantly Stroman has staged her *Frogs* that the frogs (divided, according to my program, into two types: "Fire Belly Bouncing Frogs" and "A Splash of Frogs") are the least glitzy ingredient here. Other numbers include an elaborate scene for Hellenically attired men and maidens posing like the figures on Attic vases, a whole host of tweed-clad Shavians with pencils and pads strutting hurriedly up and down as they fawn on their idol, and a fabulous chorus line of "Hellraisers"—statuesque acolytes of Pluto whose brazen helmets erupt in flame at the end of their big number, like giant cigarette lighters.

Part of the reason these numbers feel so bloated is that the music to which they're pinned is so weak; this score does not represent Mr. Sondheim at his best. Much has been made of the fact that Sondheim agreed to write six new songs for this revival—he claimed never to have been happy with his 1974 score, which consisted of a handful of numbers—but apart from a couple of songs that show the kind of allusive wit and prosodic cleverness you expect from this composer (there's a funny one called "Dress Big" for the scene in which puny Dionysus dresses up as his half brother, Herakles), the pickings are disappointingly slim. To my mind, this is especially true of the "sentimental" song that Lane, as

Dionysus, gets to sing in Act One about his dead wife, Ariadne, a song that suggests much that is wrong here. Apart from being disappointingly pedestrian ("So I gave her a crown / on the day we were wed / if you look like a goddess / you'll feel like a goddess, I said . . ."), the song is an inorganically sentimental intrusion that slows down the show to no apparent point. Or, rather, a point that is only too apparent, which is the modern actor-writer's inevitable sense that Dionysus should be a real, live, sympathetic, warm-blooded "character." This is the kind of thing that contemporary audiences warm to, as the author of the *Times* article suggests:

> But the biggest and most surprising change is what Mr. Lane made of Dionysos: in a feat of reverse apotheosis, he turned a witty but mostly disengaged demigod into a human being. Mr. Lane imbued the character, formerly little more than a vehicle for jokes, with a strain of melancholy and longing, and a powerful wish to change the world through art.

But of course, the original Dionysus is in fact "engaged"; he just happens to be engaged not with feelings but with something less adorably ingratiating, which is the theater and its politics.

The real problem here is neither the gags nor the chorus lines: the loose structure of Aristophanic "Old Comedy" (as opposed to situation-driven "New Comedy" of the next century, the ancestor of today's sitcoms) allows for digressions from the tenuous plot in order to take potshots at any and all available targets; part of the dithery fun of Old Comedy is its zany combination of physical gags and vaudevillian randomness, which at times recalls the Marx Brothers. The problem with the Stroman-Lane *Frogs*, rather, is that none of the gags, much less any of the production numbers, adds up to the kind of political critique Lane was clearly hoping for. Lane's desire to have his political satire's main character be human and sympathetic suggests, if anything, the first and most obvious reason for this revival's larger failure: caustic Aristophanic comedy is simply the wrong vehicle for this particular star. Some critics com-

plained that this *Frogs* was too overtly political, but what was striking
about Lane's adaptation was, if anything, how wan the political humor
was—how coy, how lacking in bite. There were, it's true, some political
jokes about complacent "frogs," who here stand in for the kind of people
whose "narrow little eyes . . . match their narrow little points of view";
and there are a couple of jabs at certain politicians—"Words seem to fail
them—even the simplest words!"—who "rushed into this war for rea-
sons that are changing every day." But when you heard these, you kept
wondering why Lane couldn't bring himself to do what Aristophanes
loved to do, something that made the political humor personal, which
was to name names. Why, you kept wondering, couldn't he say "Re-
publicans" or "Bush"? Lane, an insecure actor whose palpable craving
for audience affection invariably leads him to play comic grotesques as
adorable mischief-makers—as witness both *The Producers* and *A Funny
Thing*, both originally vehicles for Zero Mostel—shouldn't do political
comedy, because he's afraid to alienate even his targets.

Lane's inability to engage incisively the material he's taken on is
most apparent in his handling—or lack thereof—of the play's most
structurally crucial and thematically important element. I refer here to
his decision not to meddle with the first of the various updatings which
Aristophanes' comedy underwent in its transformation into the show
now playing at Lincoln Center: Burt Shevelove's transformation of the
climactic debate between Aeschylus and Euripides in Aristophanes into
a contest between William Shakespeare and George Bernard Shaw.
Shevelove first had the idea of thus adapting the Greek comedy in 1941,
when the young playwright was, apparently, more concerned with the
fate of the theater than the fate of the polity. It's only in that context that
you can begin to fathom his choice of his contestants: Shaw represent-
ing "prose," a rubric apparently meant to include incisive intellect and
caustic wit ("gravity of thought . . . levity of expression"); Shakespeare
representing "poetry," under which, rather awkwardly it must be said,
are subsumed qualities including beautiful artistry, emotionality, and
overwhelming sentiment.

The conflict, for Shevelove at that time, seemed to be this: Did
people want socially edifying, but perhaps the tiniest bit boring, straight
drama, or did they want something to catch their emotions—poetry,

even music? Set against Shevelove's culminating characterization of the difference between Shaw and Shakespeare as that between "intellectual interest" and "romantic rhapsody," the fact that Shakespeare cinches his victory not by reciting verse but by singing (a song from *Cymbeline*) supports, if anything, a reading of his *Frogs* as essentially a sly comment about the theater—more specifically, about competitions between straight plays and musicals. "The theater needs a poet," Dionysus declares at the end of Shevelove's text. "A great big poet. A star of poets. That's what audiences are waiting for. Someone to lift them out of their seats, to get them going."

Leaving aside the merits of Shevelove's rather strained (indeed, false) reductions of the two playwrights, there are other reasons why Shakespeare and Shaw might have made a kind of sense in 1941. It was a time, after all, when public school graduates still had read one or two plays by Shakespeare, and Shaw the controversialist was still alive, an august yet ornery figure, a presence. (In settling on Shaw as the modern counterpart to Euripides, Shevelove might also have had in mind the famous connection between the Irishman and his fellow Fabian Gilbert Murray, the Regius Professor of Greek at Oxford, whose reading of his translation of Euripides' *Bacchae* to the Fabian Society in 1901 made a huge impression on Shaw, who went on to model *Major Barbara*'s Adolphus Cusins on the classicist.) But what must have seemed a fresh adaptation sixty (and even thirty) years ago strikes you now as sadly dated. It would indeed be hard to think of a playwright less performed, and less thought of by mainstream audiences today, than Shaw is. Lane and Stroman cannot have failed to realize that long citations from *Saint Joan* are likely to fall today on ears innocent of any Shaw at all—and, one suspects, nearly as innocent of the St. Crispin's Day speech from *Henry V*, which is also cited in Shevelove's *Frogs*. And yet, bizarrely, the creative duo behind the most recent *Frogs* haven't touched the Shaw–Shakespeare debate—haven't bothered to update Shevelove's updating.

In light of their professed desire to render the play more relevant, this unwillingness to freshen the Aeschylus–Euripides conflict once more, substituting playwrights who occupy a more vivid place in the imaginations of today's audiences, is curious. For one thing, it has the

unintentional effect of making the theater itself seem irrelevant: one awful irony of the decision to leave Shevelove's now-stale choices in place is that it makes the climactic contest of this *Frogs* into precisely what it wasn't in Aristophanes' *Frogs*, or even in Shevelove's: the property of the "cultural minority." To the Athenians, Euripides was a *modern*, and Aeschylus, however august, still someone worth arguing about; by allowing the aesthetic debate to become a spat between two (now) wholly canonical writers, Lane has emptied it of any urgency it might have had.

The specifically political implications of Lane's unwillingness (or inability) to find contemporary analogues for Aeschylus and Euripides (or even Shakespeare and Shaw) are more dire. It's no accident that most of the new political jokes, such as they are, occur in the first part of the play—the part before the onstage debate between the playwrights. You suspect that Lane figured that "politicizing" *Frogs* meant adding the veiled jabs at Hillary and Dubya and leaving things at that—that the debate about theater in both Aristophanes' and Shevelove's versions, in other words, had nothing to do with politics. This, however, results in an awkward and ultimately disastrous structure that fails to graft Lane's politicizing version onto Shevelove's "aesthetic" version. All those lavishly sprinkled contemporary references in the first half of the play, when Dionysus and Xanthias are trying to get to Hades, suddenly peter out, and the laughter suddenly dwindles during the much-anticipated climactic contest, with its long stretches of literary references, and quotes from Shakespeare and Shaw, and the talk about art that Lane has attempted to tweak in a vaguely political way—but only very superficially. Shevelove's version, for instance, comes to a climax when Dionysus abandons his favorite, Shaw, upon realizing that what he needs is a "great big poet" to get people to jump out of their seats. Lane has satisfied himself with altering this line to give it an ostensibly political twist: "I now realize," his Dionysus says, "a poet is what we need—to touch people's hearts as well as their minds."

The lazy invocation of tired clichés of political speeches at this point suggests, if anything, that Lane's unwillingness or inability to grapple

438 HOW BEAUTIFUL IT IS AND HOW EASILY IT CAN BE BROKEN

with the meanings of his source material has resulted in a play that is, if anything, "political" in a way he surely didn't intend. I had to wonder, as I sat through the grinding last hour of Nathan Lane's *Frogs*, just how seriously the adapter was thinking about the issues he professes to be interested in—politics, war, the conduct of the democratic state—when he decided to seal the play's climactic debate with a call for more "heart" in politics: a call that all too faithfully reproduces the ideology of Aristophanes' original, as it turns out. It's obvious that Nathan Lane did some research about Aristophanes and Greek theater—after all, he's added some explanatory material to the opening, for instance the information that "everything that was of interest to the average Athenian was fodder for the author's savage wit"—but his research cannot, in the end, have been thorough. For if he'd really done his homework, he'd have understood that the antiwar position of the average Athenian in 405 was hardly concentric with the antiwar views of the well-intentioned liberal audiences cheering Lane's *Frogs* on at Lincoln Center. He would have learned, indeed, that in Athens, it was the conservatives who were the peaceniks, and that it was the extreme democrats, under the sway of one demagogue after another, who were the hawks, who again and again disdained peace offers during the thirty bitter years of the Peloponnesian War. Mr. Lane had learned enough that he could add, to his introductory patter, the information that Aristophanes' *Frogs* enjoyed a rare repeat performance, but he doesn't seem to be aware that the likely reason it was so popular among "average Athenians" was that there was, sandwiched into the play, a direct appeal to the audience in which the playwright called for an amnesty for those many citizens who had participated in an antidemocratic coup d'état a few years earlier.

For the real reason that *Frogs* cannot, in any version, succeed as the liberal antiwar play that Lane and his cocreators want it to be is that it is a deeply conservative play, by a deeply conservative author: the conservatism is so intricately woven into the structure of the action, indeed—particularly in that final debate—that there's no way it could work in the way the Lincoln Center production wants it to work. The debate, of course, is the part Lane didn't even bother to freshen up, because although he was hell-bent on politicizing this old comedy, it never occurred to him that its politics lay in the debate about literature more than anywhere else. As Professor Dover observed, the "average

Athenian" would have immediately understood the conflict between Aeschylus and Euripides as a coded debate between two incompatible worldviews:

> Aiskhylos was the poet of the generation which fought off the Persians and created the Athenian empire, Euripides the poet of their own more precarious days. This makes it possible for Aristophanes to assimilate the context between Aiskhylos and Euripides to the familiar antithesis between the valour, virtue and security of the past, sustained by what seemed from a distance to be unanimity in the maintenance of traditional usage and belief, and the insecurity of the present, beset by doubt, 'unhealthy' curiosity and 'irresponsible' artistic innovations.

Frogs, then, is a play that—because of the triumph of Aeschylus which is a deep part of its plot (and a deep part of Shevelove's adaptation, too)—inevitably exalts nostalgia over hardheaded confrontations with the present; that prefers to moon about past triumphs than to expose the causes of present anxieties; that, if anything, endorses the artist who will distract the people from solving their problems rather than force them to do so. If Lane and his collaborators in this superficially rewritten, superficially repoliticized adaptation of that play had thought hard about what it actually meant, they might have chosen another vehicle altogether for their rather woolly attempt to condemn the current political crisis. (*Trojan Women*, say—but then, you doubt that even Lane would have a go at Hecuba.) They might, at least, have rethought their approval of Aristophanes' "savage wit" and the way it punctuates the climactic exchanges between the two playwrights: for instance, when Aeschylus smugly boasts that drama ought to provide clean moral models for exemplary civic behavior, and "set . . . a standard of purity," and Euripides desperately counters that tragedy must be subversive, that it should show "what really has happened" in order that audiences "come away from seeing a play / in a questioning mood, with 'where are we at?,' / and 'who's got my this?,' and 'who took my that?'"

You'd have thought that such exchanges about purity and subversiveness in art would have rung some political bells in Mr. Lane's head;

but he merely blithely conforms to his model. What he doesn't seem to have realized—and what, in the end, makes his play such a mess—is that in siding himself with "Aeschylus" at the end of his own play (with "heart") he has sided with the people whom, you suspect, he's voted against—the purity-in-art people, the family values people, the people who always go on about (and promise) the security of the golden past while vociferously despising subversive innovation (and nowhere more, as we know, than in the arts).

It is indeed odd that he should have ended up producing a play that everywhere values distracting pomp and sentimentality over rigorous intellectual engagement, a play that ends, however naively, with a call for more sentiment about the past and less braininess about the present—with, you might even say, an implicit endorsement of Romantic over Enlightenment ideals and values. Such a play (like its ancient model) could be said to serve the political aims of those real-life politicians who keep calling on us to be satisfied with the safe, grandiose nostrums of the past, rather than trying to see for ourselves what has really happened, and where we are at, and who got our this, and who took our that. In the end, Mr. Lane's failure to understand his own source material made his adaptation of *Frogs* not very funny at all; if you think deeply about politics and theater, it's actually pretty depressing.

This unhappy consideration put me in mind of another text having to do with the lives of the ancient poets. The *Vita* of Aristophanes himself is largely a drab list of publications; far more interesting are the comedian's cameo appearances in certain other works of the period. One is Plato's *Apology*, in which Socrates, on trial for his life, blames the average Athenian's bad opinion of him on Aristophanes' *Clouds*—a vicious lampoon of Socrates and of intellectuals in general. Another is Plato's *Symposium*, which purports to record a conversation that took place at a drinking party held in 416 B.C. to celebrate the tragic victory of another of Aristophanes' victims—Agathon, whose effeminacy was so savagely mocked in *Women at the Thesmophoria*. The conversation in this dialogue is ostensibly about love, but like so many Athenian texts, it's really about a lot of things at once. Theater—inevitably, under the circumstances—is one of the things that come up.

The dialogue ends with all the revelers passed out except for Socrates, Aristophanes, and Agathon—the philosopher, the comedian, the tragedian. The first of the three, Plato tells us, "was trying to prove to them that authors should be able to write both comedy and tragedy." You have to wonder whether Plato, given the terrible hindsight he had—the dialogue was written long after Socrates' execution, a fate his "apology" failed to prevent—had Aristophanes in mind, the comedian whose savage wit did so much damage. In the dialogue, you never find out, since just as Socrates was "about to clinch his point," his interlocutors—unwilling, no doubt, to contemplate this intrusion into their respective turfs—lost interest and drifted off. He undoubtedly thought he was offering a comic solution to the world's woes; and yet everything about the way he has approached his play—not least, the total failure to comprehend what history tells us, and the rather hopeful substitution of woolly sentimentality for the hardheaded critique—is, if anything, characteristic of the tragic problem.

—*The New York Review of Books*, December 2, 2004

September 11 at the Movies

At a quarter to nine on the morning of September 11, 2001, I was driving down the West Side Highway in Manhattan in a car filled with scholarly texts about Greek tragedy. It was a Tuesday, and the first session of the seminar I used to teach each fall at Princeton, "Self and Society in Classical Greek Drama," was scheduled to meet on Thursday. Because I'd recently been given a big new office, I had decided to move all of my classics texts from my apartment in New York down to Princeton; which is why, at around eight that morning, I could be found in front of my building on the Upper West Side, loading boxes of books with titles like *Tragedy and Enlightenment* and *The Greeks and the Irrational* into a friend's car. After I'd finished, I got in the car and headed south toward lower Manhattan, where the friend who was going to accompany me to New Jersey lived.

My friend and I had agreed to meet at her place at nine, but traffic on the highway was surprisingly light and I reached her neighborhood early. I picked up my cell phone—the display on its exterior said 8:45—to warn her that I was going to arrive momentarily. "Don't be mad," I said, "but I made good time." I flipped the phone shut, looked up, and a dark flash of something darted into the building that loomed directly before

me, which was the north tower of the World Trade Center. A gigantic ball of bright orange fire ballooned out of the tower, followed by vast plumes of dense, black smoke.

Today, when I tell people this story, I say it was like Vesuvius; there was, indeed, something volcanic about the quality of fire and smoke pouring out of the huge black gash in the building's side, which directly faced those of us who were looking at it from the north. But at the time, the first, irrational thought that came into my staggered mind was that someone was making a blockbuster disaster movie. What I thought, in fact, was this: In this day and age, with its sophisticated digital special effects, why would anyone use real planes?

After a stupefied moment, in which the realness of the accident (as I then thought it must be) became apparent, I swerved my car onto a side street, where already clusters of people had stopped to stare and cry out in awed horror. Shaking, I reached for my cell phone and hit redial. "What's up?" Renée asked. "Turn on the TV, turn on the TV," I said, a little hysterically. "The World Trade Center blew up." But of course there was nothing to see on the TV yet. The amazing thing had just taken place; there was no coverage yet, no media, no commentary, no evaluation, no interpretation. It was just the raw event. What had just happened had not yet become the story of what happened.

By coincidence, the way in which what happens becomes the story of what happens—another way of putting this is to say, the way in which history becomes drama—had been much on my mind earlier that morning, because the play I was going to be teaching on Thursday that week was a work I typically teach when introducing students to the subject of Greek tragedy, Aeschylus's *Persians*. First produced in the spring of 472 B.C., *Persians* is noteworthy in the corpus of the thirty-two extant Greek tragedies in that it is the only one that dramatizes an actual historical event. That event was the improbable and glorious defeat, by a relatively tiny force of Greek citizen-soldiers, of the immense expeditionary force sent by the Persian monarch Xerxes to conquer Greece: the first global geopolitical conflict between East and West that the world would see.

This remarkable event had taken place a scant eight years before

Aeschylus's drama was staged, and it is tempting to wonder just what the Athenian audience was expecting, that spring day, as they walked in the predawn light to the Theater of Dionysus. The treatment of historical material on the tragic stage had, after all, brought disaster to playwrights in the past. In 494 B.C.—in an incident that marked the beginning of the conflict between Europe and Asia whose ending, triumphant for the West, is celebrated in *Persians*—the culturally Greek city of Miletus, on the Asia Minor coast, was brutally occupied by the Persian emperor Darius. Two years later this disaster, awful for the Greeks, was dramatized on the tragic stage in a play called *The Capture of Miletus*, by a playwright called Phrynichus. It quickly became evident that it was still too soon to turn history into drama, as Herodotus's account of that ill-starred production suggests:

> The Athenians made clear their deep grief for the taking of Miletus in many ways, but especially in this: when Phrynichus wrote a play entitled "The Capture of Miletus" and produced it, the whole theater fell to weeping; they fined Phrynichus a thousand drachmas for bringing to mind a calamity that affected them so personally, and forbade the performance of that play forever.

We know next to nothing about Phrynichus's play—the ban on the work was, alas, all too effective—but the historian's description is suggestive. It would appear that Athenians were responding so strongly not so much to the drama itself (to the story of what happened) as to the memories of the real event (which is to say, to what happened). Their reaction, in other words, was not an *aesthetic* response. The emotions produced by the event itself—sorrow over the death and enslavement of fellow Greeks—seem, in this case, to have taken the place of the emotions—the catharsis that seeks to cleanse the mind, let's say—which drama seeks to elicit. You wonder, indeed, whether the Athenians' ban on *The Capture of Miletus* was necessary: the feelings aroused by Phrynichus's work were tied so specifically to the incident it depicted that, twenty years later, no one would likely have been moved by it all that much.

Twenty years later, Aeschylus was in the happier position of dra-

matizing a historical event that had turned out triumphantly for the Greeks. It's hard not to think that at least some Athenians, that long-ago day, gloated a bit as they watched *Persians*. Set in the imperial capital of Susa, the drama focuses on the grief of the Persian court as it awaits the return of its defeated emperor, Xerxes, following the Greek victory at Salamis. It must be said that to the eyes of anyone who didn't have the personal pleasure of defeating Xerxes' overweening invasion, the play's pageant of humiliation often feels rather too much like—well, like a pageant, to be what we think of as great drama. The play consists of a series of fairly static tableaux in which, one after another, anxious courtiers and royals—among them, Xerxes' mother and the ghost of his father, Darius (who, we are meant to understand, was a less foolhardy, sager autocrat)—express their fears about the fate of the Persian army. These tableaux culminate in the appearance of the ill-starred emperor himself, dust-covered, despairing, defeated. (Still, we're told that the fact that he's led his nation to ignominy will not affect him personally; he is, after all, the king.)

Before September 11, I liked to put *Persians* first on the syllabus of my tragedy seminar because this somewhat clanking play, with its stodgily predictable lessons about a bloated empire unexpectedly humbled by a tiny but fervent foe, seemed the best-available vehicle to show students that not all tragedies were structurally perfect; that not all tragedies were great, or—in the way we expect the greatest works of art to be—relevant.

———

Five years after that morning in 2001, I am once again put in mind of Aeschylus and Phrynichus, now that the first major Hollywood entertainments about the events of September 11 have appeared in theaters: Paul Greengrass's *United 93*, whose subject is the hijacking of the flight in which the passengers rebelled against their al-Qaeda tormentors (with the result that the plane crashed in a field in rural Pennsylvania and not, as is thought to have been the terrorists' plan, into the Capitol);

and the rather more conventional *World Trade Center*, directed by Oliver Stone, which treats the stories of two Port Authority police officers who were trapped in the rubble that day and eventually rescued. Both films, in different ways, raise interesting questions about the complicated relationship between history and art, fiction and—an increasingly vexed word, these days—"reality."

Reality, after all, was an obsessive concern of the makers of both movies. Both works are characterized by a severe sobriety of tone, as if to acknowledge that these are no mere entertainments; we are told that the families of victims (and, in the case of *World Trade Center*, the survivors themselves) were constantly consulted during the making of both films. Indeed, in the case of *United 93*, there is no apparent "dramatization" at all: as far as the audience knows, the film, which often has the flatly passive, affectless feel of home movies, simply, and with apparent scrupulousness, reproduces what we know of the sequence of events that day. Apart from a brief prologue sequence showing the hijackers apparently preparing themselves for the attack by praying in their motel room (that they said their prayers is, you suppose, a reasonable enough inference), most of the action takes place first in the airport—the humdrum, bored preparations for boarding and departure are nicely captured—and then in the airliner itself, before and during the violence.

The representation of the hijacking and of what we know to have followed—the murder of the pilots, the frantic, furtive cell phone calls by passengers to loved ones, the decision to fight back, the brief, horrific struggle for control of the plane ending in its plummeting into the field near Shanksville, Pennsylvania—occur in "real" time. (After the crash, as if in homage to the fact that real people perished in the calamity being portrayed, the screen simply goes black, as if to say that there can be no dramatic "ending" here, no authorial editorializing.) In that real time, there is some degree of cross-cutting between what's taking place in the air and the confusion on the ground, particularly in the air traffic control centers, where a horrified realization of the nature of the day's events gradually dawns—and where a frustrating inability to get the United States government to react intelligently is soon felt.

As if to underscore this almost documentary approach, the director chose to have members of the air crews depicted in the film played

by real pilots and stewardesses; and certain other characters, including some of the air traffic controllers and air traffic control officials who were on duty that day, played themselves. Much was made of this remarkable gesture in the admiring press at the time. Furthermore, the director avoided using well-known actors; the faces you see on screen could be anyone's faces. The kinds of faces you see, without really seeing them, in airports.

Overall, this approach to the material was thought to be an appropriate one. "As far as possible, the movie plays it straight," the enthusiastic critic in *The New Yorker* wrote. "As far as possible" covers some noteworthy exceptions, naturally; there was not, presumably, a throbbing sound track playing before and during the real-life hijacking, as there is in the film.

The presence of a good deal of material that is not, strictly speaking, "authentic"—that sound track, marking moments of high drama; the inevitable approximation of what was said, what people did, things that can never, really, be known—raises the question of just what kind of film this is, and what it thinks it's doing. Audiences and critics were so swept up in the ostensibly reverent gesture of using "real" people in the cinematic re-creation of the events of that day, for instance, that nobody bothered to wonder what purpose, precisely, using those people in a film was meant to serve. Apart from the relatively few people who knew them, no one watching the movie could possibly know or care what, say, this or that air traffic controller looked like or sounded like; artistically or dramatically speaking, there is no difference whatever if the person saying "There's nothing on the screen" in the movie is the person who actually said it, or a well-trained actor doing a reliable imitation of a functionary in a technical job. (Except that the actor will probably seem less stiff and unrealistic.)

Using the real-life people in the movie is a showy but ultimately hollow gesture; it advertises a certain kind of solemnity, even piety, about "authenticity" that has great currency in an era in which, in so many popular entertainments, a great premium is placed on getting as close as possible to "reality"—although in such entertainments the reality, of course, is an artfully constructed one. (An apparently growing

confusion in mass culture about the differences among reality, truth, "truthiness," and fiction has, as we know, had effects beyond the world of entertainment. The evidence is now overwhelming that an artful admixing of reality and invention, never acknowledged as such, characterized the government's attempt to "sell" its response to the events of September 11.) There can, therefore, be no useful aesthetic value in the decision to use real people, only a symbolic and perhaps sentimental one: by emphasizing such authenticity and realism, the film reassures its audience—which may well be anxious about its own motives for paying to see a film about real-life violence and horror—that what they're seeing is not, in fact, "drama" (and therefore presumably mere "entertainment"), but "real life," and hence in some way edifying.

The problem with all this realness is that the film itself—like reality—has no structure: and without structure, without shaping, the events can have no large meaning. When *United 93* first came out, I was struck by one enthusiastic critic's glowing comment, in a London *Observer* review entitled "Brilliant, Brutal and Utterly Real," that Greengrass's movie was "gripping from first to last, partly because, like a Greek tragedy, we are only too aware of where everything is heading. . . ." But what makes Greek tragedy significant as art is precisely the way in which the foreordained trajectory of the events that take place onstage is made to seem part of a larger moral scheme; when (for instance) we see the horrible spectacle of the humbled king at the end of *Persians*, we know why he has been humbled (his greedy overreaching) and who has humbled him (the gods, the moral order that obtains in the cosmos).

What can *United 93* tell us about the moral order, the cosmos? We know, of course, that the hijackers perpetrated a great horror on innocent people, and that many of those people displayed remarkable and moving bravery in the face of circumstances that must remain largely unimaginable to the rest of us. (Well, many of those American people: we're treated to a scene in which one of the passengers, who has a Central European accent of some kind, urges the others to cooperate with the hijackers.) But merely to passively show people being villainous or brave is not the same as structuring a text in a way that makes sense of their villainy or bravery—that makes the villainy and bravery be about something. If *United 93* brings to mind any genre, it's not Greek tragedy, with its artfully wrought moral conundrums, but something

much tinier: the innumerable made-for-television programs available on cable TV that are dedicated to reenactments of real-life crimes, complete with phony "realism." (The stylistic hallmark of these shows is the same jittery handheld camerawork that Greengrass uses to represent the violence in the cabin of Flight 93.)

This isn't to say that the emotions evoked by *United 93* aren't strong. But your feelings of horror while watching the hand-to-hand violence in *United 93* don't derive from the way in which the action has been treated by the writer and the director, but rather from the prior historical knowledge you already bring to the occasion—it's only awful to watch because you know something like it happened to real people. If *United 93* were a fictional TV movie of the week, you might watch it with friends, and then go out for pizza without thinking about it ever again, except perhaps to wonder why there was no real ending, or why you never really knew anything about the characters (and hence wondered why they act the way they do). As I left the theater after seeing it, it occurred to me that what I was feeling—the sorrow for the real people of whom the show's characters reminded me—was probably very much like what the audience felt as they left the first, and only, performance of *The Capture of Miletus.*

———

Oliver Stone's *World Trade Center* has a similarly hobbled feel. As with *United 93*, you sense, as you're watching it, that the film is wearing blinders; that it isn't looking, or can't look, at what we all know now to have been a very big picture.

This isn't the kind of movie you expect from Stone, who has a penchant for the epic, even the operatic, and who, in films like *Born on the Fourth of July* and *JFK* and *Nixon*, has enjoyed riling audiences with interpretations of recent political history that smack of a certain paranoia of the kind often associated with liberal cranks. (*JFK* strongly hints that Lyndon Johnson was in on the plot to kill Kennedy, along with a band of rich, cross-dressing gay men in New Orleans.) Accordingly, before the movie's release, there was a general expectation that *World Trade Center*

would be a grand treatment of that epic day. These expectations were not in any way disappointed by the preview that ran in theaters across the country in the weeks leading up to the film's release (a respectful one month's distance from the fifth anniversary of September 11). In that preview, images floated across the screen with ominous, almost mythic grace—montages of ordinary people beginning their workdays, the shadow of a plane flying bizarrely low overhead, millions of sheets of paper fluttering to the ground—suggesting the great and terrible arc of events that morning. The first time I saw the preview, I burst into tears, because it brought it all back. I was afraid to see the movie when it came out.

But what you saw, finally, was something very small—something that was, once again, more like television than like cinema. *World Trade Center* is, indeed, a misleading title: after an opening sequence that does, very beautifully, bring back the sense of ordinary life, spread across classes and boroughs, that was soon to be brutalized (and for that reason seduces you into thinking it's going to be about many people on that day of many deaths) the movie shrinks into the kind of narrative you associate with prime-time TV. Once again, it's as if the aura of sanctification around the event—"you cannot cheapen this material with drama"—seems to have cowed people. The only story that *World Trade Center* dares to tell is the tale of two Port Authority policemen who were trapped in the rubble of a collapsing building and who, after keeping themselves and each other alive by trading stories through a hellish day and night, are rescued by courageous Marines and firefighters.

This true story is without question a moving one, and the representation of the anxiety of the officers' families, driven to distraction by conflicting reports about the two men's probable fates, makes for effective drama. But after that big opening sequence, the sudden and disorienting shift in focus feels odd; the movie very quickly acquires the predictable feel of an episode of *ER*. Only during a brief and extraneous-feeling sequence toward the end (about David Karnes, a square-jawed Marine vet living in Connecticut who, on watching the news that day, dons his uniform and heads to ground zero, where he will be the one to find the two trapped policemen) does the focus open out at all to suggest the larger world. "We're gonna need some good men out there to avenge this," he says, ramrod-straight in his carefully pressed Marine

fatigues, as he surveys the wreckage. It's the only time you're reminded that what happened that day was part of a series of globally significant events, and would lead to many more.

To my mind, that scene—with its gung-ho rhetoric straight out of a Marine Corps advertisement—gives the lie to Stone's repeated protestations that, as he put it in a interview for a piece in *The New York Times*, "This is not a political film. The mantra is 'This is not a political film.'" It—and, in its way, *United 93*—is a political film; it's merely that the politics of these works lurk under a sentimentality so overpowering that it seems perverse, even hardhearted, to take issue with them. It's surely not accidental that the first two major pieces of popular entertainment to appear that have taken the events of September 11 as their subject have chosen to concentrate exclusively on events that are, strictly speaking, highly unrepresentative of what happened that day: the heroic and nearly successful passenger revolt (because only those passengers understood the real nature of the crime that was under way), the successful rescue of two cops. A title card at the end of Stone's film declares that a total of twenty people were pulled from the rubble; but as we know, thousands more perished.

There's no question that that day was also a story of heroism and bravery; but the fact that people were forced to be so heroic was the result of a vast and complicated network of political, social, and historical forces which, five years later, it is irresponsible not to want to acknowledge. The pretty much exclusive emphasis thus far on the "good"—the heroism and the bravery of ordinary Americans—in these entertainments is noteworthy, because it reminds you of the unwillingness to grapple with and acknowledge the larger issues, the larger causes and effects that culminated in what happened on September 11, which has characterized much of the national response to this pivotal trauma. That both films, like so much we have seen on various screens over the past five years, clothe their fictions and their editorializing in the pious garment of reverence for authentic reality—a pose that will elicit tears, if not serious thinking—should be cause for alarm rather than applause.

You could write a real tragedy, a Greek tragedy, about September 11 and what it has led to—a story with a true Aristotelian arc, a drama with a beginning that leads organically to a middle that leads organically, reasonably, to its inexorable end. This tragedy could, for instance, be about the seemingly inevitable way in which even the greatest empires can be thrown into confusion by a small number of enemies whose ideological fervor makes them unafraid of death. Or it could be about a specific empire, one whose contemptuous refusal to take its enemies seriously has made it deeply vulnerable. Or it could say something about a foolish and unseasoned ruler whose desire to outshine his more accomplished father has an unfortunate effect on his policymaking, with the result that he ends up seeming even more foolish and unseasoned in comparison to his father. Or it could be about the seemingly irreducible strangeness of the West to the East, and vice versa. Or it could even be a kind of black farce (a genre not strange to Greek tragedy) about the injustices of power—about a ruler so inept that he brings his country to ruin and yet never suffers, personally, for his errors. You could write such a tragedy today and to some people, at least, it might have a larger meaning. But then, someone has already written such a play; it's called *Persians*.

It was on the Thursday after September 11 that *Persians* first started making sense to me. All those years I'd been teaching it, I'd failed to notice the most obviously remarkable thing about it—the device that transmutes the raw and chaotic stuff of lived history into something bigger, something with a universal resonance. As I have said, the play was produced a mere eight years after the Greeks' fabulous and unexpected victory over their immense foe. How much more striking, then, that Aeschylus—who, it's perhaps necessary to point out, fought in the Persian Wars himself and lost a brother, called Cynegirus, in the aftermath of the great triumph at Marathon, a death that would become a popular talking point in the later Greek rhetoric about heroism—should have chosen to focus his imaginative sympathy not on the exulting Greeks, but on the sorrowing Persians. Which is to say that, in the very moment of their greatest victory, he asked his fellow Athenians to think radically, to imagine something outside of their own experience, to situate the feelings they were having just then—about themselves, about those others—in a vaster frame: one in which they might see

that present triumph could induce a complacency that just might bring about future disaster. The sense of these larger, moral themes hovering over the play's spectacle is, in the end, what gives the drama a resonance that transcends the particulars of the history it purports to represent. No wonder the Athenians, for whom tragedy was a form of political dialogue as well as popular entertainment, gave it the prize that year.

Lucky Athenians. There's a point in *World Trade Center* when the square-jawed Marine, who apart from being an all-American patriot is clearly deeply religious, too—one of our first glimpses of this hitherto unexplained character is of him sitting in a church pew, staring fervently at an enormous crucifix—arrives at the disaster zone and, peering through the ghostly smoke and soot, says to another would-be rescuer, "It's like God made a curtain with the smoke, shielding us from what we're not yet ready to see." There's shielding going on in this film, but I'm not so sure God's behind it. A title at the end of *World Trade Center* informs you that, after rescuing the lucky Port Authority cops, the Marine went on to serve two tours of duty in Iraq; the clear implication is that he has nobly risen to his own earlier challenge—that he is, in fact, one of the "good men" who went on to "avenge this." But of course, as we all know now, Iraq had nothing to do with the attacks on the World Trade Center, and so that bit of "vengeance" was misguided, to say the least—a fact the title card omits to mention. And so, five years later, the film asks you to make the same fuzzy, unthinking link between the two events that certain people were asking you to make at the time it all happened. However much they seek to illumine what happened on September 11, the films of Greengrass and Stone are, in the end, more like curtains than windows. For the present, at least, we still can't bring ourselves to look.

—*The New York Review of Books*, September 21, 2006

Acknowledgments

The acknowledgments on the last page of this collection most appropriately take the form of an explanation of the dedication to be found on the first; in keeping with the strictures of my dedicatees, I'll keep this short. Every working writer knows exactly how much he owes to his editors, and I think it is fair to say that few working writers have been as privileged (*lucky*, I can hear one of them saying) in their editors as I have been in mine—both official and unofficial. To the former category belong Chip McGrath, who as the editor of *The New York Times Book Review* gave me my first serious berth as a critic, and from whom I learned more about reviewing, and writing, and indeed literature in general than I could begin to say here (and with whom it was always a good time, too); and of course Bob Silvers, whose trust in and generosity to me from the beginning of my relationship with *The New York Review of Books* have been more than I ever hoped for and mean more to me than I can say. As the provenance of most of the pieces in this collection clearly indicates, I owe him my career. This book is, in many ways, his.

As for "unofficial": I never wrote for Bob Gottlieb while he was running a publication, but it is safe (and true) to say that I have, nonethe-

less, been writing for him my entire professional life from almost the moment I finished graduate school and arrived in New York, in 1994, to start my freelancing career, which also happened to be the moment I met him. From the start (as he likes me to write), he was a treasured mentor: generously reading and rereading, correcting, prodding, line-editing, everything-else-editing, shaping, and always improving pretty much everything I wrote, from the Ra-Men noodle days of QW and OUT on through everything else. Along the way, he's become the greatest of (as he likes to say) my "great friends." There's no question in my mind that whatever's strong in my writing is largely due to his teaching (and, as he and I both know, that what's not so great is due to the times I didn't listen to him). I couldn't be more grateful to him.

I am, as I so often have been, happy to acknowledge my gratitude to Tim Duggan, for shepherding this project with his usual professionalism, enthusiasm, and grace; to Allison Lorentzen, for dealing with countless bundles and phone calls with her usual expert aplomb; and of course to my agent and friend, Lydia Wills, who since 1994 has made it her job to know everything I write as well as I do, and who for that reason was a particularly precious help during the ongoing process of *krisis* necessary to assembling this volume. Without her judgment, I'd be lost.

ALSO BY
DANIEL MENDELSOHN

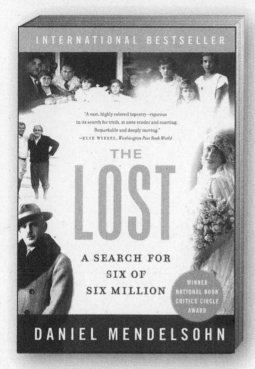

"Poignant and heart-rending."
—*USA Today*

"Mesmerizing . . . Mendelsohn's accomplishment is enormous."
—*The Los Angeles Times Book Review*

"Hugely ambitious yet intensely engaging."
—*The New York Times Book Review*

ISBN 978-0-06-054299-3 (paperback)

In this rich and riveting narrative, a writer's search for the truth behind his family's tragic past in World War II becomes a remarkably original epic—part memoir, part reportage, part mystery, and part scholarly detective work—that brilliantly explores the nature of time and memory, family and history.